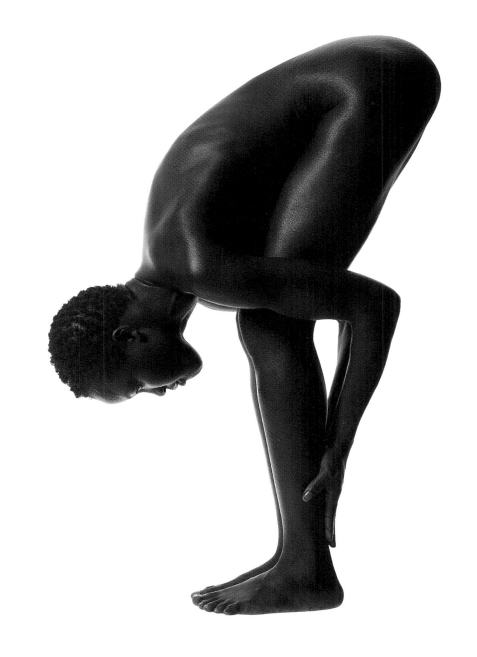

ANATOMY
FOR THE ARTIST

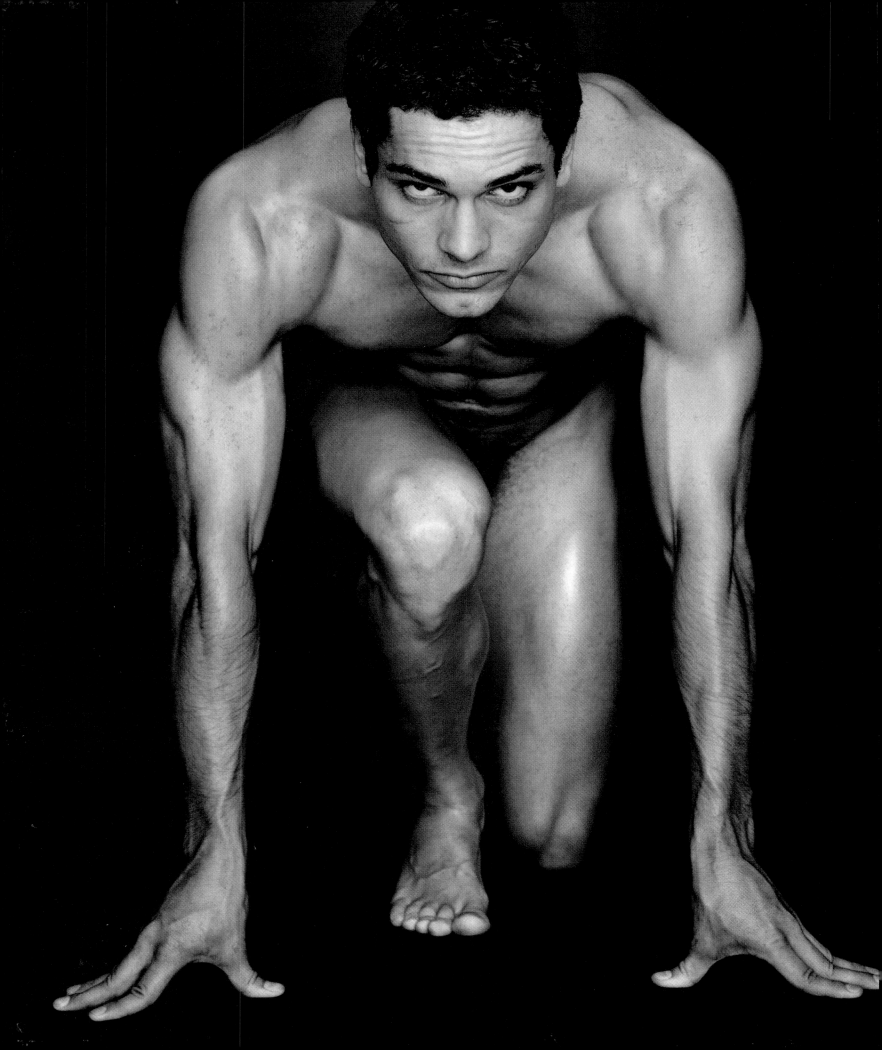

ANATOMY
FOR THE ARTIST

SARAH SIMBLET

PHOTOGRAPHY BY JOHN DAVIS

DK PUBLISHING

LONDON, NEW YORK, MUNICH,
MELBOURNE, DELHI

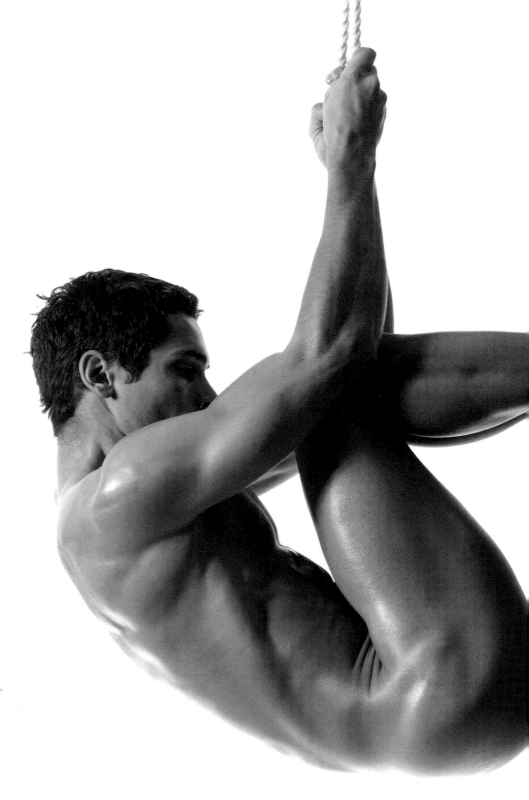

Category Publisher Judith More
Art Director Janis Utton
Design XAB Design
Senior Editor Heather Jones
Editor Mary Davies
Designer Louise Pudwell
Picture Research Anna Grapes
DTP Designer Sonia Charbonnier
Production Controller Melissa Allsopp
Production Manager Sarah Coltman

First American Edition, 2001

12 11 20 19 18
033 AA056 Sept/2001

Published in the United States by
DK Publishing, Inc.
375 Hudson St.
New York, New York 10014

Copyright © 2001
DK Publishing

*This book is dedicated to May Nelson, my grandmother,
whose gifts of clarity, courage, and wisdom will always be
remembered.*

A Cataloging in Publication record is available from the
Library of Congress

ISBN-13: 978-0-7894-8045-3
ISBN-10: 0-7894-8045-X

Reproduced by GRB Editrice, Verona, Italy
Printed and bound in Singapore Tien Wah Press.
D.L TO: 629 - 2001

See our complete product line at
www.dk.com

CONTENTS

INTRO

DUCTION

The study of human anatomy is so much more than the naming of parts and the understanding of their function; it is the celebration of our wondrous physicality in the world. The biological complexity of the body can be weighed against its aesthetic beauty, so that the life that drives us is seen to ripple and pulse above and below the boundary of skin. Art is the perfect tool for revealing such knowledge. Throughout history, artists have used their trained eyes to look deep into our lives and into our very existence. They have given much to the history of medicine and they have also removed the taboo from seeing too much.

THE ART OF ANATOMY

The body has always been a core subject for the artist, be it to honor God, or to question and doubt the very nature of humanity itself. Artists and anatomists have for centuries shared their views and have contributed equally to our knowledge. I have had the pleasure of teaching anatomy through drawing to a wide spectrum of artists – beginners and professionals, young and old, in schools, colleges, universities, and evening classes. The excitement and sense of achievement evident in learning about the body is always a palpable delight; to gain the ability with a pencil or pen to catch the perfection of form and reveal its magnificent machinery is highly rewarding. Anatomy is a very potent subject, and the subject is us.

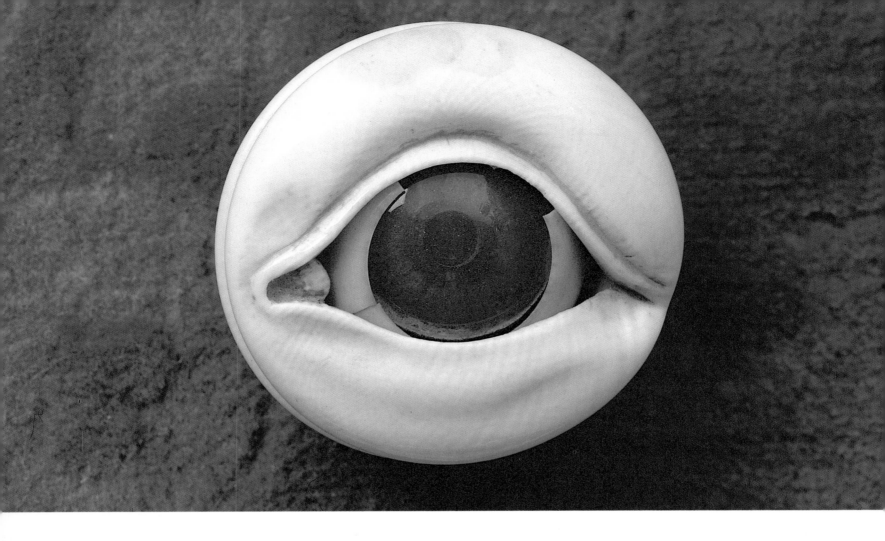

THE ART OF ANATOMY A BRIEF HISTORY

The very early history of anatomy is embedded in tantalizing myth, where its facts are fragmented and obscured. The ancient Egyptians knew much, and pictured even more, yet few records survive of the anatomical knowledge they must have accumulated in the process of mummifying more than 70 million of their dead. Investigative dissection appears to have begun in China as early as 1,000 BC. The ancient Greeks also made tentative explorations into the interior details of human form. However, many, including Aristotle, confined themselves to the dissection of animals; and confusions between animal and human anatomy led to numerous astonishing theories, some of which survived totally unquestioned until as late as the sixteenth century. More importantly, the ancient Greeks produced speculative views of the body and its mysterious workings that are rich in ontological potency.

The history of factual anatomy begins with the Ptolemaic school of medicine, founded in Egypt circa 300 BC. There, human dissection was practiced intensively. So much so that censorial figures of later history, including Saint Augustine, laid accusations of horrific practices (namely human vivisection) upon the heads of these pioneers.

Claudius Galen (AD 129–201) is the most dominant figure in early European anatomy. He was a medical officer to gladiators in the Roman Empire, and later physician to the emperor Marcus Aurelius. Galen was a prolific writer, boasting the employment of 12 scribes to record his voluminous human anatomical research, much of which was based upon the dissection of pigs and apes. This enshrined dogma was set into a ritualized performance that crippled the development of anatomical knowledge until the Renaissance. In the Middle Ages, translations and derivations of Galen's works were read from a pulpit, while below a barber cut open a body, and a demonstrator pointed with a stick to the salient parts. These events were always of great interest to the general public. During the late Middle Ages, the dissection of noted criminals often took place at a carnival, sharing their audiences with

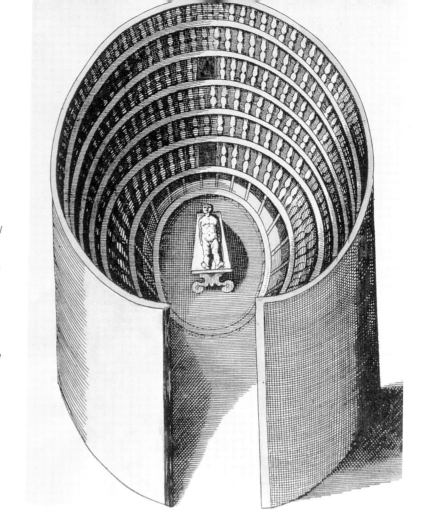

executions and street-staged morality plays. In Bologna they erected temporary scaffolds and tickets may have been sold for the event.

The first anatomical theater, built at Padua by the anatomist Hieronymus Fabricius ab Aquapendente in 1594 (see above), changed much, by placing dissection firmly inside a new academic framework. Here, the philosophical pursuit of anatomy became attached to the growing respectability of medicine. By the end of the sixteenth century, anatomy had become a fashionable scholastic enterprise, and centers at Padua, Bologna, and Leiden attracted many of the brightest minds in Europe. The enclosure of anatomy both educationally and architecturally gave it a new status and established a protected place where fresh ideas could grow. However, the theatrical drama attached to the subject continued for some time.

In 1597, a very similar theater to the one in Padua was built at the University of Leiden inside a derelict church. In one engraving dated 1610 (not shown),

the tiered seating in the theater is occupied by both the living and the dead. Skeletons of animals, birds, and humans stride about, some holding banners to remind visitors of their mortality. The Latin inscriptions on this print, translated as: "Know thy self," "We are dust and shadow," and "Being born we die", direct our attention to an outstretched and eviscerated corpse beneath a sheet at the center of the scene. The image reads like a bizarre political rally or the middle act of a surrealist play.

It is in fact a record of two different times and functions within the theater's annual cycle. The dissection of human bodies was a seasonal activity. Icy winters kept a cadaver fresh and gave the anatomists time to work. The body was placed on a revolving table at the center of the theater, and the audience was packed into the stalls. In the heat of summer, dissection was impossible, the table was removed to make a standing space and the stalls were filled with curiosities. The church became a *Kunstkammer* (a cabinet of wonders), the genesis of The Museum.

Medieval anatomical manuscripts contain often fanciful diagrams of bones, muscles, veins, arteries, or nerves. This graphic tradition was based upon the repeated copying and embellishment of previous images, not observations of real bodies. Leonardo da Vinci read the ancient texts of Galen, consulted leading anatomists, and performed his own dissections and research. This drawing of a female body stands at the gateway between maplike medieval stylization and the solid, lifelike anatomies of Renaissance art. The upper torso is drawn as a solid form. Space on each side of the liver and stomach suggest their containment by ribs. Surrounding the uterus, major vessels are carried straight through the pelvis as if the bone is absent. At this point the form of the body dissolves into a diagrammatic outline, subservient to the study of visceral parts. This drawing repeats the ancient error of amalgamating human and animal anatomy, and presents a marvelous and fictional bicornate uterus.

Leonardo da Vinci, *Dissection of the Principal Organs and Vascular and Urio-genital Systems of a Woman*, c. 1510

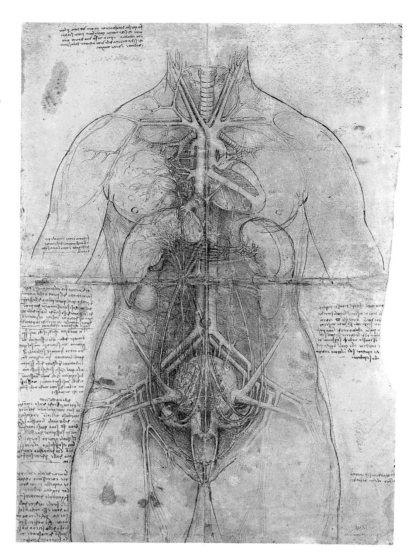

Leonardo da Vinci established methods of studying and representing dissection that are now so widespread it seems as if they have always existed. He recommended that the body be treated from the inside out, and built up in ordered layers. This study of the shoulder shows his method of reducing muscles and tendons to fine threads, the better to show their layered attachment to bone. Leonardo dissected with a form of scalpel, and drew with pen and ink, using these tools to first define and then reinvent the interior of the body. Both tools are fine metal blades, which mirror each other – one adds while the other takes away. The scalpel gently opens, dismantles, and defines structures deeply concealed within the body. It strokes away fine fibers and draws out each linear contour. Like a scalpel operating in reverse, the pen cuts through the illusory space of the paper, laying down ink to reveal a similar form to the dissection. The pen is used to edit and rebuild the dissected body, often retracing marks and divisions made earlier by the scalpel.

Leonardo da Vinci, *Anatomical Studies*, 1510

Leonardo da Vinci's place in the history of art and anatomy is unique. The detailed observations and speculations that fill his notebooks are both inspirational and startlingly original. His studies were driven by intense curiosity.

Working privately, outside any institution, he dissected subjects to look at and map the body anew. His knowledge of mechanics, architecture, and engineering guided his understanding inside the body. Leonardo saw structures that demonstrated how the body should work; and although not wholly accurate, he invented a new attitude and mind-set that carried the subject forward to greater heights. These are the drawings of a thinking hand; they are views into the mystery of humanity that are guided equally by imagination and objective dissection. The level of detail in his work asks for greater insight, the level of imagination demands that we see the physical structure of the human body in relation to other things in the world.

His interpretive drawings remain unparalleled in their invention of a living dissected body (see glossary). They are not perfect guides to the interior of man, but a visual testament to the power of creative thinking.

His drawn conjectures locating the human soul at the center of the skull, and his vision of the turbulent, fluid power of blood in the heart will motivate and influence artistic invention forever. Leonardo wrote extensive notebooks and planned a study of man. His knowledge was considerably in advance of contemporary science. This is because descriptive anatomy did not even begin until Galenic anatomy was overthrown by the work of Andreas Vesalius in his magnificent treatise *De Humani Corporis Fabrica*, published in Basel, Switzerland, in 1543 – 24 years after Leonardo's death. However, Leonardo contributed nothing to the development of science, and was overtaken by Vesalius because he did not complete or publish his work. After his death his notebooks passed through generations of private hands, remaining largely

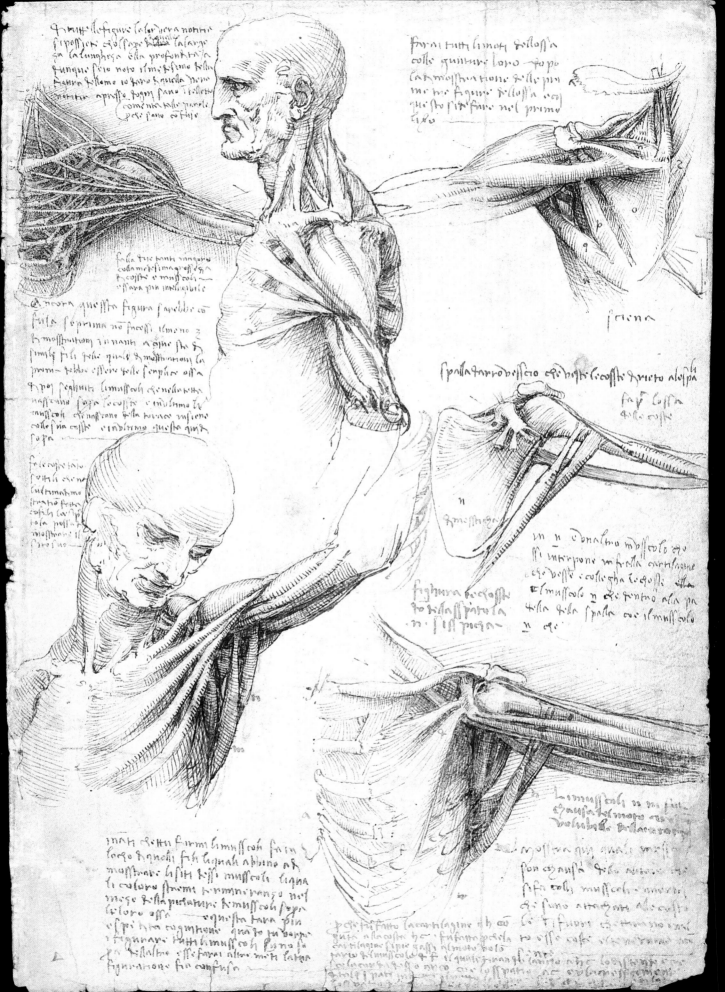

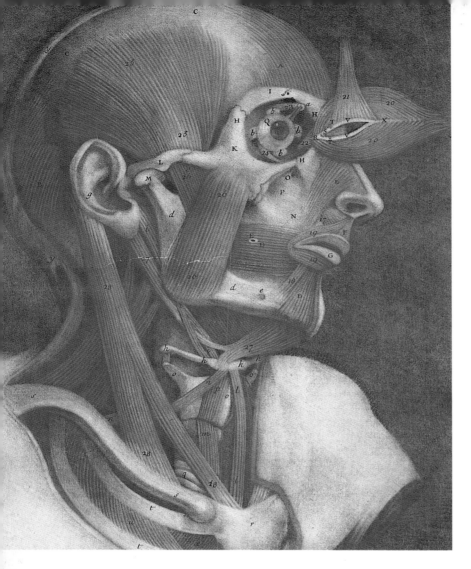

unknown for 300 years. They were not published in facsimile edition until the late nineteenth century. In spite of this, they are still universally regarded as the finest anatomical drawings ever made, and when they finally came into view they had a great impact on the representation of the body in nineteenth- and twentieth-century medicine.

In the twenty-first century, the subject of human anatomy continues to fascinate and inspire artists. Its very recent rise in popularity has many contributing factors, but perhaps one of the strongest is the subject's own demand that the artist use their imagination to visually translate hidden secrets that exist within us all. And how much more exciting is this than the often tired life-room nude drawing class? The wonderful images that bejewel this introduction exalt the power of human imagination. They elucidate the physical mystery of the body with a visual erudition that is original, extraordinary, and relentless in its ambition to evolve. The bodies here that have been peeled or cleaved, fragmented and exposed, do not present

themselves to us amid the trauma of violence, nor in the triumph of death. They occupy a carefully devised life that is at once immortal and eager to demonstrate the glory of its disrepair.

An excellent example of this is seen in the mezzotint right, by the eighteenth-century French artist Jacques Fabien Gautier d'Agoty. It represents a young woman seated with her back decoratively unfolded toward us like great Egyptian silk fins. She turns her head with lowered eyes as if to acknowledge our admiration, and the artist has brought us to stand so close that we are made present, and implicated. As if at her request, we have just unbuttoned her body, relieving her of this heavy gown of flesh. Rich in its qualities of intimacy, sensuality, and engagement with space, this image elegantly shows how muscles of the spine, shoulders, and lower back might, like an expensive and complicated garment, peel away from the ribs in a single movement. Calm and dismay are seamlessly married without a hint of paradox to lure and trap our gaze, as we are given time and permission to

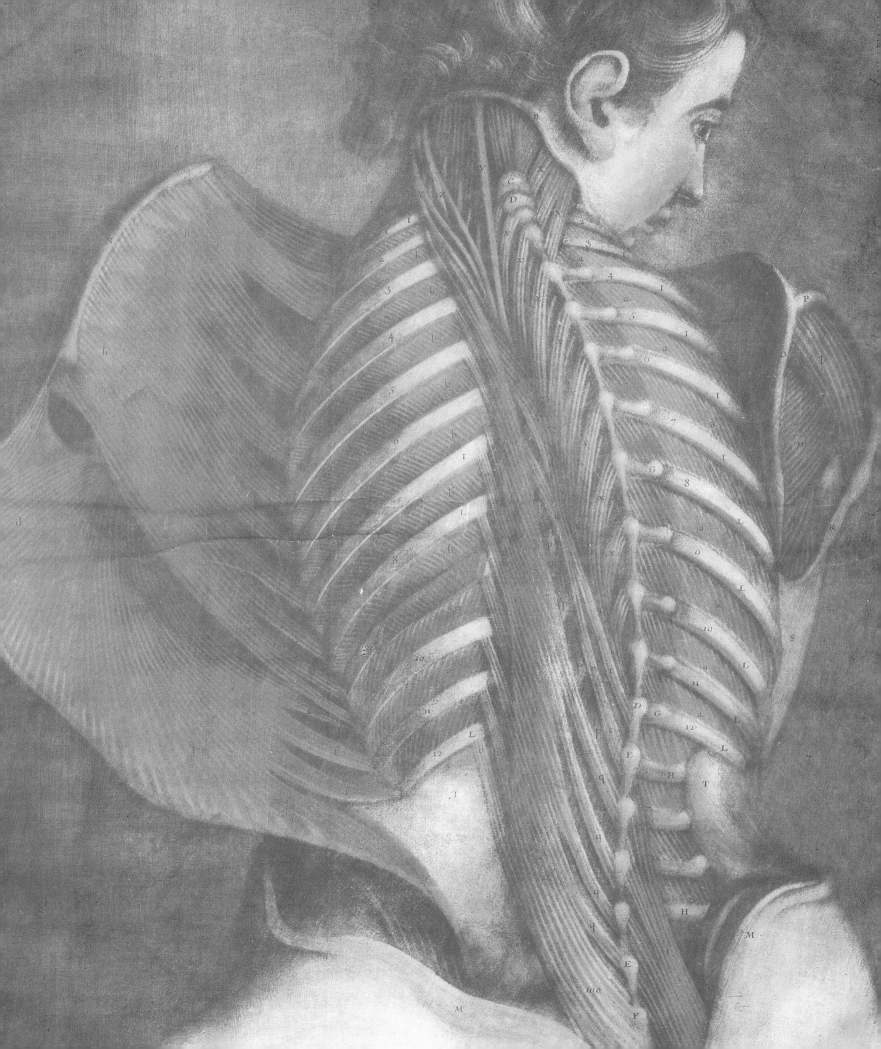

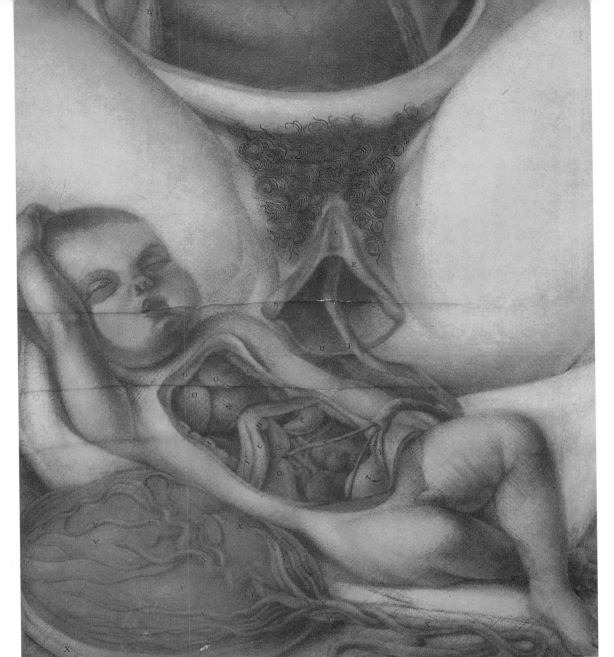

LEFT

Medieval anatomical manuscripts often present a stylized series of six squatting, froglike human figures: bone-man, muscle-man, vein-man, artery-man, nerve-man, and pregnant-woman. For many centuries the female body was considered an inferior form, almost always reserved for the display of visceral organs, pregnancy, childbirth, and sexual difference, while the male body displays the full scope of all other systems. Obstetrics was significantly advanced during the eighteenth century, and many artworks were produced. Among the finest and most sensitive are the drawings of Jan van Riemsdyck, who illustrated The Gravid Uterus *by William Hunter. Anatomical wax collections such as La Specola (pp. 21–23) devoted great attention to the study of obstetrics, and particular representational programs were developed. Often the lower limbs and upper torso are removed, presenting only the central portion of the body. It is also more usual for cloth, books, or other devices to be placed so as to veil the woman's modesty.*

J. F. Gautier d'Agoty,
***Anatomical Study*, 1746**

closely examine the interior of her winged torso. Notched levers of the spine gleam brightly, where we could imagine buttons were placed before.

Subtle differences between images belonging to the Western histories of anatomy, pathology, and surgery seem to reflect the historical position of anatomy as the more noble and ancient art. Disease and disorder were for a long time seen as punishment from God, to be healed through prayer and intercession, rather than the examination, collection, and comparison of affected parts. Anatomy describes the interior of a perfectly formed body, pathology investigates what can go wrong, and it is the role of medicine and surgery to heal it. These roles divide traditions of representation within

medical art and display. Pathological specimens are normally disconnected from the whole body. They are preserved or illustrated plainly, as part of a catalog of abnormality, disease, atrophy, and malfunction. Surgical displays are concerned with healing the body and must convey technicalities as methods of procedure. Where a patient's body is represented, it is nearly always passive or a victim, overlaid with directive hands and tools. Anatomical artworks present the opposite – they use life to illustrate the wonder of its own mechanism. They intrigue, beguile, and astonish us, and sometimes shock us with their frankness. In the modern world, human dissection is carried out under the guidance and protection of strict laws and regulations of conduct. Governments and medical professions have together

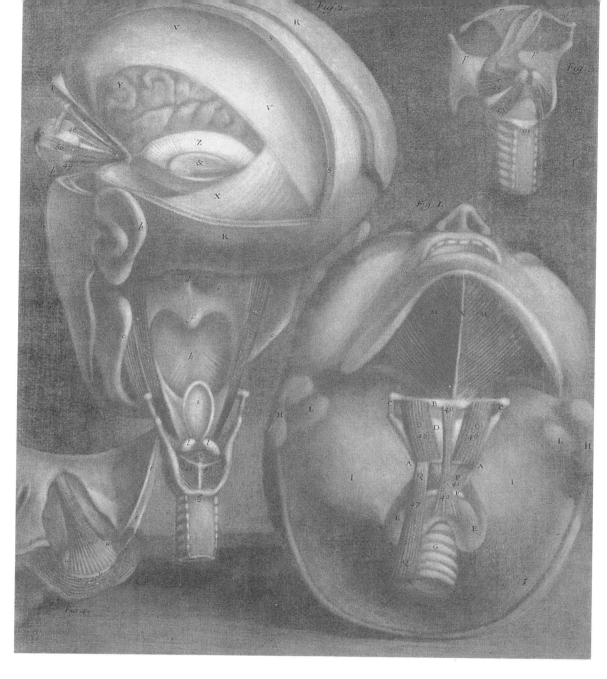

carefully constructed an air of trust and morality, greatly distanced from the earlier periods of terror and malpractice through which anatomy grew. The modern cadaver is obtained and cared for within a tight legal framework. This makes it possible for members of the public to feel both comfortable about and committed to bequeathing their own bodies. Through a system of donation, more subjects are available now than at any other time in history.

In the past, many of anatomy's finest artworks, including some of those reproduced here (pp. 20, 22), were commissioned to raise and distance the "noble study" from the distasteful proximity of the corpse, whose presence at the center of anatomy has been more closely attached to fear

and a powerful hatred of state punishment, than the universally beneficial pursuit of knowledge.

Thomas Vicary, surgeon to Henry VIII of England, persuaded the king to unite the London Guilds of Barbers and Surgeons in 1540. He was elected their first master, and in the same year they were granted four hanged criminals (per year) for dissection. Execution, followed by the public opening of the body was at this time the most feared sentence – a penalty usually reserved for murder or treason, and viewed as a fate worse than death. During the last years of Henry's reign, execution scaffolds worked ferociously, dispatching an average of 560 people each year. But the fact

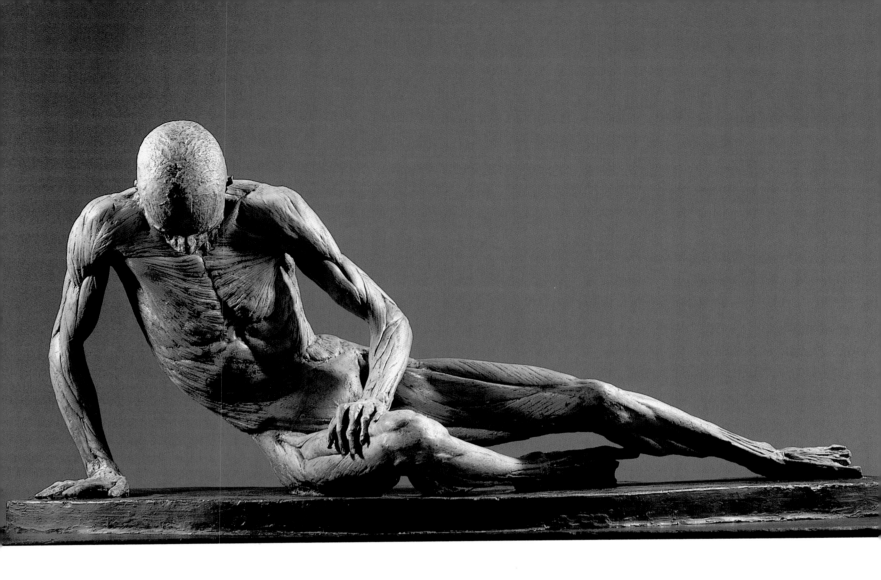

that such a majority of victims were deemed innocent enough to be spared the explanatory knife confirms that while one might have been hanged for a misdemeanor less than theft, dissection was not, in its early history, a threat to the general public.

As the science of anatomy expanded, so did its demand for subjects. The dawn of the eighteenth century saw a desperate shortage of specimens in centers such as London and Edinburgh, where private anatomy tuition was beginning to thrive as a lucrative business. Few bodies could be legally retrieved from the gallows or authorities. Corpses became a profitable commodity, and the shallow graves of paupers offered a rich vein. The earliest grave robbers were surgeons and their pupils, but fear of public outrage and loss of reputation soon led the medical establishment to employ resurrectionists; body snatchers were paid handsomely with no questions asked for each corpse that they delivered to the back door of the medical school or eminent surgeon's house.

Methods of anatomical preparation were significantly developed during the nineteenth and twentieth centuries. These are now highly refined, and the public has been encouraged to donate its own bodies to medicine. Donation is now sufficiently popular for all departments to be highly selective in their choice of suitable subjects. A visual index of the body created from two cadavers (male and female) is even available on the Internet. The Visible Human Project, USA, enables the viewer to use their mouse as a scalpel.

However, the taboo of seeing the interior of the body is still affected by its history. Something of the primal fear of the dead, and the distaste of the historical misuse of corpses has woven together, and can still sometimes outweigh the wonder of enlightenment. Professor Gunther von Hagens' astonishing and yet controversial exhibition, *Körperwelten*, currently tours major international venues, bringing an intensely detailed anatomy education to the general public, and attracting record numbers of visitors. This show embodies and unites notions of display and donation in a way that brings

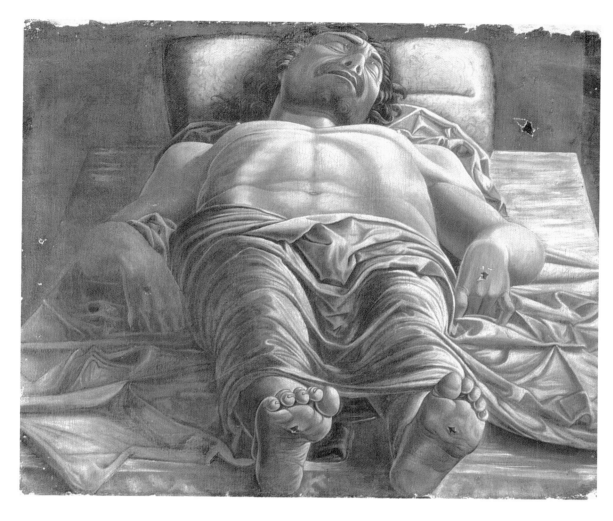

both processes full circle. Together with small teaching specimens (pp. 42, 43), von Hagens exhibits whole dissected, plastinated (see glossary) human bodies, set in familiar poses as sportsmen and women, and figures from classical and modern art. At the exhibition exit is a rack of printed papers – legal forms for donation. Visitors may and often do agree to become part of a future display by bequeathing their body to von Hagens' Anatomy Institute. Willingly, they will join the growing caravanserai of sculptured cadavers that demonstrate their art of anatomy.

The eighteenth century saw the greatest proliferation of anatomical art. The expansion and refinement of printing technology fuelled a widespread distribution of new knowledge. The most profoundly influential printed atlas to follow the works of Vesalius was *Tabulae Sceleti et Musculorum Corporis Humani*, published at the University of Leiden in 1747. The atlas was the unified work of artist Jan Wandelaar and eminent scholar and anatomist Bernard Siegfried Albinus, whose friendship and collaboration lasted more

than 30 years. Each of the 28 engravings composing this volume (p. 20) displays a level of precision, elegance, and care that is rarely matched, and never surpassed in the history of anatomical illustration. Dissatisfied with the prevalent tendency among anatomists before him to begin with the skin, and then present successively deep layers, Albinus (as Leonardo before) began with the skeleton and built the body from its architecture of bone. His diary tells of how he soaked the ligaments of a prepared skeleton in vinegar to preserve them, how the body was suspended within a frame of delicately adjusted ropes that filled the room, and how this froze in winter ice until the life model employed for comparisons would not, and indeed could not, stand without a fire.

Albinus and Wandelaar devised scenery to complete each plate, with exotic animals, botanical specimens, classical ruins, and the occasional cherub flying amid billowing silk. Designs of great beauty and elegance, they were fitting to the ideals, interests, and social pursuits of the refined eighteenth-

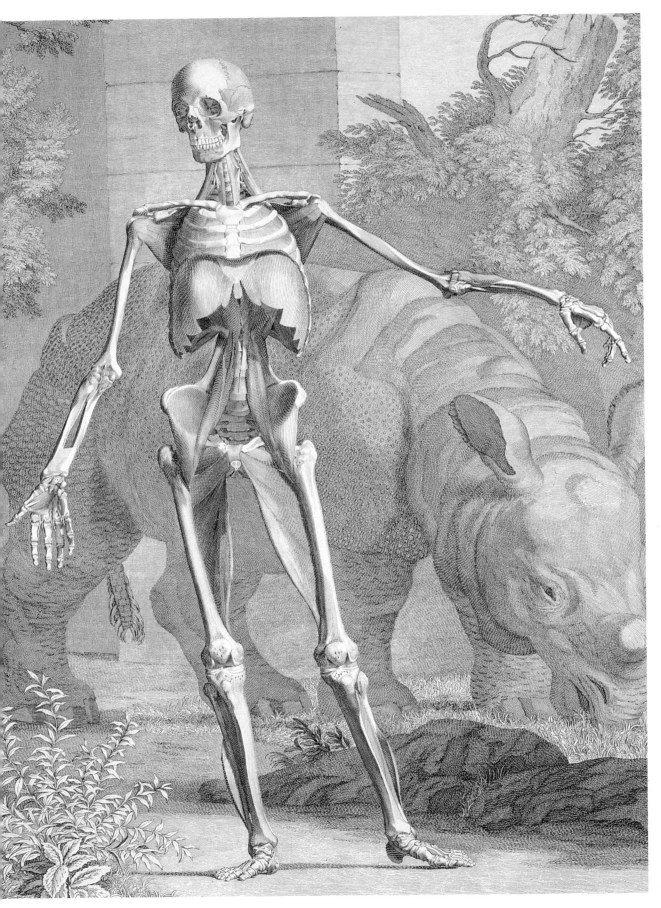

This is the proud gesture of a hollow man in his yard, where he struts and poses the hubris of his anatomy and defiant life. The walking cadaver displays itself with elegance, in a believable space where light and shade lend its body a solid stance. This is one of 28 beautiful images, highly significant in the power and grace of their visual imagination. These striking and unforgettable skeletons who grow layers of flesh, as they pass through shadow-filled arcadian boughs, were made for utilitarian purposes. Their poetic eeriness, which has since influenced generations of artists, seems curiously to have been a side effect in their original production.

Bernard Siegfried Albinus, *A Skeleton,* **1747**

RIGHT

Sometimes the balance between the fact and drama of an image becomes biased. The Cattani foot is a prime example. The visual power of this engraving is so convincing that any anatomical inaccuracies may be overlooked. A great part of its strength comes from its monumentality. This single foot fills the page with an architectural presence reminiscent of the massive fragments of ancient Greek sculpture that were shipped to Rome so that artists might study their perfection and draw their grandeur. This foot has the weight and authority of stone, while displaying the finer details of transitory dissection. The engraving plays with contradiction to keep our attention focused – the inclusion of the well-used and frayed string that tilts the foot for our inspection inserts an ad hoc detail that tethers the whole image to a moment. Osteografia e miografia della teste, manie piedi was published as a folio of 20 plates by the press of Antonio Cattani and Antonio Nerozzi in 1780. The plates had been previously released as single prints by subscription.

Antonio Cattani, *Muscles and Tendons of the Dorsum of the Foot,* **1780**

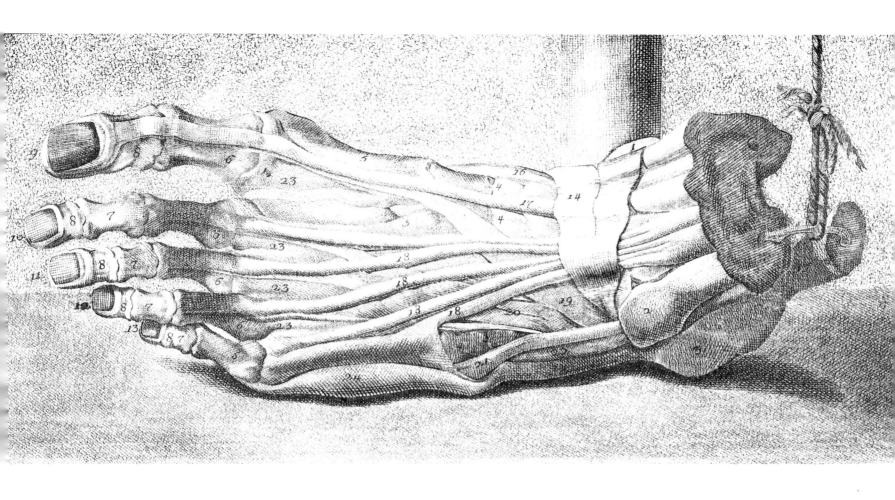

century Dutch gentlemen. The English edition was sensitively reproduced by the engraver Charles Grignion in 1749. Influential throughout much of Europe, Albinus and Wandelaar's work was to have its greatest consequence in Florence, where it inspired the character, detail, and modeling of the world's most outstanding collection of anatomical waxes.

The gently bemused flayed man that looks out wistfully from the next page (p. 22) is a cousin, if not a brother, of Albinus's walking *écorchés* (see glossary). He stands at the heart of Museo Zoologico della Specola at the University of Florence, together with more than 800 life-size models sculpted from dissection between 1771 and 1814. These masterworks in wax were devised and created by Felice Fontana in long-term collaboration with Clemente Susini and with the assistance of Paulo Mascagni.

La Specola was funded by Grand Duke Peter Leopold of Lorraine, upon the persuasion that it would secure an end to the social, political, moral, and religious problems of legalized dissection in Florence. The collection was created as an investment in an ideal future of anatomical teaching. To

achieve this, artists would attempt to develop a colder, more detached view of the dissected corpse. However, the obsessive, highly imaginative eye that shapes La Specola is far from objective. Boxed rows of severed, dismantled heads and upper thoraxes turn and posture within their cabinets. They each observe their viewer as they politely tilt their heads to expose the sinuous undercarriage of their throat. Separated limbs rest for observation, but retain an uncanny freshness which is both shocking and marvelous.

At the center of each room are glass cabinets that contain full-length anatomized wax figures who disport themselves in an appearance of life, seemingly animated and in control of their environment as they display different aspects of their dissection. The walls of one small room are filled with wax bones surrounding a wax skeleton sitting up in its glass vitrine, demonstrating an intricate web of fibrous ligaments. Modelled with a little more than just the cartilages of its nose and ears, but no other flesh, there is some pathetic humor in its smile, as if it has just pushed itself up onto its elbows, honor bound to greet yet another visitor. Its smooth bowed limbs droop to betray the demand of too many hot summers and very old age. In

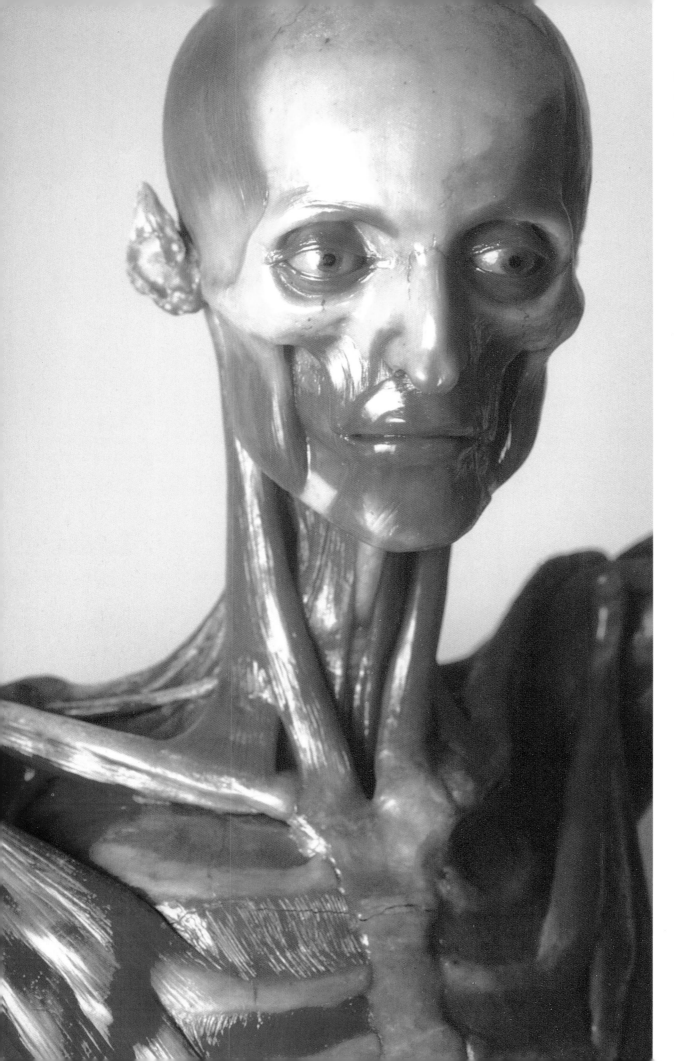

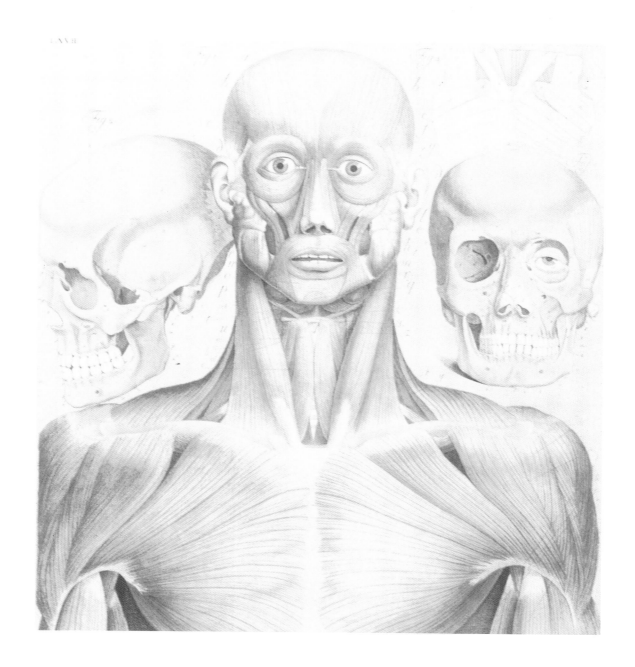

another room, three parallel cabinets contain life-size reclining women – young, beautiful, and entirely naked, wearing lace bridal veils and wigs of long blonde hair. Each raises one thigh to slightly cross the other, and their arms reach down by their side to clasp their silk bed or else lift their braided hair. Each of their bodies has been opened to release a flowering of bright viscera, and they tilt their heads to smile faintly at their viewer. The detailed realism and erotic allure of a similar set of these figures was so convincing that they became broken and crushed under the drunken embraces of maurading Napoleonic soldiers. La Specola was so greatly admired that complete copies of the exhibits were commissioned and sent abroad. Napoleon ordered a collection for Paris, and in 1786 a 1,200 piece replica was transported to Vienna across the Alps, on the backs of several hundred mules. Other wax collections were greatly influenced by La Specola, especially the nineteenth-century Spitzner collection, which traveled and was seen in Belgium and France. It had a heightened dramatic element, where anatomical specimens were mixed with proto-ethnography and elements of side-show abnormalities. The Spitzner collection directly influenced members of the surrealist movement and excited the contemporary imagination that was coming to terms with Freudian interpretations of the world. In 1971, the surrealist painter Paul Delvaux still talked about this disturbing, strange, and beautiful exhibition that once influenced his vision.

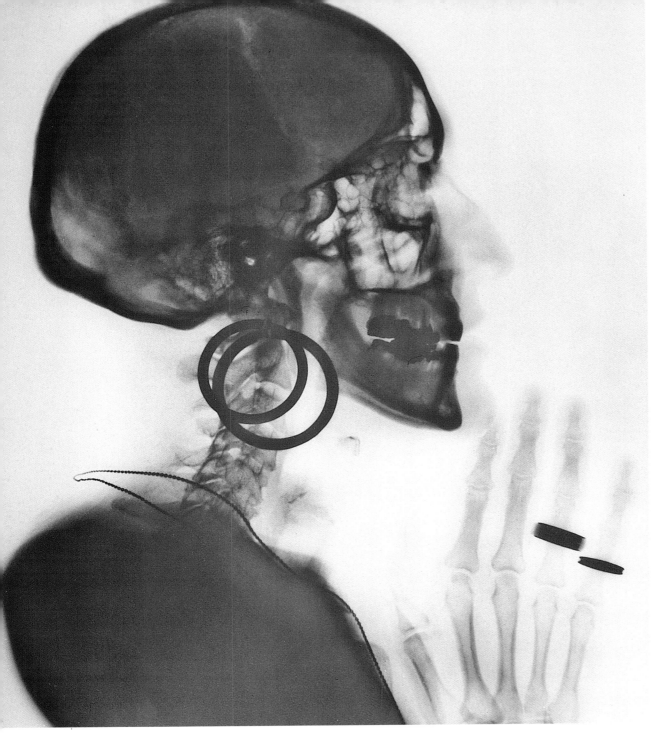

LEFT

This image is strongly reminiscent of early published X-ray photographs taken of Egyptian mummies, where jewellery, Shabti figures, and other talismanic emblems are enclosed within the mummies' bindings. The enigma of this work seems very like Oppenheim's other great and widely reproduced image of a fur-covered breakfast cup and saucer. The resonance of surrealist humor is clearly defined and pointed in these works. Some contemporary artists are now using techniques such as MRI (magnetic resonance imaging), thermal imaging, and computer reconstruction to make portraits of their internal structure, and indeed to physically map their thoughts and dreams. The use of medical technologies to expose new versions of ourselves is an attractive and unpredictable tool in the hands of artists.

Meret Oppenheim, *X-ray of a Skeleton*, 1964

Because artists chronicle and illuminate all aspects of the human condition, it is natural that many give images of the body a macabre or sinister aspect. The violence of conflict, illness, and abnormality have been potent in the artistic imagination throughout history.

Contemporary art often uses the shock of the exposed body to make its point. However, there are a number of artists working today whose fascination with the human interior is centered in awe and the enigma of life itself. These artists use aspects of the figure expressively, to confront issues of mortality, identity, gender, and race. Meret Oppenheim's *X-ray of a Skeleton*, 1964, is a witty and elegant self-portrait in the European *vanitas* tradition, where the presence of life and death share the same moment, the same stage, without anxiety or morbidity. Her beautiful X-ray cameo shows the artist herself in full costume dress with earrings, a necklace, and rings. These intimate items have the same opacity as her bones, etched into a very rich dense black. The everyday fleshier features of her face and hands are

It is interesting to compare Access to the
three acid-corrosion-cast medical specimens
shown on pages 42 and 43, produced
separately by Thompsett and von Hagens.
There is a strong superficial resemblance in
their tracery. They each draw organs of the
body by delineating their absence. But
between them, we can see the essential
difference between illustration and art. The
acid-corrosion casts are superb models of
another object, or substance, grown out of its
demise. This gives them authority and a
sympathetic power in their process that is
almost poetic. The corrosion casts present the
crafted art of an object. Cattrell's breath made
solid is poetic in both its concept and in its
task to conjure our experience of the world, to
question rather than illustrate substance and
mortality. This is art, that is also an object. The
problem of significance is one that has been
hotly debated between artists and craftspeople
for many years.

Annie Cattrell, *Access*, 1998

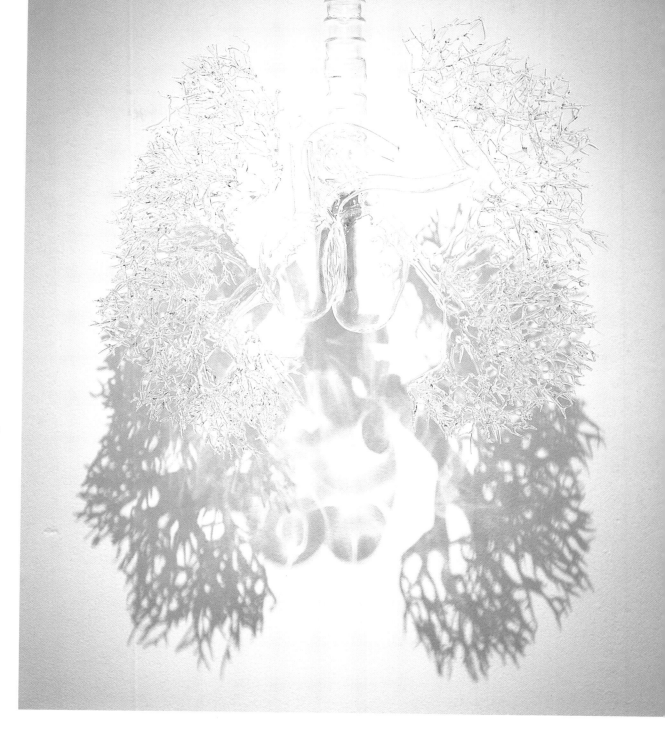

poised in a more delicate ethereal shadow that flutters with life, and the whole image seems set in a vivacious moment of conversation – an icon more of a cocktail party than a medical screening.

The shadow cast by Annie Cattrell's *Access* echoes a similar ambiguity of solid and reflection, object and ghost. Only here, the shadows seem more substantial than the lungs and heart of glass that cast them. *Access* is about one of the invisible or unconscious roads into our body, a delicate and erudite sculptural presence of the hidden. Annie Cattrell has used her own breath to blow a glass trachea, fine bronchia, and the chambers and leading blood vessels of a heart. Carefully channeling her concentration and skill, she has heated, bent, and fused brittle laboratory glass into a transparent tracery of breathing. Here the artist's process makes an analogy between drawing and surgery, constructing a paradoxical artwork that uses rigidity and light to describe and evoke two of the most essential and automatic rhythms of life.

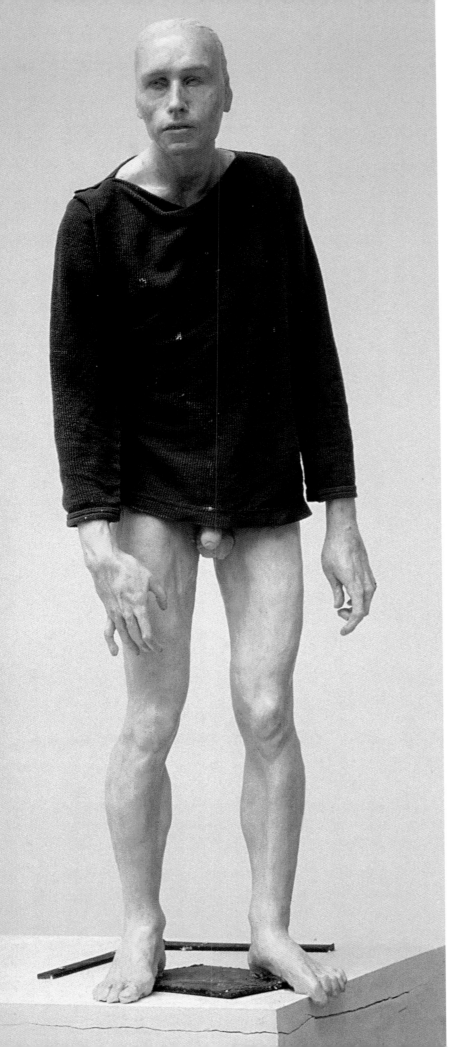

LEFT

What this half-size man shares with us, and his wax predecessors, is the kinship of similarity. Flesh and wax have a long associative likeness (this has been recognized by artists as diverse as Auguste Rodin and Joseph Beuys). They share a pliant brightness and a warm impermanence. Wax is a potent metaphor even before it is used, and in the hands of an artist with Eleanor Crook's sensibility and perception, it becomes painfully human. Crook is based in London, England, where she teaches and researches her work among the collections of the Royal College of Surgeons of England.

Eleanor Crook, *Martin was Dismissive of Popular Psychology*, 1996

The figure that looks out uncertainly from this page is called Martin. His identity is the subject of this sculpture by Eleanor Crook. But this is more than just a portrait. It is a summoning of a very different kind of person from those we see elsewhere in this book. His balance and stance is far from the athletic prototypes who demonstrate their uncluttered anatomy on other pages. Crook has used her anatomical knowledge to catch a posture between defeat and indifference, tiredness and surprise. She has modeled directly into wax an off-guard moment in her sitter's day, in her sitter's life. The man in this work, titled *Martin Was Dismissive Of Popular Psychology*, is very naked; he is like a model resting between classical nudity, talking, drinking tea, and wearing his well-used humanity like a familiar sweater. The most alarming element of his striking presence is that he is only half-human size – a miniature anatomy fashioned to a large-scale anxiety. By this device, Crook distances the viewer and increases our implication as voyeur with the precision of her touch. She has sculpted a whole troupe of darkly humourous figures that conspire in their mimicry of our foibles and fears.

Among the most recent is *Snuffy*, who was shown at the Old Operating Theater of St. Thomas's Hospital in London, England. This wax sculpture is of a partially dissected reclining man, reluctantly demonstrating the history of his kind. He is shown uncomfortably astride a real but child-sized operating table made of tarnished aluminum, its surface dimmed by the suggestion of frequent use, and the shadow of its subject's whitened pallor.

The artist twists the body, turning it inside out to comprehend its emotional reflection. Contemporary artists have become involved in the growing drama of the molecular and the viral, exposing the vulnerability of our fragile kind. These confrontations of mortality are moments in the history and the future of the body. Anatomy is a constant study, a tangible vision of the wondrous mechanism of human life, from the elegant white shadow of our bone architecture to the pliant, sensual color of our skins.

Jenny Saville and Glen Luchford,
Closed Contact #3, 1995–96

The dense issue of bodily fat is not a major concern within the study of human anatomy, although in art sometimes it is primary and essential, especially when made as expressive and confrontational as in the work shown on this page, by Jenny Saville and Glen Luchford. It is one of a large series of images that are both recognizable and bizarre, as the structural elements of the body are obliterated by point-blank kneadings of flesh. The artist's own body is pressed against a transparent surface, so that its impact is flattened into suffocating blocks of pressure. Her pliant skin and fatty tissue are mauled and wrestled like clay before the camera lens. Bone and muscle have been dissolved into a landscape where the woman's surface weight is everything. Saville has painted other such panoramas of flesh that encompass and swamp any horizon other than that of the mortality of meat. These pre-occupations of the twenty-first century can block our view of the uniformity of the body's structure and the infinite variation of its individuality.

The beginning of the twenty-first century is a very interesting time to look at the development of art and anatomy. Many artists are returning to a figurative narrative, be it in painting, sculpture, video, or performance. Many contemporary artists question the physicality of our being, or else expose the vulnerable transience of our frame.

We are now entering a different vista of the body, where microanatomy and gene-manipulated medicine are at the forefront. Gross anatomy (see glossary) may have again become a philosophic venture. What artists will bring to this subject will always be as diverse as the images made in its history. The artist interprets equally a vision and a view, working with skill, new technologies, and an ever-changing imagination to make it possible for us to see and sometimes draw ourselves with a bold but knowledgeable hand, in wonder and surprise situated on both sides of our mortality.

STRUCTU
HUMAN

RE OF THE
BODY

An adult human body weighing about 150lbs (68 kilograms) contains approximately 100,000 billion cells. Each cell is highly specialized and, grouped together with similar cells, creates living tissue. There are four principal types of tissue in the human body: epithelial (relating to glands and fine membranes as in the lining of the nose; blood vessels and the digestive tract); connective (binding and protecting all internal parts); nervous; and muscular. Throughout the body, tissues combine to create more complex units named organs, and each organ performs its own particular role with marvelous ingenuity.

SYSTEMS

Organs are discrete structures, distinguishable by their shape, size, and function, but they cannot work alone. A single organ must combine with others to create a system, the most complex organizational unit of the body. For example, the brain, spinal cord, and peripheral nerves (composed of nerve and connective tissues) are component organs, and together they function as the nervous system. Eleven systems combine to make up the whole body: they are the integumentary (skin, hair, nails, and mammary glands), skeletal (bone, cartilage, and ligaments), skeleto-muscular (muscles and tendons of the skeleton), nervous (brain, spinal cord, and peripheral nerves), endocrine (glands and hormones), cardiovascular (blood supply), lymphatic (fluid drainage and immunity), respiratory, digestive, urinary, and reproductive systems. Together, these maintain the balanced, integrated, and conscious whole that we think of as ourselves and that we examine here as artists.

Before beginning a study of human anatomy it is important to view the terms in which the anatomized body is described. This begins with the "anatomical position" demonstrated here. The body stands upright, arms to the side, head, feet, and palms facing forward. This is the position that gives meaning to all directional terms and measurements used to discuss the body. The term axial skeleton refers to all of the bones comprising the skull, spine, thorax, and pelvis. Appendular skeleton refers to all of the bones of the limbs. Further key anatomical terms are explained on page 244 and used throughout the text.

SYSTEMS SKELETON

The skeletal system, composed of bones, cartilage, and ligaments, creates a rigid framework of support and protection. It holds the body in shape, provides anchor for most muscles, produces movement through the articulation of joints, protects organs such as our brain, spinal cord, heart, lungs, and liver, and plays a vital role in blood-cell production. An adult human skeleton possesses more than 200 bones.

Weight for weight, bone is one of the strongest known materials. It develops at about 98.6°F and yet only a few modern materials produced at extremely high temperatures surpass its strength. It can withstand compression forces twice as well as granite, and stretching forces four times as well as concrete. This is due to its unique composition of 66 percent earth matter (needlelike mineral salts, chiefly calcium and phosphate) and 33 percent animal material (protein and polysaccharides), which converts to gelatine or glue when boiled. If the animal material is removed by burning, residual earth matter will retain its shape, but turn to dust on being touched. Conversely, if earth matter is dissolved out using dilute acid, residual animal material will also retain its shape but it becomes surprisingly flexible: a long bone such as the femur could be tied into a knot before returning slowly to its natural shape.

Living bone is pinkish white, moist, and provided with blood vessels and nerves passing to its core via small holes named foramina. The whole skeleton (except the articular surfaces of joints) is clothed in a vascular fibrous membrane called periosteum and, being far from fixed, adapts and changes considerably throughout our life cycle. Osteoclasts dismantle bone tissue, as osteoblasts rebuild it elsewhere, following the demand of long-term repeated muscle action and the strain of local pressure or weight.

Bones are not solid, but composed of an outer shell (or cortex) and an inner network of trabeculae (from the Latin, *trabs*, beam). Also named spongiosa, these small beams give cross-sections of bone a honeycomb appearance. In long bones trabeculae are denser at the articular extremities, more open in the shaft. All bones are curved and undulating to increase the surface area for muscle attachment; long bones are also cylindrical for strength. Surfaces are rough or smooth, ridged or pitted, with cavities and protrusions.

Cartilage is connective tissue made largely of collagen. Three types are found in extension of bone: fibrous cartilage forms the symphysis pubis (p. 89) and intervertebral disks (p. 64); elastic cartilage gives shape to the outer flesh of the ears; hyaline cartilage (the most common) covers the articular surfaces of bones, forms the rings of the trachea, bronchi of the lungs, and gives shape to the lower rib cage and nose. "Hyaline" comes from the Greek for glass: within the body it has a translucent, opalescent sheen.

Joints are bound by ligaments, which stabilize, strengthen, and define their movement. Fine, densely layered, translucent collagen fibers, varying in thickness, length, and opacity, they appear as the lines of a drawing, perfectly describing the depth, surface, and complex curvature of each joint.

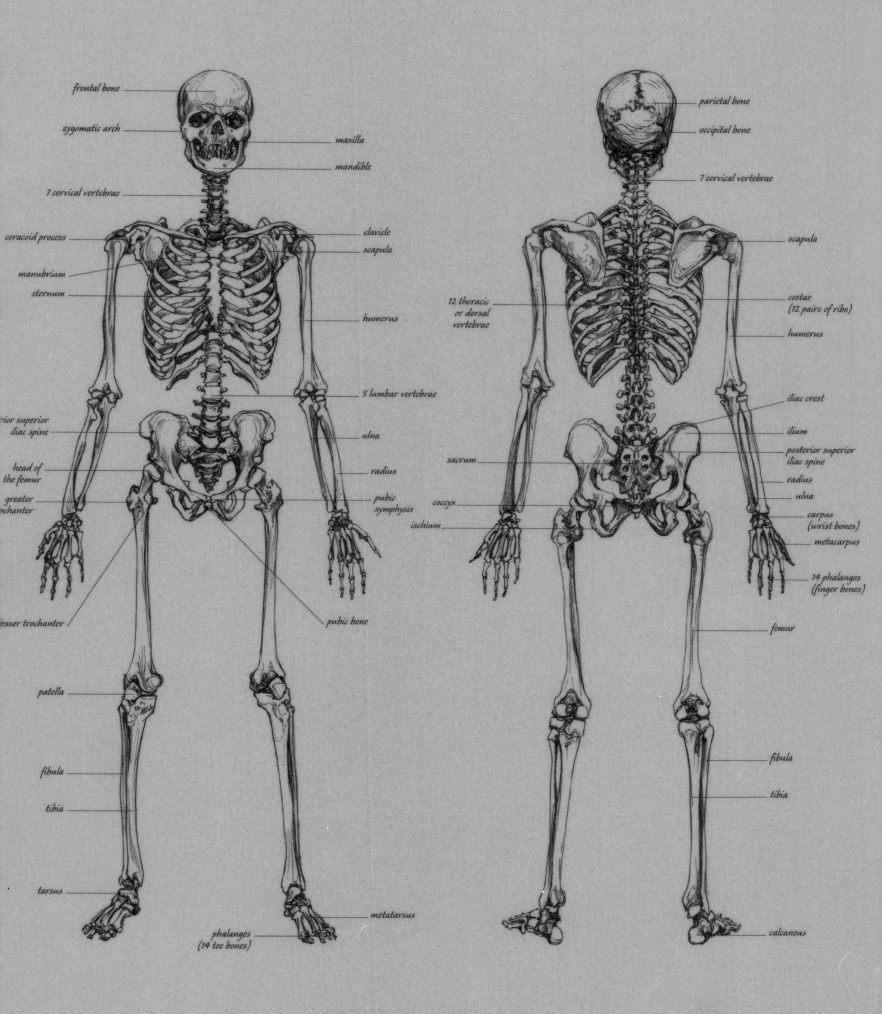

frontal bone

zygomatic arch

7 cervical vertebrae

coracoid process

manubrium

sternum

rior superior
iliac spine

head of
the femur

greater
chanter

esser trochanter

patella

fibula

tibia

tarsus

maxilla

mandible

clavicle

scapula

humerus

5 lumbar vertebrae

ulna

radius

pubic
symphysis

pubic bone

metatarsus

phalanges
(14 toe bones)

parietal bone

occipital bone

7 cervical vertebrae

scapula

12 thoracic
or dorsal
vertebrae

sacrum

coccyx

ischium

costae
(12 pairs of ribs)

humerus

iliac crest

ilium

posterior superior
iliac spine

radius

ulna

carpus
(wrist bones)

metacarpus

14 phalanges
(finger bones)

femur

fibula

tibia

calcaneus

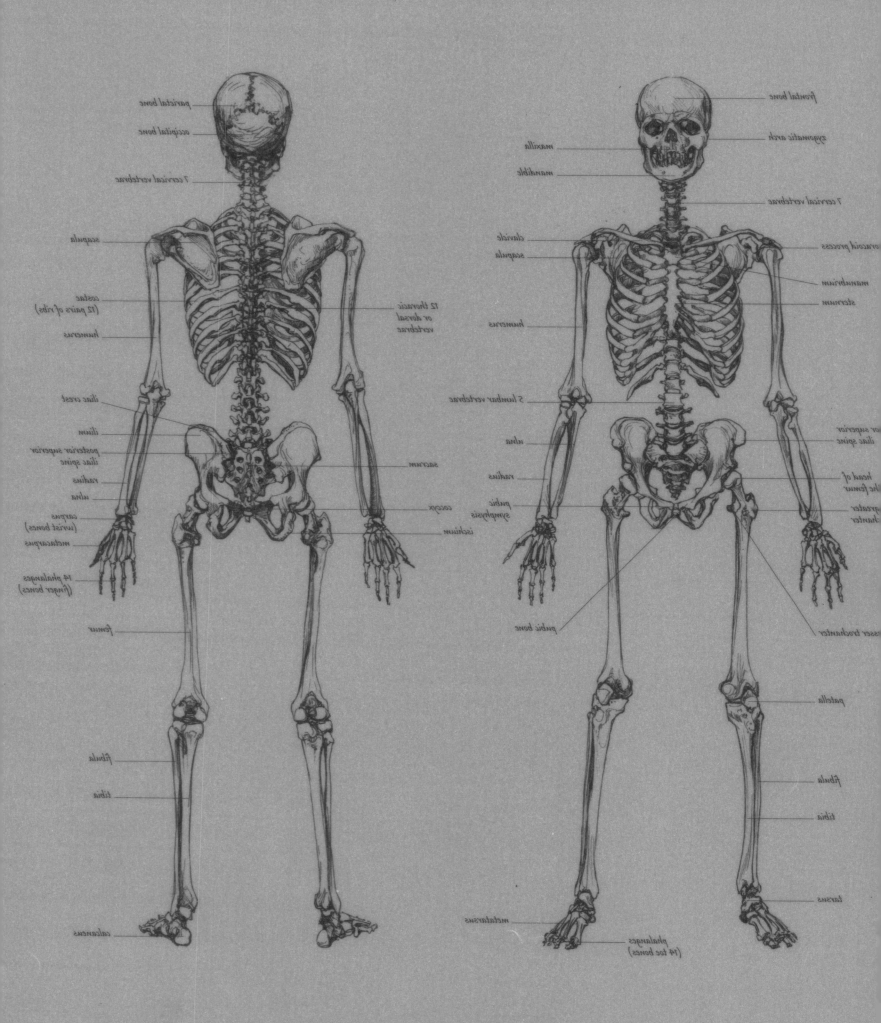

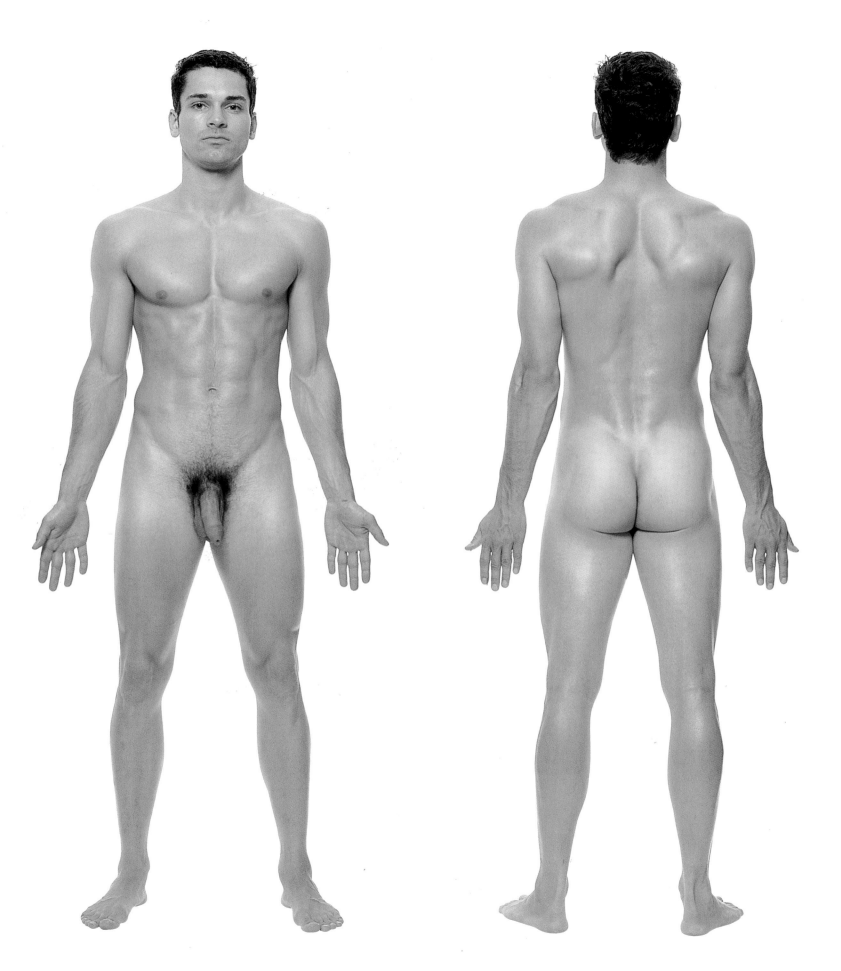

Skeletal muscles cover most of the skeleton and vary greatly in size, shape, and strength. As a rule, muscles of the torso form broad, expansive sheets, and muscles of the limbs are longer, more cylindrical, and may have divided tendons reaching several bones. Short thick muscles are designed for strength, long slender muscles for precision. Their names may reflect their shape (deltoid), action (adductor), size (magnus), orientation (rectus), position (anterior), number of parts (biceps), underlying bones (temporalis), or attachment between several bones (iliotibial tract). Skeletal muscles may function as flexors, extensors, adductors, abductors, pronators, supinators, rotators, elevators, depressors, compressors, dilators, and fixators (p. 244). All skeletal muscles have points of origin and insertion, rooted to the periosteum of bone (p. 32) as plants might cling to a rock face. Large muscles exert great forces on bone so their tendons must be very strongly attached. The stronger the attachment, the more bitten the surface of the bone will become.

SYSTEMS
SKELETO-MUSCULAR

Muscle is a biological contractor that produces movement and heat, operating the joints, pumps, and valves of the body. There are three types: striated, smooth, and cardiac. Striated muscle (appearing striped under a microscope) is also called voluntary muscle since it is under our conscious control. Over 640 voluntary muscles make up 40 to 50 percent of body weight. This is the red flesh of the body. Organized into groups and arranged in two or more layers, voluntary or skeletal muscles give the human form its characteristic shape beneath layers of fat and skin. Smooth muscle (without striations) is confined to the walls of hollow organs, such as the intestines, and blood vessels. It functions beyond our conscious control and is termed involuntary. Cardiac muscle is particular to the heart. It is both striated and involuntary, with a cell structure that ensures synchronized contraction.

Tendons tie skeletal muscles to bone. Inside the body, they appear silver and highly polished, with minute parallel grooves between the collagen fibers. They are inextensible, allowing muscles to pull hard against them. Numerous tendons (especially in the forearm) are longer than the muscles they serve. Long tendons convey the action of a muscle over a distance, may divide to insert into numerous bones, taper the form of the body, aid in lightening weight, and allow large quantities of muscle tissue to act on comparatively small surface areas of bone. An aponeurosis is a white fibrous sheet of connective tissue extending across the surface of a muscle or between muscles, providing additional attachment like an expansive tendon.

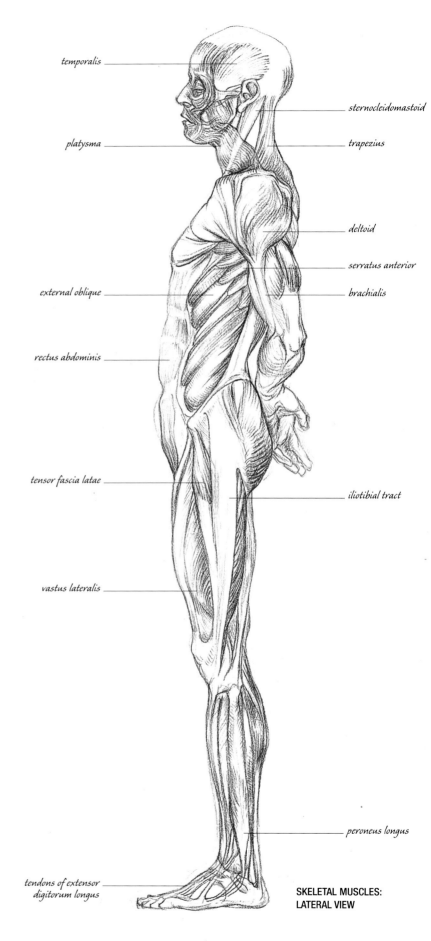

temporalis

platysma

sternocleidomastoid

trapezius

deltoid

serratus anterior

external oblique

brachialis

rectus abdominis

tensor fascia latae

iliotibial tract

vastus lateralis

peroneus longus

tendons of extensor digitorum longus

SKELETAL MUSCLES: LATERAL VIEW

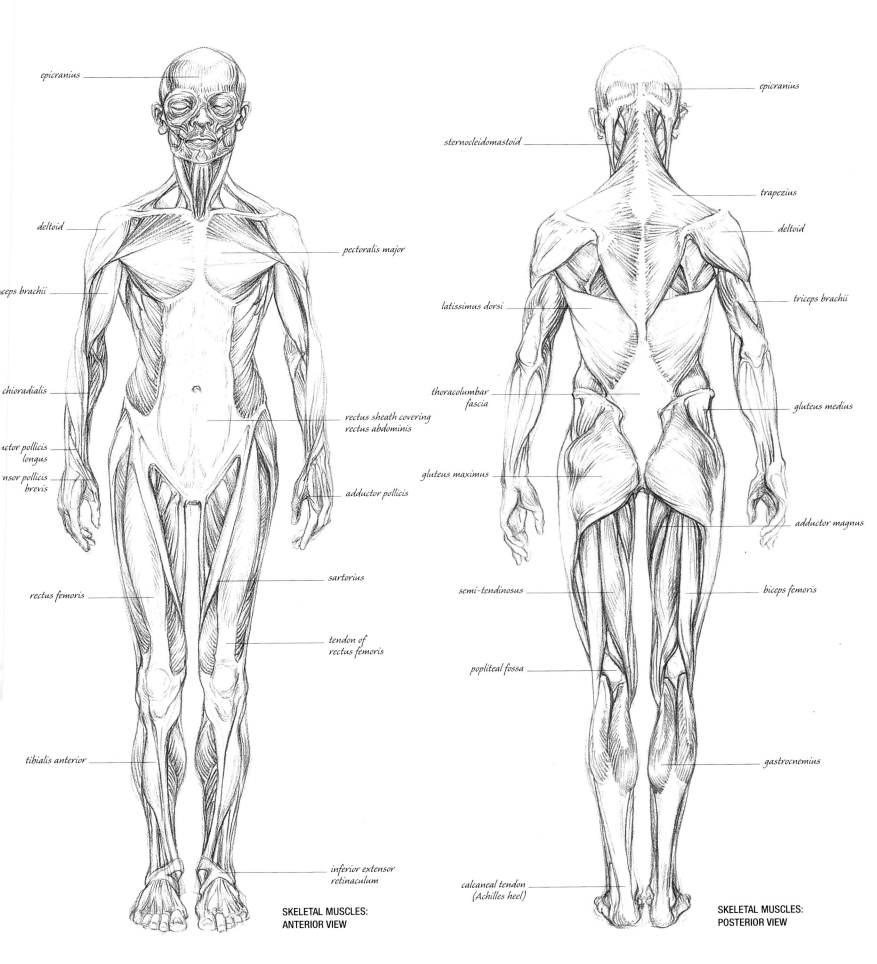

epicranius

deltoid

ceps brachii

chioradialis

uctor pollicis
longus

nsor pollicis
brevis

rectus femoris

tibialis anterior

pectoralis major

rectus sheath covering
rectus abdominis

adductor pollicis

sartorius

tendon of
rectus femoris

inferior extensor
retinaculum

**SKELETAL MUSCLES:
ANTERIOR VIEW**

epicranius

sternocleidomastoid

trapezius

deltoid

latissimus dorsi

triceps brachii

thoracolumbar
fascia

gluteus medius

gluteus maximus

adductor magnus

semi-tendinosus

biceps femoris

popliteal fossa

gastrocnemius

calcaneal tendon
(Achilles heel)

**SKELETAL MUSCLES:
POSTERIOR VIEW**

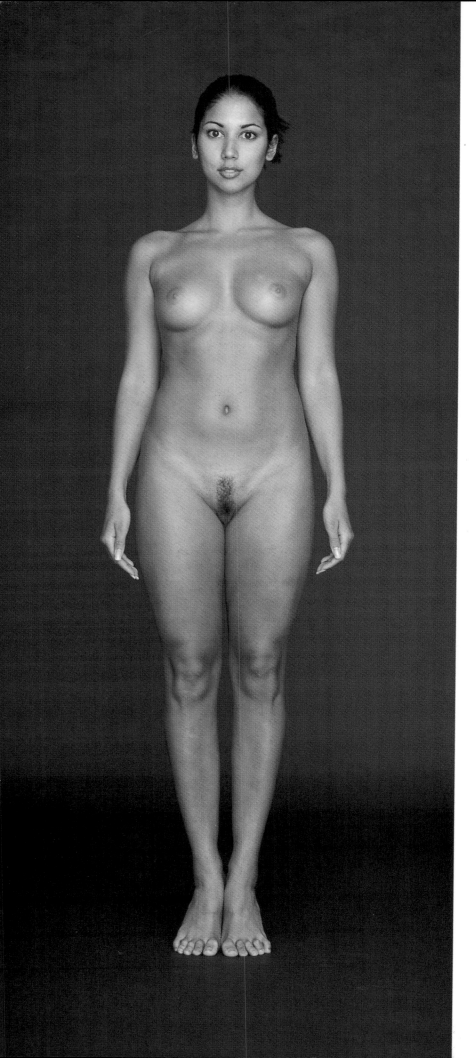

SYSTEMS
INTEGUMENTARY

The integumentary system includes our skin and its appendages – hair (p. 60), nails (p. 156), and specialized glands for the production of sweat, oil, and breast milk. Skin is a tough, self-replenishing membrane, defining the boundary between our internal and external environments. The average thickness of human skin is 0.04–0.12in (1–3mm). It is thickest on the upper back, soles of the feet, and palms of the hands (up to 0.2in/5mm), thinnest on the eyelids. A highly sophisticated sense organ and the location of our feeling of touch, it also protects us from abrasions, fluid loss, the penetration of harmful substances or microorganisms, and regulates our body temperature through the production of sweat and the cooling effect of surface veins.

Skin is the largest organ of the body and it is arranged in two distinct layers. The upper layer, called the epidermis, is a sheet of self-replacing dead and dying cells, and these are chiefly composed of a sulfur-rich, water- and bacteria-repellent protein called keratin. Beneath lies the dermis. This is a thicker, vascularized (with blood vessels) layer of loose connective tissue, consisting of a mesh of collagen and elastic fibers. These account for skin's strength and tonicity. Below the dermis lies the hypodermis, a fine layer of white connective fatty tissue that is also named the superficial fascia. This in turn meets with the uppermost layers of deep fascia. Deep fascia is a vast, thin fibrous membrane, devoid of fat, which envelops all muscles and muscle groups, blood vessels, nerves, joints,

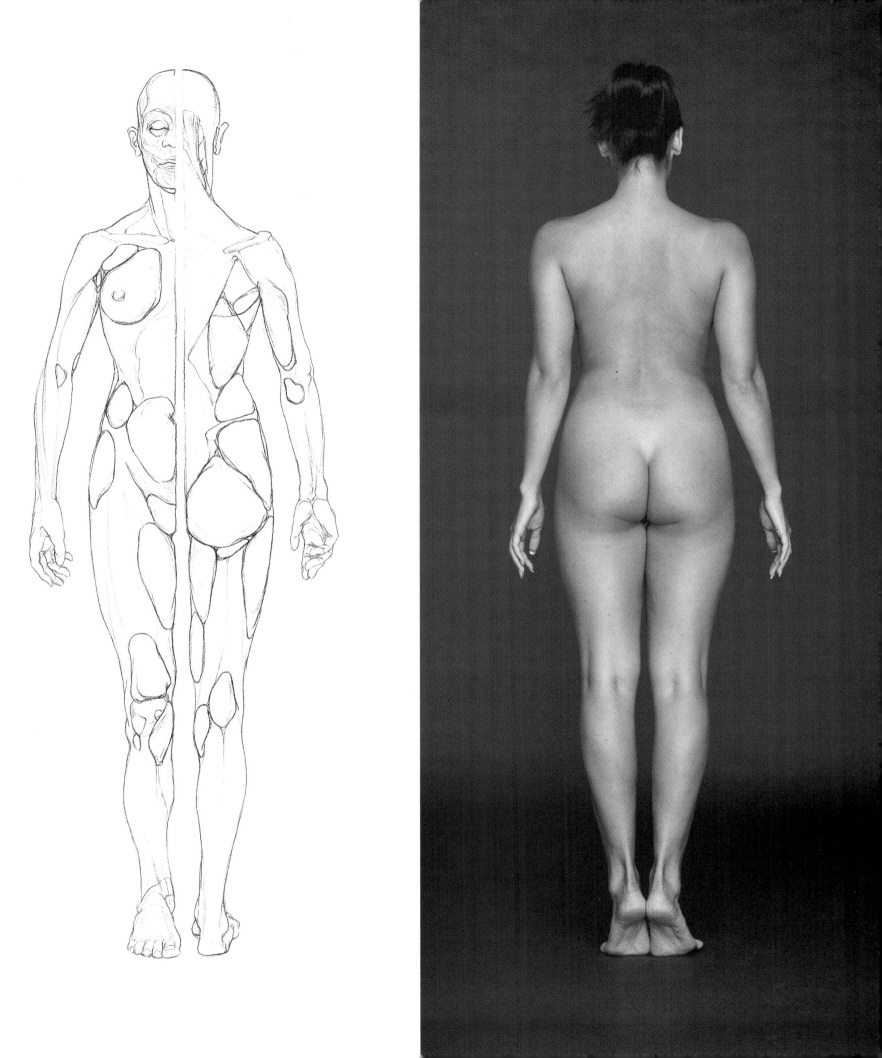

This schematic drawing shows the tension or cleavage lines of human skin – that is the directions in which skin will crease. These lines were discovered and mapped in 1862 by the Viennese anatomist Karl Ritter von Edenburg Langer. He proved that skin is always under tension, and that its deep elastic fibers are arranged in banded patterns to accommodate body movement. An incision along these lines will heal well because the skin's tension pulls the cut together, whereas a cut across them will pucker and scar.

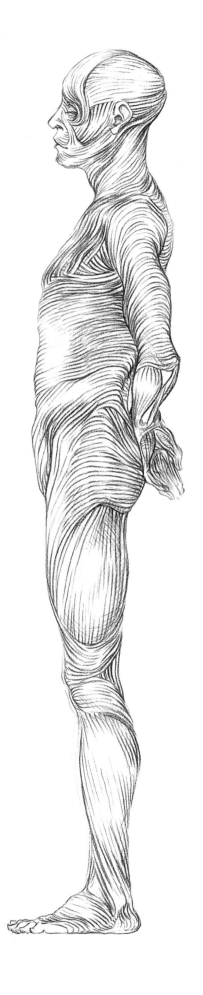

organs, and glands. Throughout the body it creates silklike pockets, through which muscles and tendons glide smoothly. These prevent friction and restrict the expansion of muscles as they contract, thus pressing against veins to help push blood back to the heart. Thickened sheets of fascia named intermuscular septa separate muscle groups, giving partial origin to some muscles, while often tying from surface structures down to bone. Where muscles flex and bulge either side of septa, dimples or indentations appear in the skin. These are often prominent in muscular limbs.

Fat is the body's energy resource or onboard food supply. The fat stored within the hypodermis is called superficial or panniculus adiposus, and is made of soft adipose tissue (or specialized fat cells). This layer softens the contours of the angular skeleto-muscular frame and provides insulation against cold. The largest concentration of fat is in the buttocks: it fills the angles of the gluteal muscles (p. 35) to create a cushion for the ishcial bones of the pelvis (p. 33). Other surface fat is stored in specific pads, which are usually more pronounced in the female (pp. 36–7). The most notable areas occur around the navel, above the hips, over the inner and outer thigh, above the front of the knee, beneath the nipples (forming breasts in the female), on the back of the arms, in the cheeks, and below the chin. Fat also fills the cavities of the armpit (or axilla), behind the knee, between the tendons of the wrist and ankle, and between every separable structure of the body, down to the bones. It is lack of body fat (not increased muscularity) that gives clearer definition to muscles seen through the skin.

Anterior and posterior views of the large organs in the thoracic and abdominal cavities: the diaphragm is represented by a dotted line. These are the organs of the respiratory, digestive, and urinary systems, responsible for processing, regulation, and maintenance within the body. Note how very tightly packed the organs are, separated from each other by fat, specialized membranes, and connective tissue. The lungs rise above the collarbone, and the intestine is pressed into the bowl of the pelvis and against the spine.

SYSTEMS RESPIRATORY, DIGESTIVE, URINARY

The lungs almost entirely surround and protect the heart, and their outer surface describes the interior space of the upper rib cage. They weigh very little and are composed of over 700 million tiny air sacs called alveoli. Inhaled air is warmed and humidified in the nose and trachea (or windpipe), and drawn into the lungs by the contraction of the diaphragm. A powerful muscle fixed to the inner walls of the ribs, it stretches over the liver and stomach, dividing the thorax and abdomen. Once in the lungs, oxygen passes into the bloodstream in exchange for carbon dioxide.

The esophagus, stomach, large and small intestines, and rectum combine to create almost 26ft (8m) of digestive tract or alimentary canal. The stomach receives food from the esophagus, breaks it down with gastric juices (mostly hydrochloric acid to kill bacteria), and passes it to the small intestine, where it is further digested by secretions from the pancreas and gall bladder. Bile produced by the liver, our largest gland, and stored in the gall bladder acts as a detergent, breaking fats down into an emulsion. (The liver also processes, stores, and converts nutrients, generates waste or urea, and changes poisons into less harmful products for excretion.) Nutrients are absorbed into the bloodstream. In the large intestine water is absorbed, and the remaining content is condensed into feces. The kidneys filter the blood, removing waste and excess water. They also produce hormones to control blood pressure, and stimulate the growth of red blood cells. Urine excreted from the kidneys passes through the ureters and is stored in the bladder.

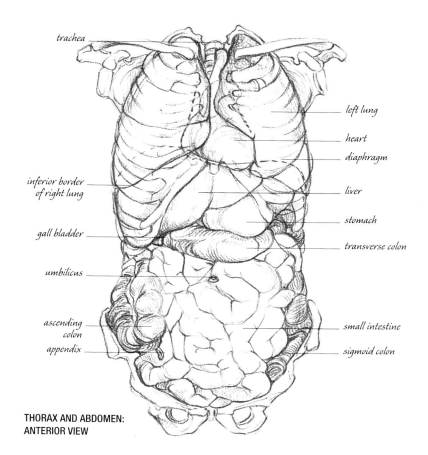

THORAX AND ABDOMEN: ANTERIOR VIEW

trachea · left lung · heart · diaphragm · inferior border of right lung · liver · stomach · gall bladder · transverse colon · umbilicus · ascending colon · appendix · small intestine · sigmoid colon

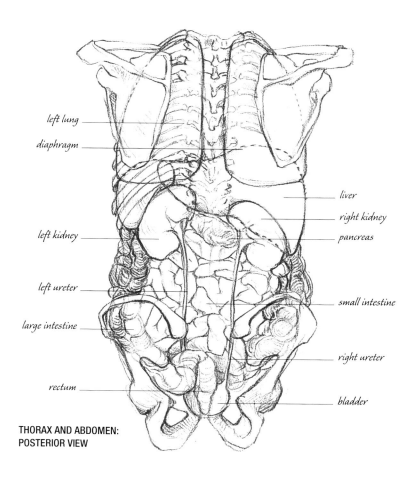

THORAX AND ABDOMEN: POSTERIOR VIEW

left lung · diaphragm · liver · right kidney · pancreas · left kidney · small intestine · left ureter · large intestine · right ureter · rectum · bladder

These three drawings show (from left to right) the arrangement of veins, arteries, and nerves within the body. Veins and arteries form the principal elements of a closed circuit of hollow vessels for the passage of blood. Blood volume varies among individuals, although an average adult should carry about 8 pints (5 liters). Pushed around the body by the heart, blood is supplied to all parts except the hair, nails, cartilage, and corneas.

Large vessels lie deep beside bones or beneath flexor surfaces (p. 244), protected by our impulse to fold forward under attack. Many large blood vessels (and nerves) take their names from bones they pass. Surface veins are often visible through skin, especially in the face, feet, and hands. The brain, spinal cord, and peripheral nerves shape the body's system of communication, using electrical impulses to encode and transmit information.

SYSTEMS ENDOCRINE, NERVOUS, LYMPHATIC, CARDIOVASCULAR

The nervous system is composed of the brain, spinal cord, and about 93,000 miles (150,000 km) of peripheral nerves. Its function is to communicate. Every second of our lives, it brings together, makes sense of, and reacts to millions of fragments of information. Nerves large enough to be seen appear as white threads running through the body. These contain many hundreds of parallel fibers formed of cells called neurons. Neurons carry electrical impulses, the number and timing of which encode information travelling from one part of the body to another. A large nerve fiber could carry as many as 300 impulses nearly 394ft (120m) in one second.

The brain is the center of the nervous system. Its uppermost mass (or cerebrum) is recognized by its division into two equal hemispheres: the right hemisphere controls the left side of the body, and the left controls the right. It is composed largely of white matter, surrounded by a 0.16in (4mm) undulating cortex of gray matter. White matter carries information to and from gray matter. Gray matter is our seat of consciousness and thought. The cerebrum houses our memory, emotions, capacity to learn, feel, and make voluntary movement. Below and behind the cerebrum is the three-lobed cerebellum, which coordinates skeletal muscles and maintains tone, balance, posture, and smooth movement. Below the cerebrum and in front of the cerebellum is the stalklike brain stem, regulating our heart beat and breathing, while the spinal cord mediates other simple reflexes.

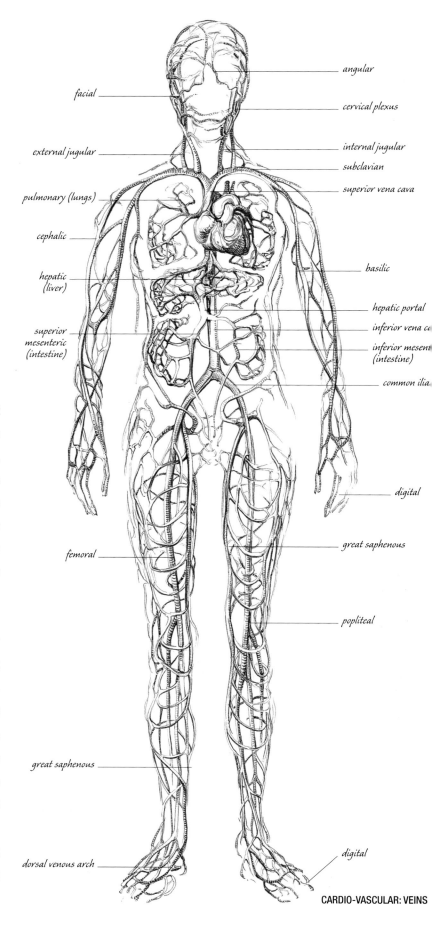

facial

external jugular

pulmonary (lungs)

cephalic

hepatic (liver)

superior mesenteric (intestine)

femoral

great saphenous

dorsal venous arch

angular

cervical plexus

internal jugular

subclavian

superior vena cava

basilic

hepatic portal

inferior vena ca

inferior mesent (intestine)

common ilia

digital

great saphenous

popliteal

digital

CARDIO-VASCULAR: VEINS

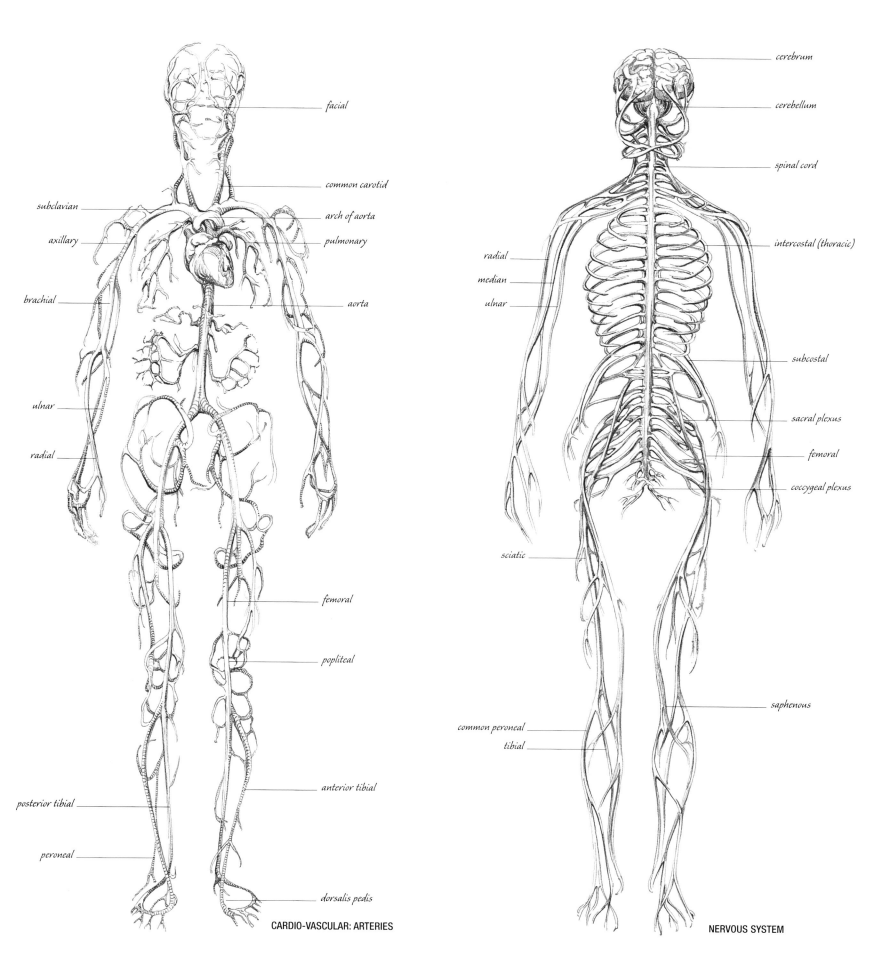

facial

common carotid

subclavian

arch of aorta

axillary

pulmonary

brachial

aorta

ulnar

radial

femoral

popliteal

posterior tibial

anterior tibial

peroneal

dorsalis pedis

CARDIO-VASCULAR: ARTERIES

cerebrum

cerebellum

spinal cord

radial

intercostal (thoracic)

median

ulnar

subcostal

sacral plexus

femoral

coccygeal plexus

sciatic

saphenous

common peroneal

tibial

NERVOUS SYSTEM

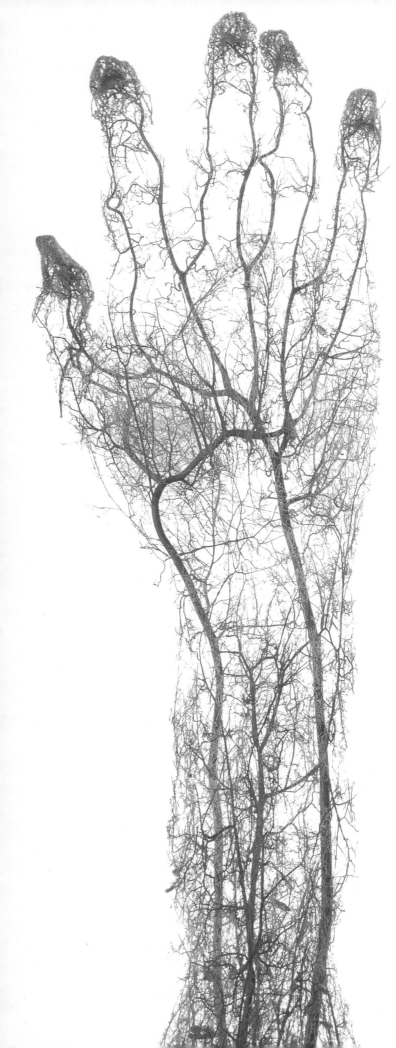

The spinal cord is the body's largest nerve. It is a two-way conduction channel. Ascending tracts (lines of nerve fiber) take impulses up to the brain. Descending tracts bring impulses down from it. Beyond the spinal cord are peripheral nerves: a vast tracery joining every detail of the body. Afferent (incoming) sensory pathways carry touch, pain, temperature, vision, hearing, taste, smell, and so on. Efferent (outgoing) paths carry motor signals for action and response, and divide into somatic communications, with skeletal muscles under our conscious control, and autonomic communications, with smooth and cardiac muscle or glands and epithelial tissue functioning beyond our conscious control. Autonomic communications subdivide into a sympathetic division, which prepares the body for attack (the "fight or flight" response), and the parasympathetic division, which calms the body and stimulates digestion.

The nervous system also works in concert with the system of endocrine glands scattered throughout the body. These produce chemicals called hormones. Poured into the bloodstream as needed, they act like prime-time broadcasts. Nerves send targeted information at up to 300mph (480kph), while hormones transmit to the whole body but are registered only by tissues sensitive to them. They act within minutes, days, or years, to control development, reproduction, blood-sugar levels, and adrenaline.

The heart is the powerhouse of the cardiovascular system. Blood collects oxygen from the lungs as well as nutrients from the digestive tract,

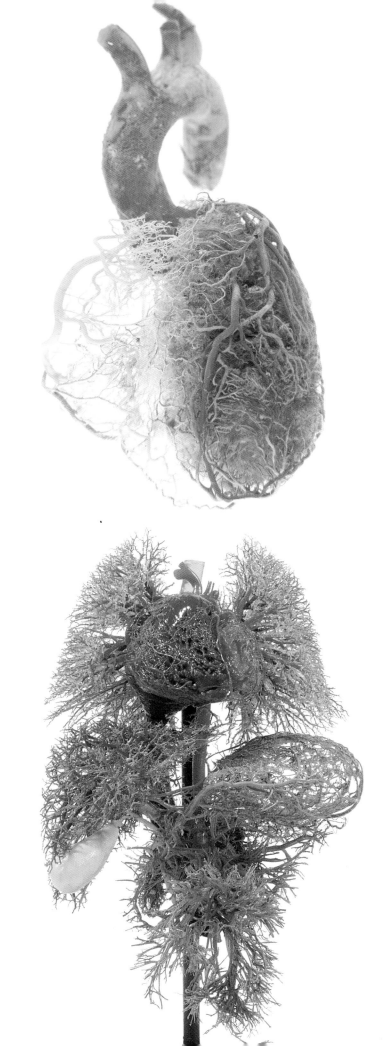

Two more acid-corrosion casts: of the heart (above) by von Hagens (see opposite), and of the lungs, heart, liver, gall bladder, stomach, and intestine of an adult (below) by Dr. D.H. Tompsett (1909–91), prosector to The Royal College of Surgeons of England, London. Collections of Tompsett's work can be seen there and in the Cole Museum at the University of Reading, England. Casts of the arterial systems of stillborn infants were a feature of his research. He also made zoological pieces, for example a pale gold resin cast of the lungs of a horse. (These may be seen by appointment in the London Hunterian, see p. 250.) William Harvey introduced the practice of arterial injection when he discovered the circulation of the blood (declared in 1628). The technique was advanced by Frederik Ruych (1638–1731), who taught anatomy in Amsterdam and produced a 1,300-piece cabinet of anatomical tableaux, later purchased by Peter the Great of Russia.

delivering these throughout the body in return for waste products that are then deposited in excretory organs. The embryonic heart begins to beat regularly in its fourth week of life. Before death it should beat an average of 2.5 billion times. A powerful muscular pump, it is composed of four chambers: two atria above two ventricles. The right atrium receives oxygen-depleted blood from the veins of the body, channels it to the right ventricle from where it is pumped to the lungs. There carbon dioxide is expelled in exchange for oxygen. Reoxygenated blood returns to the heart through the left atrium, and then the left ventricle, from where it is pumped back around the body via the aorta. (Blood circulates through the lungs in 4–8 seconds; through the body in 25–30.) The aorta is a huge artery. About 1in (2.5 cm) in diameter, it is 3,000 times the width of the smallest blood vessel. Like the branches of a tree, arteries divide and divide again, until they become small arterioles, and finally microscopic capillaries. Capillaries then unite into vessels of increasing size until they become visible to the eye as venules. Venules unite to form veins. Veins in turn become larger and larger as they carry blood back to the heart.

The cardiovascular system is supported by a vital drainage network. Excess fluid (or lymph), proteins, and fats seeping from the capillaries are collected, filtered, and returned to the bloodstream by the lymphatic system. A multitude of tributary vessels and nodes also monitor the health of the body, remove harmful particles and microorganisms, and form a vital internal line of defense.

BONES &

MUSCLES

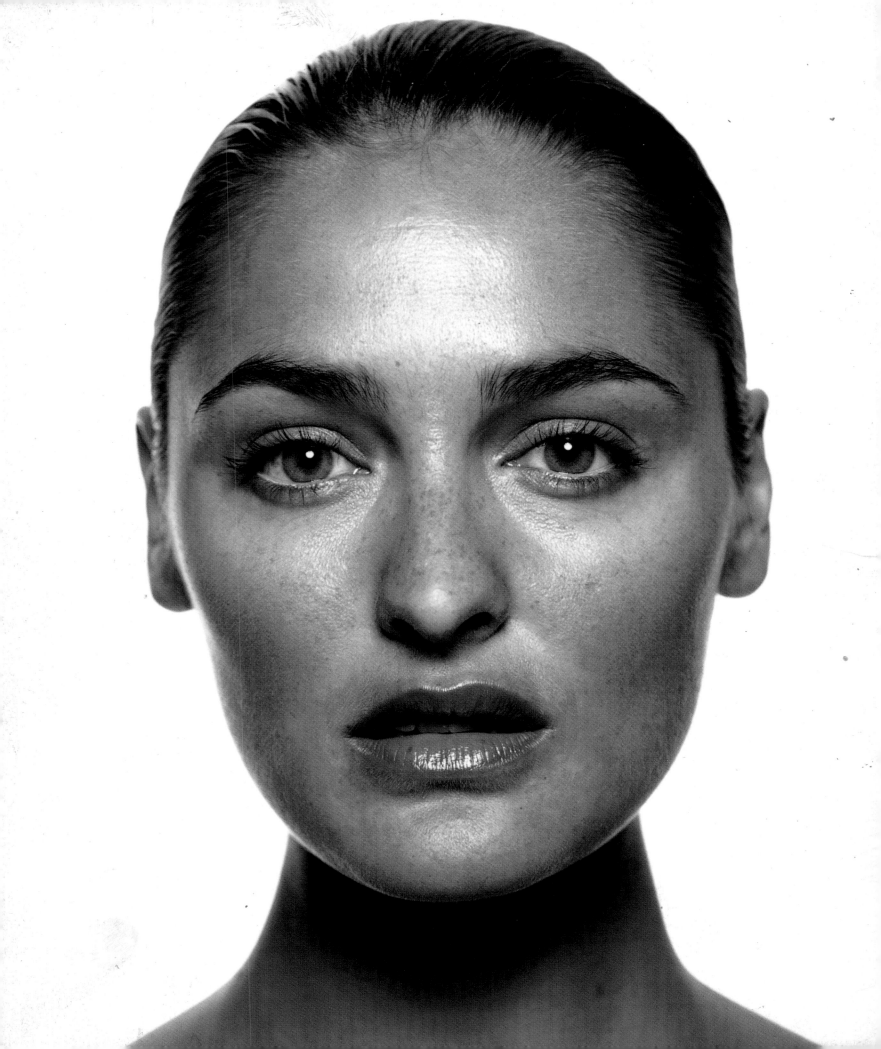

The head is the vital sign and engine of our being. We see, hear, taste, and smell within it. We breathe, eat, and converse through it. We recognize each other and think with it. This complex ball of bone and soft tissue is our main gateway to the world and the seat of all our understanding. The structure of the face begins deep within the bones of the skull, which are overlaid by the cartilages of the nose and ears, the globe of each eye, and a large amount of fat beneath the skin. This is stretched, compressed, and often wrinkled into an astonishing range of expression by a thin and very delicate layer of muscles.

THE HEAD

Arising from the skull, facial muscles attach into each other and partly into deep layers of the skin. Quite hidden beneath fat, they strictly control but cannot directly form our expression as notions of beauty, ugliness, character, health, and feeling are read into supple shifts, hues, and textures of the fat and skin lying above. Minute movements of the face tilt the pronunciation of speech and mutate the emphasis of silent communication. Conversely, our first language trains, stengthens, and discreetly shapes our instinctive and habitual facial movements. An expert anatomist might claim to tell which language a person speaks from the tone and development of certain facial muscles. And it is largely the training of the first language that prevents us from mastering the correct pronunciation of a second language. Such mechanical nuances, continually shifting and changing the facial cast, make the human head an obsessive and constant subject for the artist.

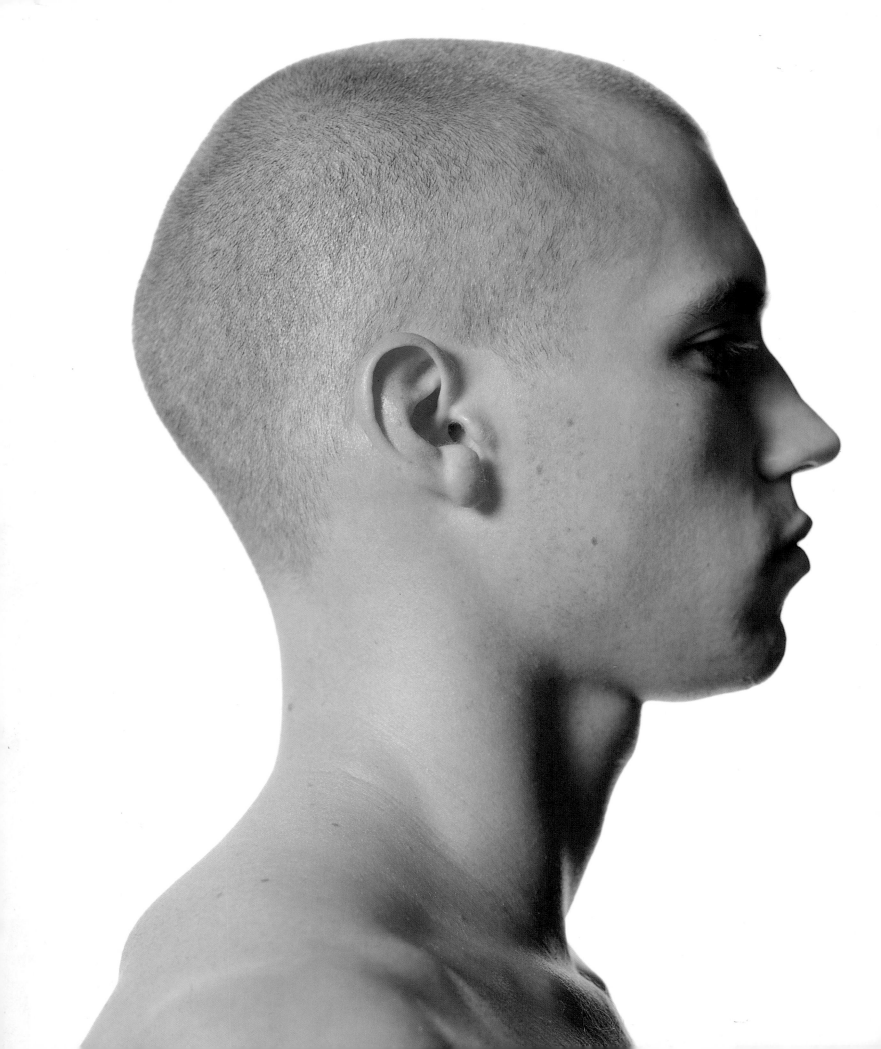

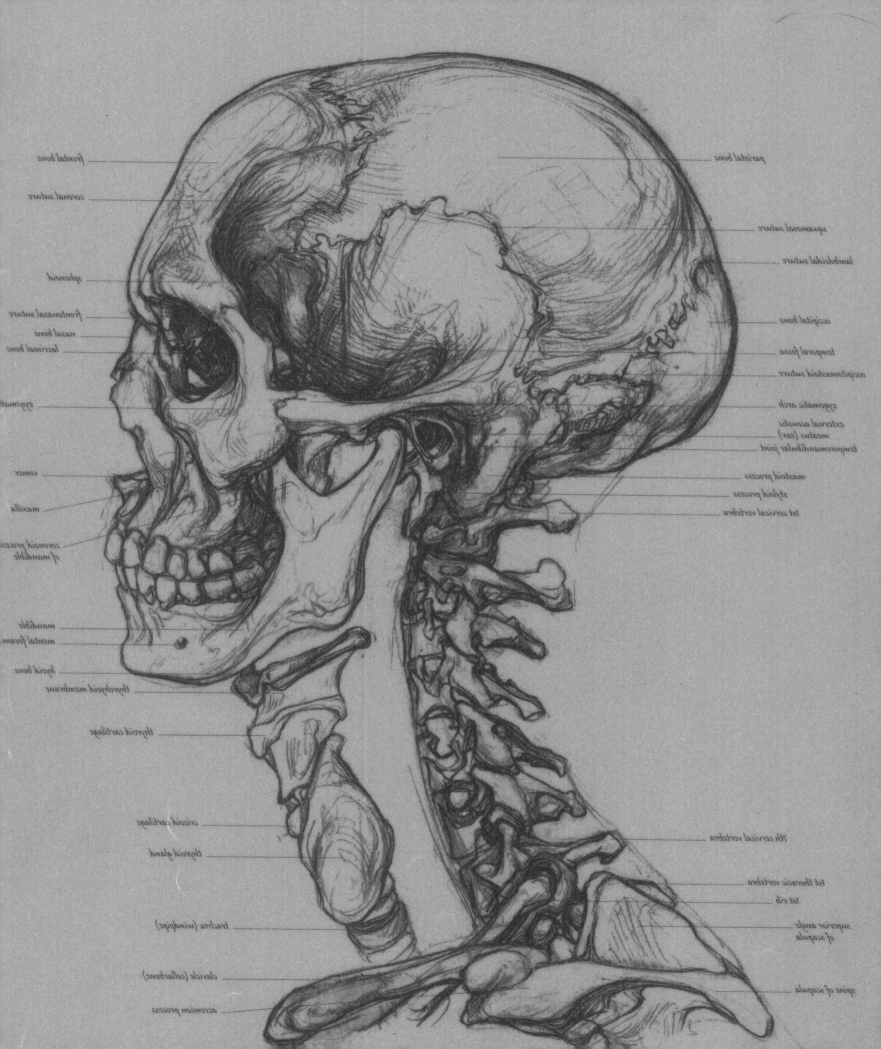

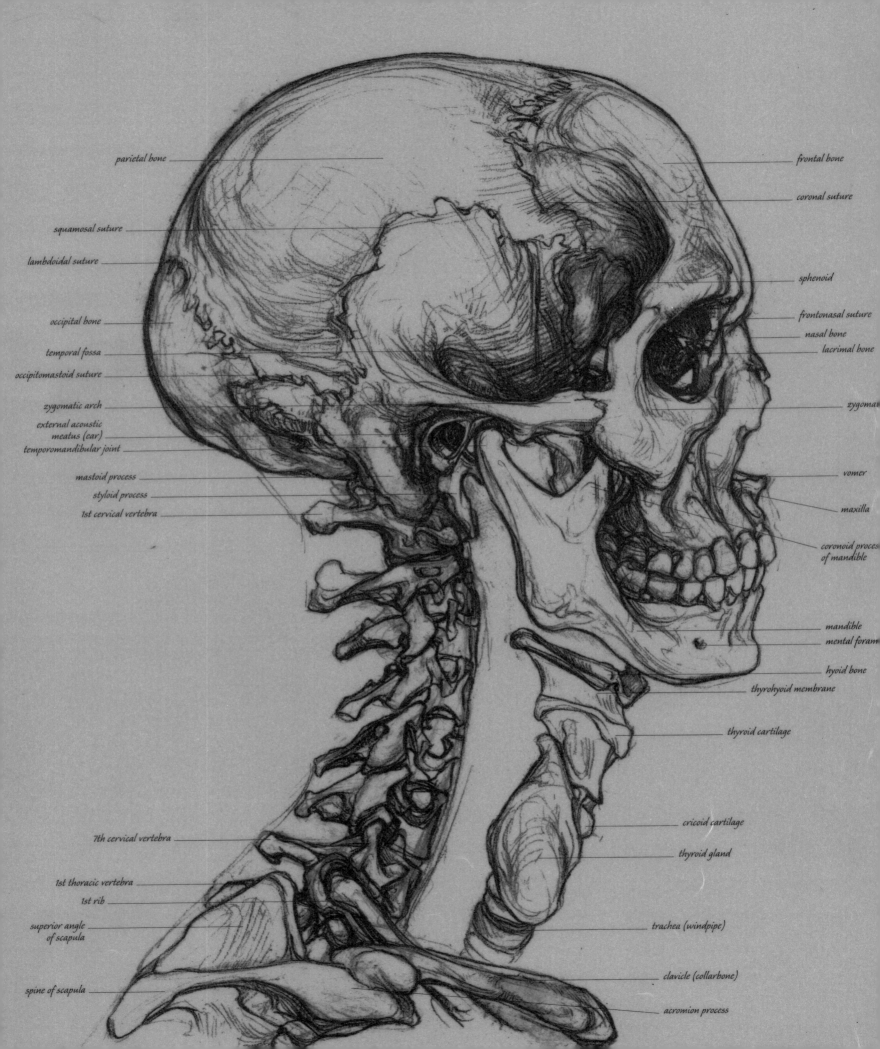

parietal bone

frontal bone

coronal suture

squamosal suture

lambdoidal suture

sphenoid

frontonasal suture

occipital bone

nasal bone

temporal fossa

lacrimal bone

occipitomastoid suture

zygomatic arch

zygoma

external acoustic
meatus (ear)

temporomandibular joint

vomer

mastoid process

styloid process

maxilla

1st cervical vertebra

coronoid process
of mandible

mandible

mental foramen

hyoid bone

thyrohyoid membrane

thyroid cartilage

cricoid cartilage

7th cervical vertebra

thyroid gland

1st thoracic vertebra

1st rib

superior angle
of scapula

trachea (windpipe)

clavicle (collarbone)

spine of scapula

acromion process

Left: observe the significant relationships between the bones of the skull. The halfway point from the top of skull to the lower edge of the lower jaw is just below the center of the eyes. From front to back, it is just behind the temporomandibular joint (p. 51), and in front of the spinal column. The top of the cranium descends downward and forward, with the highest point directly above the mastoid process. The foramen magnum is level with the base of the nose. The mandible overlaps the hyoid bone situated at the top of the neck

when the head is lowered. The thyroid cartilage (or Adam's apple) suspends by a membrane from the hyoid bone. The thyroid and cricoid cartilages are larger, more pronounced, and lower in the male. In the female, an enlarged thyroid gland gives a softened shape to the front of the neck.

Right: important details of the skull, including prominent sutures, the shape of the palate at the roof of the mouth, and the foramen magnum, through which the spinal cord connects with the brain.

THE HEAD
SKULL BONES

The skull, supported directly on top of the vertebral column, is the uppermost mass of the axial skeleton (p. 32). It determines the shape of the whole head, and it is composed of 22 bones. These can be classified in two groups: bones of the cranium, surrounding the brain, and bones of the face, supporting the eyes, nose, and mouth. With only one exception (the lower jaw), all the bones of the skull fit together closely by means of irregular edges which look like long rows of tiny, interlocking teeth. Called sutures (from the Latin, sutura, to seam), these create immovable junctions, holding the bones firmly in place, while also allowing for the growth of the head. Tiny islets of separate bone, called wormian bones, are occasionally found within a suture. Sutures may gradually ossify and disappear in the course of a long life.

The cranium (also named the cranial vault or calvaria) encloses and protects the brain and organs of hearing. Formed from smoothly curved, expanded, and interlocking plates of bone, it imparts the characteristically domed shape of the head. Viewed from above, it is almost egg shaped, narrower towards the forehead, and wider behind. In lateral view it is also egg-like if a curved line is drawn from the top of the nose (between the eyes), past the earhole, to beneath the occipital bone.

The occipital bone or occiput (from the Latin, ob, against, and caput, head), situated at the posterior and inferior part of the head, rests directly on top of the spine. It is a gently cupped bone pierced by a large hole named the

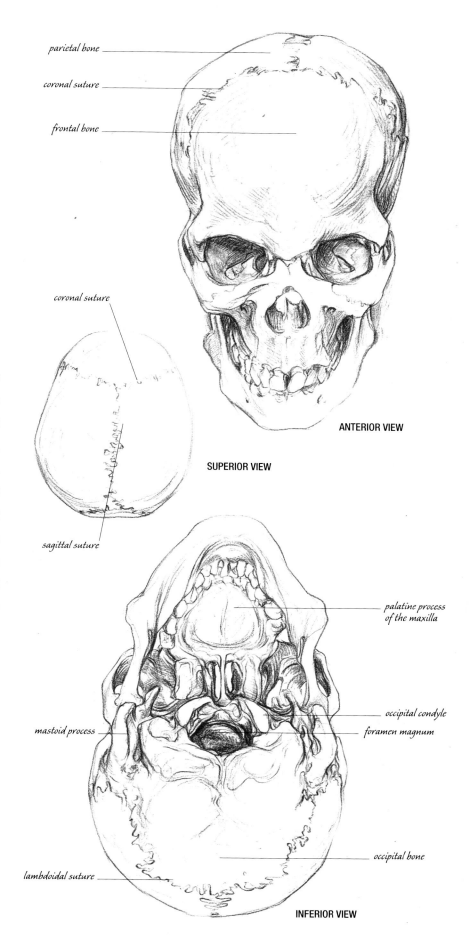

parietal bone

coronal suture

frontal bone

ANTERIOR VIEW

coronal suture

SUPERIOR VIEW

sagittal suture

palatine process of the maxilla

occipital condyle

mastoid process

foramen magnum

occipital bone

lambdoidal suture

INFERIOR VIEW

foramen magnum (p. 49), through which the brain connects with the spinal cord. The exterior surface of the occiput is particularly marked and pitted by the insertion of powerful neck muscles.

Two smooth parietal bones (p. 48, from the Latin, *paries*, wall) form the roof and upper sides of the head and abut the frontal or forehead bone, which contains the frontal air sinuses (or spaces) above and between the eyes. Together with those of the sphenoid and ethmoid (below) and the maxillae (pp. 48 and 51), these sinuses are termed paranasal because they have channels opening into the nose. They give resonance to the voice, unless they are blocked, as in a heavy cold.

Two temporal bones form the lower sides of the cranium, part of the cranial floor, and encase the middle and inner ear. Each terminates to the rear, behind the ear hole, in the mastoid process (pp. 48 and 49), an important bony landmark for the artist. The ethmoid is a complicated irregular bone hidden deep within the head behind the nose. The sphenoid (p. 48) is also largely hidden, except for a small part (the ala or wing), which reaches the surface on both sides of the cranium between the temporal and frontal bones just above the zygomatic arch (p. 48) to complete the temples.

The bones of the face, together with the lower jaw, are grouped in front of and generally below the cranium, giving shape to the eyes, nose, cheeks,

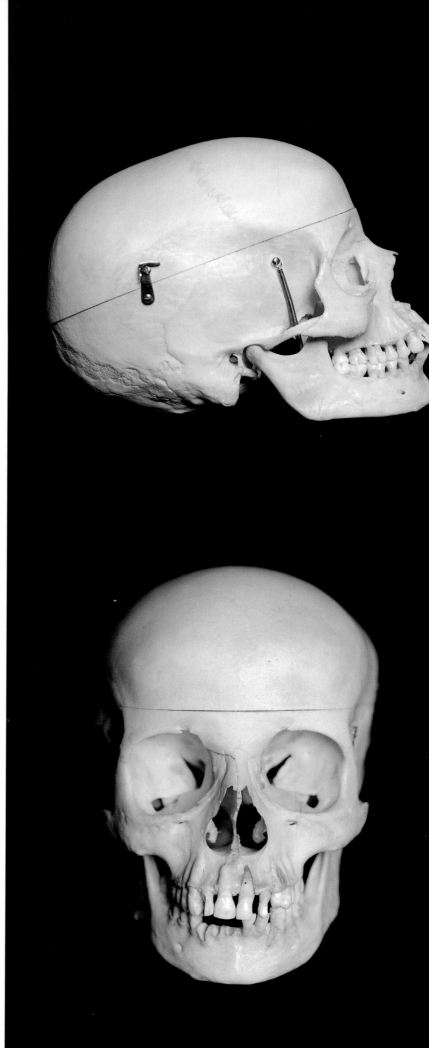

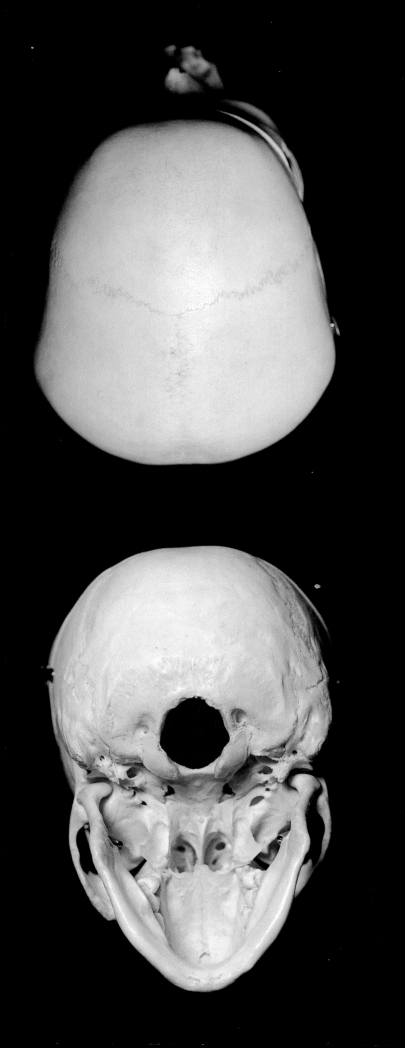

and mouth. Seven bones contribute to the eye sockets (also called orbits), and these appear as deep pyramidal cavities, the square apertures of which are gently rounded. Two small nasal bones (see also p. 48) form the bridge of the nose, and together these project forward and upward to meet the nasal cartilage which gives shape to the nostrils. A single median bone named the vomer (or plow) divides the right and left nasal apertures, and deep inside the nose are three finely curled paper-thin bones named turbinates (from the Latin, *turbo*, spinning top) or conchae, because they resemble a conch shell. These are designed to spin air as it is inhaled, so flinging dust particles against the mucous lining of the nose, where they are trapped and prevented from entering the lungs.

The zygomatic (or malar) bones give the face its broadest measurement. Narrow posteriorly, they sweep over the temporal fossa (the hollows below the temples) like flying buttresses and widen to form the cheekbones beneath the eyes (p. 48). The maxillae shape the upper lip and the walls of the nose, and then run deep into the head to contribute to the floor of the eye sockets. Together they also form part of the hard palate at the roof of the mouth (p. 49) and hold the upper row of teeth, closing over and in front of the lower teeth. The lower jaw, also named the submaxilla or mandible (from the Latin, *mandere*, to chew), is the largest and strongest bone of the face. The body of the mandible is v-shaped if seen from above or below. It supports the lower teeth and articulates with the temporal bones just in front of the ears at the temporomandibular joints.

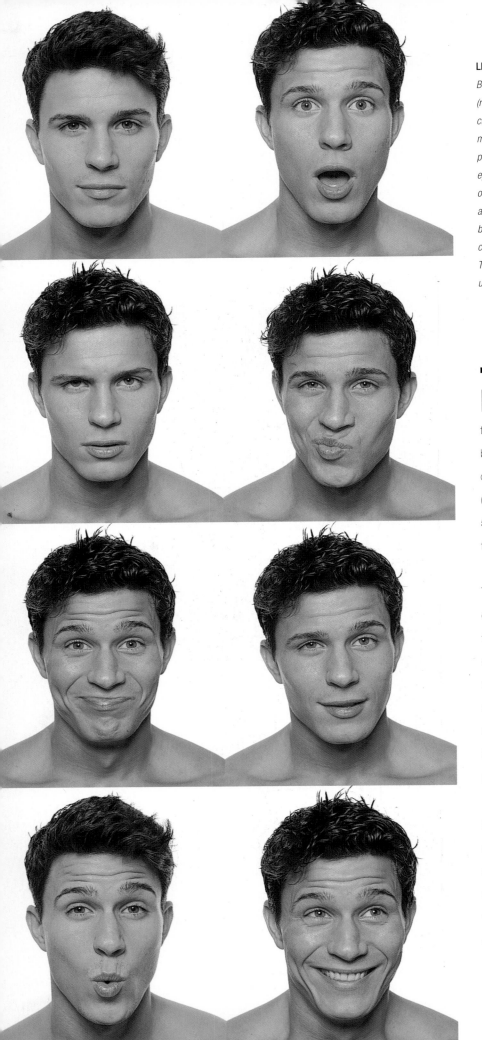

LEFT AND RIGHT

Behind the protection of orbicularis oculi (right), the globe of the eye rests in a soft cushion of fat. Six muscles direct its movement, and a seventh muscle (levator palpebrae superioris) raises the upper eyelid (left). If the eye's cushion is limited, or reduced with age, the whole globe may appear sunken or deep set beneath the brow. Conversely, certain conditions can cause the eye to bulge from its socket. Tears are generated behind and within the upper eyelid, which is thicker and longer than the lower lid. The upper eyelashes (arranged in two or three rows) are long and curl upward, whereas the lower lashes are much shorter and curl downward so that they do not catch the upper lashes when the eye blinks. The white of the eye is called the sclera, and the colored muscle of the iris controls the aperture of the pupil, which appears as a black hole at the center of the iris. In profile it is possible to see the cornea as a transparent dome projecting forward of the whole eye.

THE HEAD
FACIAL MUSCLES

Directly over the top of the head a musculo-fibrous sheet covers the skull from the occipital bone (p. 48) to the eyebrows. This is the epicranius. It is made of three distinct parts: two portions of muscle, occipitalis (posterior) and frontalis (anterior), connected by an aponeurosis named galea aponeurotica (p. 55). The frontalis portion raises the eyebrows and draws the scalp forward; occipitalis draws the scalp backward.

The broad elliptical fibers of orbicularis oculi surround the eye socket (or orbit) and create the sphincter muscle of the eyelid. This acts involuntarily to blink or close the eye in sleep. When consciously contracted, orbicularis oculi draws skin inward upon the eye in tiny creases, as when narrowing the eyes in bright light. Beneath orbicularis oculi, a muscle lies deep along the medial portion of the eyebrow. This is the corrugator, which draws the eyebrows together and downward, forming vertical creases at the center of the forehead, as in a frown. Procerus also draws the brow downward, producing horizontal folds across the bridge of the nose.

Nasalis, flexed at different points, allows us to close or flare the nostrils slightly. Levator labii superioris also assists in flaring the nostrils while raising and everting the upper lip. The infraorbital and zygomatic parts of this muscle partly form the nasolabial furrow – the crease from the side of the nose to the corner of the mouth. When flexed, levator labii superioris opens the lips in an expression of contempt or disdain. In contrast,

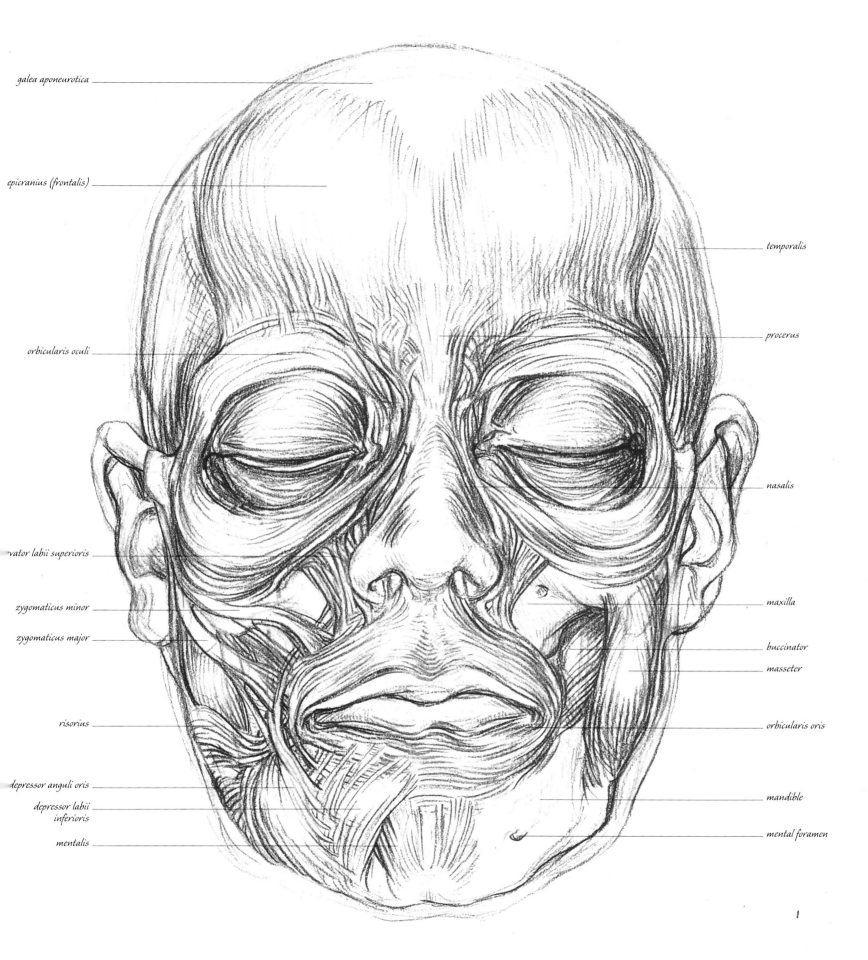

galea aponeurotica

epicranius (frontalis)

orbicularis oculi

vator labii superioris

zygomaticus minor

zygomaticus major

risorius

depressor anguli oris

depressor labii
inferioris

mentalis

temporalis

procerus

nasalis

maxilla

buccinator

masseter

orbicularis oris

mandible

mental foramen

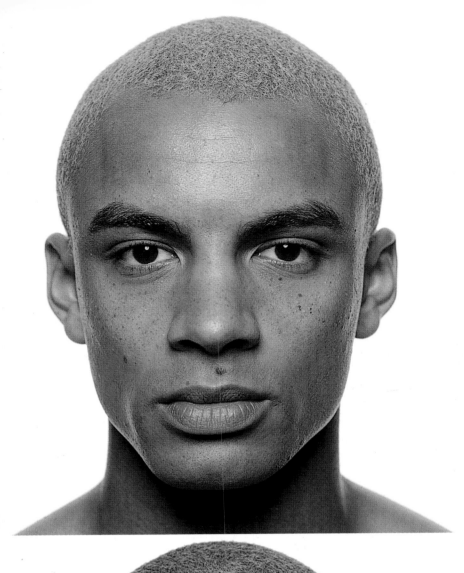

LEFT

These two photographs show the relative measurements of the head. The base of the ear lobe is about level with the base of the skull, and the length of the nose from the brow to its tip is about one third of the total length of the face (measuring from the hairline to the point of the chin). It is important to note the angle at which the nasal bones (p. 48) meet the nasal cartilage, the width and thickness of the nostrils (made of cartilage and fat), and the degree to which the nostrils curve down or up to reveal the nasal cavities.

RIGHT AND OVERLEAF

The superficial muscles of the face and neck (right) and their action (overleaf): the fibres of each muscle determine the direction in which it pulls. More muscles contribute to shaping and moving the mouth than any other part of the face. When the face is relaxed, the corners of the mouth are almost beneath the center of each eye (p. 57, above right). The flesh of the whole mouth is held in shape by the cheek bones, jaws, and teeth. Think of an elderly person with a reduced lower jaw and no teeth – the mouth is drawn severely inward.

zygomaticus (major and minor, p. 53) draws the corners of the mouth upward to smile or laugh, whereas risorius (p. 53) pulls the corners of the mouth across the face in a level grin. Depressors labii inferioris and anguli oris (p. 53) can be felt just below the lateral portion of the lower lip. Their fibers contain a lot of soft fat to shape this part of the face, and they draw the lower lip down and outward in a grimace of disgust. Mentalis above the point of the chin (p. 53) protrudes the lower lip in an expression of doubt.

Buccinator (p. 53, from the Latin, *buccina*, trumpet) is a strong quadrilateral muscle connecting the maxilla to the mandible. Also called the trumpeter's muscle (it holds the cheeks firm when air is blown strongly through the lips), it forms the wall of the mouth and presses the cheeks against the teeth. Orbicularis oris (p. 53), unlike the simple ring muscle of the eye, is made of fibers running in different directions. Some are proper to the lips, but most derive from muscles surrounding the mouth. Orbicularis oris can purse the lips, press them flat against the teeth, or push them outward to blow a kiss.

Masseter (p. 53) is a thick and powerful muscle giving shape to the back of the jaw. It pulls the mandible hard against the maxilla, enabling us to bite and grip with our teeth. Temporalis is a large thin fan-shaped muscle covering the side of the cranium. The fibers converge to form a tendon that descends behind the zygomatic arch and inserts onto the coronoid process of the jaw (p. 48). It closes the mouth, pulling the jaw upward and back against the upper teeth. A thick fibrous sheet, the temporal fascia covers temporalis.

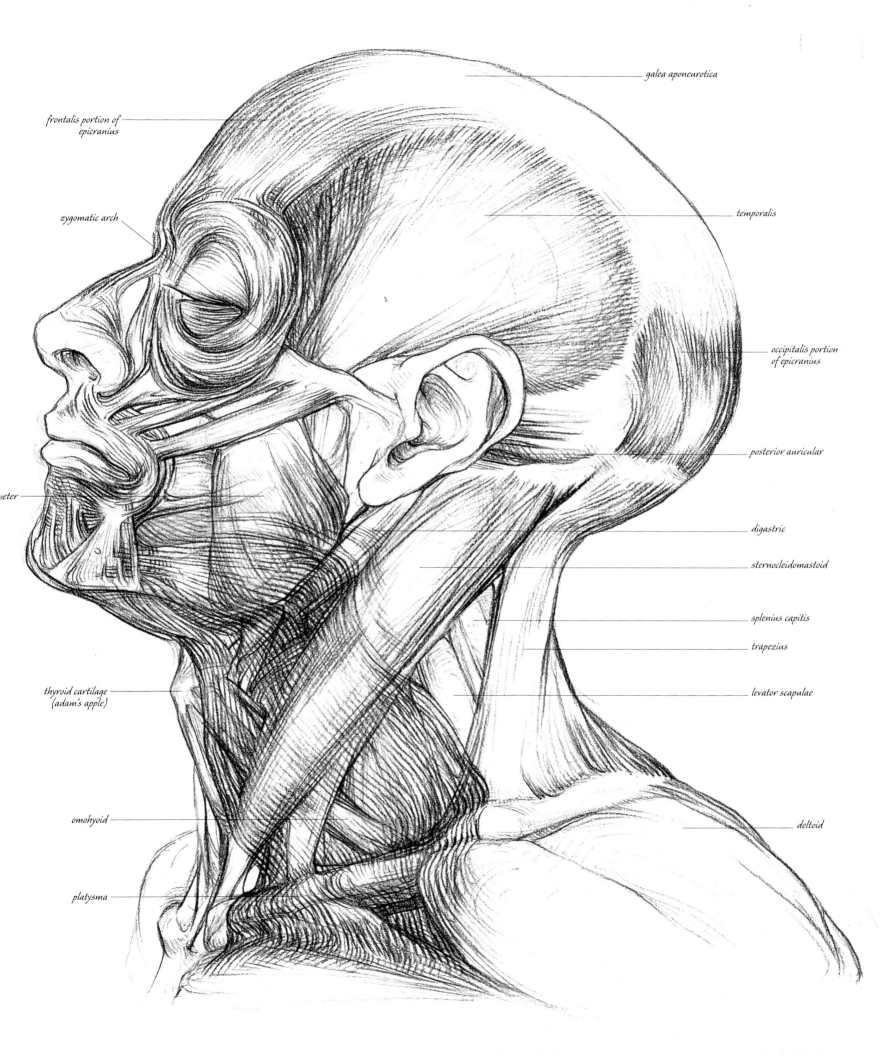

galea aponeurotica

frontalis portion of
epicranius

zygomatic arch

temporalis

occipitalis portion
of epicranius

posterior auricular

eter

digastric

sternocleidomastoid

splenius capitis

trapezius

thyroid cartilage
(adam's apple)

levator scapulae

omohyoid

deltoid

platysma

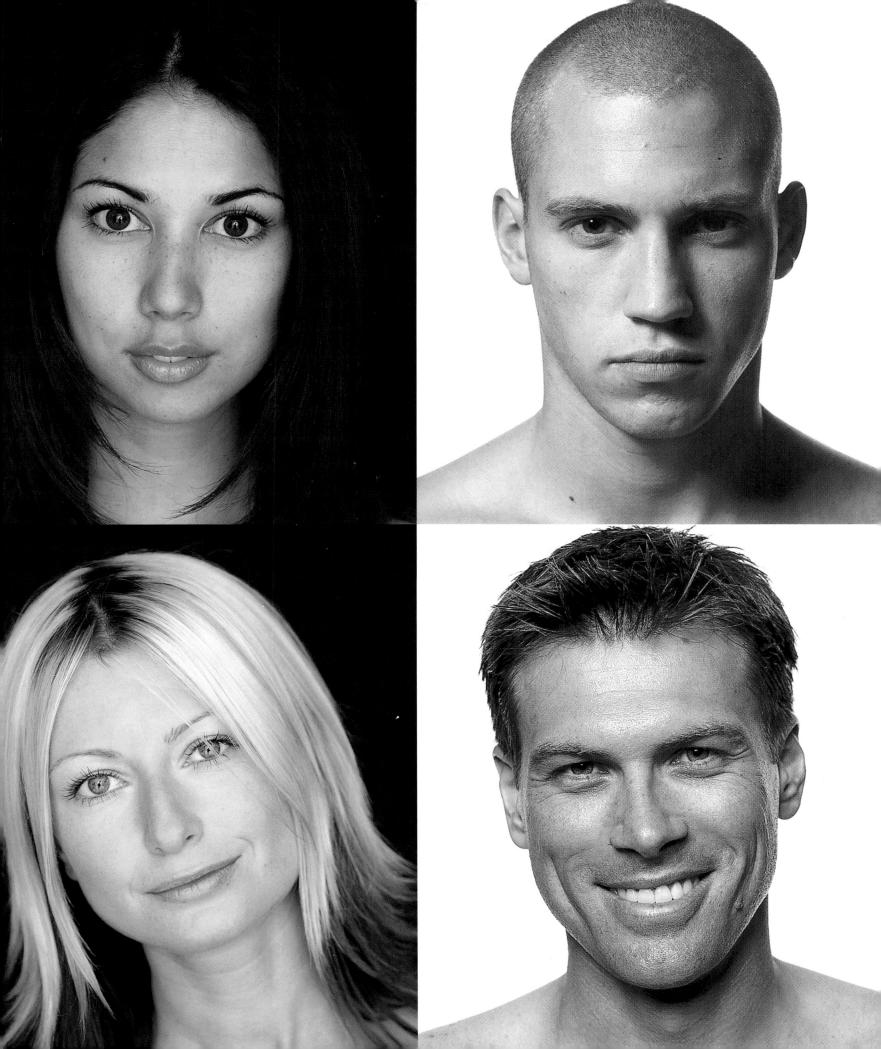

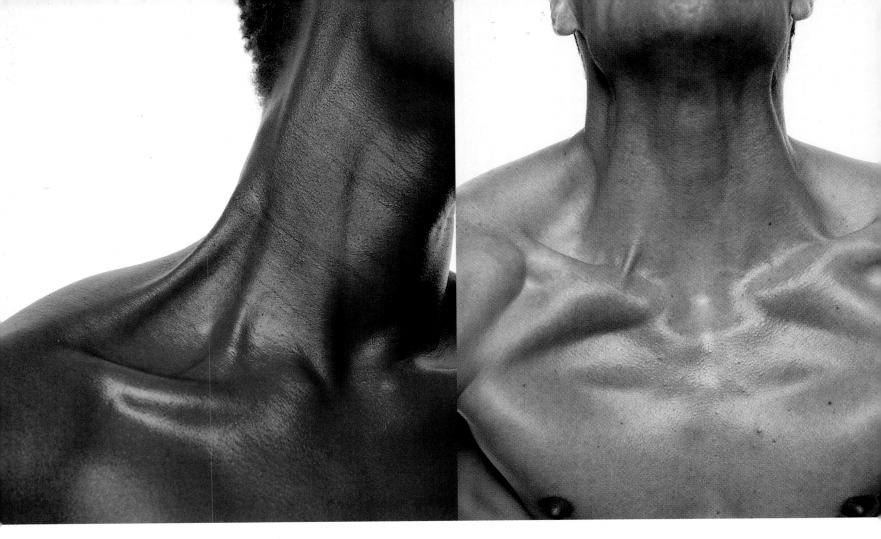

THE HEAD NECK MUSCLES

Large strong muscles clothe the back and sides of the neck, and surround the curve of seven cervical vertebrae (C1–7, p. 48). Arranged in layers, these flex, extend, and rotate the head, and raise the shoulders toward the ears.

The throat, at the front of the neck, is shaped by very thin muscles overlying a long upright column of cartilages, ligaments, and taut membranes. This is the superficial architecture of our speech, swallowing, and breathing. The small hyoid bone marks the root of the tongue, and is suspended by ligaments from the styloid process beneath each temporal bone (p. 48). The larynx (or voice box), palpable at the top of the neck, is the entire hard-throat structure, from the root of the tongue to the trachea (or windpipe) below. It is composed of nine cartilages (two arytaenoid, two corniculate, two cuneiform, the epiglottis, cricoid, and thyroid), joined by numerous ligaments, membranes, and delicate muscles, and lined by a mucous membrane, continuous with that of the trachea below. The thyroid cartilage is the largest of the throat. Suspended from the hyoid (p. 48), it is curved and pointed towards the front. Significantly larger in men than women, the thyroid cartilage is often called the Adam's apple. The cricoid cartilage situated below is also more prominent in men, where it presents a smaller bump below the center of the throat. In women, a larger thyroid gland conceals the cricoid, giving a more rounded shape to the neck. An enlarged thyroid gland (or goitre), a condition more common in women than men, has in certain periods been considered more beautiful and desirable than the normal form.

A woman's neck is also normally longer than that of a man, due to the angle at which the upper ribs meet the sternum (p. 77). The top of a man's sternum is usually level with his second thoracic vertebra (p. 65). A woman's sternum is lower, and level with her third thoracic vertebra. In men and women, the front of the neck is lower than at the back, and it shortens when the whole chest is drawn up toward the chin. The female occipital bone (p. 48) is more oblique than the male, giving greater height to the back of the neck. Stronger neck muscles in men, particularly behind and either side, give greater width.

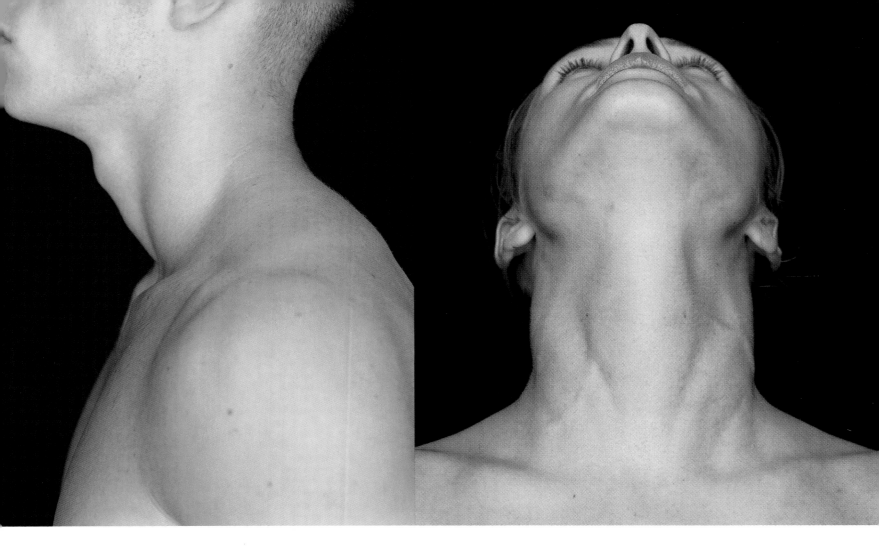

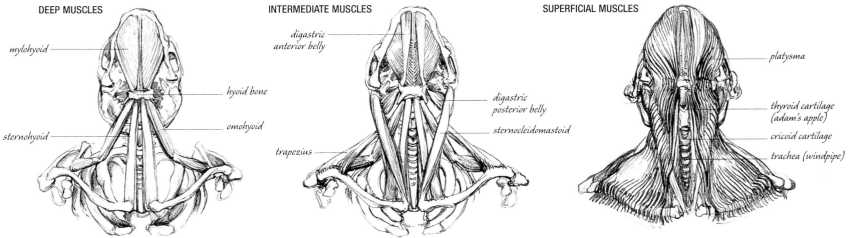

DEEP MUSCLES

mylohyoid

sternohyoid

hyoid bone

omohyoid

INTERMEDIATE MUSCLES

digastric
anterior belly

digastric
posterior belly

sternocleidomastoid

trapezius

SUPERFICIAL MUSCLES

platysma

thyroid cartilage
(adam's apple)

cricoid cartilage

trachea (windpipe)

TOP AND ABOVE

Use the drawings above to understand the photographs of neck muscles. The most prominent are trapezius (photographs, left), sternocleidomastoid (photographs, above) and platysma. Platysma is the largest cutaneous muscle of the body. It softens the front of the neck, and is our only investing muscle of the trunk (or panniculus carnosus). Found among other mammals, panniculus carnosus enables a horse to shake flies from its skin. Human platysma can flick the skin of the neck or pull the corners of the mouth into a grimace, creating folds from the jaw to the collarbone (photograph, near left). Each side of the neck is shaped by a tapered column of muscle, sternocleidomastoid, arising from the sternum and clavicle at the pit of the neck to the mastoid process behind the ear. If both contract, they draw the head forward onto the chest. If only one contracts, the head is turned to the opposite side. If the head is fixed, both help raise the thorax for forced breathing (p. 78). Beneath the jaw, mylohyoid lifts the floor of the mouth and the hyoid bone when swallowing. Digastric opens the mouth, pulling the jaw downward. Omohyoid pulls hyoid downward, assisted by sternohyoid. Smaller throat cartilages in women are concealed and softened by the thyroid gland and surface fat (photograph, above right), while male thyroid and cricoid cartilages are prominent (photograph, above left).

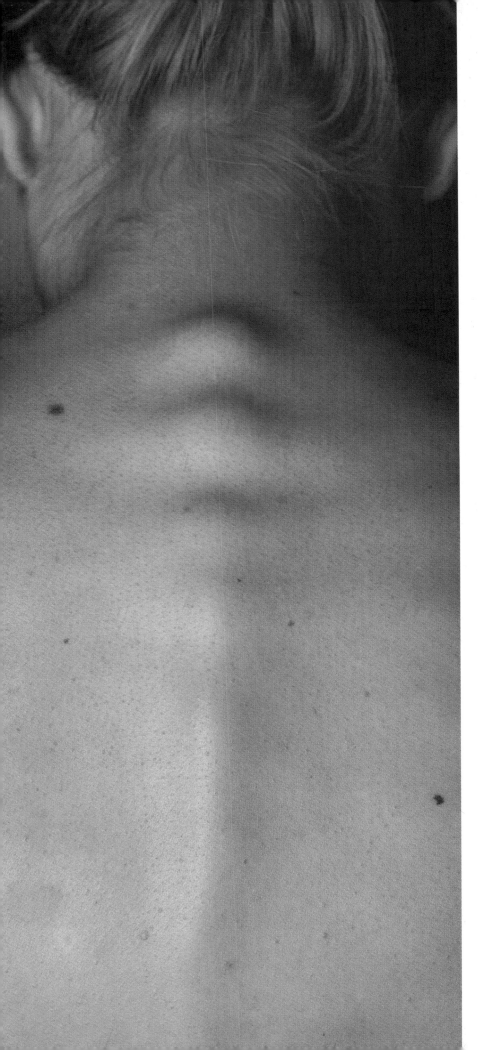

THE HEAD
EARS AND HAIR

What we call our ears are actually the auricles: the fleshy parts surrounding the ear hole. Shaped to direct sound waves into the tympanic cavity, they are made of elastic cartilage, covered in fine nerves, blood vessels, fat, fascia (p. 36), and skin. The inner and middle ear are responsible for hearing and balance.

Hair covers the entire body except for the palms of the hands, the soles of the feet, the nipples, lips, and some areas of the genitalia. Hair growth occurs in small tubes deep in the skin called follicles. The emergent shaft is made of an inner core (or medulla) and an outer cortex of dead cells impregnated with the protein keratin. Straight hair has a round or cylindrical shaft; curly hair has a flatter shaft. Varying amounts of melanin (black or brown pigment) deposited in the dead cells give hair its color. Sebaceous glands produce an oil called sebum to keep hair supple and skin soft.

Dark hair is much stronger and thicker than fair hair, is less susceptible to breaking, and can be grown to a greater length. Head hair lengthens through alternate periods of growth and rest and extends an average of 5in (12.5 cm) per year. Body hair grows much more slowly. A single head hair lives for two to six years, dies, falls out, and is replaced by a new strand. The duration of this cycle determines the natural length to which an individual's hair will grow. Contrary to popular belief, hair and nails do not grow after death. Apparent post mortem growth is merely an effect of the dehydration and recession of skin.

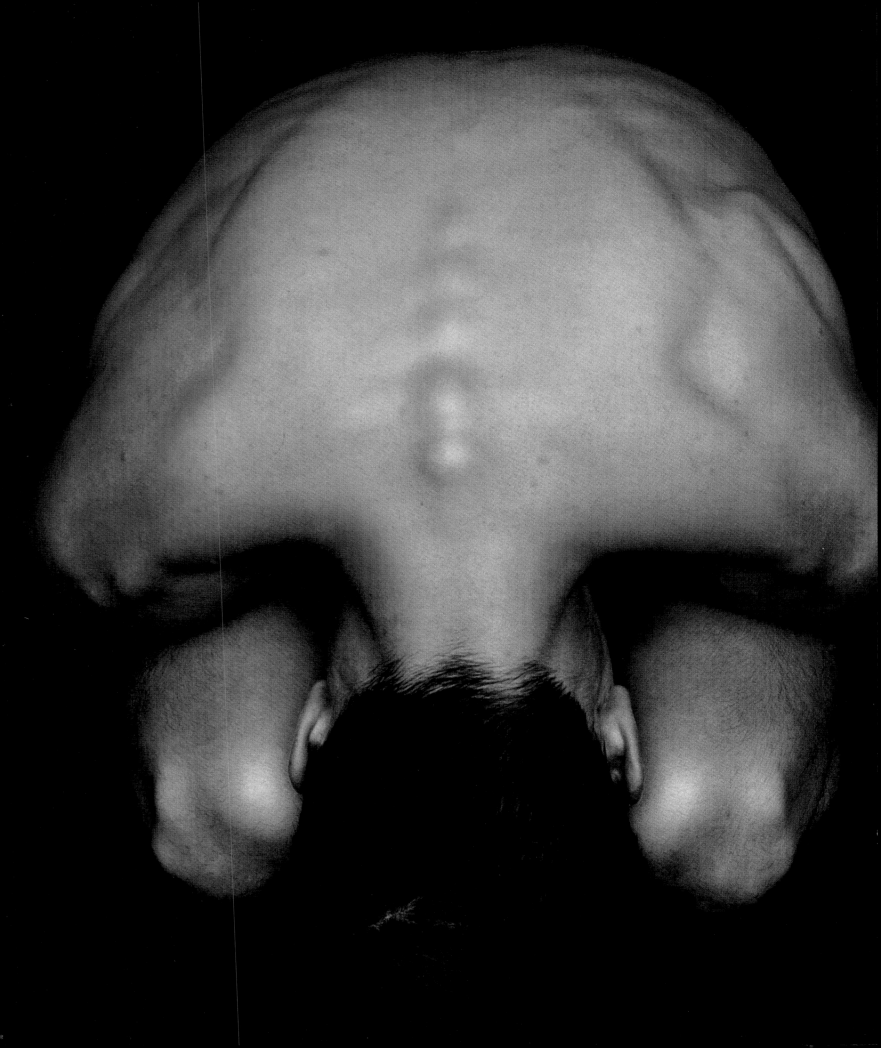

If the torso or trunk of the body is opened from the front, and the soft organs are removed, the thorax and abdomen present two empty, smooth-walled chambers. The inner walls of the thorax look like the inside of a huge, dark-red silk and pearl-lined egg. The inside of the abdomen is similarly smooth, cupped and closed at its lower end by the bowl of the pelvis. The spine at the base of these two chambers appears as a massive tapered and arching rod dividing the interior length of the torso into two very deeply cupped halves. Its curved succession of ventral bodies project so high as to reach almost the center of the torso.

THE SPINE

In life, the aorta (the greatest artery emerging from the heart), lungs, liver, kidneys, and intestines fit perfectly against the inner surface of the spine, whose segmented length is tightly bridged and smoothed by a long sheet of powerful ligaments. Shielded behind this load-bearing core, and encased within a delicate canal of vertebral arches, is the spinal cord: a pale, oval, and tapered cylinder of nerve fibers. Almost separated in two along its length by deep furrows in front and behind, the spinal cord is bathed in circulating fluid, wrapped in membranes and cushioned by fat. This is the brain's main cable of communication with the body. Paired roots emerge from either side, between the vertebrae, and these divide to form a tracery of peripheral nerves. Beyond the spinal canal, deep within many complex sheets of muscle, lie an arrangement of more than 70 spinal processes. These are fine levers of bone, pulled by muscles, to flex, extend, and rotate the whole torso.

RIGHT

This illustration locates the spine inside the living body. Observe the undulating lateral curves presented by transverse processes (p. 66) running the length of the spine. From the extended width of the axis at the top of the spine, subjacent cervical transverse processes either side of the neck grow successively wider toward the thorax. The first thoracic vertebra is clearly the widest of the twelve, and from here thoracic transverse processes successively diminish until barely

protruding at their lowest point. The lumbar transverse processes are the most extended of the whole spine, and their width draws a convex arc either side from above to below. Transverse processes give attachment to deep muscles articulating the spine and are buried by columns of muscle flanking it. Spinous processes (p. 66) are visible through the skin; here the lumbar spinous processes are apparent. The spines of C7 and T1 (p. 66) would be palpable at the base of the neck.

THE SPINE BONES

The spine (also called the spinal column, vertebral column, or backbone) is the longitudinal and central axis of the body, situated deep to the median (or center line) of the body at the posterior of the torso. It possesses incredible strength and is made of 33 interlocking collars of bone named vertebrae. They are arranged in five distinct groups.

Cervical vertebrae determine the height of the neck and are the smallest and most delicate segments of the spine. Thoracic (or dorsal) vertebrae correspond to each pair of ribs in the torso, closing the thoracic cavity behind, and forming part of the rib cage. Lumbar vertebrae shape the curve of the lower back and carry the weight of the whole torso above. They are the largest moveable vertebrae of the spine. The sacrum at the base of the spine is a thick triangular dish of bone made of five fused vertebrae, firmly fixed between the iliac bones (or wings) of the pelvis. The sacrum contributes to both the spine and the pelvis. Beneath, at its tip, are the fused bones named the coccyx. These vary in shape and number (four is the maximum) from person to person, and do not serve any structural purpose. The coccyx is often described as a vestigial tail.

The whole spine articulates with the head, rib cage, and pelvis. Moveable vertebrae – that is, the superior 24 – are separated by disks of cartilage (called intervertebral disks), and articulate with each other. The spine is stabilized by a series of powerful ligaments and maneuvered by deep muscles of the torso.

Viewed laterally (from the side), the spine presents four distinct and alternating curves (p. 67, the sacral, lumbar, thoracic, and cervical curves). These increase the carrying strength of the spine and enable the body to balance in an upright posture, with the least muscular effort. If the human spine were straight, the weight of the rib cage and viscera suspended in front would pull the whole body forward. When walking, or jumping, the curves of the spine also absorb the shock of our feet striking the ground.

Viewed from behind, the vertebral column appears perfectly upright. However, many of us who are right handed, and who give preferential use to our right arm, present a very slight and gentle curve to the left in the region of the third, fourth, and fifth thoracic vertebrae, counterbalanced by a curve to the right in the lumbar region. Those of us who are left handed show lateral curves in the opposite directions.

A typical human vertebra is made of three parts (p. 69). An anterior cylindrical block of bone with flattened upper and lower surfaces forms the ventral body. This is the main part of a vertebra and it carries the weight of the torso from one block to the next. The ventral bodies of all typical vertebrae are tapered, becoming gradually more slender as they rise through the height of the torso. Behind the ventral body is a delicate arch of bone (termed the vertebral arch). This encloses a foramen or large hole. A succession of vertebral foramina behind the spinal column forms a canal in which the medulla spinalis (or spinal cord) is lodged and protected.

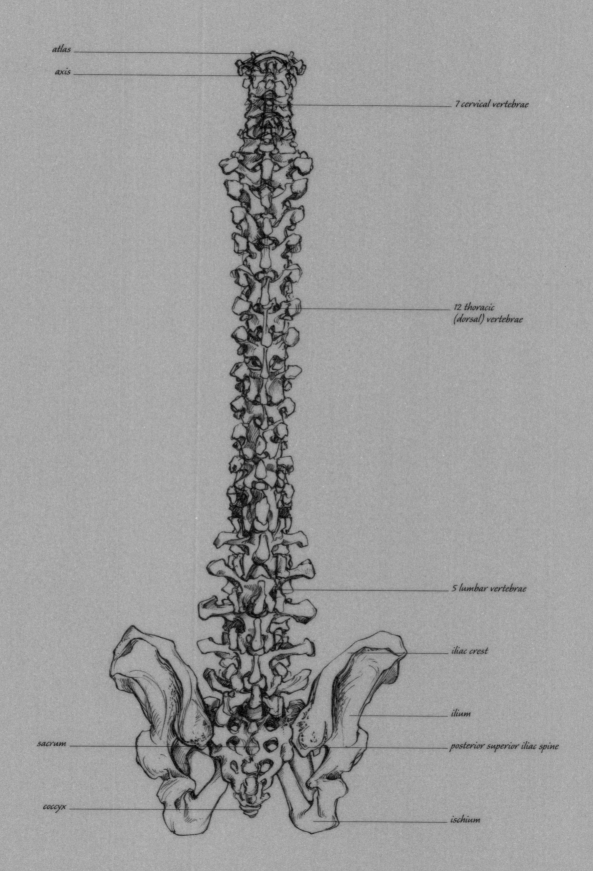

atlas

axis

7 cervical vertebrae

12 thoracic
(dorsal) vertebrae

5 lumbar vertebrae

iliac crest

ilium

sacrum

posterior superior iliac spine

coccyx

ischium

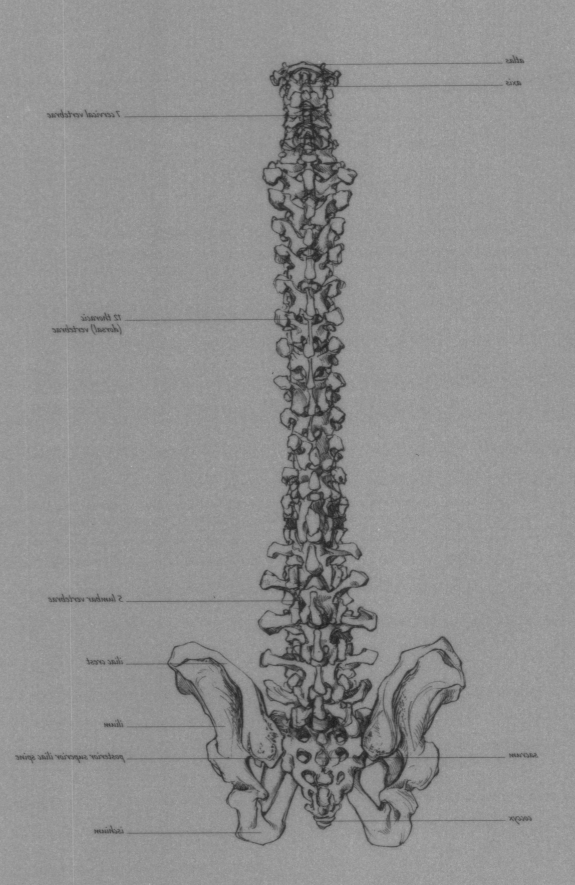

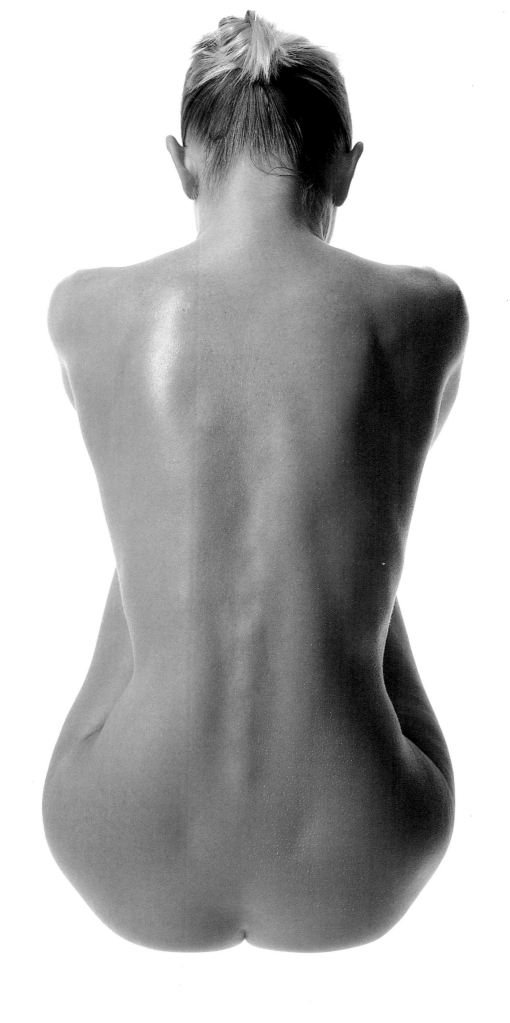

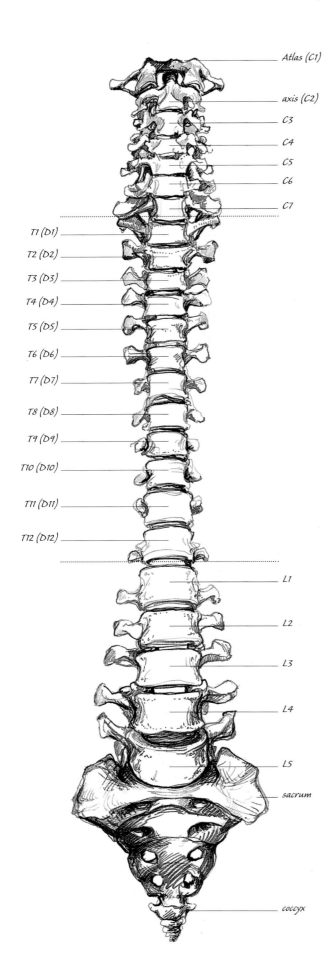

Atlas (C1)

axis (C2)

C3

C4

C5

C6

C7

T1 (D1)

T2 (D2)

T3 (D3)

T4 (D4)

T5 (D5)

T6 (D6)

T7 (D7)

T8 (D8)

T9 (D9)

T10 (D10)

T11 (D11)

T12 (D12)

L1

L2

L3

L4

L5

sacrum

coccyx

LEFT

This anterior view shows the full height of the spine with the rib cage and shoulder girdle removed. The spine is the vertical axis of the body, the core of the axial skeleton. Here the ventral bodies of the vertebrae are forwardmost, with transverse processes extended behind to either side. In perspective we see the anterior curves of the cervical and lumbar vertebrae balanced against the posterior curves of the thoracic and sacral portions of the spine. In this drawing and in the lateral view opposite note the graded increase in the size of the ventral bodies as they descend from the head to the sacrum of the pelvis, together with the specifically directed angle of each spinous process.

Each vertebral arch is composed of four segments, two pedicles (or roots), and two laminae (p. 69). Pedicles create each side of the arch, while laminae close the structure behind. Surmounting the vertebral arch are seven processes (or irregular bony protrusions, p. 69). Two transverse processes point outward to either side, and a single spinous process points backward and down from the center. Spinous processes give their name to the spine, and are the only part of it that can be seen beneath the skin. Transverse and spinous processes attach to powerful muscles and ligaments, and act as levers to flex, extend, and rotate the spine. They vary greatly in shape, thickness, length, and angle, depending upon their position along the length of the spine. Last of all, four short articular processes, two superior and two inferior, turn up and outward, or down and inward, to meet those of adjacent vertebrae. These form very small joints which both facilitate and restrict movements of the spine.

The seven cervical vertebrae in the neck are normally referred to as C1, C2, C3, C4, C5, C6, and C7. The cranium is balanced directly over the vertebral column. Two convex lips of bone named occipital condyles, positioned either side of the foramen magnum at the base of the skull (p. 49), articulate with two corresponding concavities on top of the first cervical vertebra (C1). This is the joint through which the brain connects with the spinal cord, and it is situated directly behind the mouth. C1 is named Atlas, after one of the old gods of Greek mythology, overthrown by Zeus and condemned to stand forever at the edge of world with the heavens on his shoulders. Atlas is

This lateral view (from the left) reveals the dynamic curves of the spine that in life are braced like a double bow. These increase the spine's strength and its capacity to absorb the shock of movement. When we walk, run, or jump, its sprung length compresses and expands. Tiny adjustments between each bone and its adjoining cartilaginous disks enable the body to balance upright with the least muscular effort. If the spine were straight, the weight of the rib cage and viscera would pull the whole body forward, causing us to fall.

seated over and around the second cervical vertebra (C2), named axis. Atlas and axis are unique among vertebrae in structure and range of movement.

Atlas does not have a ventral body or a spinous process. Instead, it forms a delicate open ring with two upward-facing articular dishes carrying the weight of the head, and two markedly long transverse processes projecting beyond those of subjacent vertebrae. These reach out beneath the skull toward the mastoid processes of the temporal bones (p. 48), giving powerful leverage to the deep oblique muscles which turn the head from side to side (p. 59). Each transverse process is pierced by a small foramen conducting vertebral blood vessels and a complex network of nerves through the neck. Transverse foramen are characteristic of all cervical vertebrae and help to differentiate them from thoracic vertebrae.

Axis (C2), situated beneath Atlas, is a more sturdily built vertebra, formed with a stout body in front, diminished transverse processes, a broad spinal process, and above a very prominent dens or odontoid (toothlike) projection. This projection passes upward through the anterior arch of Atlas and is held in place by a powerful ligament. The union of Atlas and axis creates a strong pivotal joint for the rotation of the head above.

The remaining cervical vertebrae are deeply buried at the center of the neck behind the esophagus, with the exception of the last – C7, whose long spinous process rises close to the skin and creates a visible landmark at the

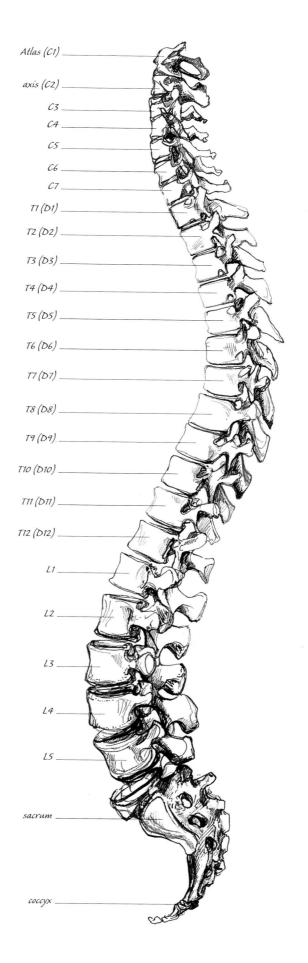

Atlas (C1)
axis (C2)
C3
C4
C5
C6
C7
T1 (D1)
T2 (D2)
T3 (D3)
T4 (D4)
T5 (D5)
T6 (D6)
T7 (D7)
T8 (D8)
T9 (D9)
T10 (D10)
T11 (D11)
T12 (D12)
L1
L2
L3
L4
L5
sacrum
coccyx

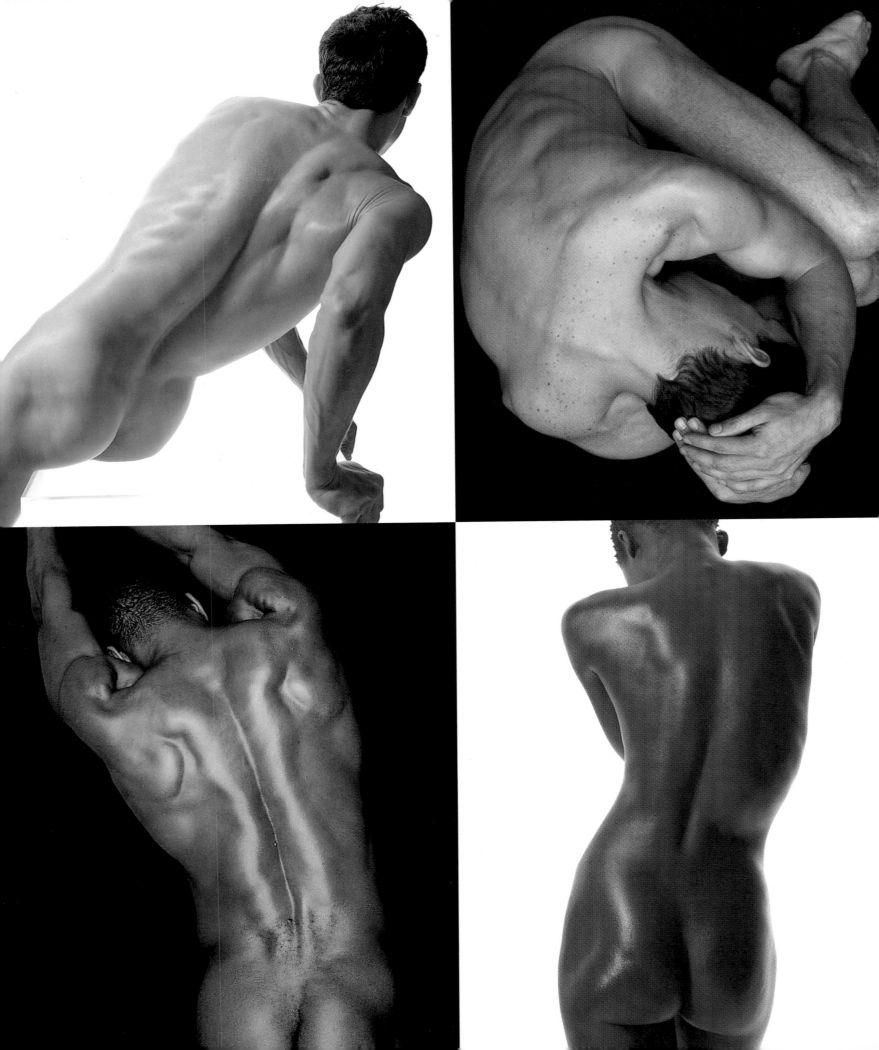

The movements photographed are shaped and controlled by layered muscles arranged either side of the vertebral column, attaching to more than 70 transverse and spinous processes. Reading from the top, the drawings of vertebrae are: 1 and 2: views of Atlas; note the angles of the four articular surfaces, two above and two below, and the aperture of the foramen, extended to receive the dens of axis. 3: axis: dens rises in front between the superior articular processes; the transverse and spinous processes are diminished in length. 4: third cervical vertebra: the smallest, note its tiny ventral body and the sharp spinous process directed down (it appears forked viewed from behind). 5: typical lumbar vertebra: displaying the curves of the ventral body. Articular processes project above and below, transverse processes to either side. 6: thoracic vertebra: two pedicles and two laminae shape the vertebral arch. 7: thoracic vertebra: note the angles of the five processes. 8: lumbar vertebra: displaying a large kidney-shaped ventral body.

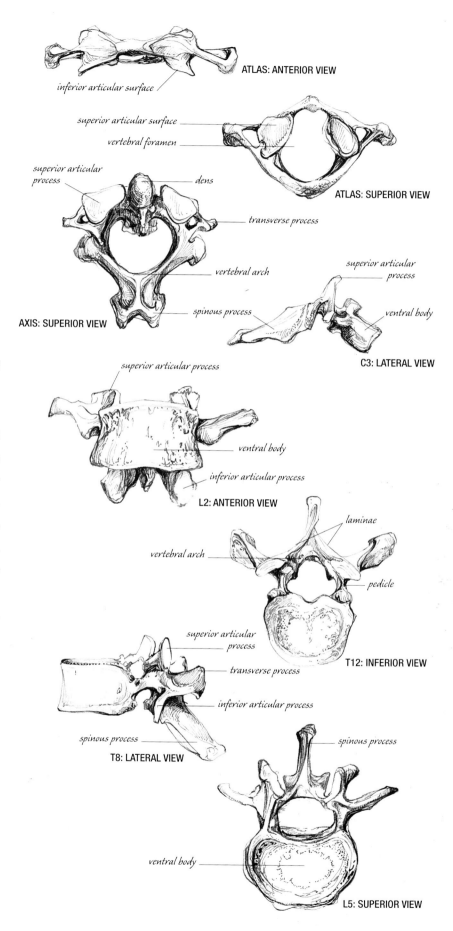

base of the neck. The cervical curve of the neck is discretely concave if viewed from behind, and greatly accentuated if the head is tilted backward.

The twelve thoracic or dorsal vertebrae (T1 to T12/D1 to D12) correspond to, and articulate with, pairs of ribs forming the rib cage (p. 74). Pairs two to 10 articulate with their corresponding vertebra and the vertebra above: for example, R5 articulates with T5 and T4. The remaining ribs (R1 and R11–12) articulate with a single vertebra (T1, T11, or T12). The thoracic vertebrae close and seal the back of the thoracic cavity, and the thoracic curve determines the posterior curve and orientation of the rib cage. The curve of the five lumbar vertebrae (L1 to L5) is concave and corresponds to the forward curve of the abdomen on the opposite side of the body. The greater the forward angle of the pelvis, the greater the curve of the lumbar vertebrae.

The twists and curves of the spine are among the most difficult elements of the body for an artist to capture. Deeply buried within the torso, the spine's complex curvature is only clearly seen from behind. However, fractional movements between each vertebra accumulate over its length, allowing the four spinal curves to be greatly accentuated, straightened, or rotated to either side. When the spine is arched backward, strong columns of muscle (erector spinae) flex and rise on either side, casting the lumbar vertebrae into a deep furrow. When the spine is curved forward into a fetal position, the erector muscles extend and stretch flat against the ribs, and the lumbar (and lower thoracic) spinous processes protrude in a line beneath the skin.

MASTERCLASS
THE VALPINÇON BATHER JEAN-AUGUSTE INGRES

Jean-Auguste Ingres (1780-1867) was 28 and in love with the now famous bather, when he painted this idealized cameo of her while staying in Rome.

As a young artist, Ingres trained in the atelier of Jacques-Louis David (see *The Death of Marat* p.106), who was 32 years his senior. David introduced him to Classicism, and Ingres eventually became the leading exponent of neoclassicism in France. His work is characterized by a mixture of realism and abstraction, coolness and sensuality, as well as a preference for line over color, the creation of shallow perspectives, and intense, almost microscopic detail, painted in smooth, glasslike surfaces.

In *The Valpinçon Bather*, there is a strong sense that the woman is caught at a moment between movements without any actual kinetic changes being shown. She appears to be distracted by something outside the picture, making her unaware of our gaze. This creates a powerful sense of intimacy. The bather is not showing herself to us, rather we have intruded into her private space while her attention is elsewhere.

Ingres has deliberately created a figure of eight within the composition of her limbs and back, which makes it difficult to stop looking at her; the eye is kept in motion within the contours of her body and this device works in contrast to the frozen languor of her pose. The painter's use of anatomy is characterized by a certain abstraction of internal structure. Ingres has suppressed the angularity of bone and instead creates the illusion of interior mass through refining the surface, density, and tension of fluent skin. She is an idealized woman in an idealized personal space into which we may forever gaze.

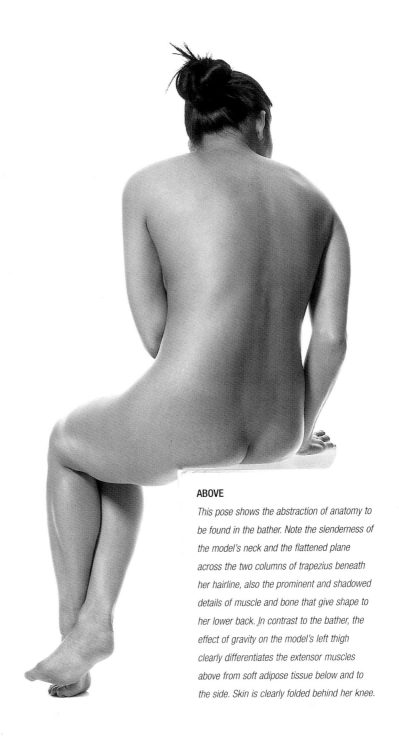

ABOVE

This pose shows the abstraction of anatomy to be found in the bather. Note the slenderness of the model's neck and the flattened plane across the two columns of trapezius beneath her hairline, also the prominent and shadowed details of muscle and bone that give shape to her lower back. In contrast to the bather, the effect of gravity on the model's left thigh clearly differentiates the extensor muscles above from soft adipose tissue below and to the side. Skin is clearly folded behind her knee.

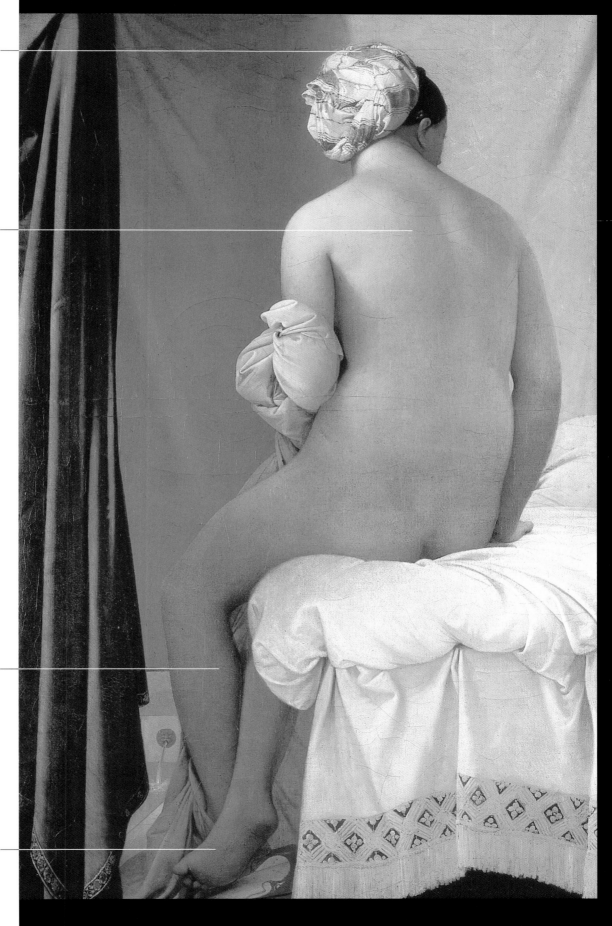

THE HEAD

The sitter's head is surprisingly small and the thickening of flesh that often occurs over the base of the neck has been drawn up toward her head. Her hairline is also raised and smooth. The cap divides her head from her body, and it appears heavy and about to fall. Mysteriously, it is the only element in the painting that is subject to gravity.

THE TORSO

The gentle twist in the woman's body has removed the support of weight from her legs. Her back is the most solid element of the painting, and her spine is deeply hidden beneath a smooth plane of flesh as it curves toward us like a bow. Her balance is clearly held by her hips, and her shoulders are softened by calm repose. This is emphasized by the focused glow of light that makes her left shoulder the bright hub of the painting.

THE LEGS

Ingres has suspended time, movement, and gravity. The bather is monumental, and yet her weight barely touches the fabric on the bed. Her right hand is weightless resting on the sheet, and her left leg gives no support to her body. Instead it curves to the left in a rounded arch. The flesh of her thigh is also without weight, and if the femur were placed within the limb, it would curve impossibly downward with a twist to the left. The calf is of almost equal size to the thigh as it plunges into the folds of the sheet.

THE FEET

Her right foot does not touch the floor at all — it merely caresses the fallen cloth, with toes curling away from any grip or stance. There are no creases or lines cast across her skin to describe the bony and tendinous frame of the ankle and foot. Instead, gentle arches of flesh run uninterrupted from her instep to the smooth curves of her calf and shin.

1808, oil on canvas, 57 x 39in,
Musée du Louvre, Paris

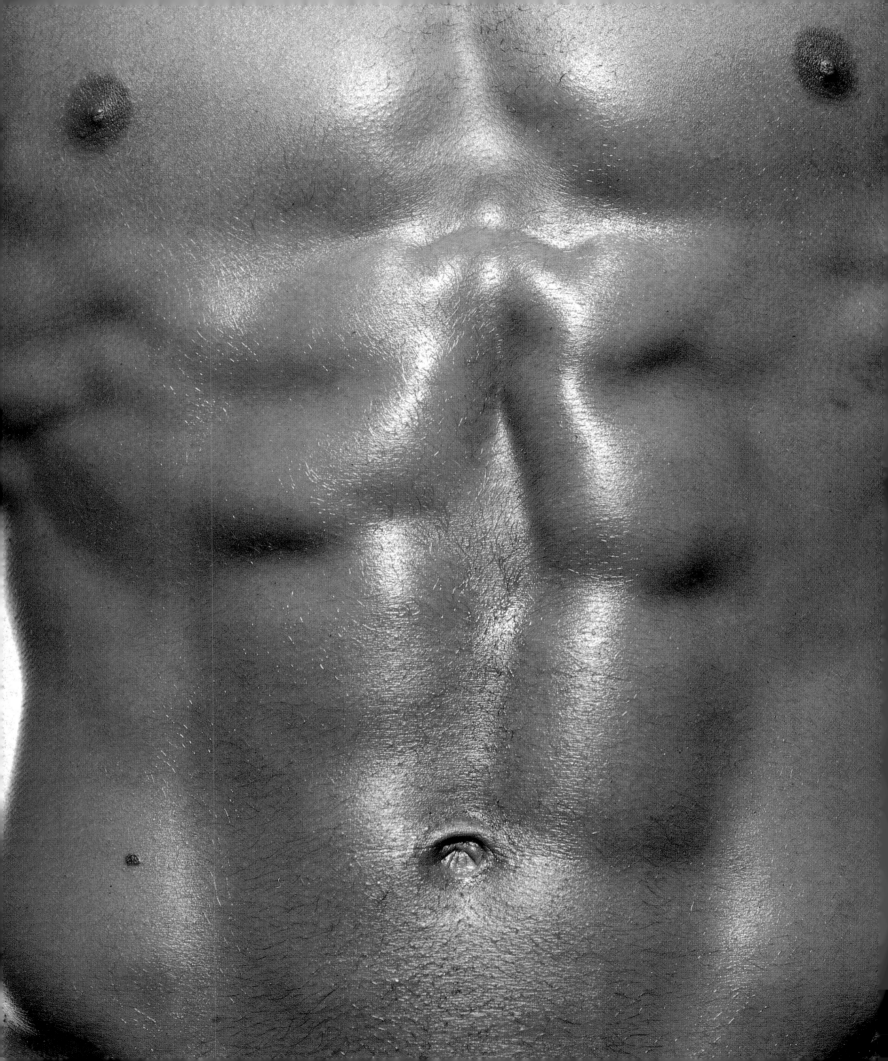

The torso is the body considered without the head and limbs. Roman artists and architects made reverent copies of art that survived from Greek antiquity, and as interest in these many fragments was reawakened in the Renaissance, some achieved great fame. Drawing these remnants, or plaster casts made from them, was soon established as part of an artist's formal training, and the torso became a sculptural subject in its own right during the nineteenth century. Auguste Rodin, for example, carved its muscular form as if it had been hidden within the stone. That conceit led directly to the work of Henry Moore and beyond.

THE TORSO

The torso extends from the base of the skull to the iliac lines (or uppermost borders) of the pelvis. It includes the whole length of the spine, the ribcage, shoulder blades, and collarbones, embedded within more than one hundred muscles (arranged in pairs). Intricately divided muscles articulate the spine, broad thin sheets enfold the abdomen, and thicker fleshier muscles give form, movement, and strength to the shoulders. The torso encloses two sealed chambers (or cavities), one above the other. The thoracic cavity protects the heart and lungs. The abdominal cavity holds urinary and digestive organs. The thorax and abdomen are divided by the diaphragm, joined by the spine, and their internal volume is reflected in the torso's external contours. The shoulder girdle crowns the ribs, and the curved wings of the scapulae glide in an arc across the back. The largest external form of the body, the torso invites study, both for its undulating solidity and for the secrets of its interior.

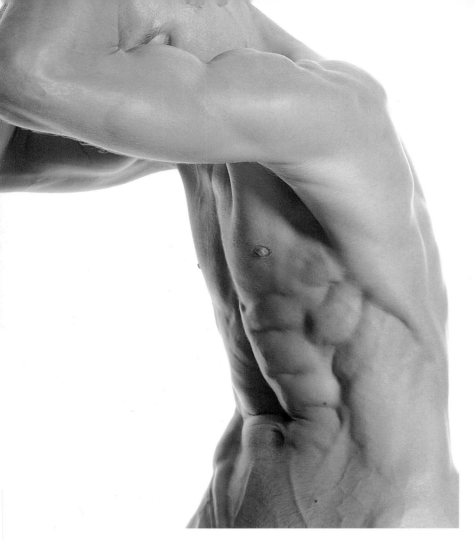
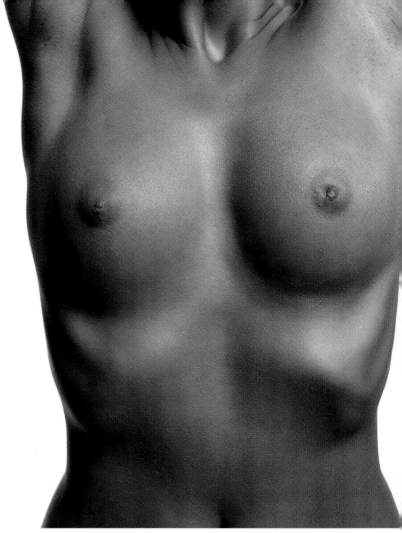

THE TORSO RIB CAGE

The rib cage is the largest structure in the human body, suspended directly from the vertebral column. It is the skeleton of the thorax or chest, embedded within layers of muscle, fat, and connective tissue: a semirigid enclosure, protecting vital organs, providing attachment to layers of muscle, and holding pressure during breathing. Men and women have the same number of ribs – usually 12 pairs which form a synchronized group of levers continually in motion, rising and falling with every breath. However, not infrequently an individual is found to have 13 pairs, or a single thirteenth rib on one side of the body. Some people have fewer than 12 pairs, and occasionally two ribs (most usually the two uppermost pairs) are found fused together, creating a single, curved plate of bone.

Anatomists number the individual ribs from the neck downward: R1 to R12. They are narrow, flattened, c-shaped arches of bone, arranged one below another, with intercostal spaces between them (from the Latin, *costis*, rib). Each rib forms a curve that is greater than the curve of the rib above. This accounts for the gradual widening of the rib cage from its narrow neck to a broad base. The head of each rib articulates with its corresponding thoracic vertebra (p. 76). The length or body of each rib sweeps around the chest wall in a forward and downward arc of about 45 degrees below horizontal. (As we breathe in, the ribs rise to near horizontal and the rib cage expands.)

All 10 ribs are extended by lengths of bluish-white hyaline cartilage (p. 32), termed the costal cartilages (p. 76). The first seven costal cartilages (extending from the first seven ribs) articulate directly with the sternum giving those ribs the name true ribs. The eighth, ninth, and tenth ribs are called the false ribs because their costal cartilages do not directly join the sternum, but turn upward, attaching to the costal cartilages of the ribs above. The last two ribs (R11 and R12) are significantly shorter, extended only a little by cartilage, and are not joined to the breastbone. They are called the floating ribs, although they do not actually float about within the body, being embedded and held firmly within the muscles of the abdominal wall.

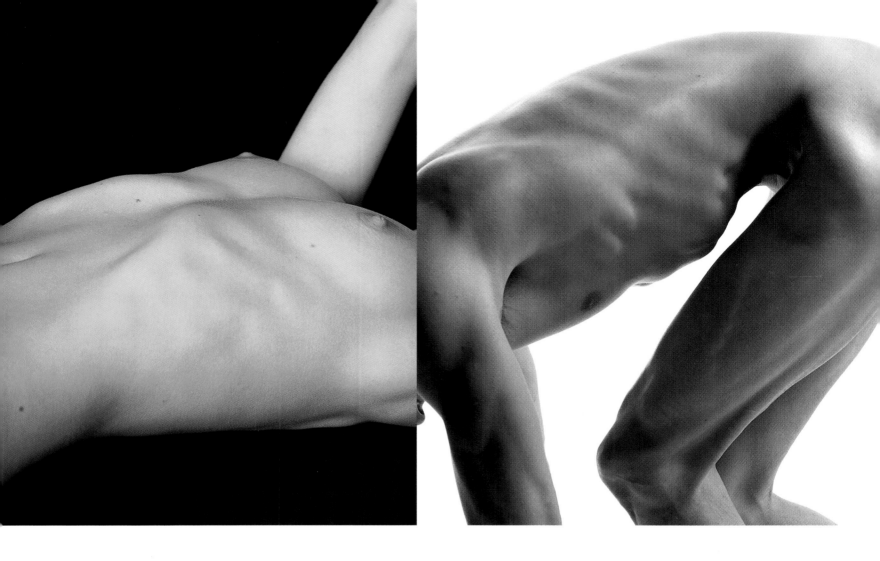

The sternum or breastbone closes the rib cage in front, and may be felt and seen along the center of the chest. It is a flattened bone, slightly convex in front and distinctly concave behind. The sternum was considered by ancient anatomists to resemble a Roman sword. It is composed of three bones and these are still occasionally named the point, the blade, and the handle.

The point of the sternum (xiphoid or ensiform, from the Greek, *ensis*, sword, p. 76) is made of cartilage which ossifies (turns to bone) in later life. This sits above the pit of the stomach. It normally points downward, but may turn forward and protrude against the skin as a single or double point. The middle portion of the sternum is named the body, blade, or gladiolus (from the Latin, *gladius*, sword). Slightly curved in women, this is straighter in men. The upper portion is named the manubrium or handle (p. 76). It is short, wide, and thickened above to support the clavicles (or collarbones) of the shoulder girdle. Its uppermost edge is also slightly cupped from side to side. This shallow indentation in the bone is named the suprasternal notch. In common

LEFT AND ABOVE

These photographs demonstrate the extent to which the uppermost portion (about one third) of the rib cage is obscured by the bones and layered muscles of the shoulder girdle. Far left: ribs describe the posterior curve of the torso, while the sternum marks a hard, straight, vertical furrow between the pectoralis major muscles in front (p. 85). This line is extended below to the navel, by a soft vertical depression between the two halves of rectus abdominis (p. 82). Near left and above left: these female models show a more curved sternum. Costal cartilages of at least R7 to R10 are shown pressing out against the skin beneath the breasts, where they shape the

infrasternal angle or thoracic arch (p. 77). Above right: like the women, this male model is raising the shoulders, holding the lungs full of air, and pulling in the muscles of the abdomen to increase the volume and definition of the lower ribs. It is also possible to trace the curvature of at least the lowest six ribs from spine to sternum. The scapula (shoulder blade, p. 96) is clearly defined, and in front of its lowest point (or inferior angle) light catches two digitations of the serratus anterior muscle (p. 100) emerging from beneath the plate of bone. These overlie the ribs and follow their contour but should never be mistaken for bone.

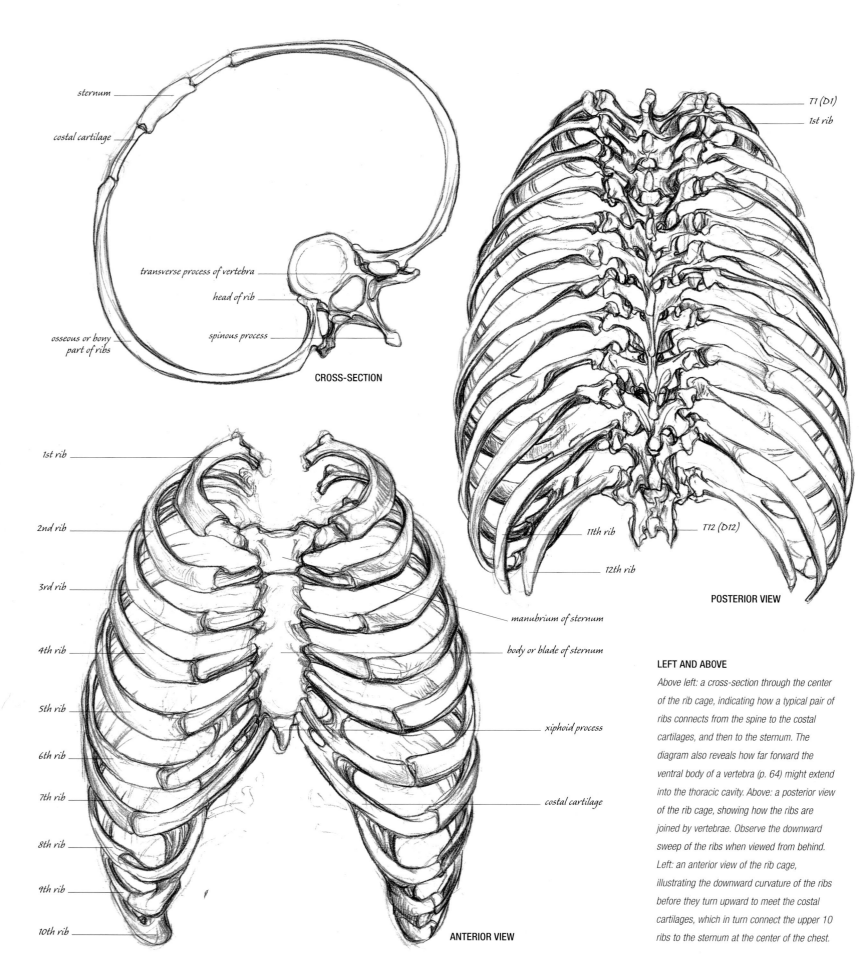

sternum

costal cartilage

transverse process of vertebra

head of rib

spinous process

osseous or bony part of ribs

CROSS-SECTION

T1 (D1)

1st rib

11th rib

12th rib

T12 (D12)

POSTERIOR VIEW

1st rib

2nd rib

3rd rib

4th rib

5th rib

6th rib

7th rib

8th rib

9th rib

10th rib

manubrium of sternum

body or blade of sternum

xiphoid process

costal cartilage

ANTERIOR VIEW

LEFT AND ABOVE

Above left: a cross-section through the center of the rib cage, indicating how a typical pair of ribs connects from the spine to the costal cartilages, and then to the sternum. The diagram also reveals how far forward the ventral body of a vertebra (p. 64) might extend into the thoracic cavity. Above: a posterior view of the rib cage, showing how the ribs are joined by vertebrae. Observe the downward sweep of the ribs when viewed from behind. Left: an anterior view of the rib cage, illustrating the downward curvature of the ribs before they turn upward to meet the costal cartilages, which in turn connect the upper 10 ribs to the sternum at the center of the chest.

Above right: the whole rib cage, including thoracic and cervical vertebrae, shown from above. The dens of axis appears between the superior articular surfaces of Atlas (p. 67). Through the foramen is a view down into the spinal cavity. Observe the narrow neck or aperture of the rib cage, shaped by the manubrium, first pair of ribs and first thoracic vertebra. Note also the relative widths of the

rib cage (front to back, and side to side), together with the depth of the furrow either side of the spinous processes. In life these furrows are filled by two powerful columns of layered muscle. Below right: the rib cage is turned to present anterior and lateral views simultaneously, revealing the interior volume of the rib cage, and the curves of the sternum, costal cartilages, and thoracic arch.

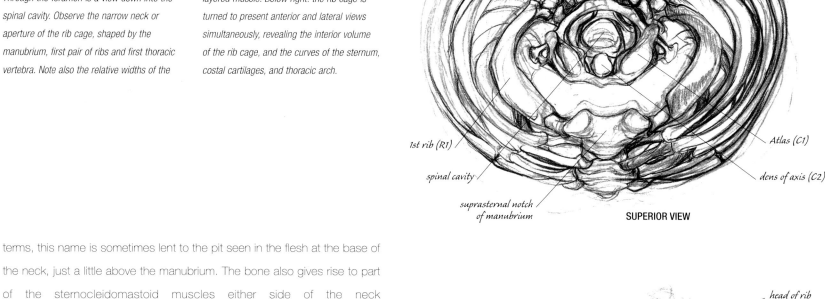

1st rib (R1)

spinal cavity

suprasternal notch
of manubrium

Atlas (C1)

dens of axis (C2)

SUPERIOR VIEW

terms, this name is sometimes lent to the pit seen in the flesh at the base of the neck, just a little above the manubrium. The bone also gives rise to part of the sternocleidomastoid muscles either side of the neck (p. 59). The manubrium joins the body of the sternum at an angle via a horizontal suture. This may be very slight in some individuals, pronounced in others. When pronounced, the joint is clearly seen through the skin of the chest, about four fingers' width beneath the suprasternal notch.

The vertical axis of the rib cage inclines backward when the body is standing straight. Its tapered cylindrical form is flattened from front to back, and it appears wide from side to side, long when viewed from behind. At the front, the inferior border rises to an inverted v-shape. This is termed the infrasternal angle or the costal or thoracic arch. The arch forms an angle of approximately 90 degrees in the male body and 60 degrees in the female, and it can be felt clearly above the navel and beneath the breasts when breathing in, or when the spine is extended backward. The tapered walls of the rib cage are defined and made complete by three fine layers of muscle tying between all of the ribs. Called the innermost, internal, and external intercostal muscles (p. 84), they raise the thorax during breathing, hold its walls firm, and present a taut surface of gleaming blue and pink pearlescent fibers, in contrast to the thick red flesh of overlying shoulder muscles.

The heart and the lungs occupy the upper two-thirds of the space inside the rib cage. Their lower surfaces rest on the diaphragm, which stretches like a

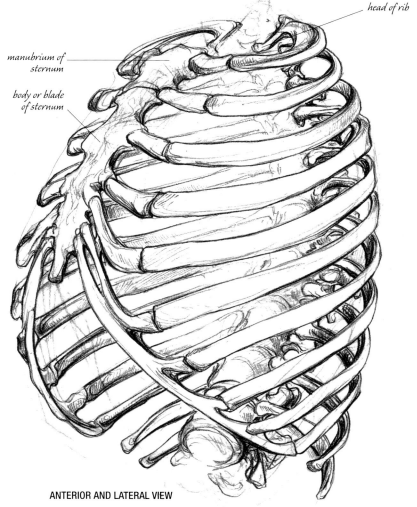

head of rib

manubrium of
sternum

body or blade
of sternum

ANTERIOR AND LATERAL VIEW

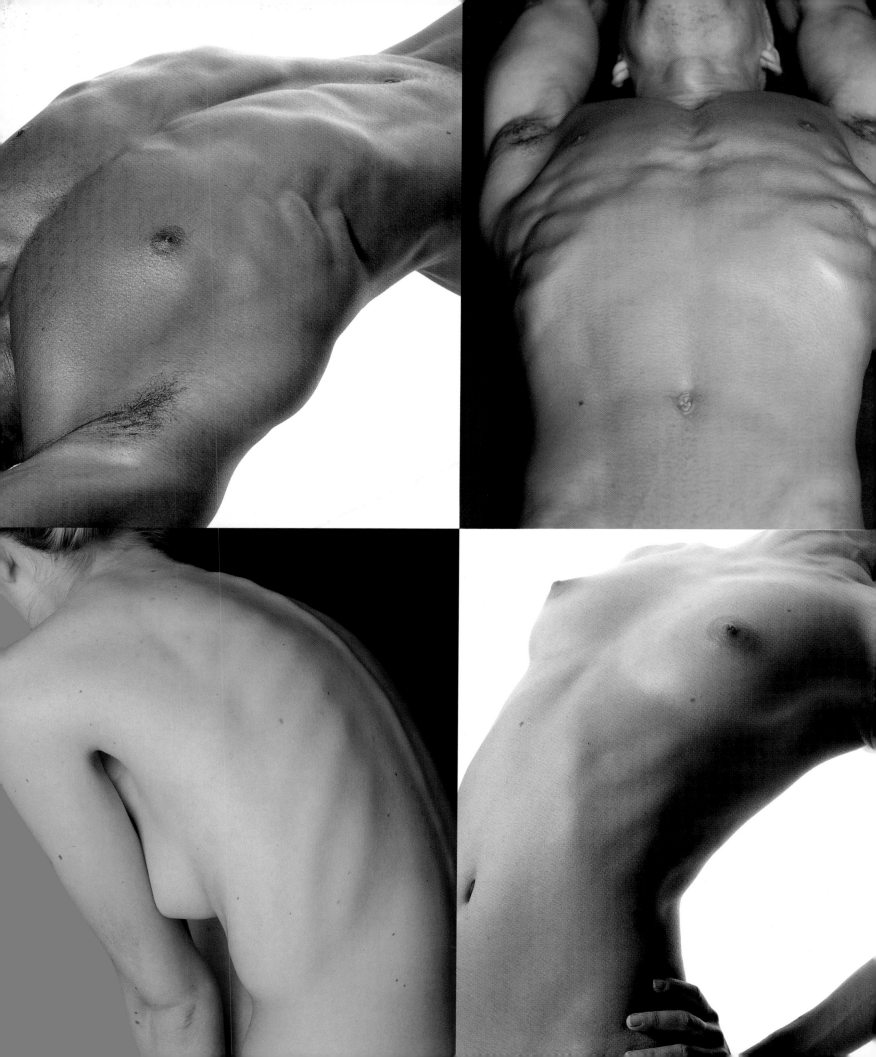

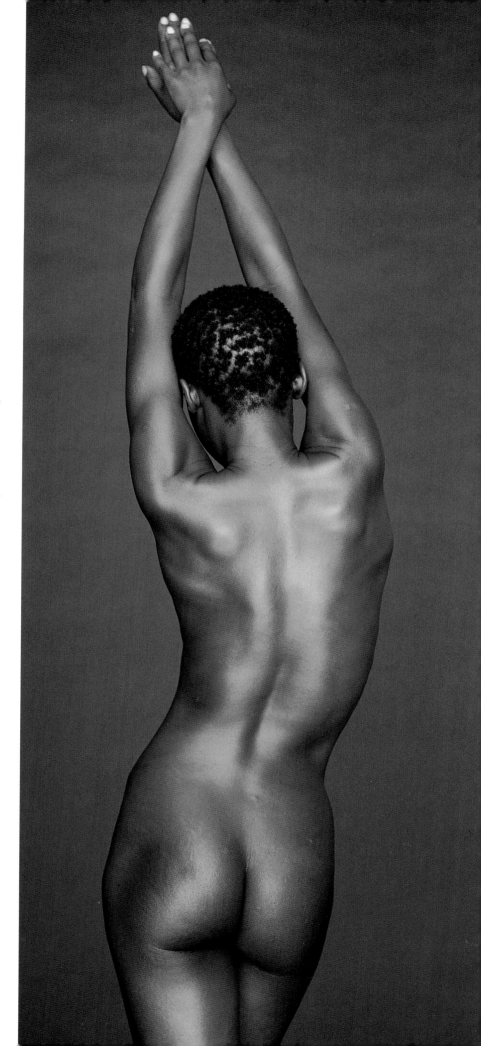

dome over the liver and stomach. The diaphram is the primary muscle of inspiration (or breathing in). Its center (situated directly beneath the heart) is tendinous (p. 34), with a circular outer border made of smooth-surfaced muscle. That outer border reaches down over the sides of the liver, stomach, and kidneys, and attaches to the inner surface of the lower ribs and spine, in this way sealing the thoracic cavity and dividing it from the abdomen.

When the diaphragm contracts, it flattens, descends, and presses down onto the liver. The cavity of the thorax is then elongated and enlarged, and air rushes in through the mouth and nose to fill the lungs and equalize the chest's internal and external pressure. As the liver moves down, it displaces the intestine, pressing this soft organ outward and forward against the abdominal wall. When the diaphragm relaxes, air is expelled from the lungs by the elastic recoil of muscles between the ribs, and the muscles of the abdomen and lower back, which compress and return the displaced viscera.

When relaxed, our breathing is shallow. The shoulders barely rise, and the abdomen moves gently in and out beneath our chest. When alarmed or out of breath from exercise, our breathing becomes deeper and more forced. In such circumstances the muscles of the abdomen may be held tense unconsciously and the shoulders are drawn up and down by muscles of the neck, shoulders, and back.

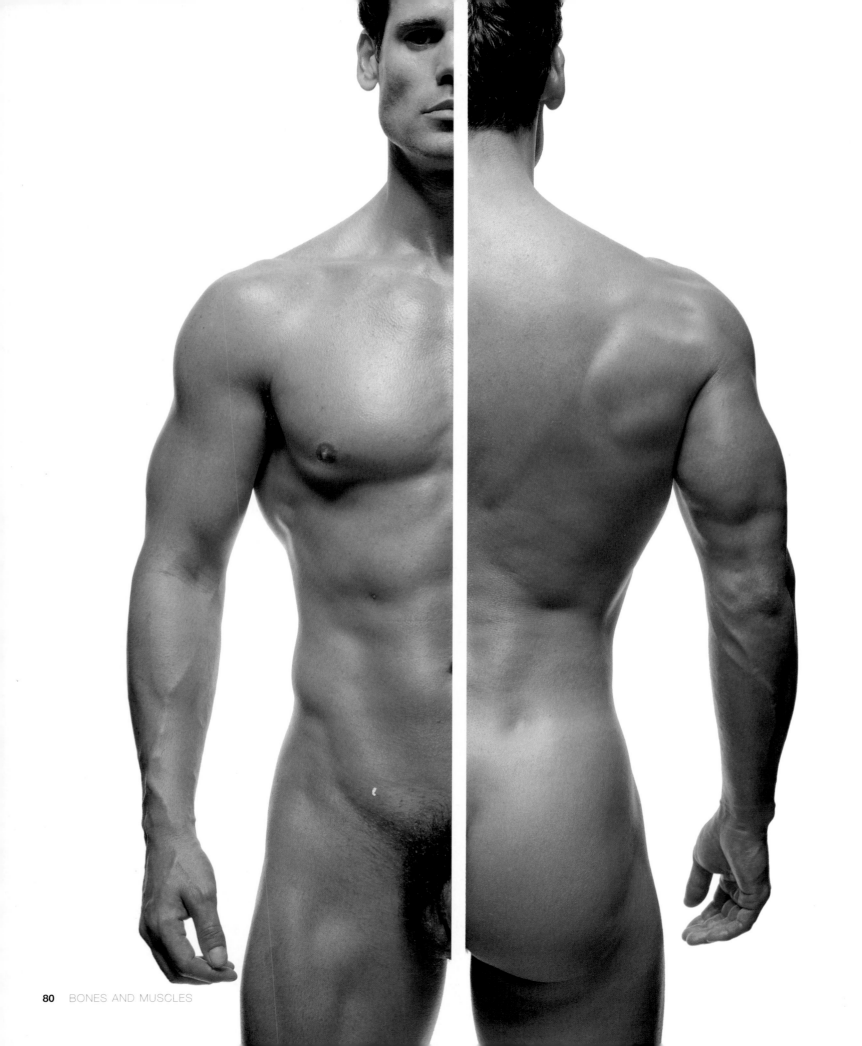

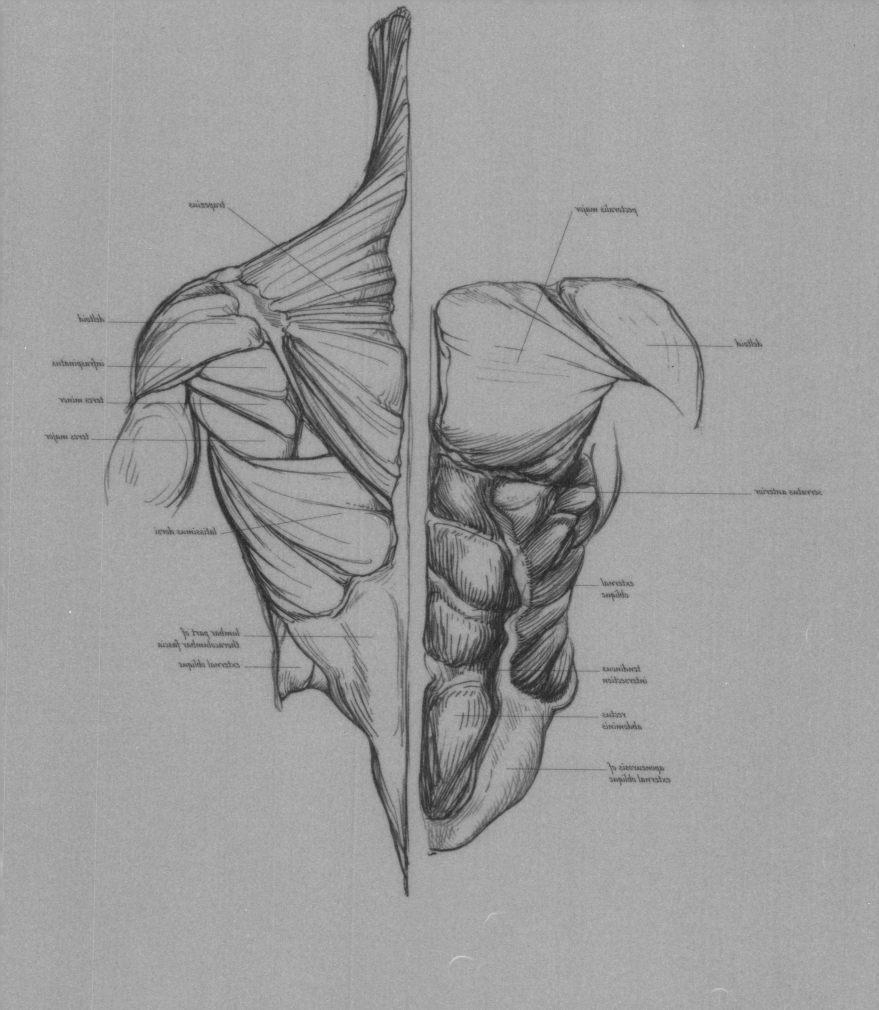

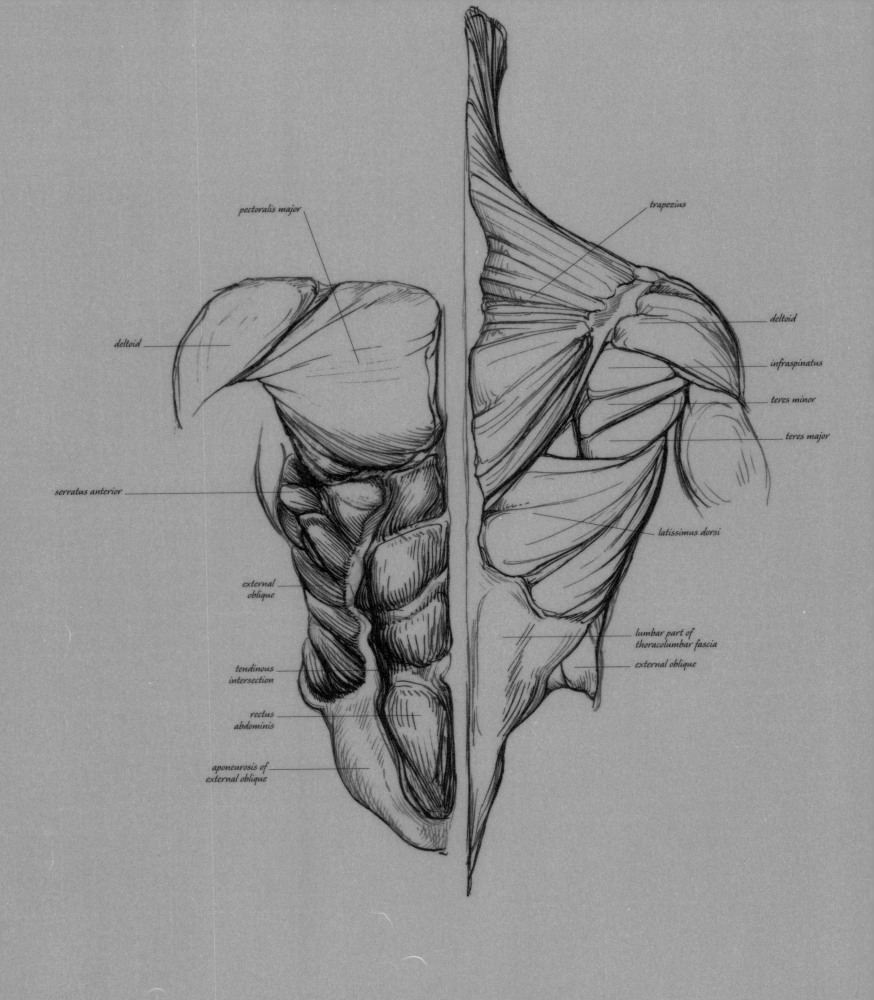

pectoralis major

trapezius

deltoid

deltoid

infraspinatus

teres minor

teres major

serratus anterior

external
oblique

latissimus dorsi

tendinous
intersection

lumbar part of
thoracolumbar fascia

external oblique

rectus
abdominis

aponeurosis of
external oblique

THE TORSO MUSCLES

More than a hundred muscles clothe or give form to the torso. These are paired (identical on each side of the body), layered one over another, and arranged in groups. Intricately divided muscles support and articulate the spine, broad thin sheets enfold the abdomen, joining the rib cage to the pelvis, while thicker fleshier muscles give shape and strength to the shoulders. This chapter concentrates on the muscles that convey both the character, arrangement, and complexity of deep layers and the shape and form of surface layers, as well as certain bones and ligaments that help the artist to map and delineate the torso's structure.

The erector spinae group (including longissimus, spinalis, and iliocostalis) form two powerful rods of muscle lying deep in the furrows either side of the spine. These muscular columns are thick and very prominent in the lumbar region, giving character to the center of the back. Above, they become thinner, flatter, and greatly divided, attaching to the ribs and spine in their passage to the head. Erector spinae muscles lift the torso when rising from a stooped position, extend the spine backward or to either side, and help to support the weight of the head. Four posterior serratus muscles brace the erector spinae. The superior pair elevate the upper ribs, helping us to breathe in (inspiratory muscles); the inferior pair are expiratory, depressing the lower ribs as we breathe out. Semispinalis capitis, two deep muscles of the neck, lie beneath trapezius (p. 59), where they help to draw the head backward or rotate it to either side. Quadratus lumborum holds firm the

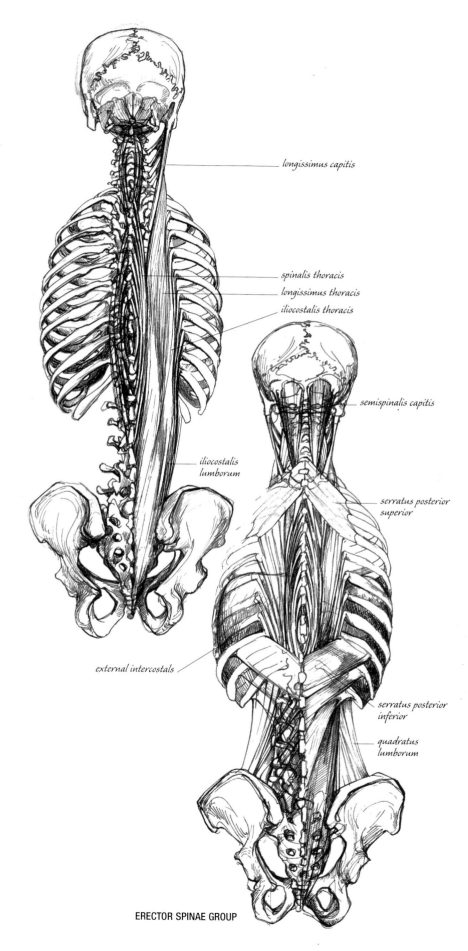

longissimus capitis

spinalis thoracis
longissimus thoracis
iliocostalis thoracis

semispinalis capitis

iliocostalis lumborum

serratus posterior superior

external intercostals

serratus posterior inferior

quadratus lumborum

ERECTOR SPINAE GROUP

To better understand the musculature of the torso, compare these photographs with the drawings in this section. Choose one superficial muscle, identify its borders, note the arrangement of any prominent tendons or aponeuroses, or characteristic divisions. Then consider the direction of the muscle's fibers. Imagine them flexing (becoming shorter) and consider the action this will produce. Which bones are linked by the muscle?

Can you see them? How will they be moved? Now, turning to the photographs, try to find the same muscle in one or more of them. Trace its border. Is it flexed or extended? What shape does it make beneath the skin, and is it softened or disguised by fat? You will soon begin to notice subtle variations presented by the same muscle in different people, and also that muscles are not identical on both sides of the same body.

twelfth rib, pulls the lumbar region of the spine to its own side, and helps to straighten or raise the pelvis. Multifidus (p. 84) extends and rotates the spine.

Abdominal muscles flex the torso forward into a curled position, straightening the arch of the lumbar vertebrae. They compress the viscera to force expiration (breathing out), or else strain in childbirth and defecation.

Three layers of muscle, arranged one over another, create strong walls on either side of the abdomen. These are transverse abdominis, covered by internal and then external oblique (p. 84). External oblique is clearly defined beneath the skin as it gives form to the outer sides of the torso. It arises by eight segments (like short fingers) from the lowest eight ribs and passes downward and across the body to insert into the vertical borders of the rectus abdominis muscle (p. 84).

Rectus abdominis, covering the center of the abdomen, is long, flat, and halved longitudinally by an aponeurosis called the linea alba (p. 85). Originating from the pubic bones at the front of the pelvis, rising the full height of the abdomen, and inserting into the cartilages of R5, R6, and R7, rectus abdominis is the most easily recognized muscle of the abdomen. Three transverse tendinous intersections divide it into eight parts (p. 85). Two extend below the navel, six are arranged above. Of those above, a block of four lie below the thoracic arch and are often clearly apparent. The highest portions are more concealed because they cross the cartilage of the ribs.

The entire height and width of rectus abdominis is enclosed beneath the converging aponeuroses of internal and external obliques. These form the rectus sheath (p. 35). The lowest borders of the oblique aponeurosis extend from the anterior superior iliac spines at the top of the pelvis (p. 89) to the pubic bones below. They form two straight ridges named the inguinal ligaments (p. 84), visible beneath the skin, delineating the borders of the torso and thighs.

The upper walls of the rib cage (closed and sealed by intercostal muscles) are crowned by the shoulder girdle, an angular ellipse of four bones, suspending the arms, and clad in the thick powerful muscles of the upper torso. These muscles shape the chest, upper back, and neck, articulate the shoulder joints, and move the arms. They are illustrated here (pp. 80, 84, and 85), and discussed in detail in the next chapter, which is devoted to the shoulder and arm. But first, it is important to look more closely at surface features of the torso – in particular at the navel, breasts, and genitals.

The navel or umbilicus (known popularly as the belly button) marks the point at which we were once physically connected to our mother. It lies within the linea alba, opposite the fourth lumbar vertebra, and mid-height between the xiphoid process of the sternum (p. 76) and the symphysis pubis (p. 89). Surface fat will soften and greatly deepen the navel; conversely a lack of fat gives the scar much sharper definition. The navel is placed about three heads' height from the top of the skull, when standing upright.

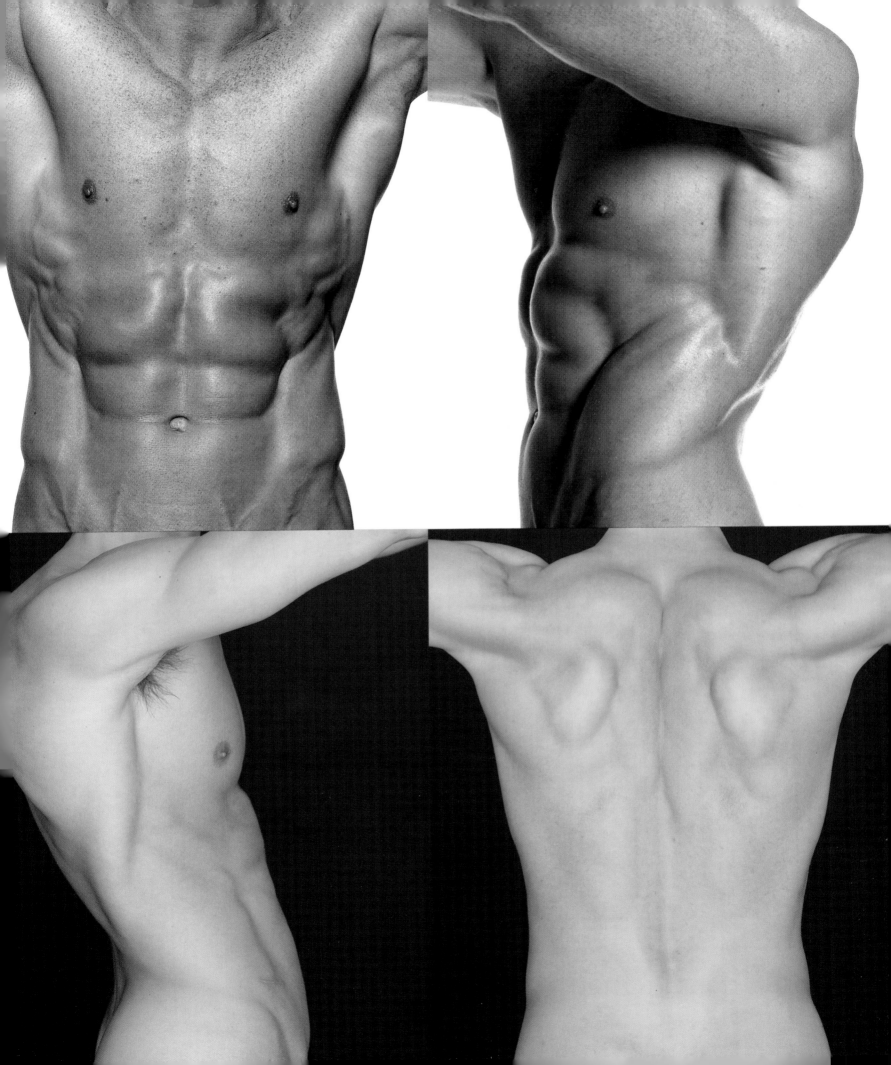

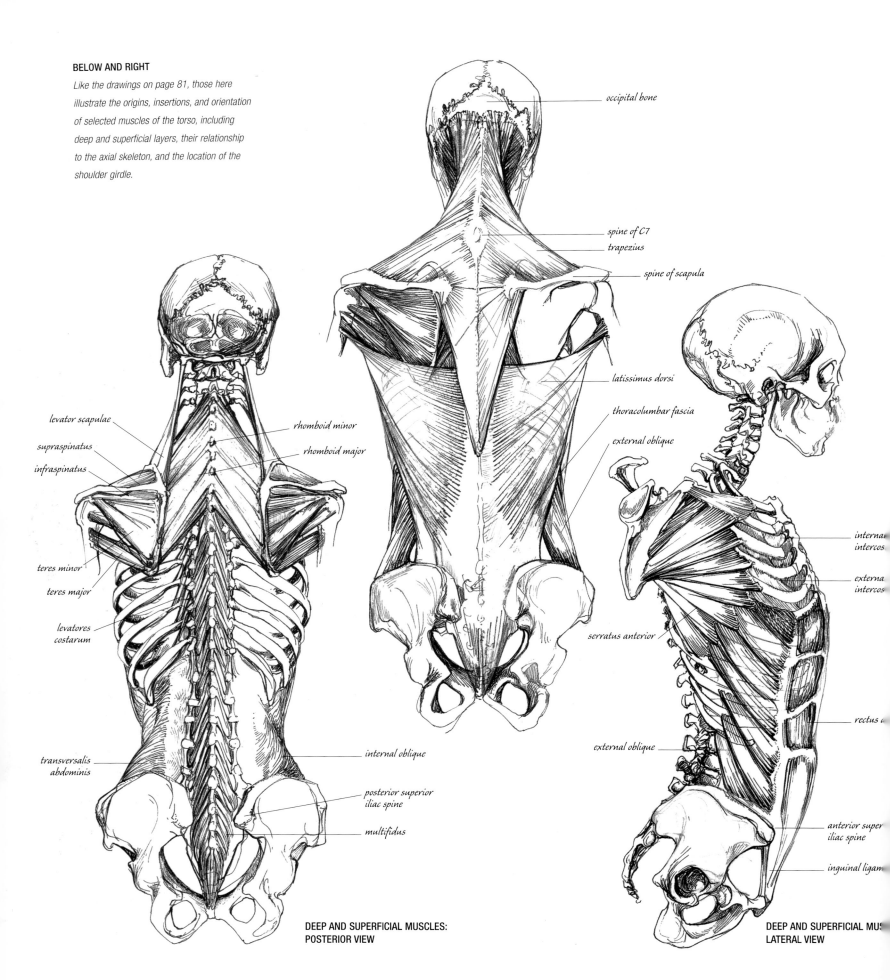

BELOW AND RIGHT

Like the drawings on page 81, those here illustrate the origins, insertions, and orientation of selected muscles of the torso, including deep and superficial layers, their relationship to the axial skeleton, and the location of the shoulder girdle.

occipital bone

spine of C7

trapezius

spine of scapula

latissimus dorsi

thoracolumbar fascia

external oblique

levator scapulae

supraspinatus

infraspinatus

rhomboid minor

rhomboid major

teres minor

teres major

levatores costarum

internal intercos

externa intercos

serratus anterior

transversalis abdominis

internal oblique

rectus

external oblique

posterior superior iliac spine

multifidus

anterior super iliac spine

inguinal ligam

DEEP AND SUPERFICIAL MUSCLES: POSTERIOR VIEW

DEEP AND SUPERFICIAL MUS LATERAL VIEW

Right: these two drawings build upon those left, showing origins, insertions, and the orientation of superficial muscles covering the front and side of the torso. Important details to observe here are the twisted fibers of pectoralis major and latissimus dorsi as they pass from the torso to the arm, inserting onto the humerus (p. 103). Their insertions have been enlarged here to show how the muscle fibers turn under each other to shape the anterior and posterior curves of the axilla (or arm pit). The eight segments of rectus abdominis are shown without the rectus sheath, a thickened aponeurosis (p.32) covering the entire surface of the muscle (p.35). Overleaf: the surface details of the torso; observe the greater depth of the female navel, softened by surface fat, in contrast to the more sharply defined scar found among lean men. When cold or aroused, both male and female nipples become erect. This reaction is produced by the involuntary contraction of tiny muscle fibers arranged within the dermis (p. 36) of the areola.

More may have been said about the proportion and shape of the female breast than any other part of the body. The fact that the same organ exists in a dormant state in men is largely overlooked. The perfect curvature in both sexes is a matter of preference and of fashion. Physical structure is unaffected by either.

Breasts contain mammary glands that are large and functional in women, small and functionless in men. Female breasts develop at puberty. They lie over R2 to R6. With age they slowly lower and become flattened above, consequently developing a more deepened fold beneath. The male nipple lies over R5, a little above the level of the xiphoid process. A line drawn from the furthest point of the shoulder to the navel will usually pass across the nipple, when standing upright.

Female mammary glands enlarge while producing milk and are surrounded by fat, which gives shape to the breasts. They rest on deep fascia (p. 36) covering the pectoral muscles and are suspended by ligaments within the skin of the chest. They are never the same on both sides of the body. One is usually larger and higher than the other, and they each point slightly to the side. The nipple (or papilla) is surrounded by a circle of pigmented skin called the areola, which may be raised or flat, large or small. Both the nipple and areola grow even darker during a woman's first pregnancy, and remain darker throughout her life. Our eyes instinctively seek out breasts from the moment we enter the world. This does not make them any easier to draw.

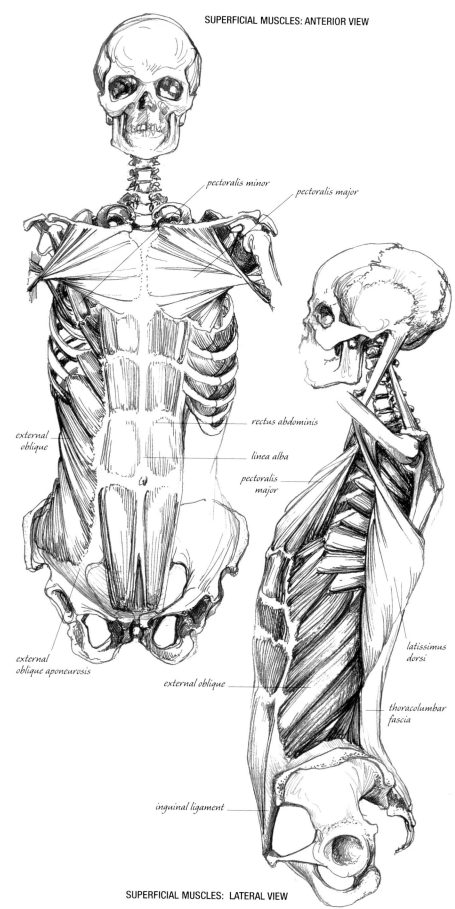

SUPERFICIAL MUSCLES: ANTERIOR VIEW

pectoralis minor

pectoralis major

external oblique

rectus abdominis

linea alba

pectoralis major

external oblique aponeurosis

external oblique

latissimus dorsi

thoracolumbar fascia

inguinal ligament

SUPERFICIAL MUSCLES: LATERAL VIEW

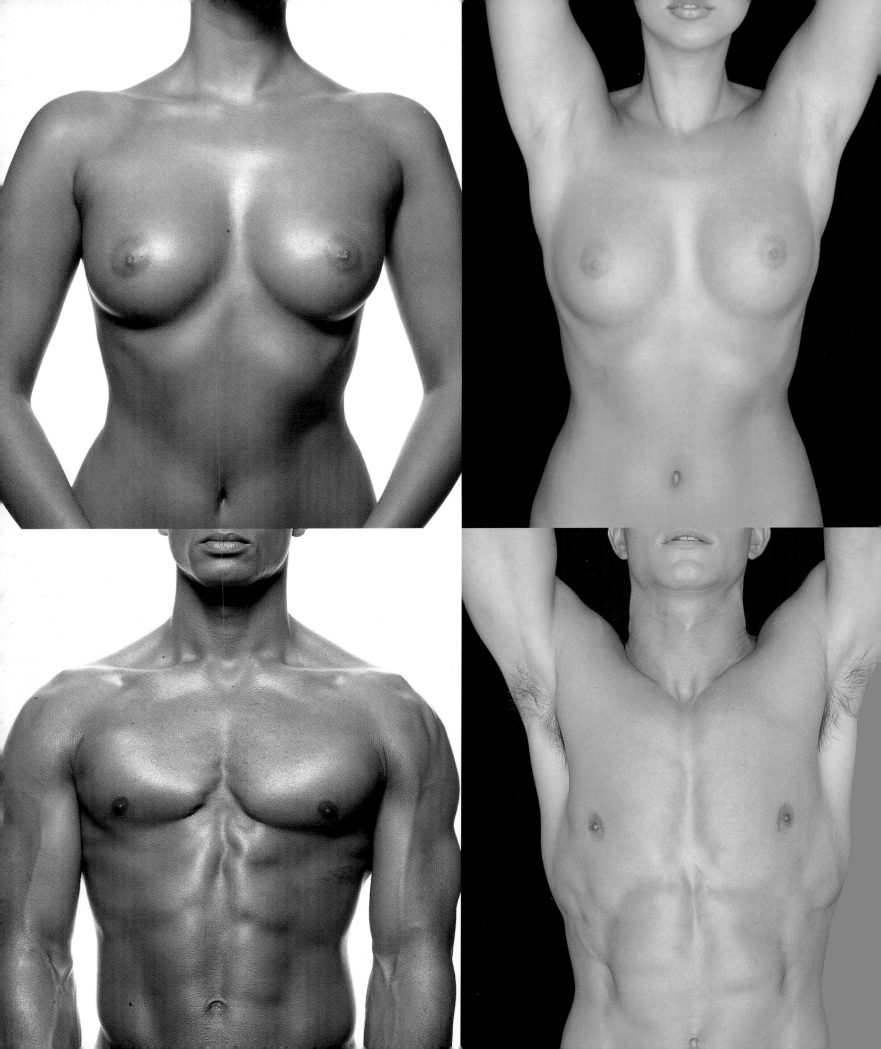

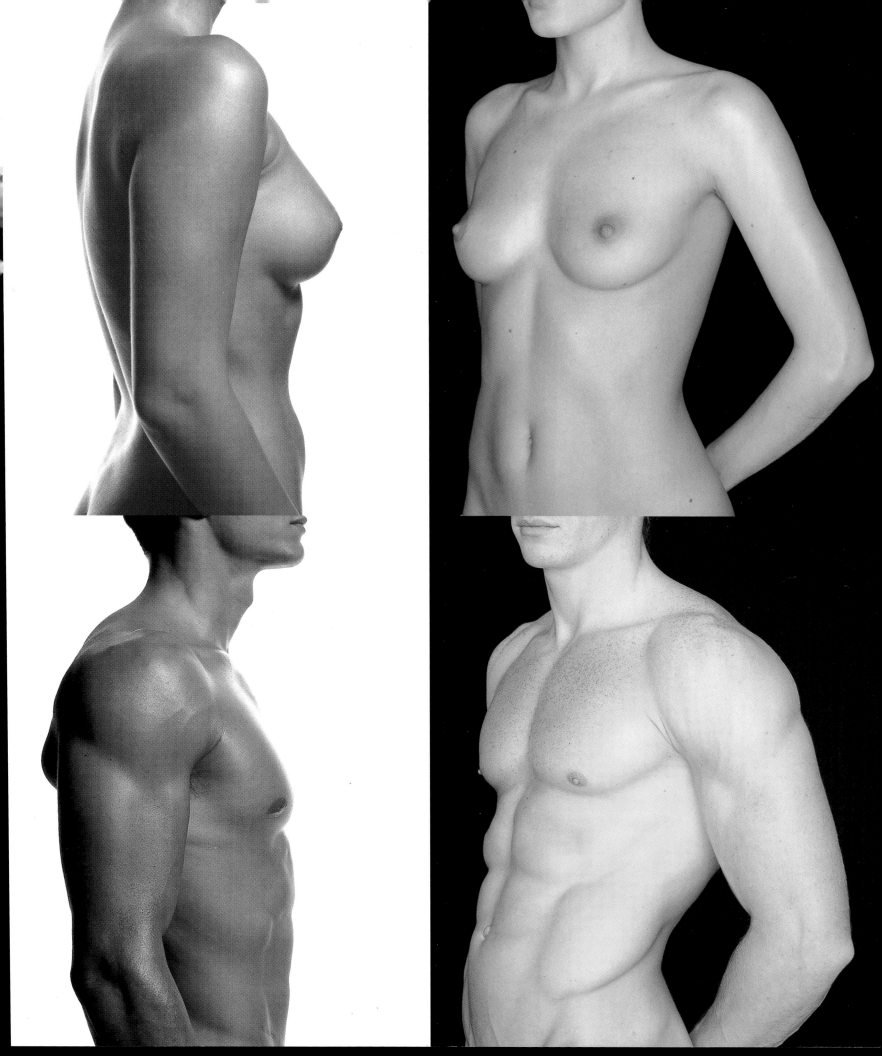

THE TORSO GENITALS

Surface genitals vary considerably in shape and size. Their nature, whether always apparent (as in the male nude) or usually concealed (as in the seated or standing female nude) is the most obvious difference between the sexes in humans. Anatomical interest in this subject has been prime since antiquity. Indeed, the diagram of the male urino-genital system by Aristotle (now lost) was the first recorded anatomical drawing.

The name penis derives from the Latin *pendere,* meaning to hang down, and testicle is from the Latin *testis,* meaning to bear witness (in this case to the masculinity of the owner). Both testicles (small ovoid glands – 1½–2in/4–5cm in length) are held within a loose muscular skin called the scrotum, from the Latin word meaning, literally, a sack. They are suspended by spermatic cords and scrotal tissue, and separated from each other by a fine membrane. When relaxed, their weight extends the scrotum downward. One testicle usually rests a little higher and further forward than the other. Two pairs of long muscles (both named cremaster) descend inside the scrotum

to lift the testicles up against the torso for protection and warmth. A specialized fine sheet of muscle and fascia (p. 36) called dartos surrounds both testicles beneath the skin of the scrotum and acts to tighten the scrotum when cold or sexually aroused.

The penis is a complex structure, suspended from the front and sides of the pubic arch of the pelvis. It is formed of three long smooth masses of soft spongelike tissue containing many blood vessels. These are bound together beneath the skin, and appear cylindrical when relaxed. Two masses are positioned side by side and the third, containing the urethra, is at the center beneath, accounting for the slightly triangular form of the erect penis. The distal end narrows slightly and then expands into a rounded head named the glans. Its circular projecting lip is the corona (or crown). The glans is longer in front, and parts to form an inverted v-shape behind. A faint seam of darkened skin runs from this point along the midline to the base of the scrotum. A foreskin (or prepuce) protects the glans. This may be short and

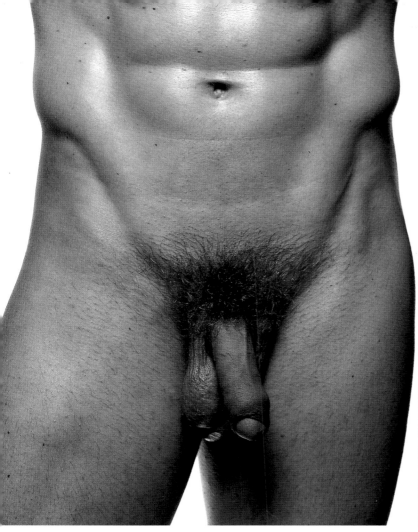

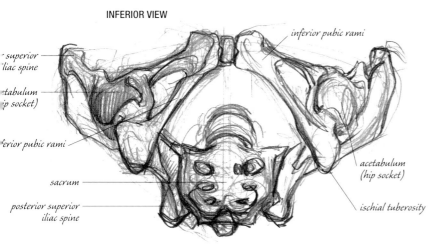

INFERIOR VIEW

superior
iliac spine

etabulum
ip socket)

erior pubic rami

sacrum

posterior superior
iliac spine

inferior pubic rami

acetabulum
(hip socket)

ischial tuberosity

SUPERIOR VIEW

symphysis pubis

pubic bone

sacrum

ala (wing) of ilium

TOP AND ABOVE

The drawings above show inferior (left) and superior (right) views of the female pelvis. A key point to note is the symphysis pubis, a fibro-cartilaginous joint connecting the pubic bones at the front of the pubic arch. This joint lies behind the penis in men and beneath the mons veneris in women. Always present, it is only functional in women during childbirth,

when it opens to increase the size of the birth canal. The word for pelvis derives from the Latin for bowl, denoting the closed curvature and depth of the structure. Located at the base of the spine, it is formed by the hip bones (ilium), sacrum, and coccyx (p. 126–7). The pelvis supports the trunk above, and suspends the genitalia within, in front, and

below. The photographs of the male pelvis clearly indicate its characteristic narrowness and height. Its structure is marked beneath the skin by the inguinal ligaments (p. 85) descending from the anterior superior iliac spines (at the sides of the body) to the pubic arch behind the genitals. Contrast that with the photograph of the wider, shallower form of

the female pelvis (far left). Here the bowl is shaped to cradle the weight of the child during pregnancy, and the width of the lower aperture is important in giving birth. On the surface of the body, the female pelvis is framed by the depth and soft curvature of the fat which overlies the muscles of the abdomen, buttocks, and thighs.

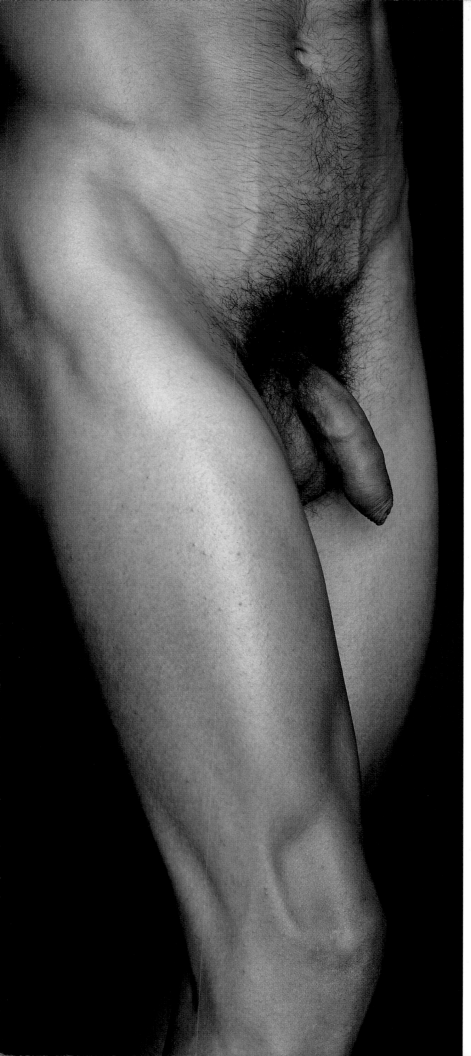

slightly expose the tip, or much longer, narrowing to a soft tube of skin. In circumcision, it is the foreskin that is surgically removed.

Female external genitalia are largely concealed beneath pubic hair. The gently domed triangular pad of fat covering the pubic arch is named the mons veneris (mound of Venus) after the Roman goddess of love. The sides of the mons meet the thighs, and may be convex or concave, depending upon the build of the woman. Below is the cleft of the labia majora. The labia minora may sometimes be visible between. Together, these conceal the clitoris, urethra, and vagina.

While most adults have witnessed an erection, they are considered immodest in a life class, as indeed they are in classical representations of the male. In later, more prudish times, it was considered proper to cover the whole genital area. The plaster cast of Michelangelo's *David*, when installed in the Victoria and Albert Museum, London, *c.* 1857, was furnished with a detachable plaster fig leaf to shield the proportions of what many believe to be the finest artist's rendition of the subject. Stylistic methods of hiding female genitalia are very different. Posture is often used so the thigh may become a screening device. Hands, long tresses, and fragments of very light or often translucent clothing have also helped to veil the classical pudenda. This convention is beautifully recalled by Sandro Botticelli's *Birth of Venus* (*c.* 1484), where Venus's protective stance increases her erotic attraction.

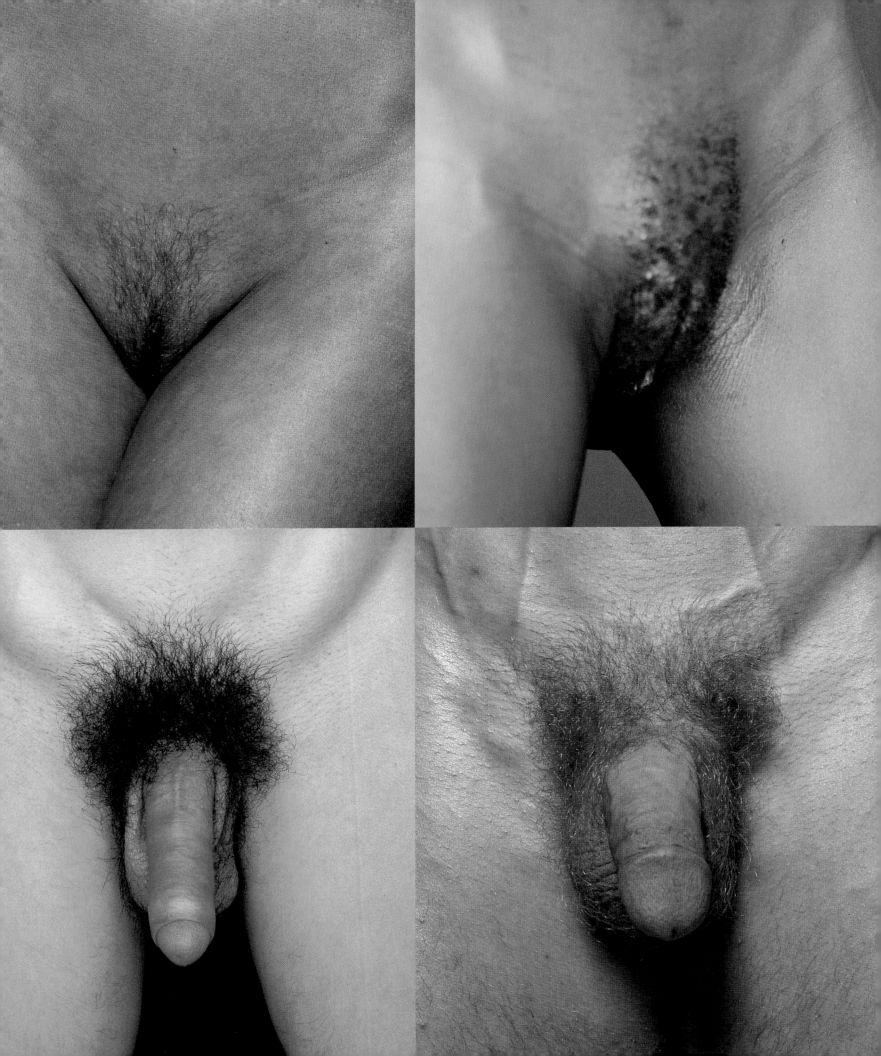

MASTERCLASS
SEATED FIGURE FRANCIS BACON

Francis Bacon (1909-1992) always wanted to squeeze the dangerous humanity of his subject into the visceral slither of his paint. This *Seated Figure* is one of many paintings that savagely haunts art galleries and history with their rancor and originality.

In this disturbing panel both the sickly colored room and its occupant have become distorted and twisted by the tension of their psychological junction. The anatomy of the human figure has been reinvented through dark conflict and brooding violence. Maimed and constrained, the body writhes and smears its limbs and facial expressions in a claustrophobic perspective that tortures them further with its bright blankness.

There is another being that is in the doorway, window, or mirror that seems not to be human at all. It flutters inside out part pig, part mule, part moth and all repellent. Like a reflection, its anatomy is mutated, and its envy of the sitter pathetic and mistaken. The distortions of flesh in Bacon's wrenched figures are constant. These works suggest a violence that radiates from a dark inner anatomy to burn in the bright frame of their painted environment.

In his studio, Francis Bacon frequently used anatomical reference books to summon the physicality that is so potently locked into his canvases. He mixed these with some early Eadweard Muybridge photographs of movement and a mélange of more personal and explicit images of carnage, sex, and surgery to inspire the naked butchery and isolation of his subjects.

The seated figure depicted in the painting seems to be enjoying his torment. His body writhes into the chair that equally shares his pain, discomfort, or pleasure.

The figure's whole torso is twisted, and the lower part of the chest is enlarged, straining its skin to suggest an invisible straightjacket grown into its anatomy. The face is smeared backward into the fore part of the skull in an expression of pleasure, leering slurred speech into its own right shoulder, which, grossly bloated, floats like a featureless second head.

LEFT

This photograph of a model clearly demonstrates Bacon's knowledge and distortion of anatomy. No matter how much the model contorts, he cannot achieve the same level of deformity as is expressed in the painting. Bacon's sitter is twisted about the axis of his own spine, as if the vertebrae are unlocked, and this is emphasized by the rectilinear elements of the room.

THE HEAD

Bacon has dissolved the figure's skull behind the face, and flesh that should be attached to bone is distorting itself through the pleasure of attempted speech. The neck is thickened, suggesting the support of powerful muscles beneath the dense liquid mass of the head. Sternocleidomastoid is clearly defined beneath the ear. The smile of the whole head is heightened by upward curves in the jaw, lips, nasolabial furrow, and in the thicket of black hair that surrounds the left cheek and eye.

TORSO

The torso holds itself steady against the moving shoulder and head. The lower ribs press through the skin and are distended as if holding a deep breath. There is a strong suggestion of restraint; ties hang from the chair, and the right arm is wrapped flat across the chest.

THE LEGS

The legs are knotted and agitated. They shuffle together and rub themselves into their own shadow. Heavy and boneless, they hold the weight of the body onto the chair. The ellipse surrounding the knees ties their movement, and, like the head, the left foot is sucked into the dark interior of the wall.

Seated Figure by Francis Bacon 1974, oil and pastel on canvas, 78 x 58in, Gilbert de Botton Collection, Switzerland.

The shoulders and arms are the seat of our strength when employed to carry a burden. "Make broad thy shoulders to receive my weight, And bear me to the margin," King Arthur bids Sir Bedivere, in Alfred, Lord Tennyson's poem *Morte d'Arthur*, and in Greek mythology Atlas is condemned to carry the weight of the heavens on his shoulders, as punishment for his part in the revolt of the Titans. As mediators between head and hands, the shoulders are a focus of nonverbal expression. Raised and drawn inward, they communicate indifference, disdain, or lack of knowledge. Sharply dropped, they express frustration or fatigue.

THE SHOULDER AND ARM

The significance of the shoulder is recognized in several idiomatic expressions too. Hence we speak of rubbing shoulders with someone, turning a cold shoulder, or shouldering a burden. Among western women, shoulders have for centuries been a focus of fashion and sensuality. Society portraiture of the eighteenth century, influenced by the softened torso of the classical nude, exaggerated the form in excessively sloping shoulders – roundness then symbolized a woman's status and class. A hundred years later, in 1878, Degas was commenting with mournful regret, "One no longer sees society women with sloping shoulders." Today catwalk models jut one shoulder consciously to emphasize the length and dynamic of their bodies.

This illustration shows how the bones of the shoulder girdle and arm are arranged within the flesh of the torso. Two clavicles (collarbones) and two scapulae (shoulder blades) crown the thorax and disguise the neck of the rib cage. The single long bone of the arm, named the humerus, suspends from the outer corner of the scapula. Framed by the acromium and coracoid processes, the head of the humerus articulates with the glenoid cavity (p. 98) of the scapula. Clavicles determine the breadth of the shoulders. Situated just beneath the skin, with muscles attaching to their borders above and below, they can be seen and felt throughout their length. The spine, acromion, and base and inferior angle of each scapula can be palpated and often seen through muscle and skin.

THE SHOULDER AND ARM BONES

The shoulder blade, named the scapula, is thin, curved, triangular, and often described as a wing. It rests between layers of muscle, with its base (or vertebral border) facing the spine. It is slightly cupped against the posterior thoracic wall, while extending from the second to seventh rib. The scapula's movement is semicircular and gliding. Two broad surfaces (one facing the rib cage and one facing the skin) – with three borders, three angles, and two distinctive projections (the coracoid and acromion processes) – give root to sheets of muscle controlling the shoulder and arm.

The ala, wing, or body of the scapula is strong and thickened around the edge, while toward the center it is thin, and often as translucent as paper. At the lateral angle (or outer corner) there is a shallow dish or concavity the size of a thumb print. This surface (called the glenoid, p. 98) articulates with the long bone of the arm, named the humerus. Above, a thickened ridge (the acromion) projects to the side, giving a roof to the shoulder joint as it curves round to face the front of the body. The acromion is the bony point of the shoulder that can always be felt beneath the skin. Below, the coracoid process pushes through from the back to the front of the body. Named by the Greeks after the beak of a raven, the hooked coracoid suspends slender muscles of the arm and chest.

The upper third, or apex, of the scapula (termed the superior angle) is buried deep beneath flesh. In life it is never seen. The spine or spinous process arising from the wing, preceding the acromion, is usually visible through the skin. For the artist this is the key detail of the scapula. If a person is thin, the spine will draw a raised ridge across the shoulder. If surrounding muscles are highly developed, they will bulge, rise, and cast the bone into a pit or indentation. In certain martial arts the position of the shoulder blades, more than the expression of the eyes, betrays which movement is being prepared.

The clavicle or collarbone is shaped like the italic lower-case letter *f*. It is long, curved, and nearly horizontal as it passes from its saddle-shaped gliding joint with the manubrium (at the top of the sternum or breastbone) across the first rib to meet the inner surface of the acromion. It is the clavicle that links the scapula with the axial skeleton. They join to the manubrium on either side of the suprasternal notch – a shallow indentation on the uppermost surface of the manubrium.

The clavicle lies just beneath the skin. It determines the breadth of the shoulder, and can be felt throughout its length. The shaft is slender, rounded, and made of compact bone. The ends are broad and cancellated (slightly hollow within). The lateral end is flattened, and often sits raised above the shoulder, creating a small bump. The curves of the clavicles vary greatly from person to person. They will thicken and increase with a long life of physical labor. The bone is also shaped by the dominance of one limb. A greater curve develops on the right side of a right-handed person.

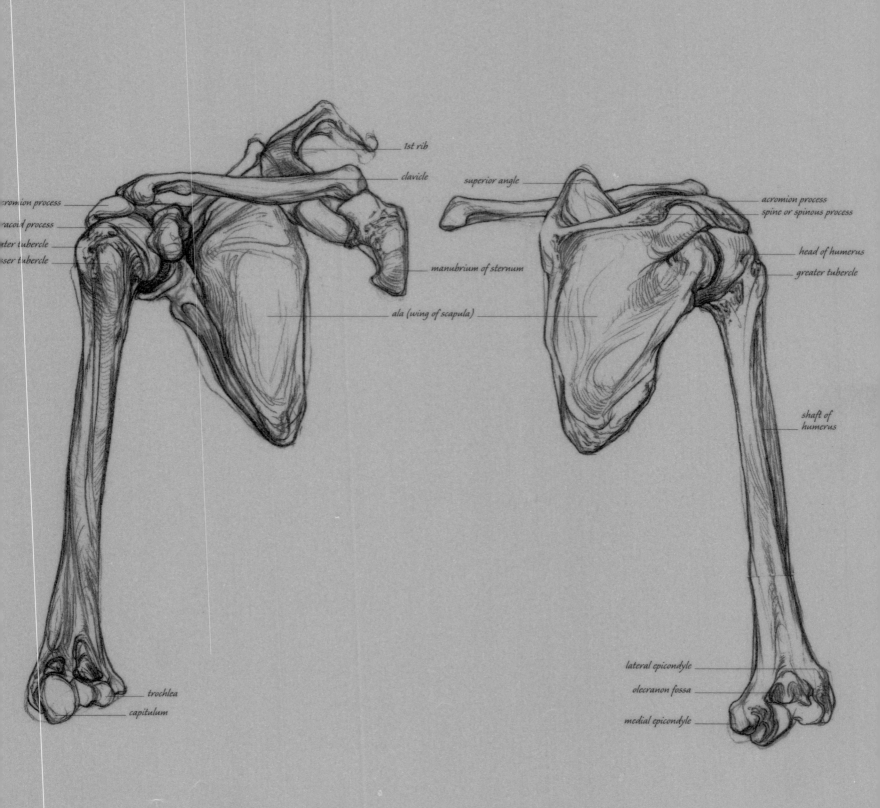

1st rib

clavicle

acromion process

racoid process

ater tubercle

sser tubercle

manubrium of sternum

ala (wing of scapula)

superior angle

acromion process

spine or spinous process

head of humerus

greater tubercle

shaft of humerus

trochlea

capitulum

lateral epicondyle

olecranon fossa

medial epicondyle

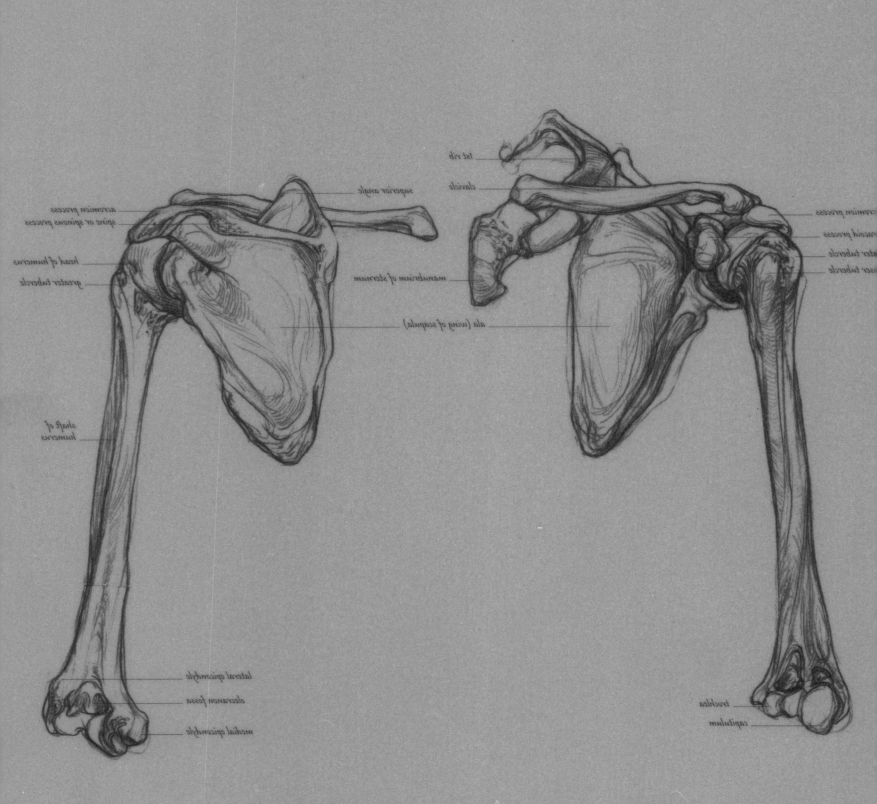

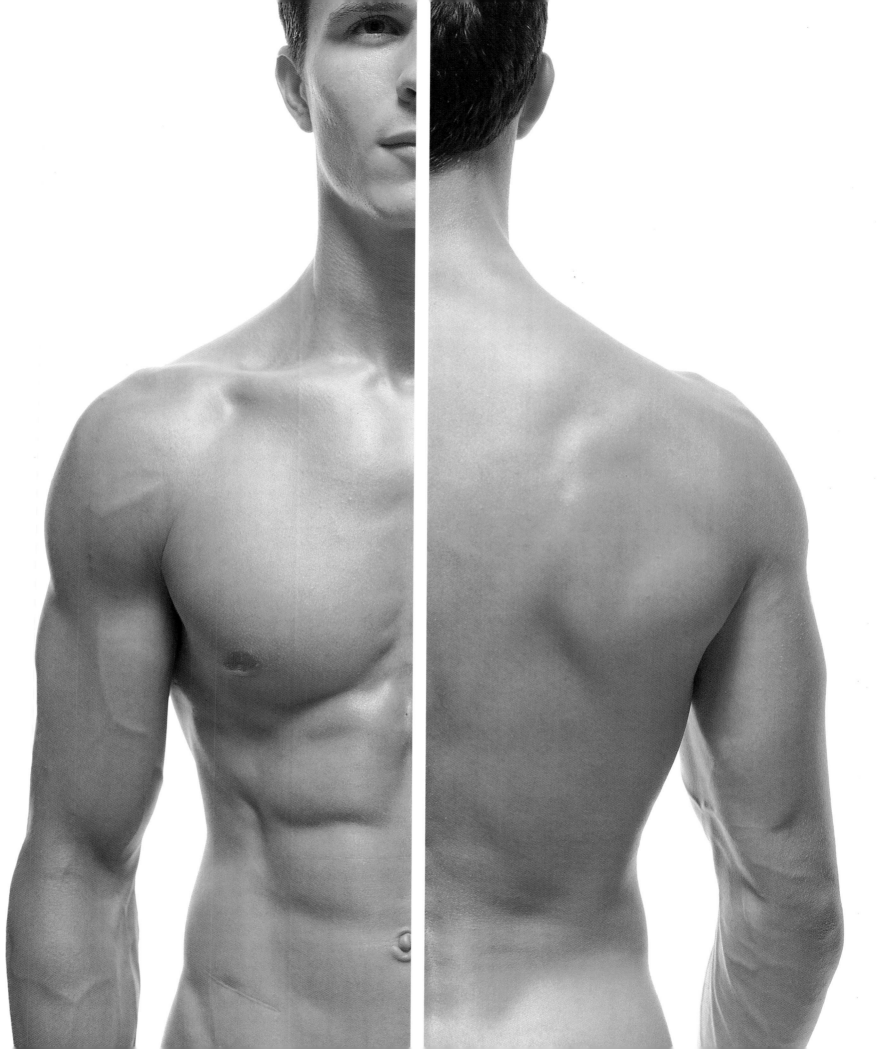

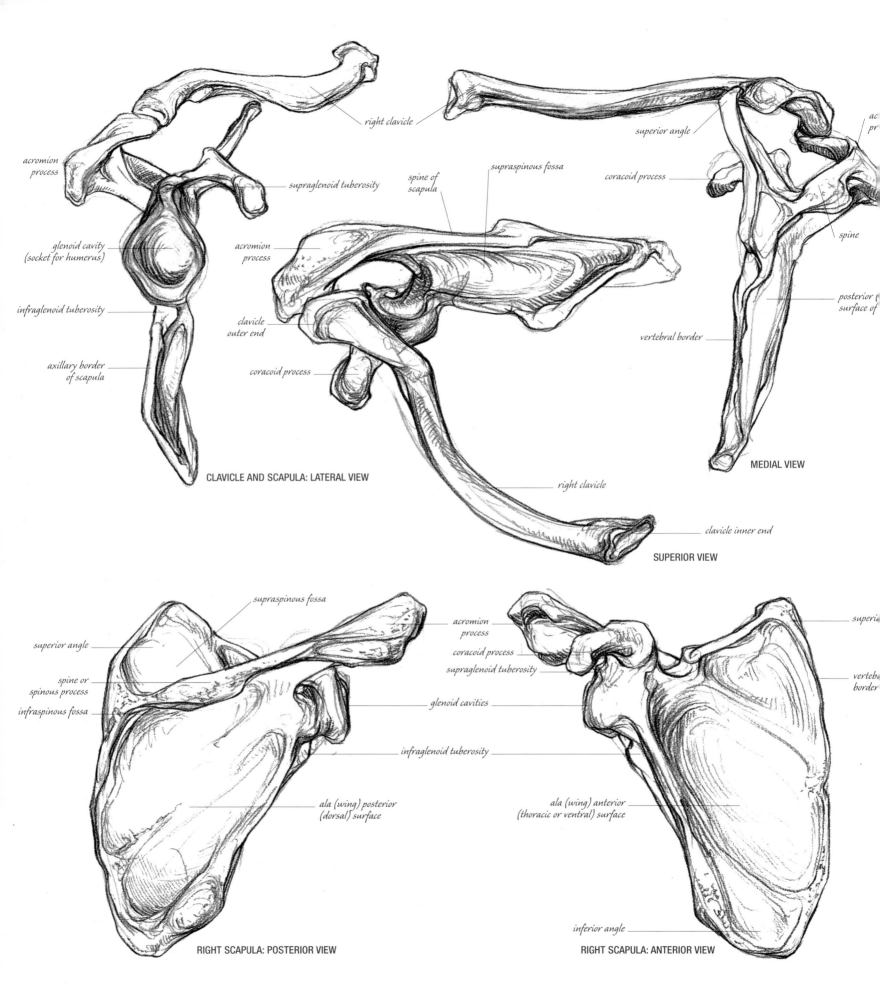

right clavicle

acromion
process

supraglenoid tuberosity

spine of
scapula

supraspinous fossa

superior angle

ac
pr

coracoid process

glenoid cavity
(socket for humerus)

acromion
process

spine

infraglenoid tuberosity

clavicle
outer end

posterior
surface of

axillary border
of scapula

coracoid process

vertebral border

CLAVICLE AND SCAPULA: LATERAL VIEW

MEDIAL VIEW

right clavicle

clavicle inner end

SUPERIOR VIEW

supraspinous fossa

superior angle

spine or
spinous process

infraspinous fossa

acromion
process

coracoid process

supraglenoid tuberosity

superi

vertebi
border

glenoid cavities

infraglenoid tuberosity

ala (wing) posterior
(dorsal) surface

ala (wing) anterior
(thoracic or ventral) surface

inferior angle

RIGHT SCAPULA: POSTERIOR VIEW

RIGHT SCAPULA: ANTERIOR VIEW

Above left: three views of the right clavicle and scapula. Far left: lateral view, with the humerus removed; note the size and shape of the glenoid cavity. Center left: superior view; note the union of the acromion and clavicle, the protuberance of the coracoid beneath, and the depth of the supraspinous fossa. Near left: medial view (from the vertebral column); note the slight curve of the scapula and the outward and upward projection of the spine. Below left: two views of the right scapula. Far left: posterior view, showing the dorsal surface of the scapula (the side facing the skin) without the clavicle; note the rising angle of the spine, the relative length of each border, the projection of the acromion, and the position of the glenoid cavity beneath. Near left: anterior view of the ventral surface of the scapula (the side facing the ribs); note the cupped dish of the wing, the hook of the coracoid, and the length of the vertebral border. Right: lateral and medial views of the right humerus. Note the relative sizes and shapes of articular ends and protuberances.

In anatomical terms, the "arm" is the portion of the upper limb that is above the elbow. Called the humerus, the bone of the arm is a typical long bone, composed of a shaft and two articular ends. The head above fits snugly against the glenoid cavity of the scapula. Its articular surface is coated in glasslike hyaline cartilage (p. 32), and bound into a capsule of fluid and ligaments, to form the shoulder joint. The capitulum and trochlea below are rounded articular surfaces which carry the bones of the forearm (the radius and ulna), discussed in the following chapter. These joints are similarly coated with hyaline cartilage.

The shaft of the humerus is almost cylindrical beneath the head, becoming triangular, and then distinctly flattened and curved forward below. The greater and lesser tubercles of the head are small lumps projecting forward and to the lateral side. The greater tubercle is the most lateral point on the whole skeleton. The groove between the tubercles (called the bicipital groove) carries the long tendon (or long head) of the biceps brachii muscle (p. 103), which passes down across the head of the humerus from its origin above the glenoid cavity of the scapula. The entire humerus is deeply buried in flesh, and its inner surface shields major blood vessels and nerves. The distal end can be felt either side of the elbow. At this point, facing the body, is a protuberance of bone called the medial epicondyle (the so-called funny bone). This sits next to the ulna nerve, which passes close to the skin and is therefore barely protected. When the nerve (not the bone) is knocked, it causes sharp pain to drive a line of numbness down into the little finger.

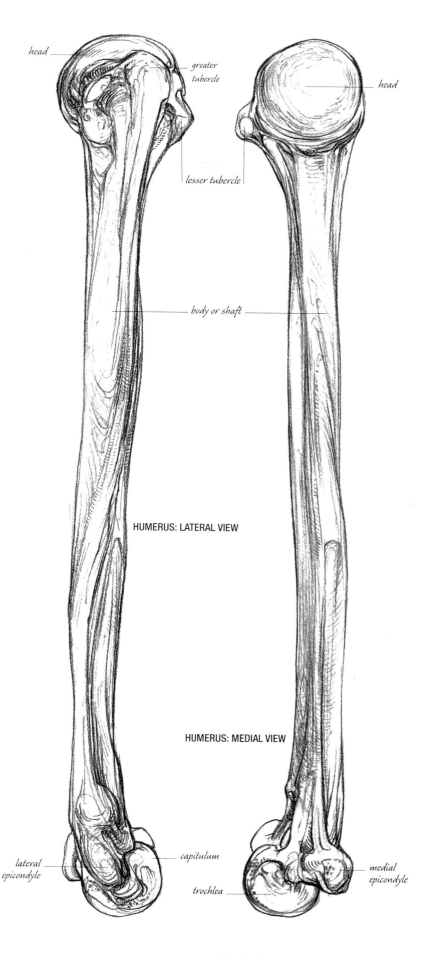

head

greater tubercle

head

lesser tubercle

body or shaft

HUMERUS: LATERAL VIEW

HUMERUS: MEDIAL VIEW

lateral epicondyle

capitulum

medial epicondyle

trochlea

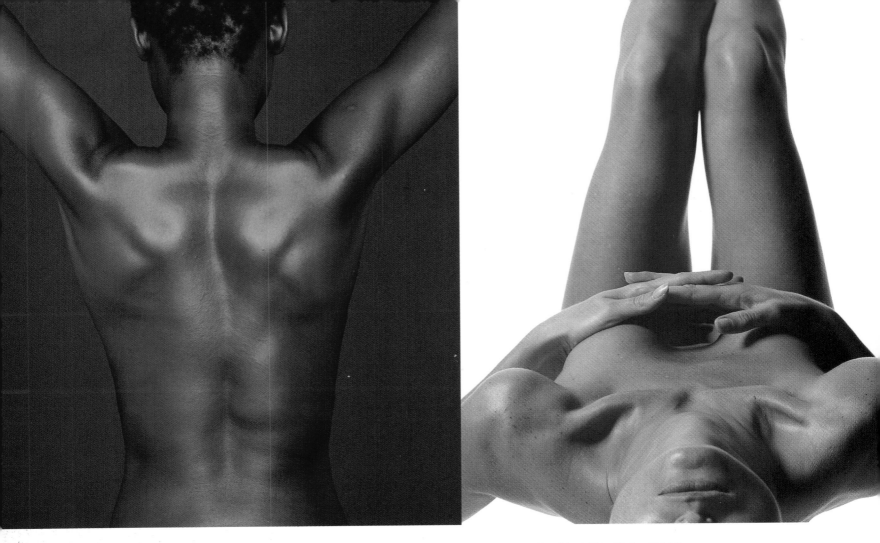

THE SHOULDER AND ARM MUSCLES

The muscles of the shoulder and arm may be considered in three groups: those which cover the upper torso to act on the shoulder girdle, those which cross the shoulder joint to move the arm, and those which cross the shoulder and/or elbow joints to manipulate the forearm. Groups of muscles at the front of the arm act as flexors, folding the limb at the shoulder and elbow; extensors, sited behind, work against them, straightening these joints; adductors draw the limb close to the torso; and abductors carry it out to the side. Deep muscles clothing the scapula rotate the limb backward and forward in its shoulder socket.

Trapezius (pp. 34 and 35) shapes the upper back and neck above the shoulder blades. It raises and lowers the shoulders, draws the head to either side, and is sometimes called cucullaris because it resembles a monk's cowl or hood. A tendinous border, descending in a line from the base of the skull to the twelfth thoracic vertebra (T12), marks the center and origin of the muscle. This line widens into an often diamond-shaped aponeurosis at the base of the neck, where spinous processes (p. 64) are often visible through the skin. Trapezius inserts onto the lateral third of the clavicle (in front), the acromion process (to the side), and the spine of the scapula (behind). Note how the lowest fibers arising from T12 (the twelfth thoracic vertebra) and above tie together onto the medial angle (or corner) of the scapula (p. 84).

Pectoralis minor (p. 85), on the front of the chest, is by contrast a small, deep muscle. It helps to hold the scapula still against the rib cage or raise the ribs during forced breathing. It also pulls the shoulder down and forward. Pectoralis minor originates from the fifth to third ribs, inserts onto the coracoid process, and works in partnership with serratus anterior (p. 84).

Serratus anterior (also named great serratus) looks like a hand as it reaches down from beneath the scapula to hold onto the sides of the ribs. A strong abductor and rotator, it pulls the shoulder forward, and would give force to a punch. It also prevents the shoulder blade from "winging" to the side.

FAR LEFT

Trapezius and deltoid (p. 104) are clearly defined as they hold the model's arms above her head. The spine of each scapula tilts downward, pointing to the center of her back. Lines of light define the upper borders of latissimus dorsi (p. 102) as its two halves sweep out from the spine, across the lowest tips of the shoulder blades, and up to the arms, where they shape the back of each armpit. The model's delicate build conceals the diamond-shaped aponeurosis called the thoracolumbar fascia, covering the base of her back (p. 35). But this means that we can see the strong upright columns of erector spinae (p. 81), which flank the complex curvature of her spine.

LEFT

In this view of the shoulder girdle, you can trace the curve of both clavicles as they rise from the sternum beside the suprasternal notch. They pass over the pectoral muscles (pp. 102 and 104) and curl into the center of the deltoids, on top of the shoulders. Here they join the acromion. From each acromion the spine of the scapula makes a furrow between trapezius above and deltoid below. You can also see clearly how the head of the humerus gives deltoid a pronounced curve in front while the spine of the scapula flattens the muscle behind. More fat is stored on the back of the shoulder and arm than in front. Note the depressions above and below each clavicle, median to deltoid and trapezius.

BELOW LEFT

Layered muscles clothing the shoulder joint hold the arm to the torso. They provide an extensive range of movement, and great strength in maneuvering the limb. Deltoid, for example, is typical of the short, broad, thick muscles designed for strength. Compare the shape and size of the shoulder muscles to the long, slender, tendinous muscles of the forearm, which give speed and dexterity to the fingers (p. 114–15). Note here the direction of the muscle fibers giving bulk to pectoralis major and deltoid and how they spiral around each other to reach their insertion on the arm.

BELOW RIGHT

The large irregular cupped depression on the back of each shoulder marks the wings of the scapulae. The dorsal surfaces of the bones (covered thinly by infraspinatus and teres minor, p. 102) are surrounded by the solid flesh of trapezius, deltoid, and teres major (p. 102). The upper portion of trapezius covering the neck is relaxed, allowing the head to fall forward. The middle and lower portions are tensed (and so are the rhomboids beneath, p. 102) to draw the shoulder blades upward and together. Triceps brachii (p. 104) is defined on the back of each arm, as are the medial epicondyles of the humerus inside the elbow joints. Surface veins complicate details toward the inside of each arm.

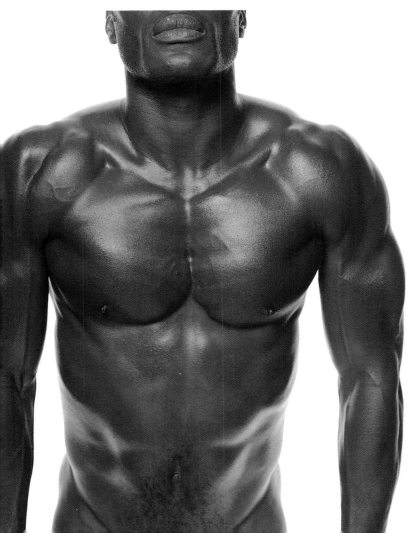

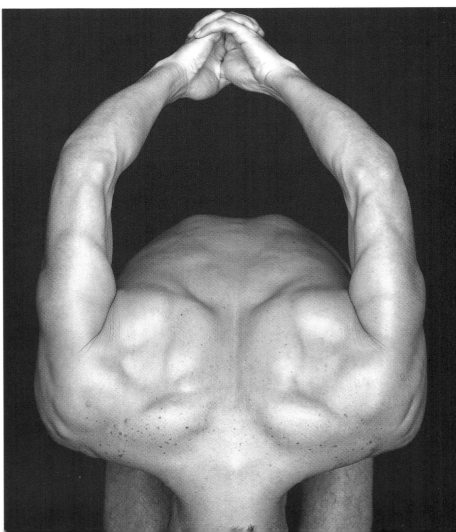

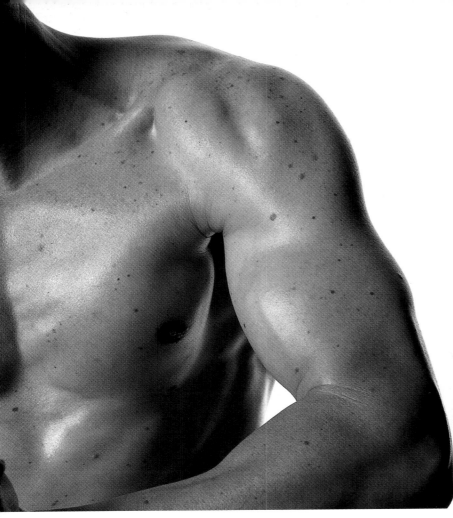

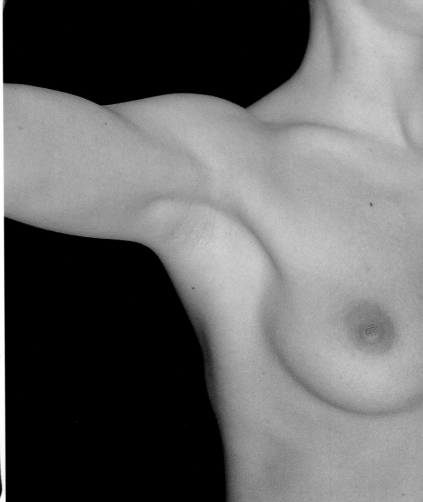

It arises from the upper eight or nine ribs and inserts onto the anterior (ventral) surface and vertebral border of the scapula, where it appears beneath the armpit. Some of its digitations are often mistaken for ribs.

Rhomboids major and minor (p. 84) – largely concealed beneath trapezius – draw the scapula toward the midline. Infraspinatus and teres minor (pp. 84 and 105) cover the posterior surface of the scapula, inserting on the greater tubercle of the humerus (p. 99) to rotate the arm backward. Subscapularis (p. 103), hidden beneath the scapula against the thoracic wall, rotates the arm forward. Teres major (pp. 84, 103, and 105) arises from the lower axillary border of the scapula. Together with latissimus dorsi, it shapes the back of the armpit, inserting beneath the head of the humerus to extend, adduct, and medially rotate the arm. Supraspinatus (pp. 84 and 105) helps to abduct the humerus.

Latissimus dorsi (pp. 84 and 103) covers the lower back, arising from the iliac crest, the thoracolumbar fascia, and the spines of the sacral, lumbar, and lower thoracic vertebrae (p. 65). Its long fibers converge, pass under the arm, and insert via a short tendon in front of and below the head of the humerus. Latissimus dorsi powerfully draws the arm backward.

Pectoralis major (pp. 80, 85, and 103) extends the arm and draws it across the front of the torso. It arises in four parts: from the medial two-thirds of the clavicle, the lateral border of the sternum, the costal cartilages of the first to sixth ribs (p. 74), and the aponeurosis of external oblique (p. 80). These parts converge, cross the front of the shoulder, and insert via one tendon beneath the head of the humerus, toward the lateral side of the bone.

The insertions of pectoralis major and latissimus dorsi turn and curve to create the front and back of the axilla (or armpit), a pyramidal cavity rising high against the the rib cage, closed on three sides by muscle and bone. The apex is to the medial side of the coracoid process (p. 98). Here large nerves and blood vessels leave the torso to enter the arm, shielded by the humerus as they pass down between biceps and triceps brachii (p. 104). Vessels within the armpit (including important lymph nodes) are protected by fatty connective tissue filling the cavity behind the inverted cup of the skin.

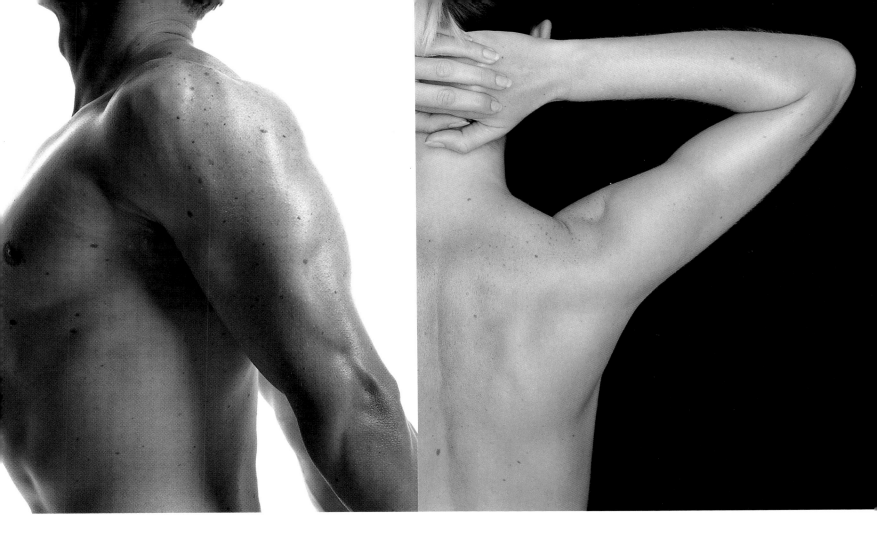

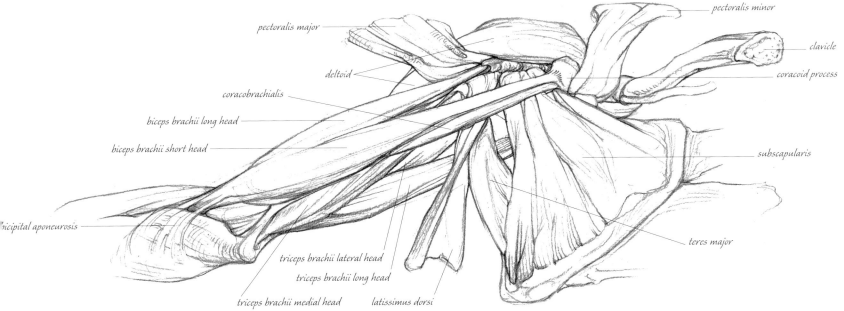

pectoralis major

pectoralis minor

clavicle

deltoid

coracoid process

coracobrachialis

biceps brachii long head

biceps brachii short head

subscapularis

bicipital aponeurosis

teres major

triceps brachii lateral head

triceps brachii long head

triceps brachii medial head

latissimus dorsi

TOP AND ABOVE

The photographs show the most superficial muscles of the shoulder and arm. Far left: the long indentation in front of deltoid (p. 104) separates the anterior and lateral portions of the muscle. Near left: biceps brachii (p. 104) is defined, emerging from beneath pectoralis major. Above left: the long aponeurosis and tendon of triceps (p. 104) flatten the back of the arm above the elbow. Above right: deltoid's lateral attachment to the acromion (p. 98) forces a depression on the top of the shoulder if the arm is raised. The drawing represents a deep dissection of the shoulder and arm seen from in front. Note particularly the two heads of biceps brachii emerging beneath pectoralis major, which has been lifted away.

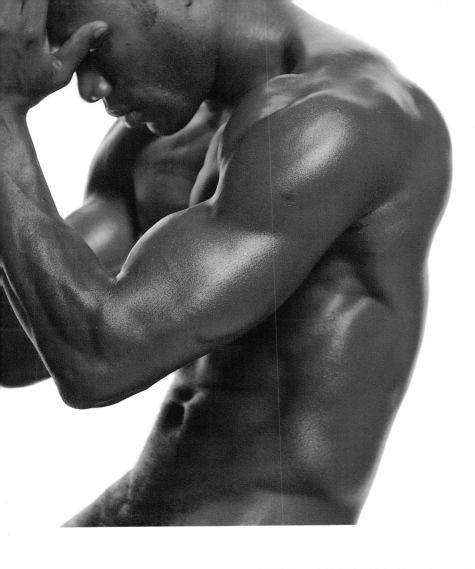

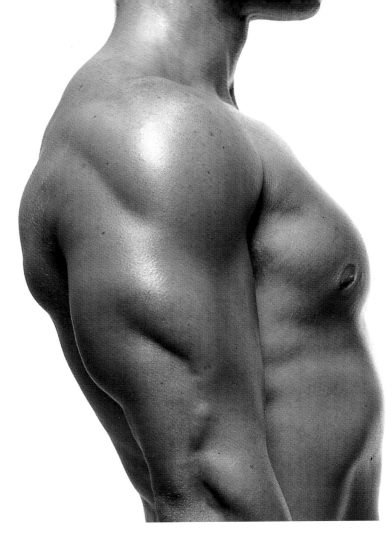

The shoulder-cap muscle, deltoid (p. 34, 35, and 105), is thick, triangular, and also composed of three parts. These surround the joint, converge into one tendon, and insert onto the outside of the humerus, about halfway down. The anterior third arises from the lateral third of the clavicle. This pulls the limb forward when the arm is raised level with the shoulder. The lateral third, arising from the acromion process, raises and holds the arm horizontal, and the posterior third, arising from the spine of the scapula, draws the limb backward, when horizontal.

The arm has two muscle compartments separated by an intermuscular septum (p. 38): an anterior compartment containing three flexor muscles (biceps brachii, coracobrachialis, and brachialis), and a posterior compartment containing triceps brachii, a single extensor muscle.

Biceps brachii (p. 103) shapes the front of the arm. Biceps means two heads: a long head arises from the supraglenoid tuberosity (p. 98, above the shoulder joint on the scapula), while a short head arises from the coracoid process. These converge to form one tapering belly of muscle, flowing into a single tendon to cross the elbow in front. This inserts onto the radial tuberosity (p. 111) to flex the elbow joint and supinate the forearm (turning the palm downward). The bicipital aponeurosis (p. 103) is a pearly sheet of fine fibers separated from the tendon, attaching superficially into deep fascia (p. 38) at the inside elbow. Coracobrachialis (p. 103), a small, slender and deep muscle of the arm, flexes and adducts the shoulder while largely hidden beneath the short head of biceps. Brachialis (p. 105) arises from the anterior distal half of the humerus, covers the front of the elbow joint, and inserts onto the ulna to flex the forearm. Partly visible along the lateral side of the arm, it is seen extending below deltoid. Triceps brachii – it has three heads – shapes the back of the arm, and extends the limb. Lateral and medial heads arise from the posterior surface of the humerus, and a long head arises from the infraglenoid tuberosity (p. 98) of the scapula. All three converge into a single aponeurosis which covers the lower half of the muscle. This crosses the elbow joint behind and inserts onto the olecranon (or elbow bone) at the back of the ulna.

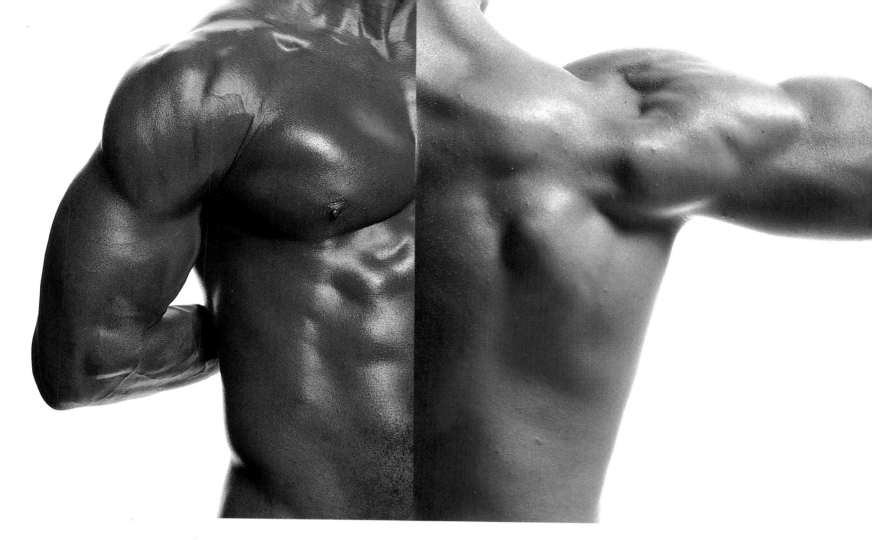

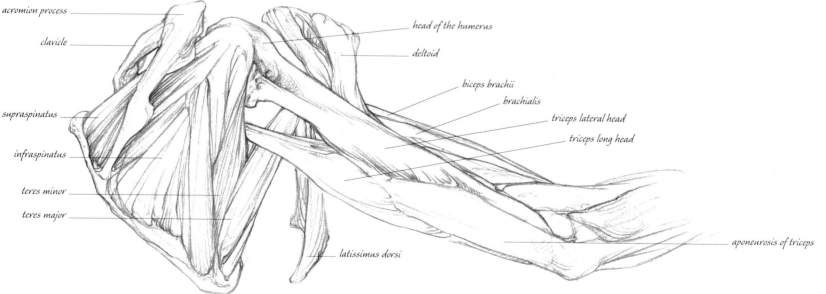

acromion process

clavicle

head of the humerus

deltoid

biceps brachii

brachialis

triceps lateral head

supraspinatus

triceps long head

infraspinatus

teres minor

teres major

latissimus dorsi

aponeurosis of triceps

TOP AND ABOVE

These photographs display the superficial muscles of the shoulder and arm, in particular trapezius, deltoid, pectoralis major, and latissimus dorsi, as they clothe and articulate the shoulder joint. You can also locate biceps brachii, in front of the arm, and triceps brachii behind. The drawing shows a deep dissection of rotator muscles over the shoulder blade, in particular supraspinatus, infraspinatus, teres minor and major. The lateral and long heads of triceps brachii are clearly defined beneath the skin on the back of the arm, together with the long aponeurosis, which gives a flattened plane to the arm as it crosses the back of the elbow joint to insert onto the ulna. The medial head of triceps is deeper, hidden from view, and only partly seen above the elbow on the inside (medial surface) of the arm (p. 103). The whole of triceps enfolds and is covered by fatty tissue, particularly close to the shoulder.

MASTERCLASS
THE DEATH OF MARAT JACQUES-LOUIS DAVID

Jacques-Louis David (1748-1825) flourished under the patronage of Napoleon Bonaparte, who made him official court painter. In his youth, David had been an ardent supporter of the Revolution and a personal friend of Jean-Paul Marat, who was assassinated by Charlotte Corday in 1793.

A strange and unsettling painting, *The Death of Marat* struggles between the historic moment it depicts and the anguish of its feelings. The artist also cannot decide on the mortality of the victim. In an attempt to show that the event has just happened, David has created a curiously modeled and artificial anatomy of death, a non-state between rigor mortis and collapse, where the revolutionary seems sapped not of life but vitality in a coy sexual swoon. As if witness to the actual killing, we are present at the very moment of his death. The weight of Marat's body has not yet fallen. He holds up the letter, which we can read clearly, and his right hand balances the nib of his pen on the floor. David has painted Marat in a condition of living death, which

is familiar to us through many paintings of crucified Christ. Even the stab wound echoes the fifth stigmata in Christ's side, the final wound of the spear. Here David is making the point of parallel martyrdom.

Further strangeness is added to Marat's bleak dwelling by a flood of golden light and the treatment of the wall, where a flurry of gold and marble-like flecks suggest a grand tomb looming above; a spectre of Marat's future heroic status. In contrast, and to show us the man's humility and humble beginnings, David paints Marat's wooden writing box as a simple headstone, which he signs with a personal dedication *À Marat, David* (To Marat, David). This is a painting that is very well aware of its place in the world, almost a newscast from a distant time. The artist places us like witnesses in front of an incident that changed the course of world history.

RIGHT

The model demonstrates the possible position of Marat's complete body in the bath. His pose shows David's exaggeration of the shoulder muscles in relation to those of the chest, and with different lighting makes clear the structures of the neck. Note how under the heat of the studio lights, superficial veins have risen and describe their passage across the arms and hands.

THE HEAD

Marat has unusually broad facial features. Light across his head accentuates the brow and frontal air sinuses. His eyes are deep set, wide and far apart, with large expressive eyelids. The light gives the impression of a classically straight (Roman) nose, although we can see by the depth of the nasal bones beneath the brow that in profile his nose would have been hooked.

LEFT ARM AND HAND

Marat suffered from a skin disease but it is underplayed here. His marble skin looks cold to the touch, and beneath the warm light, blue veins give a pale sheen to the skin. Clearly defined muscles hold the forearm in tension. If truly relaxed, the radius would roll forward or backward of the ulna and either the back or front of the hand would fall against the table.

RIGHT ARM AND HAND

Marat has the shoulders and arms of a classical youth. The deltoid is full and rounded, as is often found in Greek statuary. It also seems too developed (see left). Deltoid's insertion between biceps and triceps is marked, as are the brachialis, brachioradialis, and other muscles of the forearm.

À MARAT,

DAVID.

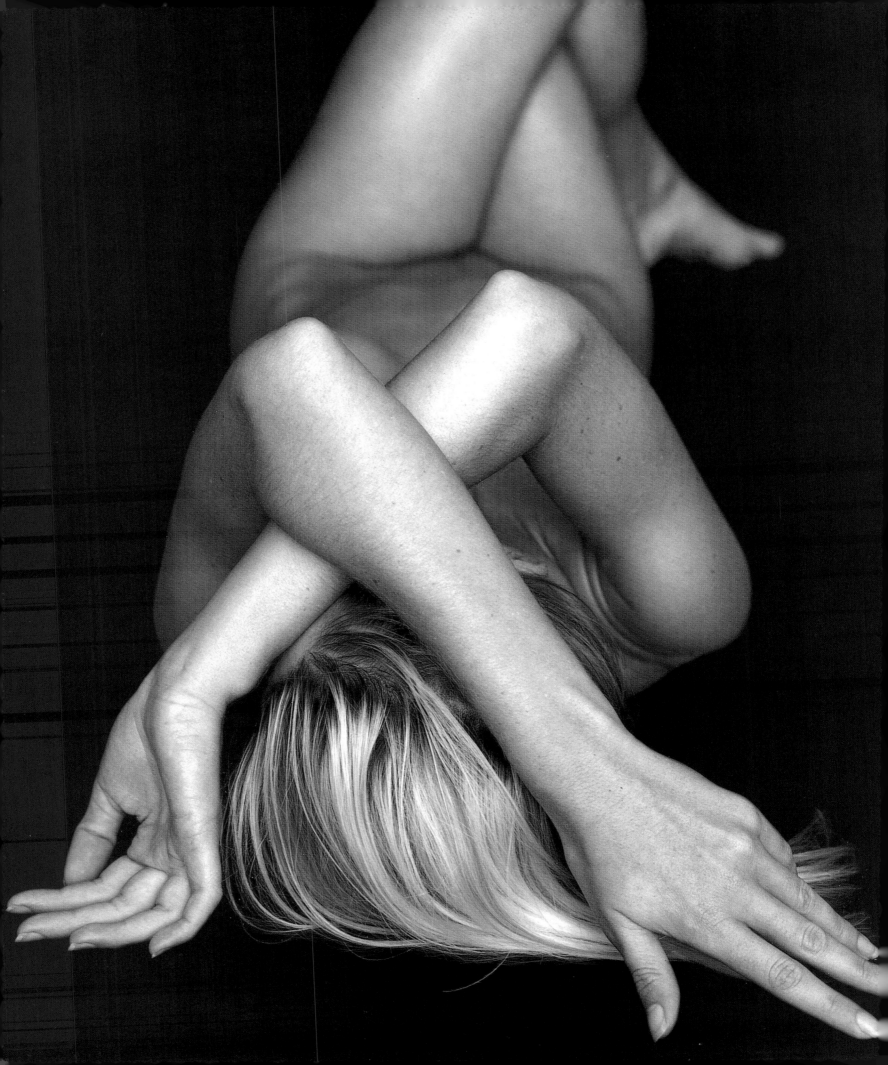

The dissection and portrayal of the forearm and hand hold a unique and special place in the history of anatomy. Like the brain, they have a significance far beyond the understanding of mechanical function and form. In Christian Europe, the forearm and hand have been seen as God's most profound creation, his tool on earth. The most famous example of this belief is Rembrandt's "Dr. Nicolaes Tulp Demonstrating the Anatomy of the Arm" (1632). The eminent surgeon stands surrounded by intrigued colleagues as he demonstrates the workings of what Aristotle had called "the instrument of instruments."

THE FOREARM AND HAND

Hands are the supreme instruments of touch. Their sensitivity and delicacy of control make them our primary antennae in our interaction with the world. Their strength and articulation have contributed enormously to our physical environment and to the entire history of artifacts. As organs of highly sophisticated engineering, hands continue to be a subject of profound interest to artists. The contemporary Australian performance artist Stelarc, who builds robotic extensions of his own anatomy, wears a third forearm and hand: a perspex-and-steel device that questions rather than copies the original. In its avoidance of simple mimicry it reflects, like Dr. Tulp, on the meaning and design of this remarkable limb.

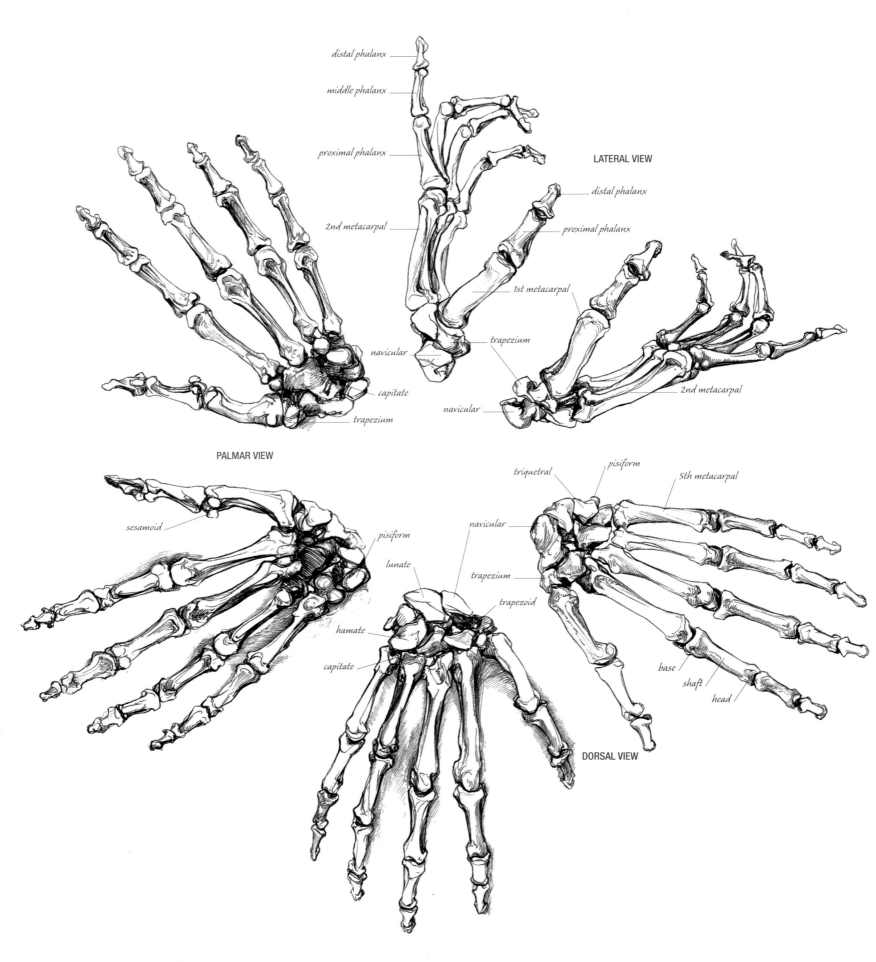

distal phalanx

middle phalanx

proximal phalanx

2nd metacarpal

navicular

capitate

trapezium

LATERAL VIEW

distal phalanx

proximal phalanx

1st metacarpal

trapezium

navicular

2nd metacarpal

PALMAR VIEW

sesamoid

pisiform

triquetral

pisiform

5th metacarpal

navicular

trapezium

lunate

trapezoid

hamate

capitate

base

shaft

head

DORSAL VIEW

Clockwise from the top: lateral (or thumbside), dorsal (back), and palmar (palmside) views of the left and right wrist and hand bones. Each hand is composed of 27 bones. Eight wrist (or carpal) bones form a curved and flexible tunnel, bridged by a strong ligament. This protects the passage of flexor tendons. Five metacarpal bones shape the palm and base of the thumb. Fourteen tapered phalanges give shape and precision to the fingers and thumb.

The long bones of the forearm. The ulna is thickened above, where it shapes the point of the elbow behind and hinges against the trochlea of the humerus in front. It tapers downward to form a small rounded head close to the wrist (on the little finger side), which can be felt and seen beneath the skin. The radius is narrow and rounded above, where it is buried in flesh, and wide and flattened below, where it is more exposed, giving width to the wrist. The radius rolls freely back and forth across the ulna to rotate the whole hand.

THE FOREARM AND HAND BONES

The long bones of the forearm are named the ulna and radius. They lie parallel to each other and are joined at the elbow and wrist. The ulna is placed on the medial or little finger side of the forearm, and the radius is lateral, on the thumb side. They are connected by a fine interosseous membrane, which gives an additional area of attachment to muscles.

The ulna is longer, set slightly higher, and behind. Its proximal end is thick and flattened, forming the familiar bony point of the elbow. This point is named the olecranon, and it fits into the olecranon fossa of the humerus, when the limb is held out straight (p. 112). The anterior surface of the bone forms a tight cup around the trochlea (p. 99). The olecranon and trochlea meet at a hinged synovial joint. Their movement is restricted to flexion and extension (backward and forward) through one plane. The shaft of the ulna is prismatic (or three sided) throughout most of its length. It gradually tapers, becoming both more slender and cylindrical toward the wrist. The rounded distal end of the ulna (named the head) is excluded from the wrist joint by an articular cartilaginous disk.

The head (or proximal end) of the radius is small, rounded, and flat. It articulates with the capitulum of the humerus above (p. 97) and the radial notch of the ulna to its medial side. It is embraced by a bandlike annular ligament. The shaft of the radius rotates freely across the ulna in its own

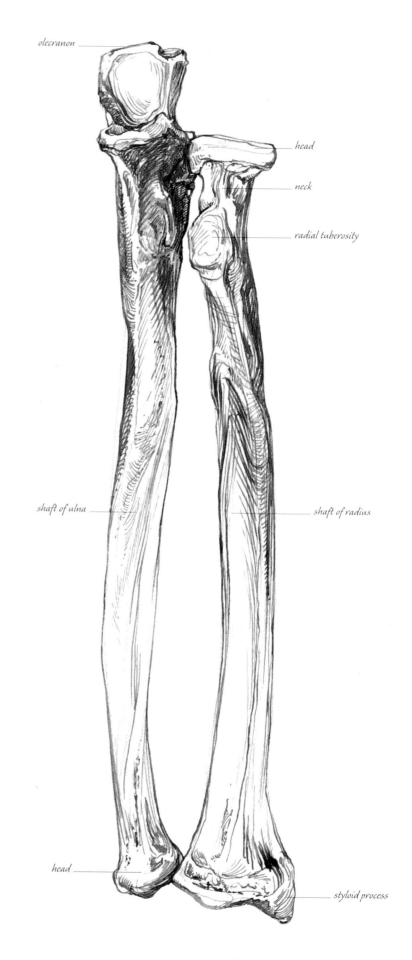

olecranon

head

neck

radial tuberosity

shaft of ulna

shaft of radius

head

styloid process

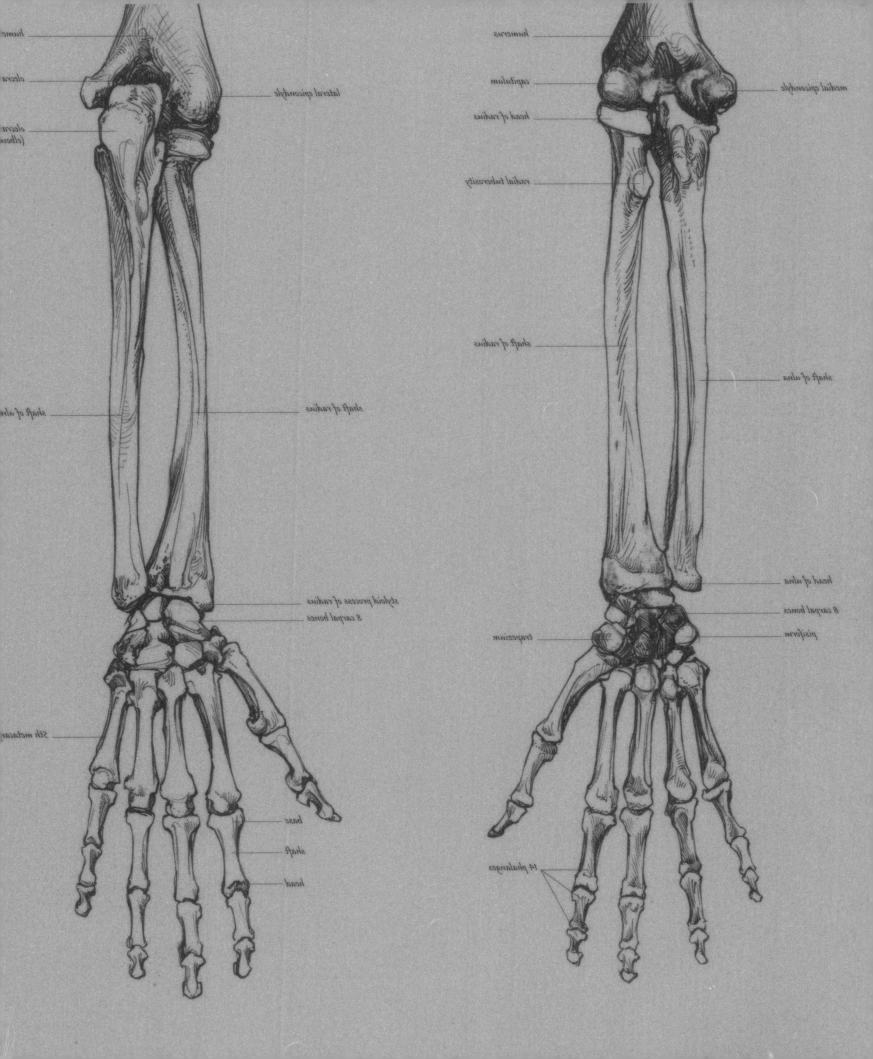

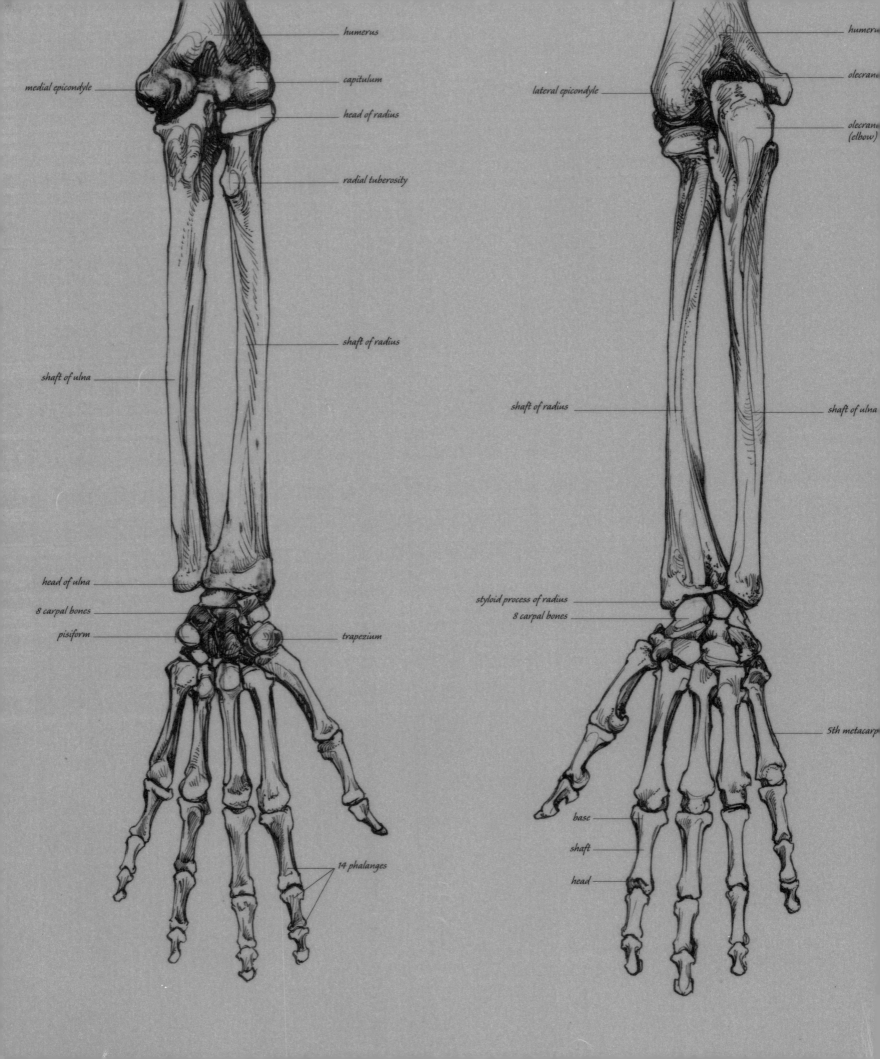

humerus

medial epicondyle

capitulum

head of radius

radial tuberosity

shaft of radius

shaft of ulna

head of ulna

8 carpal bones

pisiform

trapezium

14 phalanges

humerus

lateral epicondyle

olecranon

olecranon
(elbow)

shaft of radius

shaft of ulna

styloid process of radius

8 carpal bones

5th metacarpal

base

shaft

head

LEFT

Using this illustration, examine the relationship between the lateral and medial epicondyles of the humerus, the olecranon of the ulna, and head of the radius. Then relax one arm and, gripping your fingers around the elbow, try to locate each one. (Avoid pressing your ulna nerve, p. 99). The olecranon and both epicondyles lie just beneath the skin. Next locate the styloid process of the radius (p. 111) and head of the ulna, either side of the wrist. Pisiform and trapezium should also be palpable at the base of the palm.

RIGHT

The first line of knuckles of the fist is shaped by the heads of the metacarpals, bridged longitudinally by extensor tendons. The proximal (base) ends of the first row of phalanges are butted up under the heads of the metacarpals. The distal ends (heads) of the first phalanges form the second set of knuckles, halfway down the fingers. Again, the base ends of the next row of phalanges butt below, and their heads form the last set of knuckles, with the last set of phalanges butted beneath.

longitudinal axis. This movement carries the hand from pronation (turning the palm down) to supination (turning the palm upward). Below the head of the radius, the shaft narrows to a slim neck, at the base of which (in front) is the radial tuberosity. This supports the insertion of biceps brachii (p. 103), which flexes and supinates the forearm. The shaft of the radius is grooved and ridged for the attachment of muscles passing via tendons into the hand. The bone grows wider and flatter toward its distal end, where it articulates with the head of the ulna and the navicular and lunate bones of the wrist. The radius alone carries the skeleton of the hand.

Eight carpal bones shape the wrist. These are small, irregular, and tightly bound by ligaments. Arranged in two curved rows, they are named navicular, lunate, triquetral, pisiform, trapezoid, trapezium, capitate, and hamate (p. 110). Carpal bones form a short and flexible tunnel, which is bridged and maintained by a strong ligament. The tunnel encloses and protects tendons, blood vessels, and nerves passing beneath. Five metacarpal bones give form and curve to the palm (p. 110). These articulate at their base with one or more bones of the wrist. At their heads, they support a finger or thumb. The four metacarpals of the palm are tied together by ligaments at their distal heads (p. 121). The first metacarpal (of the thumb) is independent and rotated through 90 degrees to oppose and press against the palm. There are fourteen phalanges (or finger bones): three in each finger and two in the thumb. Each phalanx (formed of a base, shaft, and head) tapers to give shape and precision to the fingers.

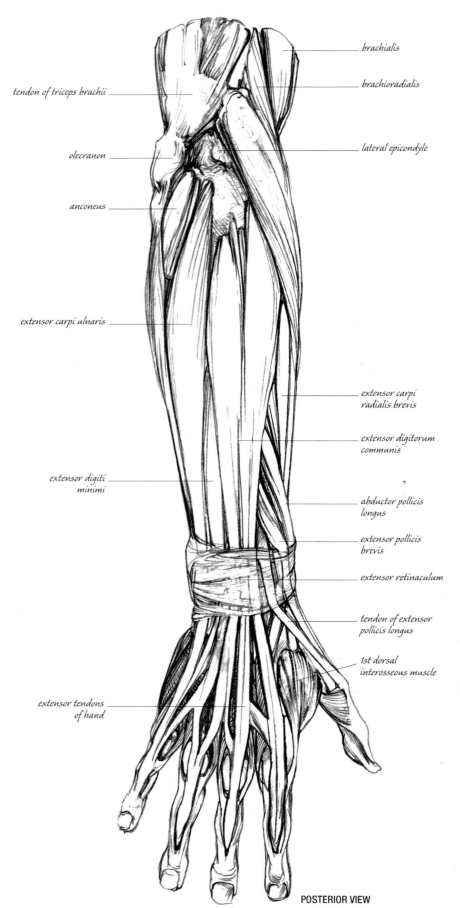

tendon of triceps brachii

olecranon

anconeus

extensor carpi ulnaris

extensor digiti minimi

extensor tendons of hand

brachialis

brachioradialis

lateral epicondyle

extensor carpi radialis brevis

extensor digitorum communis

abductor pollicis longus

extensor pollicis brevis

extensor retinaculum

tendon of extensor pollicis longus

1st dorsal interosseous muscle

POSTERIOR VIEW

Posterior (left) and lateral (near right) views of the right forearm and hand. Long extensor muscles shape the back of the arm, arising from the lateral epicondyle of the humerus, radius, and interosseous membrane, and inserting onto the back of the wrist, and the knuckles of fingers and thumb. Extensors turn the palm upward, and stretch back the wrist, fingers, and thumb. Anterior (center right) and medial (far right) views of the same limb. The front of the forearm is shaped by flexor muscles arising from the medial epicondyle of *the humerus (p. 112), ulna, radius, and a connecting interosseous membrane (p. 111). They insert into the front of the wrist, palm, and fingers. Flexors turn the palm down, curl the wrist, fingers, and thumb, and allow us to grip. Usually larger and stronger than the extensors, they are less defined under the skin. Both groups are held at the wrist by fibrous bands (or retinacula). Short muscles between the bones of the palm give mass to the hand, flex, extend, and adduct and abduct fingers and thumb.*

THE FOREARM AND HAND MUSCLES

The two bones of the forearm are almost constantly in motion throughout our lives, turning back and forth in perpetual service to the hand. Their movement of the wrist and fingers is controlled by more than 30 slender muscles, arranged in layers from the elbow to the palm.

The muscles and accompanying tendons of the forearm and hand fall into three groups. Long extensor muscles shape the posterior of the forearm and pass into the dorsum (or back) of the hand. These supinate the palm and extend the wrist, fingers, and thumb. Flexor muscles cover the anterior of the forearm and pass into the palm. These pronate the palm and flex the wrist, fingers, and thumb. Muscles contained within the palm give mass to the hand, while flexing, extending, adducting, and abducting the fingers and thumb. See the caption above and p. 244 for an explanation of the action of these muscles. The long tendons (p. 34) of the forearm divide and insert into numerous bones, giving strength and dexterity to the carpals, metacarpals, and phalanges of the hand.

Muscles and tendons of the forearm are generally named according to their origins and insertions onto bone, relative lengths, and action. Names are therefore often very long. This may seem complicated, but it is actually very helpful in understanding the movement of the limb. For example, flexor carpi ulnaris (far right) flexes the wrist (or carpus) on the side of the ulna. Extensor carpi radialis longus (near right) is the longer of two muscles extending the

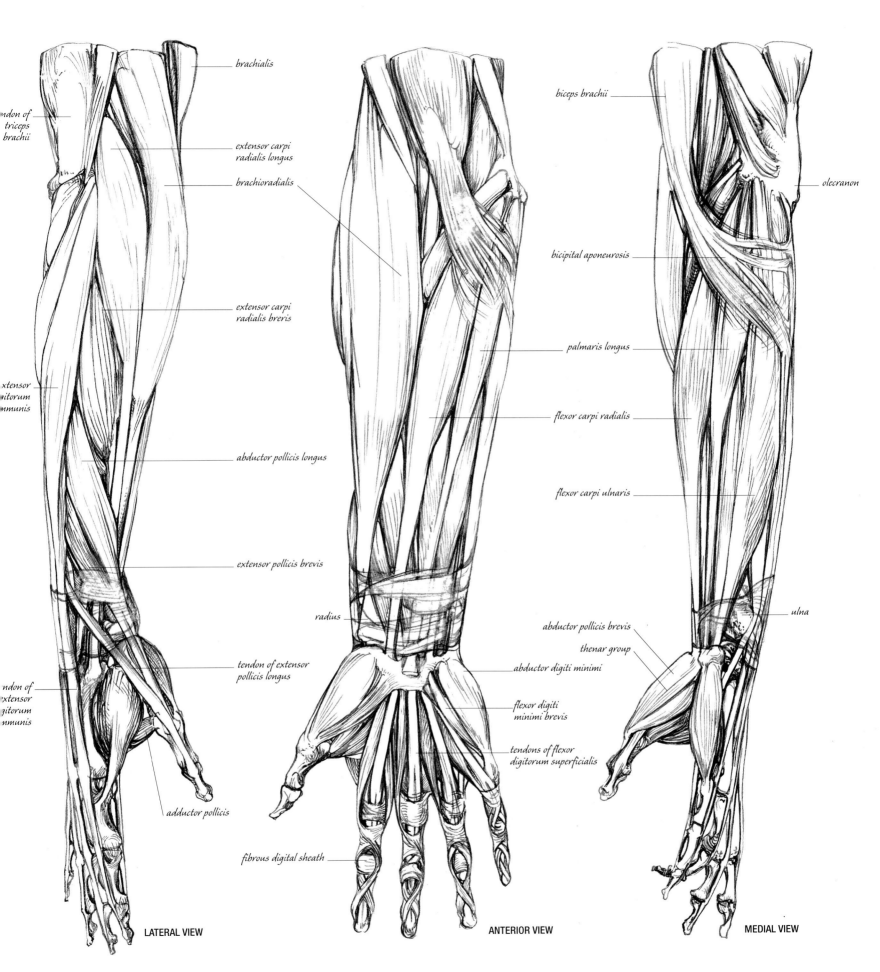

brachialis

tendon of triceps brachii

extensor carpi radialis longus

brachioradialis

extensor carpi radialis brevis

extensor digitorum communis

abductor pollicis longus

extensor pollicis brevis

tendon of extensor digitorum communis

tendon of extensor pollicis longus

adductor pollicis

LATERAL VIEW

biceps brachii

bicipital aponeurosis

palmaris longus

flexor carpi radialis

flexor carpi ulnaris

radius

abductor digiti minimi

flexor digiti minimi brevis

tendons of flexor digitorum superficialis

fibrous digital sheath

ANTERIOR VIEW

olecranon

abductor pollicis brevis

thenar group

ulna

MEDIAL VIEW

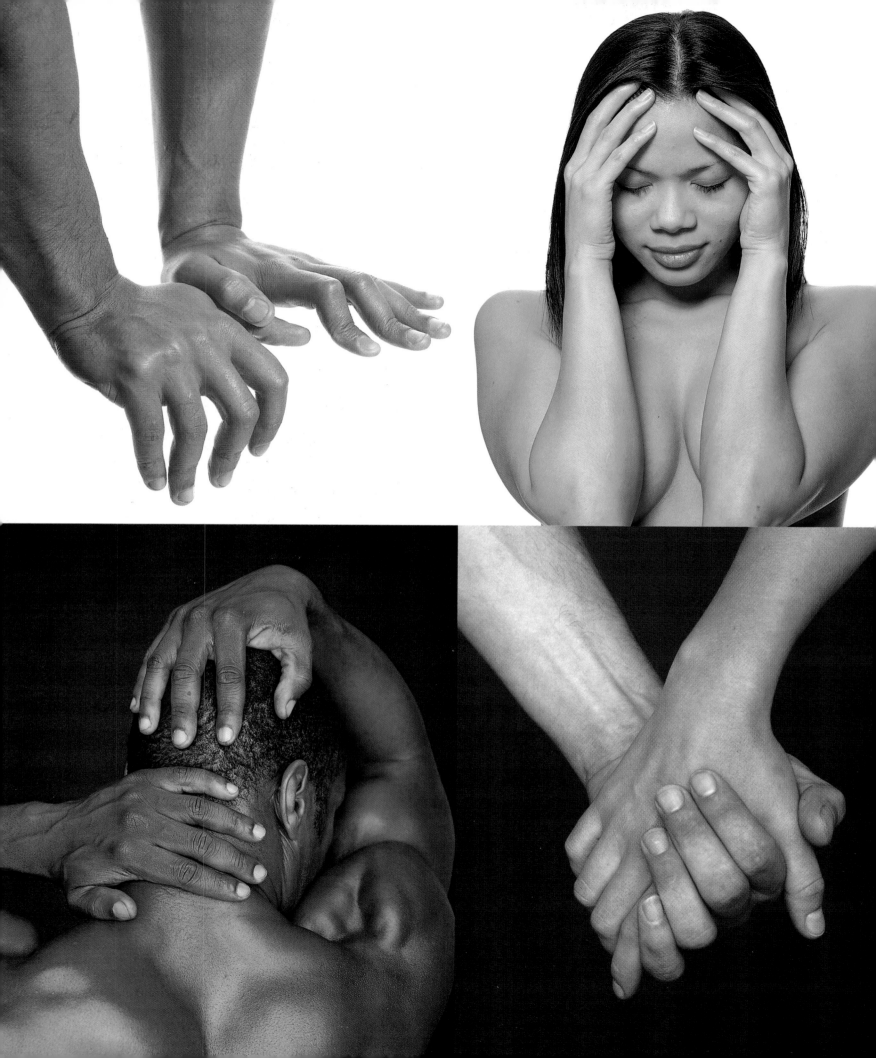

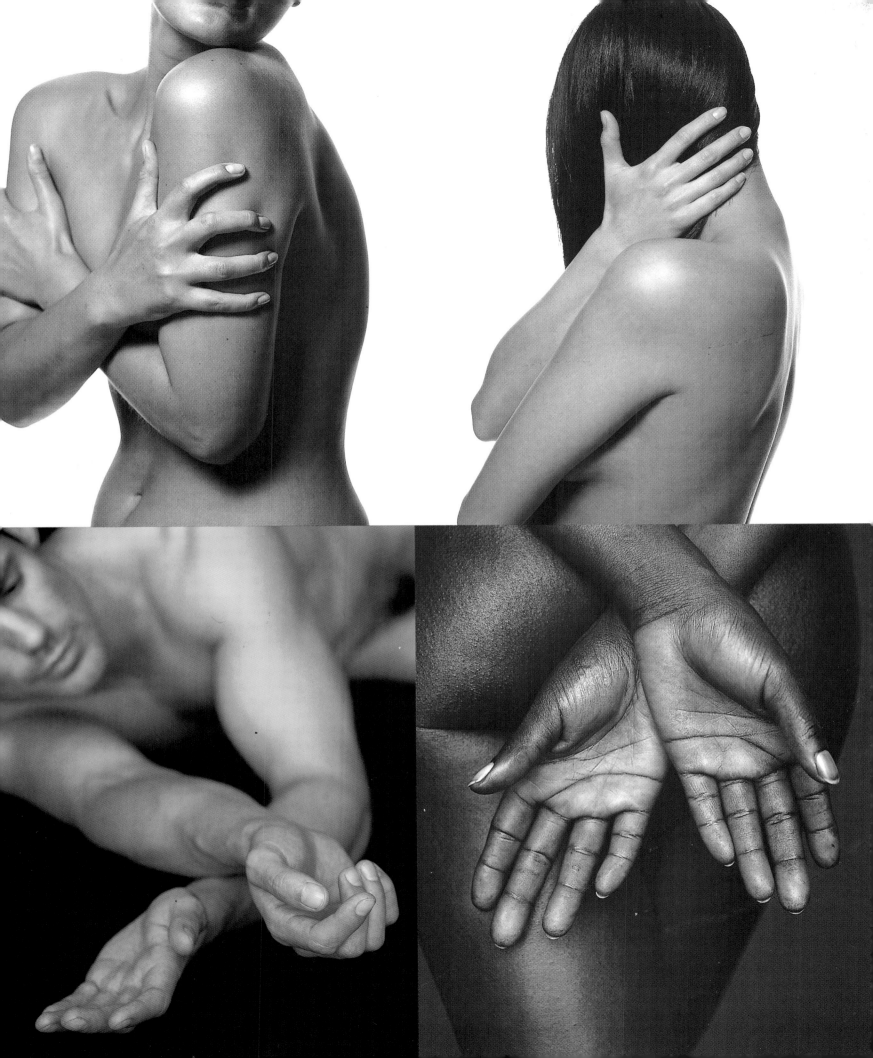

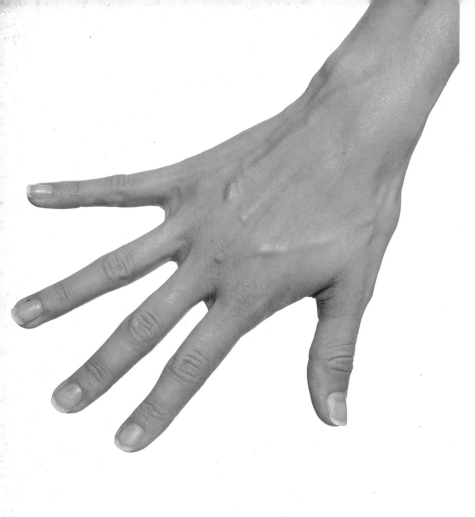

PREVIOUS PAGE, LEFT AND RIGHT

The structure and detail of the hands. Note the prominence of the knuckles and bones of the wrist, extensor tendons, regions of fatty tissue, blood vessels, and the flexibility of individual finger joints. Pressing one of your own hands reveals that the back is comparatively bony and tendinous, in contrast to the palm, which is thickened by groups of muscles and layers of fat. Dorsal veins rise to the back of the fingers between the knuckles. They gradually unite into longer and larger vessels as they wind across the hand toward the arm. Veins press against the skin if the forearm and hand are hot. They rise farther if the hot hand is held downward and kept still. Pressure builds within the veins as the blood is forced to rise against gravity in its return to the heart. Small bumps indicate valves that prevent blood from flowing backward.

wrist on the side of the radius. Flexor digiti minimi brevis (p. 115, center) is a short flexor of the little finger. Extensor pollicis longus (p. 115, left) is the long extensor of the thumb, while abductor pollicis longus (p. 115, left) is the long abductor of the thumb. Palmaris longus (p. 115, center and right) is a very long slender muscle tying to the palm (p. 121).

Of all the muscles of the forearm, palmaris is particularly weak and insignificant. However, it is of special interest because it is often missing, or only present in one forearm. Its absence is sometimes attributed to the refining process of our continuous evolution. Anatomical variations appear throughout the body. Various structures, including muscles and bones, may be either absent or multiplied on one side of the body, perhaps unusually extended, divided, pierced, or united to an adjacent part. When present, palmaris longus can be found in the wrist as a small threadlike tendon, medial to the much thicker cord of flexor carpi radialis (p. 115).

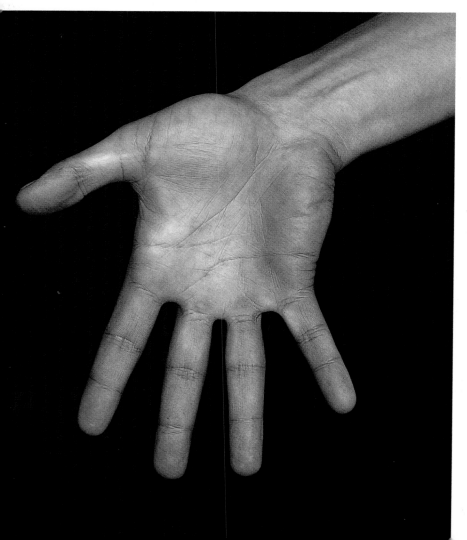

As muscles contract, they shorten, rise, pull against their tendons, and draw lines of tension between the bones into which they are rooted. Flexed muscles will try to pass in straight lines between their points of origin and insertion, and they are only prevented from doing so by intervening bones, joints, adjacent muscles, and thickened bands of fascia (p. 36) tying their straining fibers into place. More than 20 tendons pass through the wrist. A few of these are visible when taut, and they can seem to press against the skin. They are, however, tied or bound against

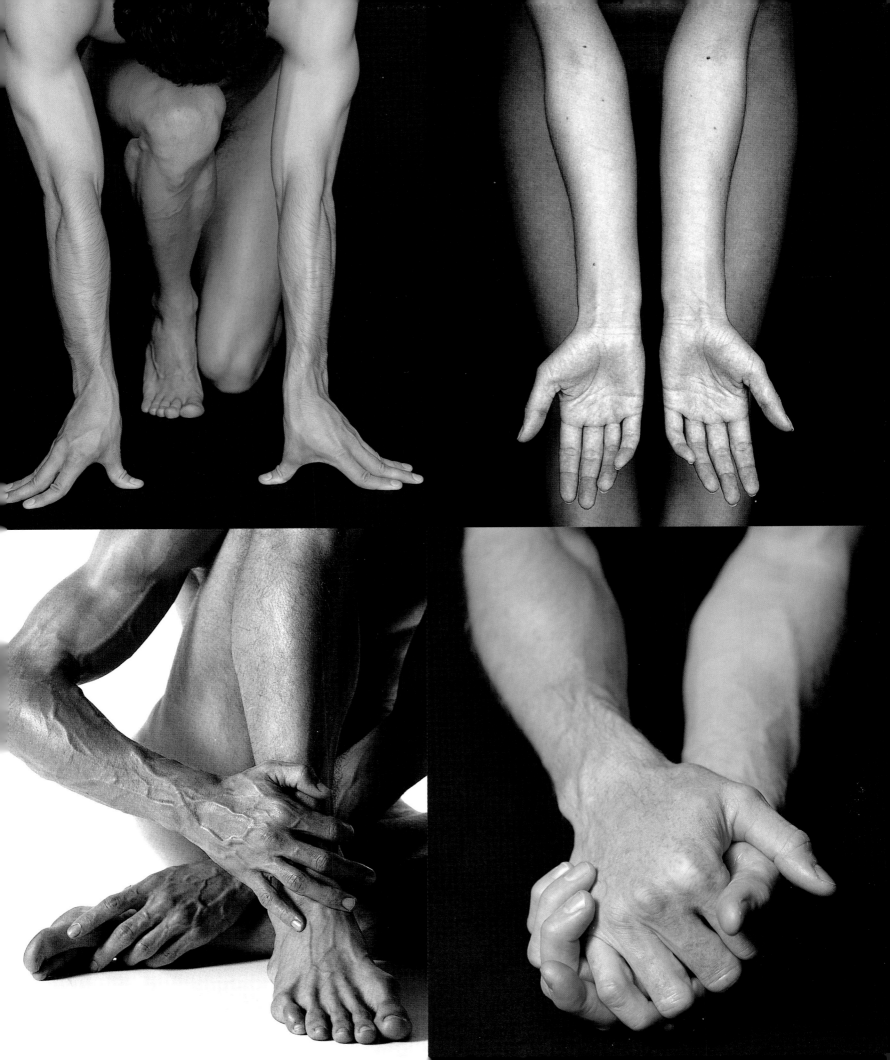

LEFT AND RIGHT

Left: flexor muscles and tendons of the forearm, straining to hold the weight of the body. The most important movement of the hand is the opposition of the four fingers to the thumb, enabling us to grip powerfully and to hold gently. Right: deep and superficial structures of the hand. Long muscles of the forearm send tendons through the wrist to articulate the fingers. Short muscles, arising from the bones of the palm, are arranged in three groups. In the palm, two layers of interosseous muscles are set deep between the metacarpals to adduct, abduct, extend, and flex the fingers and thumb, while adductor pollicis adducts the thumb, and the lumbricals flex and extend the fingers. Three thenar (or thumb) muscles (abductor pollicis brevis, flexor pollicis brevis, and opponens pollicis) shape the base of the thumb on the palm side. Three hypothenar (little finger) muscles (abductor digiti minimi, flexor digiti minimi, and opponens digiti minimi) create a smaller mass at the base of the little finger.

the bones by thickened fibrous bands named retinacula. Flexor and extensor retinacula (p. 114) enable tendons of the hand to change direction at the wrist, without taking shortcuts across to the forearm.

Tendons inserting within the fingers are similarly bound, to the knuckles. It is important to note that there are no muscles in the fingers – only tendons on either side of the bones, tied by fibrous bands into lubricated synovial sheaths. The small fleshy bellies of each finger are composed of fatty tissue, carrying blood vessels and nerves, and cushioning flexor tendons against the grip of the hand. Broadly speaking, the dorsum is bony and tendinous, beneath a covering of loose skin. The palm is more muscular and fatty. The muscles of the palm are enclosed beneath a sheet of thickened fascia. Named the palmar aponeurosis, this protects and strengthens the palm. It also ties the skin above to muscles and bones below, holding it firm, and preventing it from slipping when we grasp a surface. The palmar aponeurosis is composed of three parts: a very dense fan-shaped center, flanked by much finer medial and lateral extensions covering the base of the smallest finger and thumb and becoming continuous with the dorsal fascia of the hand. At its apex, the aponeurosis blends with the tendon of palmaris longus, leading in from the wrist. At its base, deep fibres blend with the digital sheaths of flexor tendons and with the transverse metacarpal ligament. Superficial fibres tie to the skin of the fingers and palm, while from its deep surface intermuscular septa pass between muscles of the hand to reach the metacarpal bones beneath.

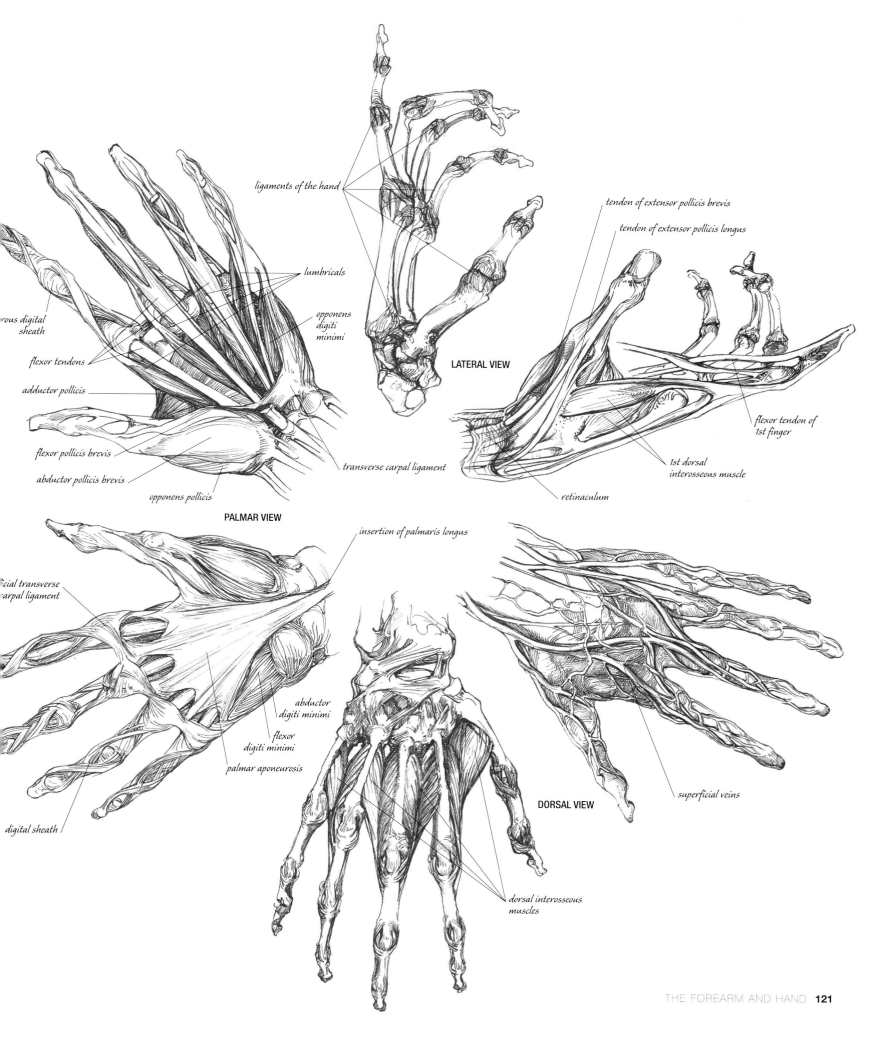

ligaments of the hand

lumbricals

opponens
digiti
minimi

~~rous~~ digital
sheath

flexor tendons

adductor pollicis

flexor pollicis brevis

abductor pollicis brevis

opponens pollicis

transverse carpal ligament

PALMAR VIEW

LATERAL VIEW

tendon of extensor pollicis brevis

tendon of extensor pollicis longus

flexor tendon of
1st finger

1st dorsal
interosseous muscle

retinaculum

insertion of palmaris longus

~~cial~~ transverse
~~arpal~~ ligament

abductor
digiti minimi

flexor
digiti minimi

palmar aponeurosis

digital sheath

superficial veins

DORSAL VIEW

dorsal interosseous
muscles

MASTERCLASS

MARTYRDOM OF SAINT PHILIP JOSE DE RIBERA

José de Ribera (1591-1652) was a genius of anatomical expression. The figures in his paintings – the Christs, saints, and angels – lean, reach, and distend their very human bodies with passionate articulation. The Martyrdom of Saint Philip was painted when Ribera was 48 years old and at the height of his powers.

This is the moment before Jesus' disciple, Saint Philip, suffers a similar fate to his master – crucifixion. The saint's body is being stretched between life and death and is undergoing a transfiguration. Part of his human form still touches the ground, its gravity swinging out toward the viewer. His legs are being pulled back to increase the painful significance of the hanging posture. His solid working-man's physique is being hoisted like a sail into the awaiting heavens, and in his agony he is already reaching to embrace God. The exaggeration of this gesture locks our attention to the center of the canvas, as Ribera carves the moment of transfiguration in straining muscle. Those gathered around the saint to perpetrate the act lean forward or pull themselves down into the abyss to balance the composition of his ascent.

Victims of crucifixion eventually die of asphyxiation because they must continually raise the whole weight of their body on nailed wrists (or hands) and feet in order to breathe, and as they weaken, they suffocate. Here, Saint Philip's rib cage is already distended and straining to breathe, while the others around him chatter, gossip, or weep. More than any other artist before or after him, Ribera used oil paint to create the actual texture of aged human skin, as well as its hue and tone. Fine creases and hairs appear to be present on the surface of the paint. This is a unique and essential quality of Ribera's work, which is difficult to see in this reproduction.

RIGHT

This model is much younger and more athletic than the saint in Ribera's painting. He has a different physical build, less body fat, and tighter skin. The strain and difficulty in holding the pose is clearly seen in his upper torso muscles. Note how pectoralis major and latisimmus dorsi suspend his weight as if in a sling. The model has just exhaled and so his ribs are barely evident beneath his skin.

THE ARMS

Saint Philip's arms are massive, elongated, and carry the weight of his whole body. They raise the clavicles in a tight and shadowed cup around the neck, and flank the sternocleidomastoid muscles, which strain to hold forward the weight of the head. The left biceps emerging clearly from beneath the deltoid is exaggerated, distorted, and casts a dark shadow over triceps at the back of the arm. The flattened hollow in between divides the flexor and extensor compartments with soft fatty tissue enfolding blood vessels and nerves. The medial epicondyle of the humerus is prominent, as are the flexor tendons of the wrist.

THE UPPER TORSO

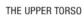

The torso is huge and elongated. Imagine the length of the spine curving behind the weight of his body. The upper torso is suspended on either side between pectoralis major and latissimus dorsi. However, these powerful muscles do not appear fully flexed. Note how the clavicular fibers of pectoralis are at rest, and compare this to the body in the photograph opposite.

THE LEGS

The muscles of the legs are beautifully modeled and very subtly defined. On the right thigh, note the tightening of the iliotibial tract beneath the mass of quadriceps. Beneath the knee, the borders of gastrocnemius and soleus, peroneus longus, and tibialis anterior are clearly defined, and on the left inner thigh, sartorius catches the light as it passes beneath vastus medialis.

1639, oil on canvas, 92 x 92in,
Museo del Prado, Madrid

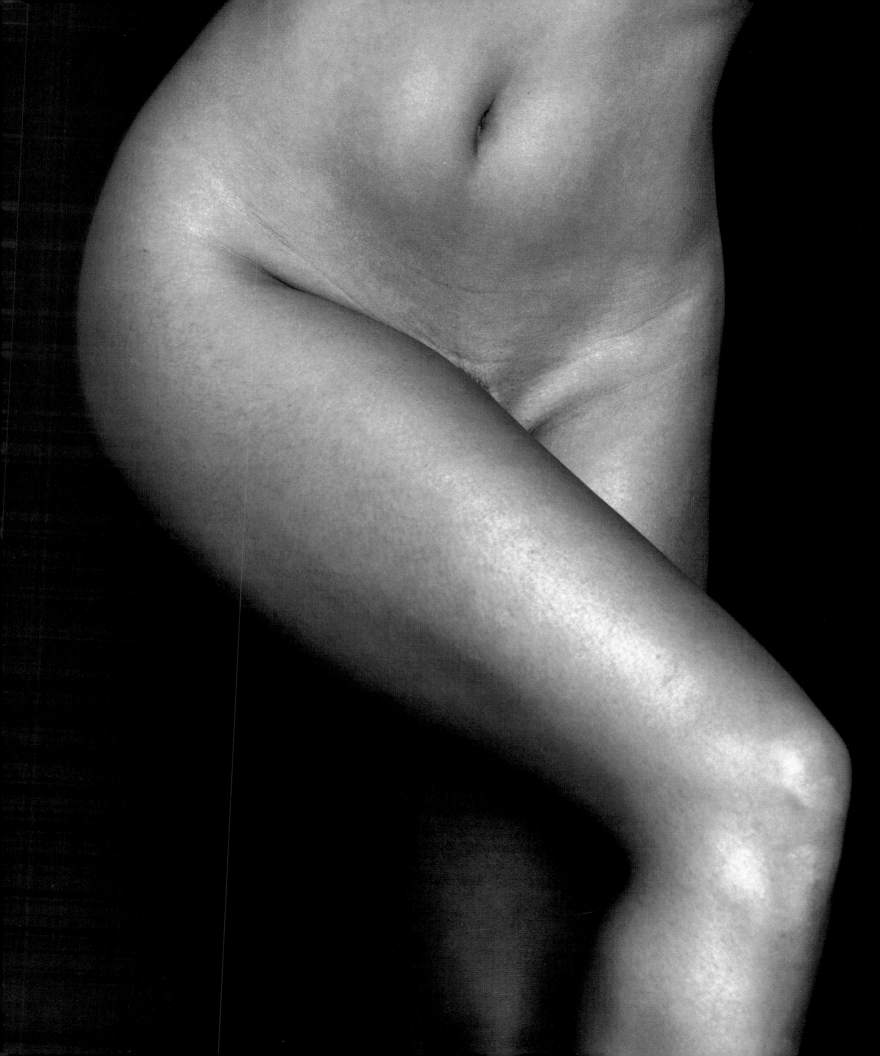

The thighbone (or femur) is the largest and heaviest long bone of the body, and its hollow core is filled with marrow. The Latin word *femur* derives, like fetus, feminine, and fecund, from the root *fe-*, which means to produce offspring. The shapely mass of the female thigh has long been an erotic symbol of fertility, but in world mythology there are instances of thigh births from male gods and mortals, which may spring from the ancient notion that marrow is the body's core of strength. The unborn Dionysus, son of Zeus and Semele, for example, was sewn into his father's thigh after the death of his mother and brought to full term.

THE HIP AND THIGH

The knee at the base of the femur has held even greater significance as an organ of fecundity and procreation. Many world languages reflect this belief. The Irish word for knee (*glun*) and the Latin (*genu*) share the same root as the word generation. The Assyrian and Babylonian word (*birku*) signified either knee or the penis, and in Anglo-Saxon *cneo maegas* means knee-relation (kinsman). And so it goes on, from the Masai to the Icelandic. The last word on this lost association is best left with Pliny, "It is these that supplicants touch, ... these that like altars they worship, perhaps because in them is the life (*vitalitas*). For in front of each knee ... there is ... a certain bulging cavity on the piercing of which, as of the throat, the spirit flows away."

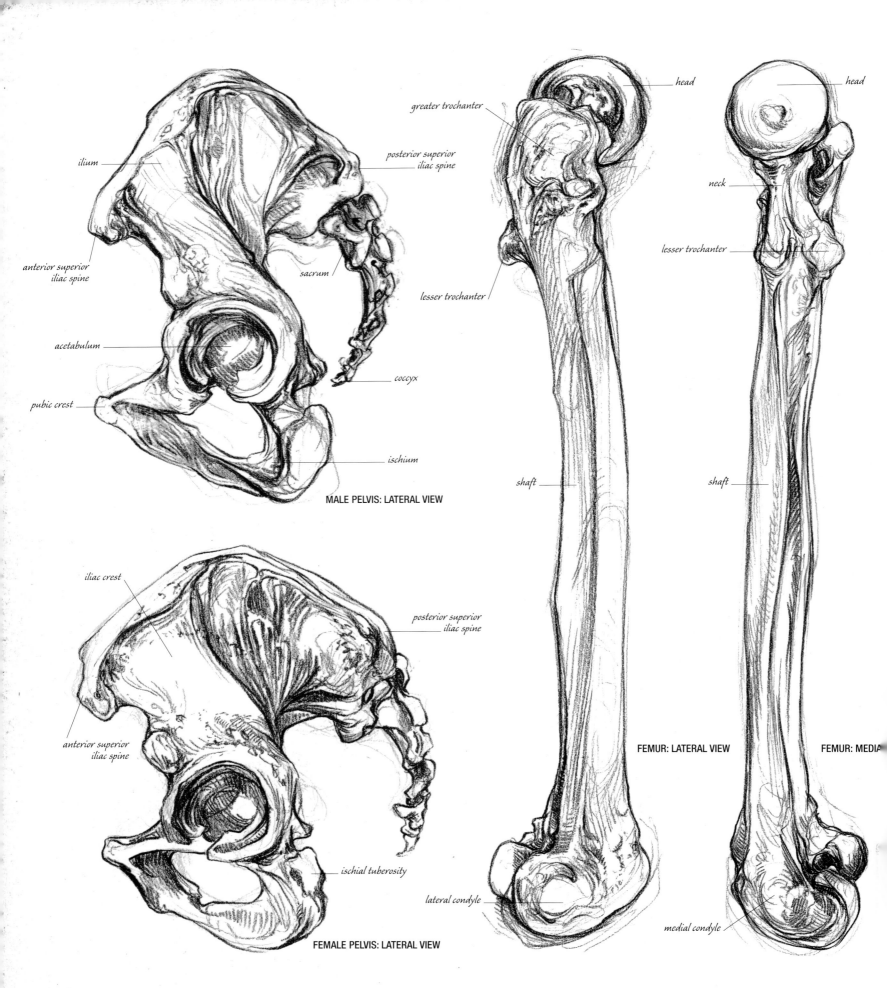

ilium

posterior superior
iliac spine

anterior superior
iliac spine

sacrum

acetabulum

coccyx

pubic crest

ischium

MALE PELVIS: LATERAL VIEW

greater trochanter

head

head

posterior superior
iliac spine

neck

lesser trochanter

lesser trochanter

iliac crest

posterior superior
iliac spine

anterior superior
iliac spine

shaft

shaft

ischial tuberosity

lateral condyle

medial condyle

FEMALE PELVIS: LATERAL VIEW

FEMUR: LATERAL VIEW

FEMUR: MEDIA

FAR LEFT

Two lateral views of a left hipbone joined with the sacrum and coccyx to form the pelvis: male (top) and female (below). It is clear how tall and narrow the male bones appear in comparison with those of the female. When standing, the anterior superior iliac spines should occupy the same vertical plane as the pubic crest below. These, together with the posterior superior iliac spines, all rise close to the skin. They are the five points by which an artist can locate the pelvis.

NEAR LEFT AND RIGHT

From left to right: drawings of the right femur, lateral and medial views. Note the angle between the head and greater trochanter, the forward curve of the shaft, and the curled mass of the medial and lateral condyles at the distal end. In the photograph flesh disguises much of the pelvis, but the dimples either side of the base of the spine are significant. These are the posterior superior iliac spines attaching via deep fascia (p. 36) to the skin.

THE HIP AND THIGH BONES

Many of the names that the early anatomists gave to parts of the body reflect a resemblance to some natural or manmade object. The coccyx is named after a cuckoo's beak, the tibia after a flute or pipe, and the fibula after the tongue of a clasp. But this system of nomenclature proved useless when they reached the hip bone. Inspiration had clearly run out when they gave it the Latin name os innominatum (bone of no name) because it was deemed to look like nothing on earth.

The two os innominatum (or innominate, hip, or haunch bones) are the largest flattened bones of the skeleton. They meet in front to shape the pubic arch, and behind they join the sacrum to complete the bowl of the pelvis (p. 89). The expanded shallow basin above is the greater (also major or false) pelvis. The short, closed, curved, and narrow canal below is the lesser (minor or true) pelvis. Together they transmit the weight of the body to the lower limbs. Each innominate bone is composed of three parts: the ilium, ischium, and pubis (or pubic bone). Separate in a child, they fuse in the adult, uniting at the deep cup of the hip joint, named the acetabulum (from the Latin for vinegar bowl). This faces downward, forward, and is surrounded by a pronounced rim, to receive the head of the femur.

The ilium (or uppermost wing of curved bone) is, like the scapula (p. 96), thickened at its borders, thin, and even translucent at its center. Its prominent crest, called the iliac crest, overhangs the hip joint and attaches

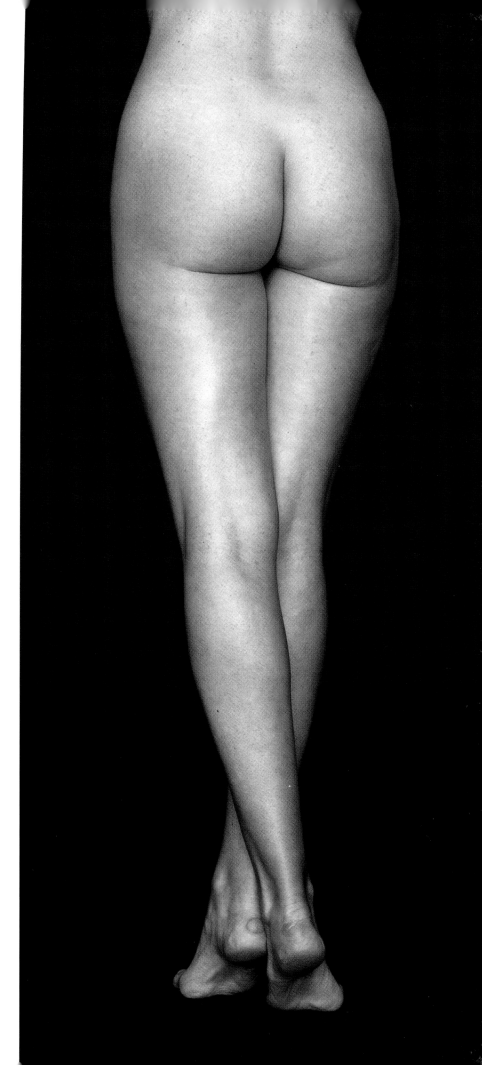

This overlay shows the approximate position of the pelvis and femurs within the body. When drawing the figure, the pelvis can seem a daunting structure to place. It helps to find the anterior and posterior superior iliac spines, in front of and behind the body. (These four points can be felt beneath your own skin.) Locate the arch of the pubic bones too. Leave aside but do not forget the ischial bones: they lie very deep within the body. Remember that if a model stands on one leg, with the other limb relaxed, the pelvis will tilt. The greater trochanter of the weight-bearing leg will push out against the skin of the hip as a hard lump. The greater trochanter of the relaxed leg may be cast into an indentation forward of the buttock. This can also be felt on your own body. It is imperative to remember the oblique angle of the femur as it passes through the thigh. In drawing, it might help at first to place a line from the greater trochanter to the medial condyle. The femur is nearer the front of the thigh, with a greater depth of flesh behind. The condyles of the femur and tibia, together with the patella (kneecap bone), create the skeleton of the knee joint. Only tendons pass across this joint (in front and to either side). These may be clad in a little fat.

to muscles of the flank. Its forward-most point, named the anterior superior iliac spine, can be felt beneath the skin, and is an important landmark for the artist. It helps locate the pelvis, and delineate the border of the torso and thigh. The posterior superior iliac spine is thicker, more gnarled, and surrounded, but not covered, by muscle. Superficial fascia of the skin (p. 36) attaches to it, which creates the familiar dimple appearing on each side of the back, just above the buttocks. At the base of the pelvis, and seen more clearly from behind, are the ischia. Together with the pubic bones above (p. 126), these appear to create two large, thickened, rough, and uneven loops of bone. We rest on the ischia when seated, and it is these that seem to ache when too much time has been spent sitting on a hard bench. Positioned in the fat of the buttocks, they give attachment to the hamstring (flexor) muscles of the thigh.

Sexual difference is more pronounced in the pelvis than in any other part of the skeleton. The photographs on pages 88 and 89 offer clear comparison between the taller and narrower form of the male pelvis and the wider and shallower form of the female. The male pelvis is also generally heavier, with more deeply etched surface detail.

The femur is the long bone of the thigh. It has a forward-curved cylindrical body or shaft and two articular ends. The upper end has a large ball-like smooth head, a long and pronounced neck, and two trochanters (or bony outcrops). The head of the femur fits into the acetabulum to create the ball and socket joint of the hip. This is enclosed within a stong fibrous capsule and supported by thick and powerful ligaments (p. 32), against which we rest when standing. The most significant of these is the iliofemoral ligament, which restricts the backward extension of the hip. It is one of the strongest ligaments in the body, arising from the lip of the acetabulum, together with the anterior inferior iliac spine (a small protuberance of bone just beneath the anterior superior iliac spine). The broad fibers of the iliofemoral ligament insert in front of the femur in a straight line between the greater and lesser trochanters. The back of the fibrous joint capsule is covered by the weaker ischiofemoral ligament; beneath, a pubofemoral ligament connects from the pubic bone to a little above the lesser trochanter.

The shaft of the femur is smooth along its anterior surface, presenting a gentle convex arch from end to end with no distinct markings. In contrast, to the posterior of the bone there is a gnarled and pitted ridge named the linea aspera, which gives attachment to most of the muscles of the thigh. This ridge is prominent throughout much of the length of the femur. Above and below, it divides into two, fading as each line passes outward to the sides of the bone. The distal end of the femur expands into two huge, rounded condyles (named medial and lateral according to their positions). These stand on, and articulate with the top of the shin bone (or tibia) to form the knee joint (p. 145). Both femurs pass obliquely through the thighs, to bring the knees into the body's line of gravity. The degree of inclination would be greatest in the limbs of a short woman, and least in a tall man.

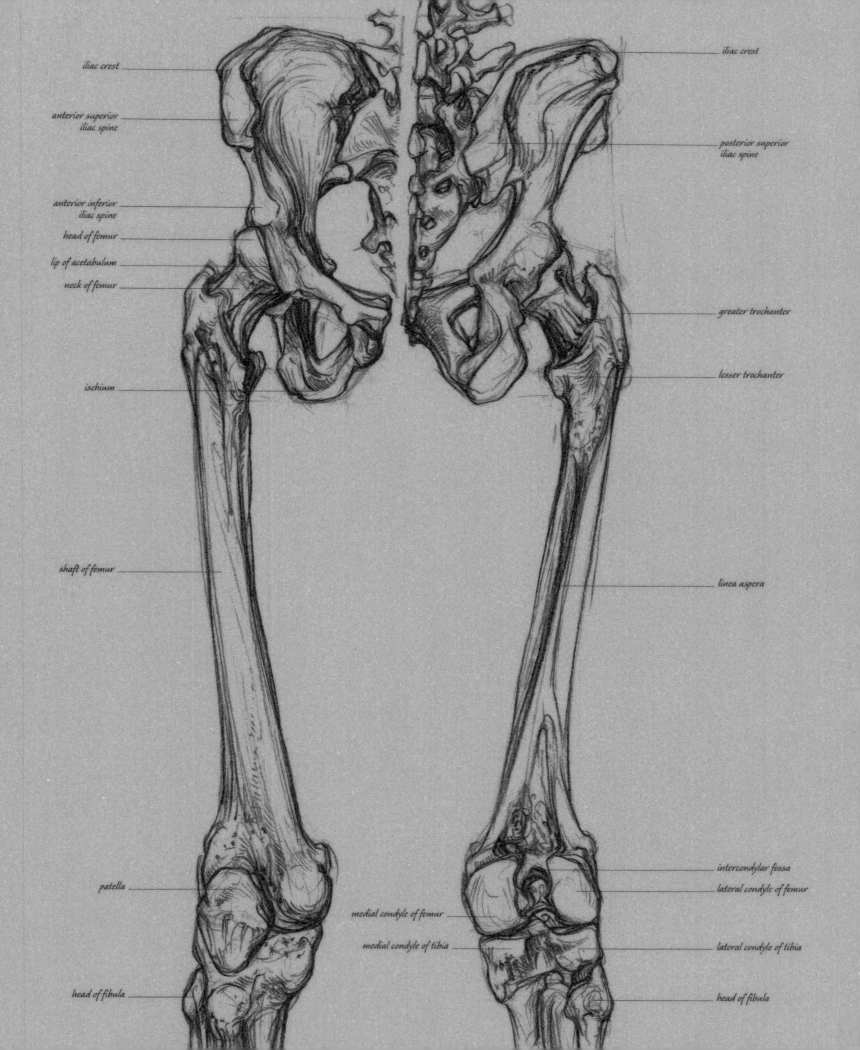

iliac crest

anterior superior
iliac spine

anterior inferior
iliac spine

head of femur

lip of acetabulum

neck of femur

ischium

shaft of femur

patella

head of fibula

medial condyle of femur

medial condyle of tibia

iliac crest

posterior superior
iliac spine

greater trochanter

lesser trochanter

linea aspera

intercondylar fossa

lateral condyle of femur

lateral condyle of tibia

head of fibula

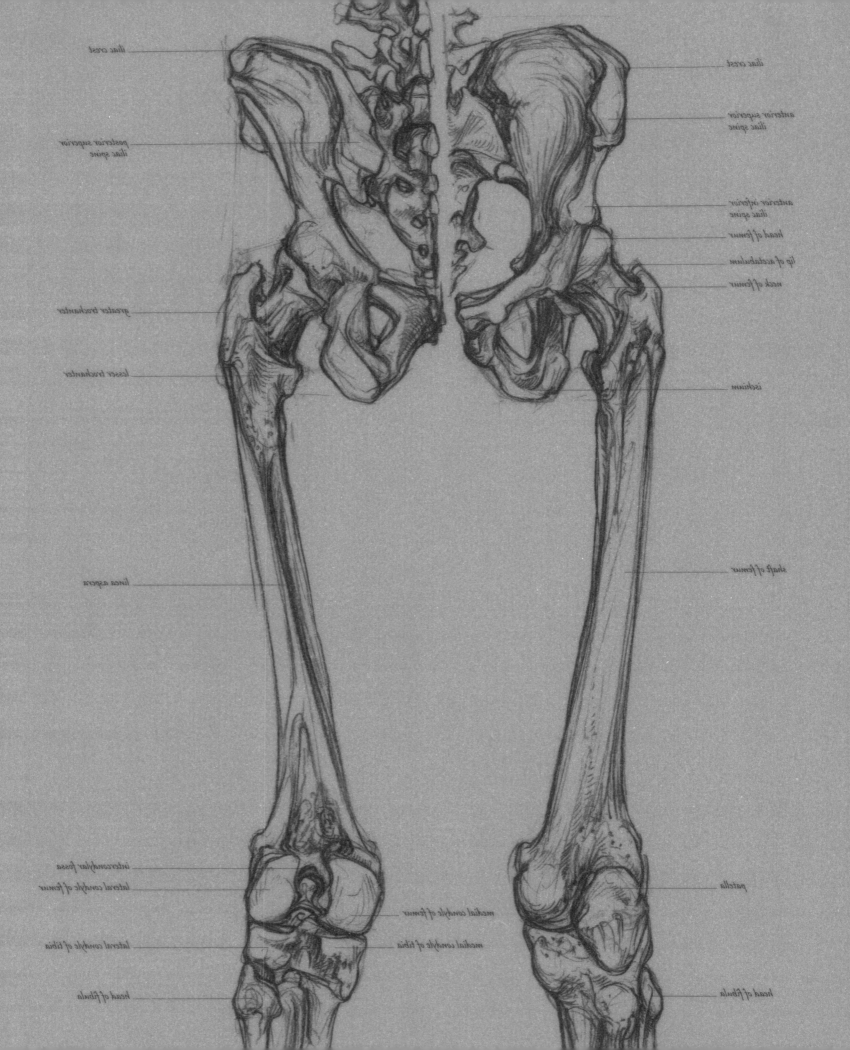

iliac crest

posterior superior
iliac spine

greater trochanter

lesser trochanter

linea aspera

intercondylar fossa

lateral condyle of femur

lateral condyle of tibia

head of fibula

iliac crest

anterior superior
iliac spine

anterior inferior
iliac spine

head of femur

lip of acetabulum

neck of femur

ischium

shaft of femur

patella

medial condyle of femur

medial condyle of tibia

head of fibula

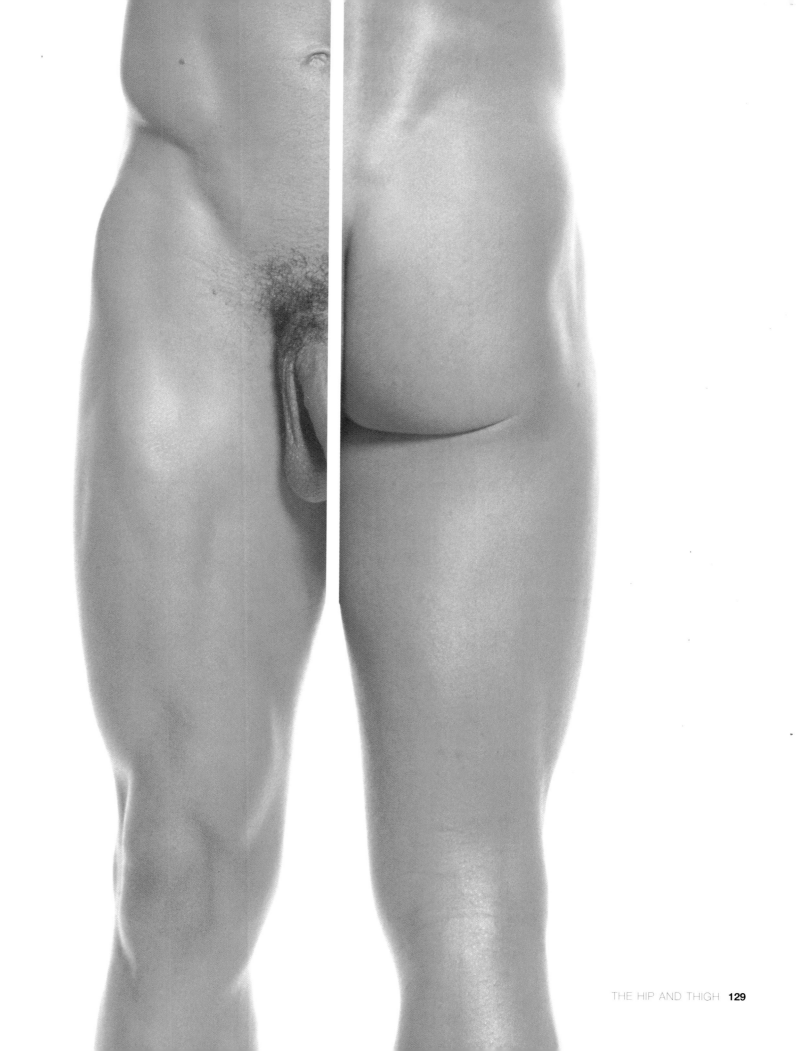

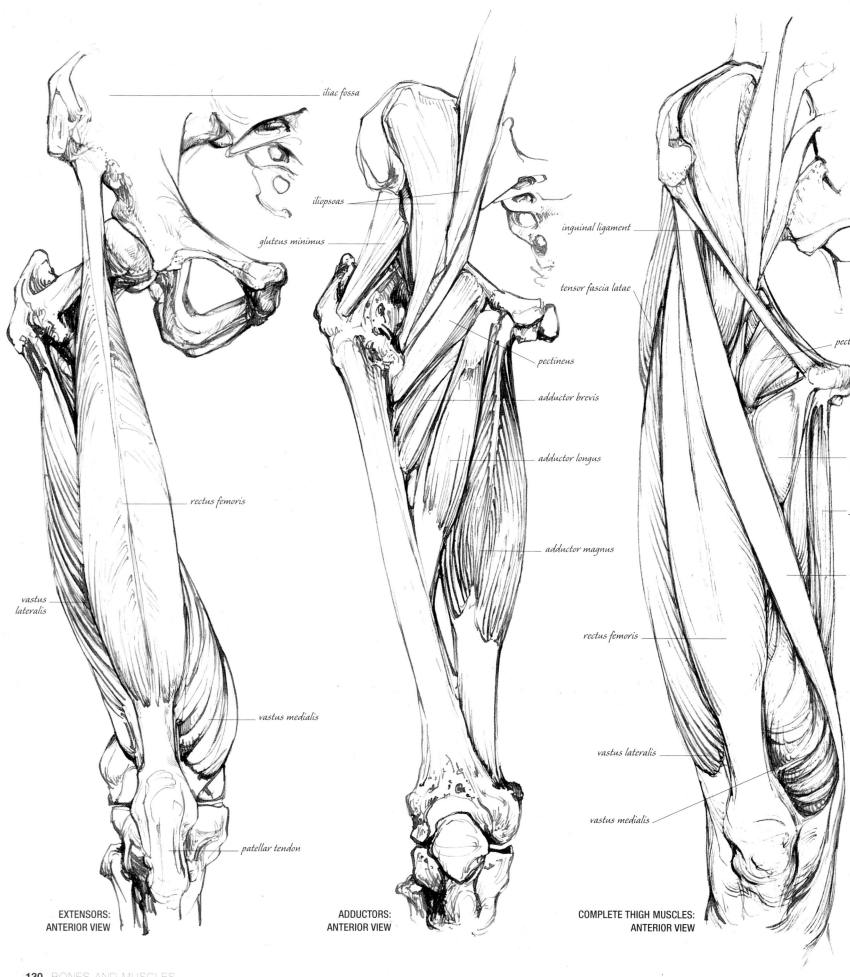

iliac fossa

iliopsoas

gluteus minimus

inguinal ligament

tensor fascia latae

pecti

pectineus

adductor brevis

rectus femoris

adductor longus

adductor magnus

vastus
lateralis

rectus femoris

vastus medialis

vastus lateralis

vastus medialis

patellar tendon

EXTENSORS:
ANTERIOR VIEW

ADDUCTORS:
ANTERIOR VIEW

COMPLETE THIGH MUSCLES:
ANTERIOR VIEW

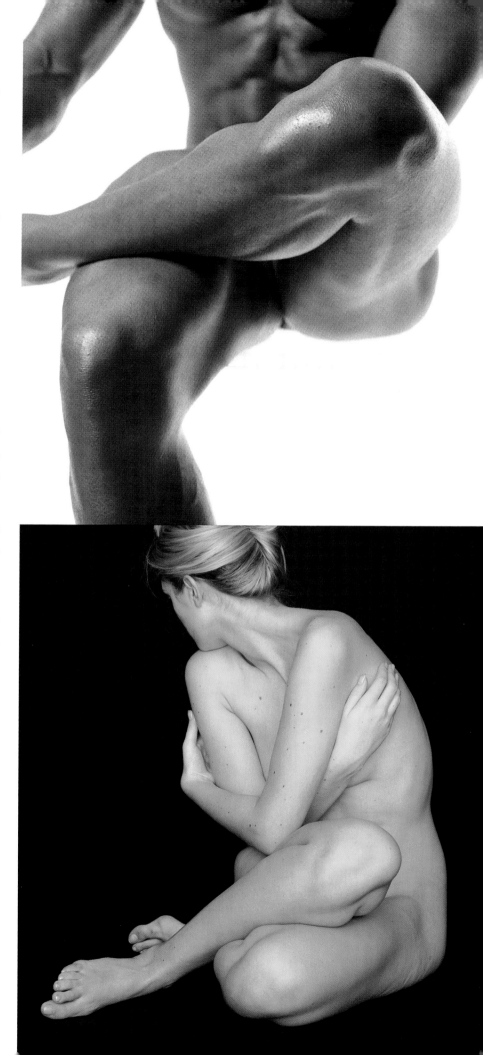

LEFT

Anterior views of the hip and thigh. Far left: powerful extensor muscles extend the knee and lift the leg at the hip. Center: adductor muscles along the inner thigh draw the femur toward or over the opposite limb. Near left: the flexor and adductor groups; superficially they are separated by sartorius. The iliopsoas (center left) comprises three muscles, arising from the lower six vertebrae and inside surface of the ilium (or iliac fossa). They insert largely onto the lesser trochanter of the femur (p. 129) to flex the thigh against the pelvis.

RIGHT

Surface definition of hip and thigh muscles is usually greater in men because their muscles tend to be larger and stronger. Women's thighs are shaped and softened by more body fat (p. 38). Surface fat often determines skin texture on buttocks and thighs, particularly among women. These photographs show the muscles of the thigh in foreshortened perspective. Above: note the division of the adductors from the quadriceps. Below: quadriceps above surface fat shape the outside of the thigh.

THE HIP AND THIGH
MUSCLES

The bones of the hip and thigh are surrounded by approximately 27 powerful muscles. Arranged in distinct groups or compartments, they are bound both individually and together by sleeves of fascia. The muscles of the thigh raise our whole body weight from a seated to standing position. They also maintain our stance and enable us to walk, jump, or run. (For an explanation of their movement, see the caption above and also the glossary of muscle actions (p. 244).)

Quadriceps femoris is the great extensor muscle of the knee. It also flexes the hip joint and gives shape to the anterior length of the thigh. It is composed of four distinct parts: vastus lateralis and vastus medialis, arising from each side of the linea aspera; vastus intermedius, arising from the anterior and lateral surfaces of the femur; and rectus femoris, arising from the anterior inferior iliac spine. These four parts unite in front into one tendon that encloses the patella, crosses the knee, and inserts onto the tibia at the top of the shin. (Note in the drawing far left how vastus intermedius is hidden from view.)

Adductor muscles spread like a fan down the inner thigh. Named pectineus, adductor brevis, adductor longus, and adductor magnus, they arise from different portions of the pubic and ischial bones. They insert in a line, from the lesser trochanter, down the length of the linea aspera, to the medial epicondyle above the knee (p. 134).

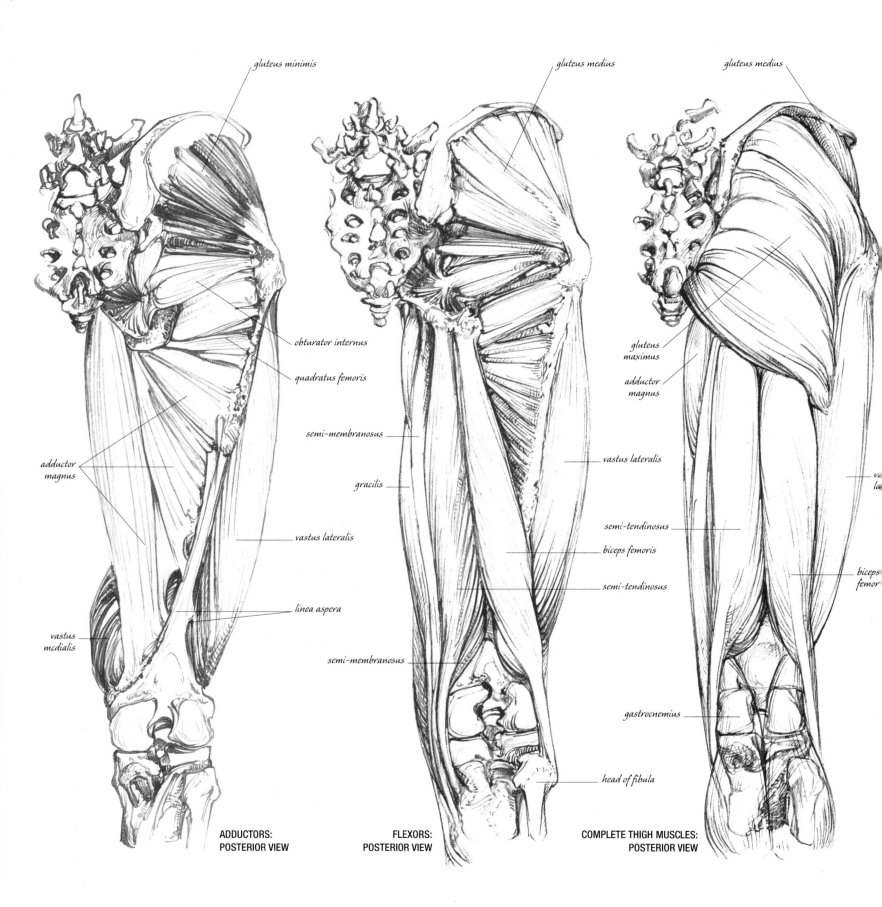

gluteus minimis

gluteus medius

gluteus medius

obturator internus

quadratus femoris

adductor
magnus

vastus
medialis

semi-membranosus

gracilis

vastus lateralis

linea aspera

gluteus
maximus

adductor
magnus

vastus lateralis

semi-tendinosus

biceps femoris

semi-tendinosus

v
la

semi-membranosus

biceps
femor

gastrocnemius

head of fibula

ADDUCTORS:
POSTERIOR VIEW

FLEXORS:
POSTERIOR VIEW

COMPLETE THIGH MUSCLES:
POSTERIOR VIEW

Far left: a deep dissection of the hip and thigh seen from behind. Adductor magnus and vastus lateralis insert into and define the linea aspera. Note its division above the knee. Center left: Overlying adductor magnus, three muscles shape the back of the thigh (biceps femoris, semi-tendinosus and semi-membranosus). Their tendons of insertion can be felt and seen passing either side of the back of the knee. Near left: the muscles of the back of the thigh and buttock. Gluteus maximus inserts deeply onto the upper part of the linea aspera between adductor magnus

and vastus lateralis. Superficially, fibres blend with the iliotibial tract and surface fascia of the thigh. Below, the two heads of gastro-cnemius (p. 155) emerge between the tendons of biceps and semi-tendinosus. The triangular space between is the popliteal fossa (p. 150). Above right: the flexion of quadriceps; its three superficial portions (vastus lateralis, rectus femoris, and vastus medialis) are clearly defined. Below right: comparing the right thigh to the drawing near left, note the divisions of biceps femoris, vastus lateralis, and gluteus maximus.

Sartorius (p. 130, from the Latin, *sartor*, tailor), the longest muscle of the body, is like a slender ribbon passing from the anterior superior iliac spine to the medial surface of the tibia. It divides the quadriceps from the adductors, bends the knee, adducts, and rotates the thigh (p. 134). Gracilis (p. 130), similarly long and thin, arises from the pubic bone, spans the length of the inner thigh, and inserts onto the upper medial surface of the tibia. It abducts the thigh, flexes the knee, and medially rotates the leg.

At the back of the thigh, semi-membranosus and semi-tendinosus arise from the ischial tuberosity to insert on the tibia. They extend the hip and flex and medially rotate the knee. The long head of biceps femoris, rising from the ischium, joins a short head (p. 150) from the lower linea aspera, and both insert on the head of the fibula to flex the knee and extend the hip.

Six short rotator muscles (including quadratus femoris and obturator internus) cross from the pelvis to the greater trochanter to rotate the hip laterally. Gluteus minimus and medius abduct and slightly rotate the hip. Gluteus maximus (the large coarse-fibered muscle of the buttock) extends and laterally rotates the hip, while tightening the iliotibial tract (p. 134). This is a long thickening of fascia (p. 36) braced in front by a small tensor muscle arising from the iliac crest. The iliotibial tract acts as a tendon tying gluteus maximus and tensor fascia latae (p. 134) to the lateral condyle of the tibia. This arrangement flattens the outside of the thigh and prevents the knee from collapsing when we stand.

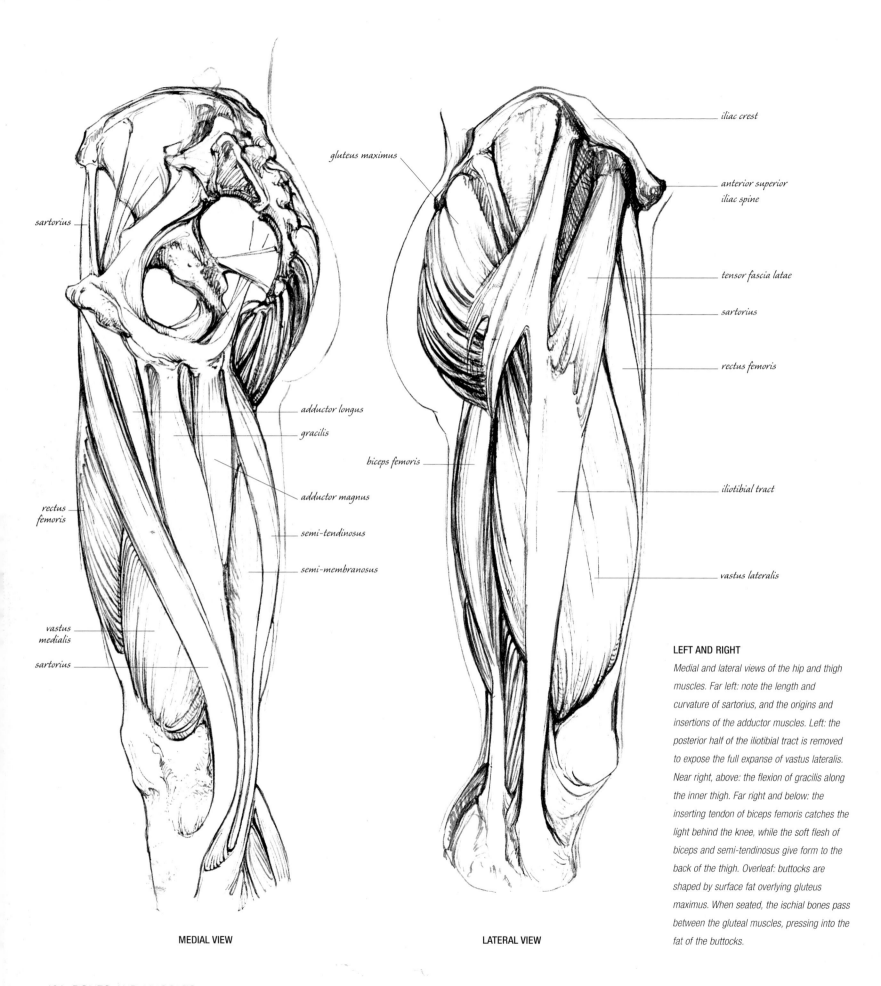

sartorius

gluteus maximus

iliac crest

anterior superior
iliac spine

tensor fascia latae

sartorius

rectus femoris

adductor longus

gracilis

biceps femoris

adductor magnus

iliotibial tract

semi-tendinosus

semi-membranosus

rectus
femoris

vastus lateralis

vastus
medialis

sartorius

LEFT AND RIGHT

Medial and lateral views of the hip and thigh
muscles. Far left: note the length and
curvature of sartorius, and the origins and
insertions of the adductor muscles. Left: the
posterior half of the iliotibial tract is removed
to expose the full expanse of vastus lateralis.
Near right, above: the flexion of gracilis along
the inner thigh. Far right and below: the
inserting tendon of biceps femoris catches the
light behind the knee, while the soft flesh of
biceps and semi-tendinosus give form to the
back of the thigh. Overleaf: buttocks are
shaped by surface fat overlying gluteus
maximus. When seated, the ischial bones pass
between the gluteal muscles, pressing into the
fat of the buttocks.

MEDIAL VIEW

LATERAL VIEW

MASTERCLASS
HOTEL ROOM EDWARD HOPPER

Edward Hopper (1882-1967) worked outside the fashionable schools of abstraction and pop art that so typified American art in the 20th century. Hopper's moving and often stark visions of American midwestern provincial life are icons of gritty and modest realism. Hotel Room tells a story in American colors similar to John Steinbeck's novels.

Somewhere in a sad American hotel bedroom, a woman looks at a letter that holds her for a moment between arrival and departure. At first glance, she appears to still be reading and her posture describes and carries the weight of her thought. But she has read the letter and is held by its meaning. The paper has been turned around and is now pondered in her outstretched hands. The heavy, resigned stillness of her limbs and shadowed head invite melancholic speculation about her emotions. The quiet power of this painting comes from its apparent simplicity and directness. It is a masterful work of understatement.

The room itself is almost an abstract composition; it is clear, perfectly ordered, and undisturbed – strangely empty of familiar detail, with nothing out of place. The luggage, furniture, curtains, and shadows make balanced blocks of neutralized color and tone. Light from the window is diffuse as if passing through a fine gauze; it appears solidified, and the woman's forlorn human bareness is striking against it. She is transient and alone, caught almost naked at a turning point in her life.

The tension and glow of this painting is familiar. Hopper was greatly influenced by Edgar Degas, extending the psychology and the interchange of place and personality into the modern world. The people of Hopper's interiors and landscapes became abstract like their surroundings, losing details to the power of light and color; they are exiles and introverts, alienated but central to the unfulfilled American dream.

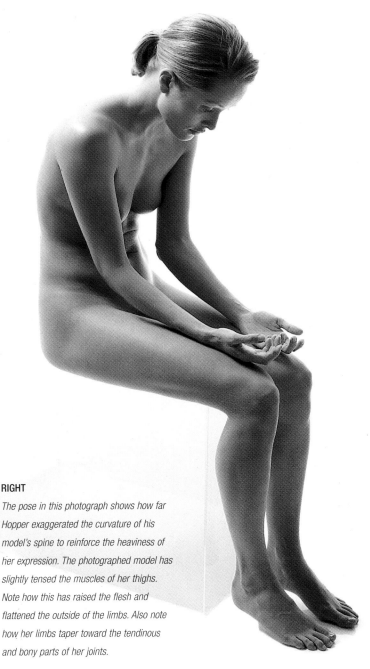

RIGHT

The pose in this photograph shows how far Hopper exaggerated the curvature of his model's spine to reinforce the heaviness of her expression. The photographed model has slightly tensed the muscles of her thighs. Note how this has raised the flesh and flattened the outside of the limbs. Also note how her limbs taper toward the tendinous and bony parts of her joints.

THE SHOULDERS

Hopper has exaggerated the expressive weight of the woman's body. In the upper torso, her shoulders are broad, rounded, and held forward, suspended by the trapezius muscle sweeping down from the back of her head. Her arms are thickened and taper only slightly from the shoulder to the elbow. They are rigid, heavy, and their verticality directs the viewer's eye onto the woman's lap.

THE TORSO

The weight of her upper body is balanced and held by the curve of her spine. This is especially exaggerated at the base of the thorax, at which point her torso folds into two parts, pulled across the waist by the tightness of her garment.

THE LEGS

The pillow concealing her hip and the bright light across her thigh create the illusion of an extended torso, intensifying our intrusion into her privacy by questioning the extent of her undress. The woman's legs and feet pull the weight of her thighs down into the mattress of the bed. The flesh of each thigh is flattened and wide, indicating that the muscles are all totally relaxed, emphasizing her stillness. The bony details of her knees and ankles are erased, smoothing the limbs and increasing their apparent weight.

1931, oil on canvas, 60 x 66in, Museo
Thyssen-Bornemisza, Madrid

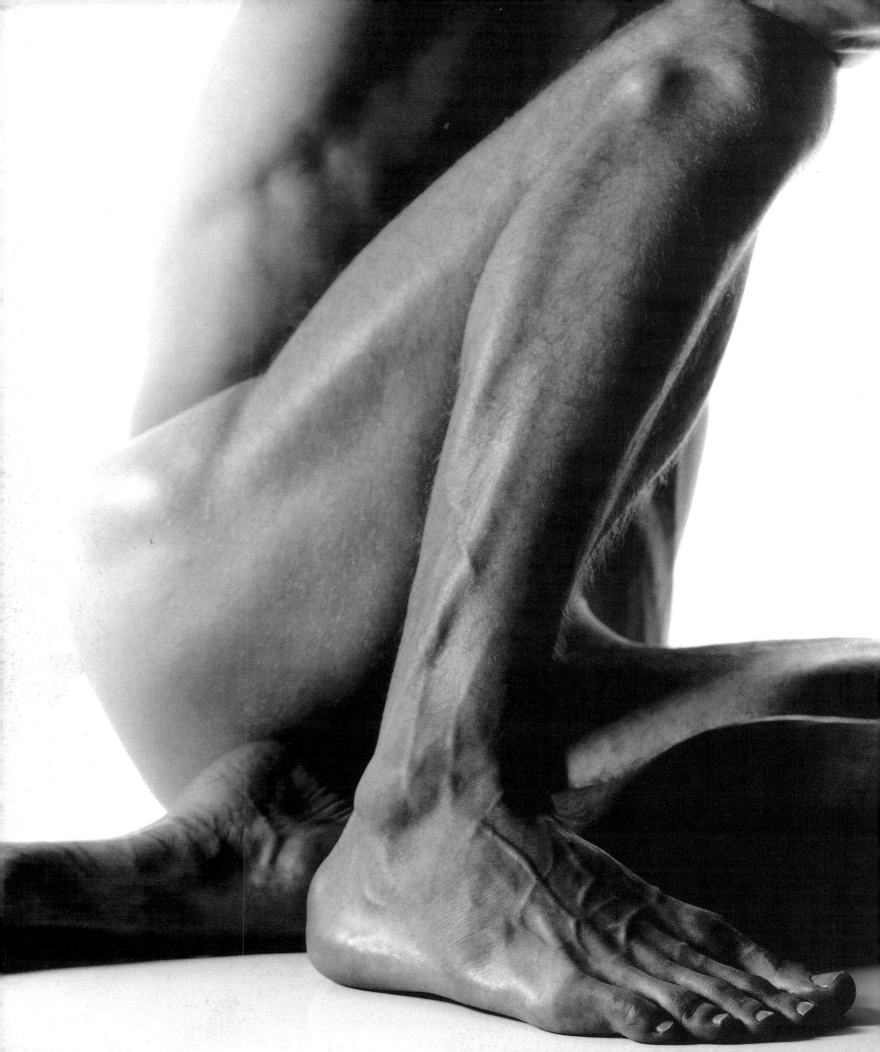

The foot is much more than an organ of locomotion. It is the focus of our balance. Its contact with the earth is recognized as of prime importance: among many ancient cultures, to lose contact with the earth was to suffer weakness, even sickness. For some, too, the foot becomes an instrument of special potency or skill. In the practice of martial arts such as karate or tae kwon do, for example, the calcaneal bone of the heel becomes an axe, and the edge of the foot from small toe to heel a sword, while ballet dancers train for years to redefine the balance of muscular strength in their legs and feet to stand *en pointe*.

THE LEG AND FOOT

Many sculptors have worked with cunning precision to ensure that a subject's feet stand naturally and resolutely on its plinth, recognizing that to ground a figure is to add credibility and significance. But, like the hand, the foot in art has also been modified and idealized in its depiction. Only 10 percent of humans have a longer second toe. Yet in the West, countless paintings and sculptures have since at least the Renaissance portrayed feet with greatly elongated second toes, presumably because it is considered more elegant. In the East the smaller the foot the greater the beauty. This found its most painful representation in Chinese foot binding, where the shape and dynamic of the growing foot were slowly crushed into conformity.

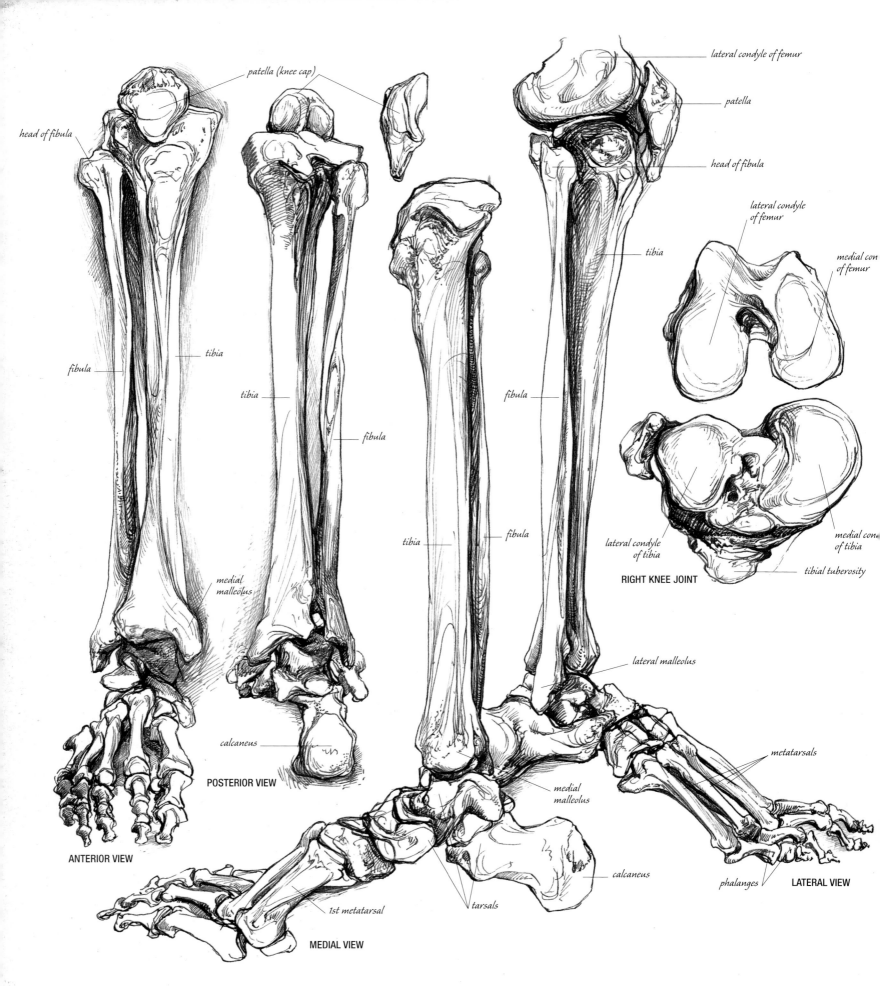

head of fibula

patella (knee cap)

lateral condyle of femur

patella

head of fibula

fibula

tibia

tibia

tibia

tibia

fibula

fibula

fibula

lateral condyle
of femur

medial con
of femur

tibia

lateral condyle
of tibia

medial con
of tibia

tibial tuberosity

RIGHT KNEE JOINT

medial
malleolus

lateral malleolus

calcaneus

metatarsals

medial
malleolus

POSTERIOR VIEW

calcaneus

phalanges

LATERAL VIEW

ANTERIOR VIEW

1st metatarsal

tarsals

MEDIAL VIEW

Far left to near left: anterior, posterior, medial, and lateral views of the leg and foot bones, and the articular surfaces of a right knee joint. A corresponding view of the patella (or kneecap bone) appears above each tibia (or shin bone). Right: note the pronounced patella at the uppermost point of each knee. This is often difficult to locate as it moves through different positions. Straighten and completely relax one of your legs, then take hold of the kneecap. Once you have located the bone, flex (or bend) your knee and follow its movement *beneath the skin. Two bony protrusions felt either side of the patella when the knee is flexed are the femoral condyles. Below and beside each knee the head of the fibula is clearly visible in this photograph. Its shaft is buried beneath muscle until it emerges at the lateral malleolus of the ankle. Both medial malleoli are also clearly shown. The bones of the feet are obscured here by tendons, fat, fascia (p. 36), and skin, but many can be located within your own feet if they are relaxed and palpated.*

THE LEG AND FOOT
BONES

The leg is the region of the lower limb below the knee. Its long bones are named the tibia and fibula. They transfer our body weight from the knee to the ankle and give attachment to the muscles that maneuver the leg and foot. The foot supports our weight when we stand. It acts as a lever to push the body forward and absorbs impact as we walk, run, or jump.

The tibia is the heavier of the two bones. It supports the weight of the body, and its sharp anterior surface is the familiar shin bone. Composed of a shaft and two articular ends, the top (or proximal end) of the bone is thick and expanded into two shallow-cupped platforms, the medial and lateral condyles. The shaft of the tibia is prismatic (or three sided) for much of its length. It gently narrows toward its center, thickening below to expand across its base to form the medial malleolus (or inner ankle bone).

The upper surface of each tibial condyle is glazed with hyaline cartilage (p. 32) and slightly cupped to receive the base of the femur (p. 128). The condyles are clearly separated behind, whereas in front they unite as one convex mass. Together they appear tapered like a triangular cornice. Their outer surface is gnarled and pitted by the attachment of many ligaments (p. 32) and tendons (p. 34) passing from above and below. The tibial tuberosity is a prominent and vertical ridge of bone that receives the insertion of the patellar (or kneecap) ligament in front. This is clearly seen below the knee when the leg is flexed and a useful landmark for the artist.

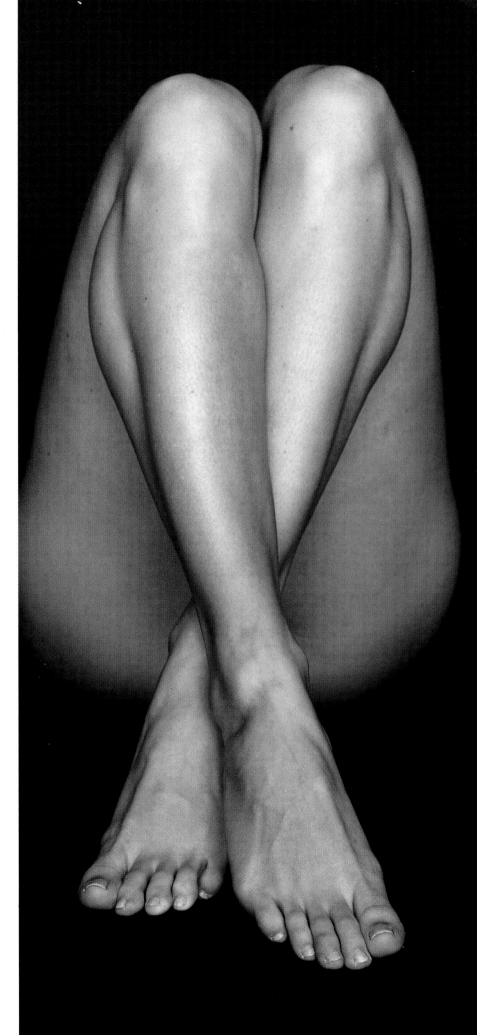

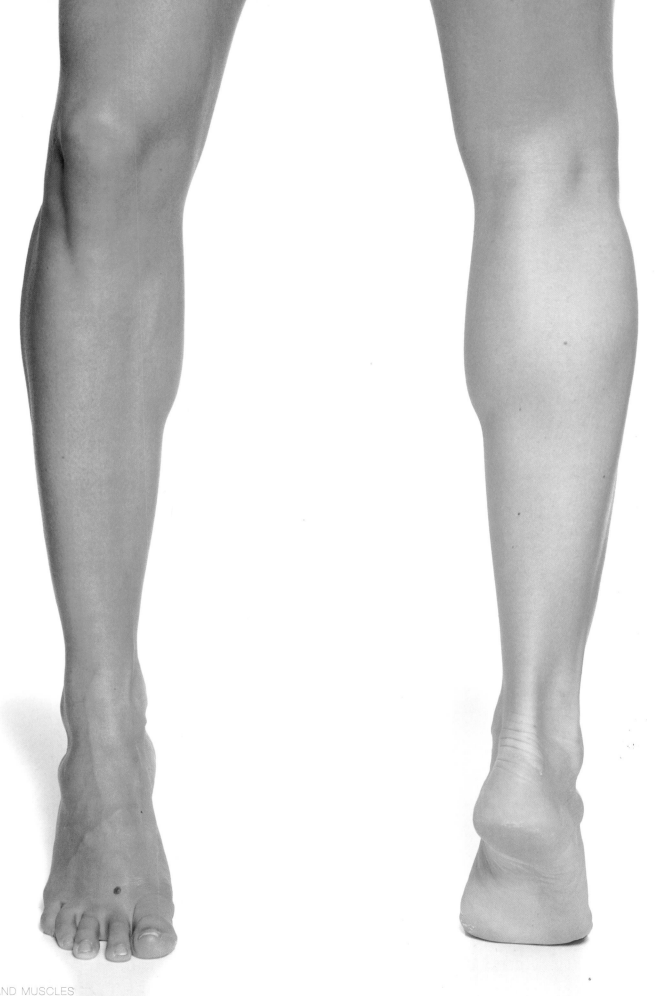

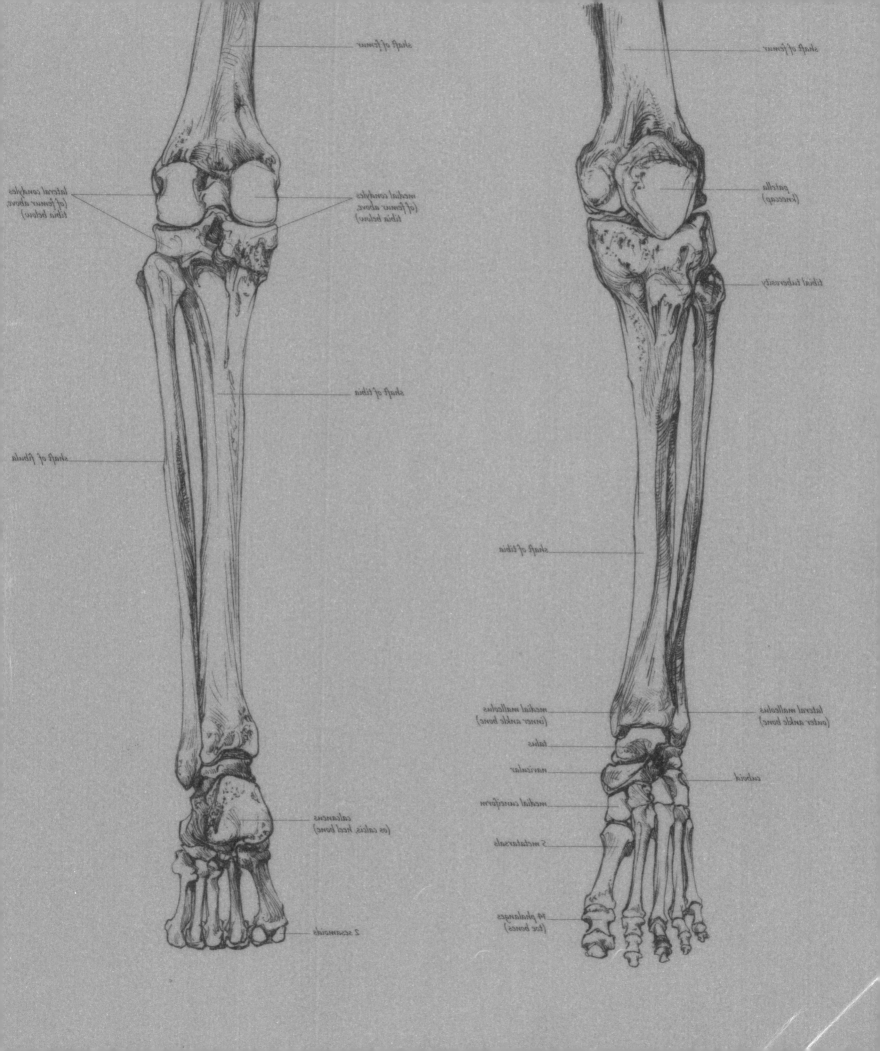

LEFT

These anterior and posterior views of the right leg (raised onto the ball of the foot) and its bone structure give an opportunity to observe the relationship between the condyles of the femur and tibia as they meet at the knee. It is possible to locate the shape of the patella (in the front view) and the head of the fibula to the side. Follow the fibula down to the foot, and note its angle and attachment to the tibia. Both bones cover the talus (p. 147) to form the ankle. Behind the right foot, at the base of the first metatarsal, are two sesamoids.

RIGHT

This photograph demonstrates the angle between the leg (below the knee) and thigh. Draw a straight line along the femur through the knee to reveal how far the leg is offset to the lateral side. Consider also the action of rectus femoris, clearly visible above the knee. It is part of the quadriceps femoris muscle, attaching to the patellar tendon (p. 130), which inserts onto the tibia. Vastus medialis (p. 130), another part of quadriceps, prevents the patella from being dislocated to the lateral side.

The fibula (p. 142) is a very delicate and slender bone, sharp edged, and splintlike. It lies lateral and parallel to the tibia, situated slightly below and behind. It is composed of a shaft and two articular ends both firmly fixed to the tibia. At the ankle joint, the fibula extends below the tibia, turning outward and down to produce the lateral malleolus (or outer ankle bone).

Throughout their length, the two bones of the leg are united by an interosseous membrane (as found between the radius and ulna). This fine translucent sheet of connective tissue divides the anterior and posterior compartments of the leg and provides an area of attachment for muscles.

The patella (p. 142) is situated above and in front of the tibia. It is the largest sesamoid of the skeleton. Sesamoids (named after sesame seeds) are very small, rounded independent bones. An inconstant number occur inside certain tendons of the hands and feet. The patella of the knee is enclosed within the tendon of quadriceps femoris (p. 131). Its purpose is to ease the passage of the tendon over the corner of the knee. The front of the patella is separated from the skin of the knee by a small bursa, which is a protective sac containing synovial fluid. Bursae occur throughout the body, within joints, between muscles and tendons, and beneath certain points on the skin. They help to reduce friction between moving parts.

The knee is the largest, most complicated and vulnerable joint of the body. Injuries to knees are common in sport because of the sudden and

excessive stresses that are put upon their component parts. The condyles of the femur are hinged to those of the tibia, so that the leg can bend and straighten, backward and forward, through one plane. The joint can also very slightly rotate to either side. It is made stable by several elements.

Two plates of fibrous cartilage, named the lateral meniscus and medial meniscus, fit directly over the upper surface of the tibia. The menisci are like shallow dishes that face upward to cup and cushion the end of the femur. The bones are then bound and held firmly together by an arrangement of strong ligaments (p. 32) situated within and around a capsule. The joint capsule is a sleevelike extension of the periosteum (p. 32), arising from each bone to cover and enclose the whole joint. It is lined by a synovial membrane that excretes and fills the knee's cavities with a fine lubricative and nourishing fluid. The components of the knee are also cushioned by as many as thirteen bursae (four anterior, four lateral, and five medial). Two very strong cruciate ligaments originate from the intercondylar surface of the tibia (p. 142). These twist past each other as they rise to insert between the femoral condyles.

The cruciate ligaments maintain the forward–backward stability of the knee, preventing the femur from slipping forward off the tibia, when the leg is flexed, and backward off the tibia, when the leg is extended. Additional protection is given by the tendons of the thigh and leg muscles as they pass either side of the joint.

The ankle joint is formed by the medial and lateral malleoli (the palpable ankle bones described above), together with the base of the tibia (p. 144). These three points fit perfectly over the upper articular surface of the talus (see below) of the foot. The ankle is strengthened and supported by a fibrous capsule full of synovial fluid, numerous short and powerful ligaments and the passage of surrounding tendons. The bones of the foot are arranged in two arches, supported by ligaments, tendons, fascia (p. 38), and layers of muscle. One arch spans from the heel to the toes, the other across the bridge of the foot (p. 142) at the base of the metatarsal bones. These arches distribute the body's weight and provide shock absorption. They are held rigid as they leave the ground and are flexible when the foot lands. When

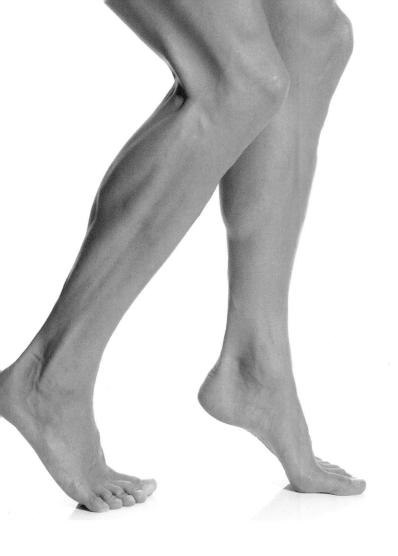

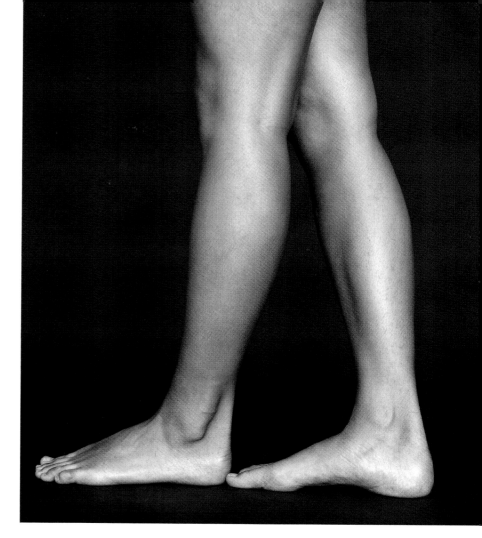

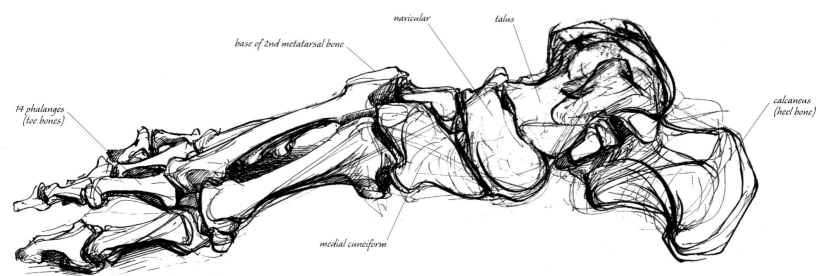

navicular

talus

base of 2nd metatarsal bone

calcaneus
(heel bone)

14 phalanges
(toe bones)

medial cuneiform

TOP AND ABOVE

The photographs show slender, almost parallel, longitudinal cords rising beneath the skin above the toes of each model's feet. There are also taut lines along the lateral side

of the male model's leg (center right). Often mistaken for bones, these are, in fact, all tendons (pp. 150 and 151). The long bones of the feet (or metatarsals and phalanges, p. 149)

are disguised by extensor tendons. They are, therefore, hardly visible, except perhaps at the joints. The drawing shows how the angle between the tarsal (p. 148) and metatarsal

bones marks a change of plane along the bridge of the foot. The base of the second metatarsal is its highest point, as seen in two of the photographs (far left and center right).

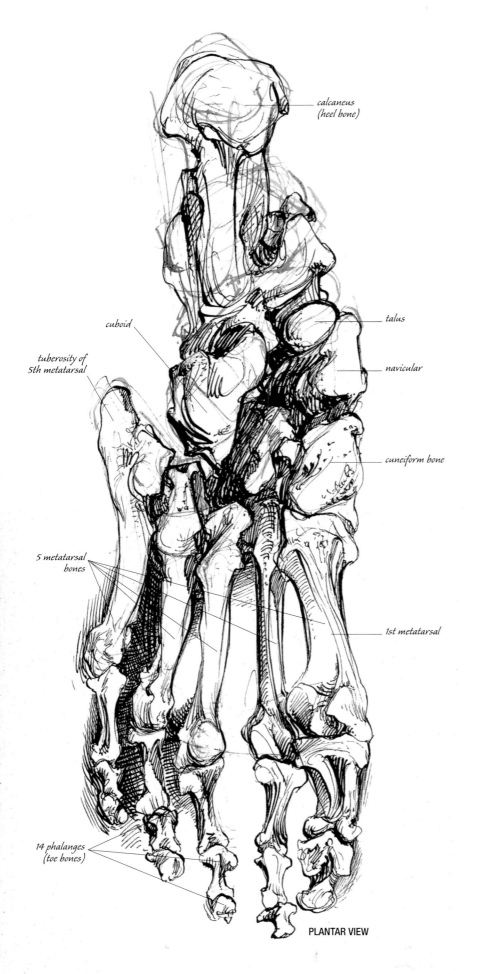

calcaneus
(heel bone)

cuboid

talus

tuberosity of
5th metatarsal

navicular

cuneiform bone

5 metatarsal
bones

1st metatarsal

14 phalanges
(toe bones)

PLANTAR VIEW

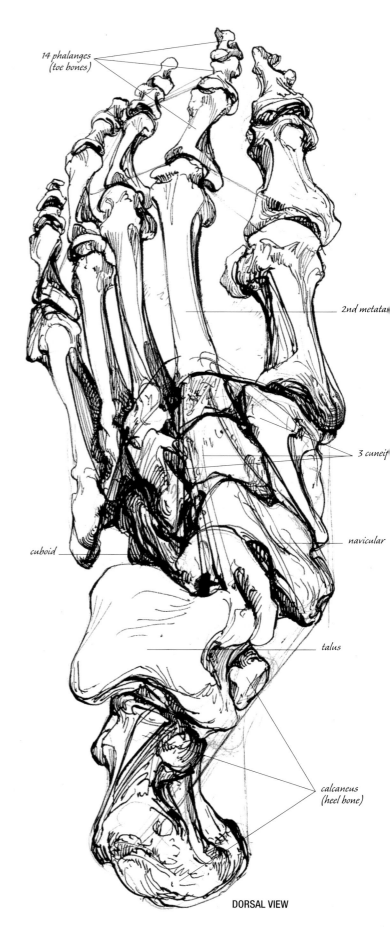

14 phalanges
(toe bones)

2nd metata

3 cunei

navicular

cuboid

talus

calcaneus
(heel bone)

DORSAL VIEW

These drawings of the bones of the foot, seen from below (far left) and above (near left), describe the relationships, proportions, and angles among the calcaneus of the heel, the talus, navicular, cuboid, and three cuneiforms of the tarsus, the five metatarsals, and the fourteen phalanges of the toes. Note that the first metatarsal, leading to the great toe, is shorter and thicker than the lateral four, and also that the phalanges of the great toe are larger than those of any other toe.

The bones of the feet are deeply covered beneath by ligaments, tendons, muscles, fascia, thickened aponeuroses (p. 34), fat and strong skin. Above: light cast across the outside of the uppermost foot catches a slight bump in the skin halfway from the heel to the little toe. This is the tuberosity of the fifth metatarsal. It can be felt, and sometimes seen, on the outside of the foot. Below: note how tendons disguise the metatarsal bones.

compared to the bones of the hand, those of the foot appear very similar. But they are modified to exchange dexterity for stability and strength.

Seven tarsal bones — named the talus, calcaneus, cuboid, navicular, and three cuneiforms — shape the ankle and heel. The talus is the uppermost tarsal bone. Its smooth, curved mass articulates with the tibia and fibula above, and transmits weight from the leg to the heel. The heel bone, named the calcaneus (or os calcis), is the largest bone of the foot. Its long, thickened body passes backward beneath talus, angled down and toward the outside of the foot. The calcaneus strikes the ground when we walk, providing a strong lever for raising the foot off the ground. The navicular, cuboid, and three cuneiforms are tied by ligaments into one solid mass, shaping the bridge of the foot in front of the ankle. Further forward are five slender, tapering metatarsal bones. These articulate with the toes. The fourteen bones of the toes (phalanges digitorum pedis) correspond in arrangement to the fingers: three phalanges in each toe, except the great toe, which (like the thumb) has only two.

When standing still, our body weight rests between the calcaneus and the heads of the metatarsals. As we step forward, calcaneus touches the ground first. Weight passes smoothly down the outside of the foot, and, at the heads of the metatarsals, rolls across to the base of the great toe, which then propels the body forward. This pattern of movement is usually etched onto the soles of our shoes. It is also clearly apparent in a footprint.

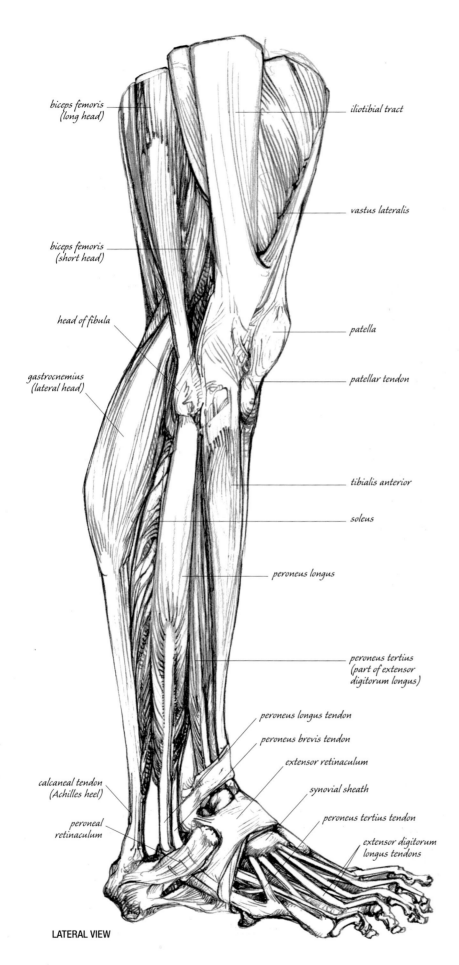

biceps femoris
(long head)

iliotibial tract

vastus lateralis

biceps femoris
(short head)

head of fibula

patella

patellar tendon

gastrocnemius
(lateral head)

tibialis anterior

soleus

peroneus longus

peroneus tertius
(part of extensor
digitorum longus)

peroneus longus tendon

peroneus brevis tendon

extensor retinaculum

calcaneal tendon
(Achilles heel)

synovial sheath

peroneus tertius tendon

peroneal
retinaculum

extensor digitorum
longus tendons

LATERAL VIEW

LEFT AND RIGHT

From left to right: lateral, anterior, and two posterior views of the muscles of the right leg. The posterior views show the intermediate (far right) and superficial (center right) layers of calf muscle. Arranged from the knee to the toes, the muscles of the leg occur in two compartments, one anterior and one posterior, bound into layers and groups by sleeves of deep fascia (p. 38). The compartments are separated by the tibia, fibula, and a connecting interosseous membrane. Gastrocnemius (centre right), the most superficial muscle of the calf, arises from the medial and lateral femoral condyles (p. 144) and emerges between the descending tendons of the thigh – biceps femoris (shown left) and semi-membranosus (p. 153). The diamond-shaped hollow at the back of the knee created by the borders of these muscles is named the popliteal fossa (p. 35). It is filled with soft fat (or adipose tissue, p. 38), which makes a distinct and rounded bulge beneath the skin.

THE LEG AND FOOT MUSCLES

The bones of the leg and foot are clothed by more than 30 muscles. These are bound into layers, groups, and compartments to give mass, form, and refined movement to the toes, sole, ankle, calf, and shin. They assist in maintaining our balance and give strength, grace, and poise to our movement through space.

Muscles of the leg are arranged in two compartments, one situated in front, to the outside of the shin, and the other behind, giving shape to the calf. These are largely separated by the tibia, fibula, and a connecting interosseous membrane. Together they are responsible for the dorsiflexion (drawing back), plantarflexion (pointing down or curling under), inversion (turning inward), and eversion (turning outward) of the whole foot. Layers of short muscles arranged within the foot itself (largely beneath) serve to flex, extend, abduct, and adduct the toes. For a description of muscle action, see page 244. The bones and tendons of the foot are more distinct on its upper surface, where they are near to, and covered by, very thin skin. Beneath the foot, within its sole, bones are covered by thicker muscles, fatty connective tissue, and greatly thickened, harder skin.

Tibialis anterior is the strongest dorsiflexor of the foot. Its gently tapered mass shapes the front of the leg to the outside of the shin. The muscle arises from the lateral condyle, the upper lateral shaft of the tibia, and the interosseous membrane. As it descends, it narrows into a long tendon that

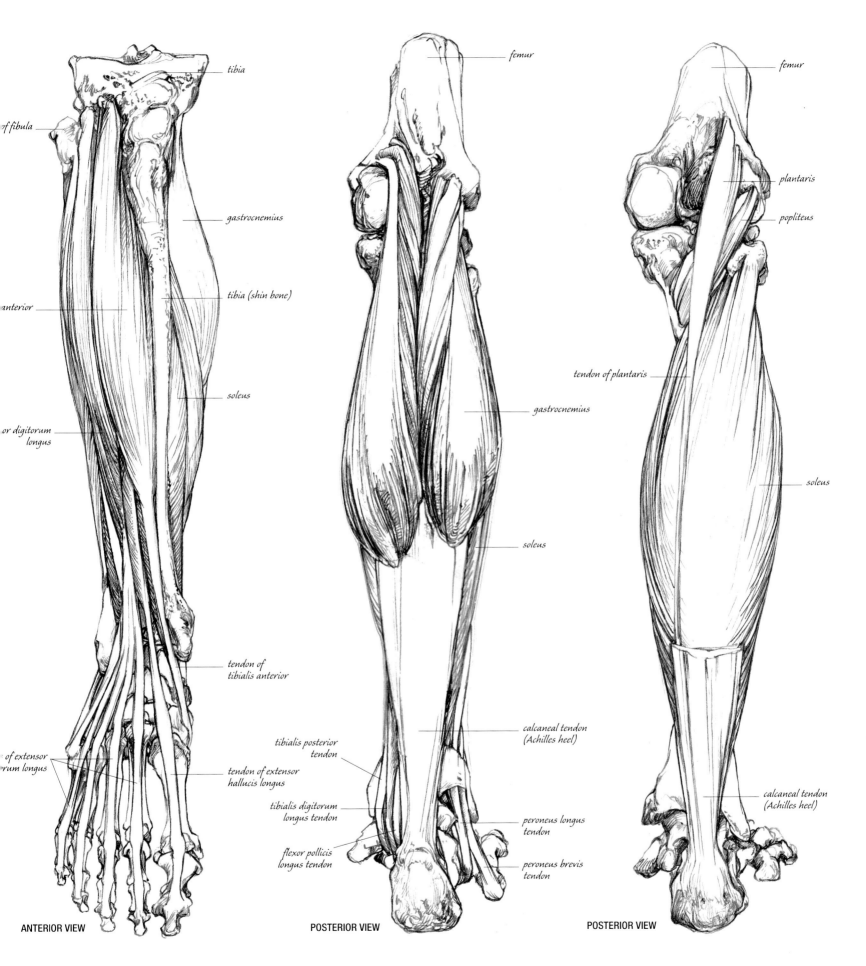

tibia

of fibula

gastrocnemius

anterior

tibia (shin bone)

soleus

or digitorum
longus

tendon of
tibialis anterior

of extensor
rum longus

tendon of extensor
hallucis longus

ANTERIOR VIEW

femur

gastrocnemius

soleus

calcaneal tendon
(Achilles heel)

tibialis posterior
tendon

tibialis digitorum
longus tendon

flexor pollicis
longus tendon

peroneus longus
tendon

peroneus brevis
tendon

POSTERIOR VIEW

femur

plantaris

popliteus

tendon of plantaris

soleus

calcaneal tendon
(Achilles heel)

POSTERIOR VIEW

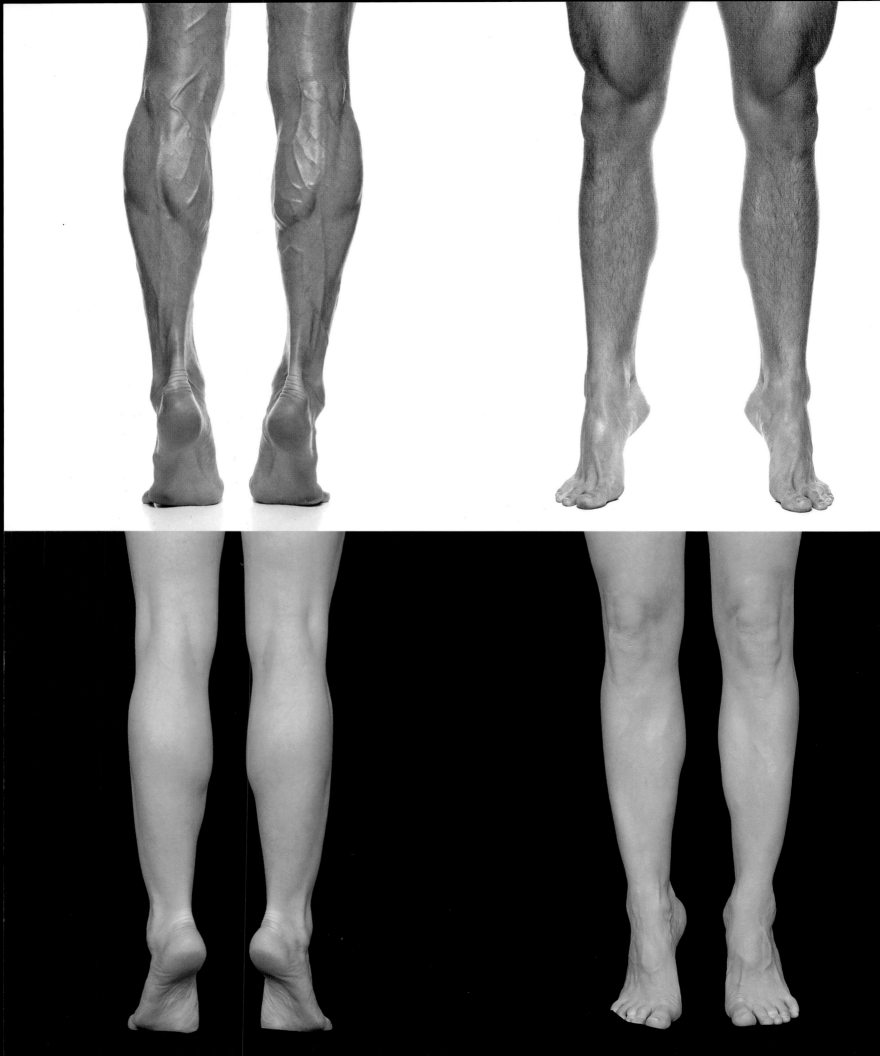

LEFT

A comparison of these photographs and the drawings on page 151 reveals how muscle and tendon shape the leg and foot beneath skin, fat, and blood vessels. Note here (bottom left) how soft fat fills the popliteal fossa, and a line of light above each lateral malleolus (outer ankle bone) distinguishes peroneus longus to the side from gastrocnemius and soleus behind (p. 151). Beneath the surface veins carrying blood to the heart, note (top left) the heads of gastrocnemius and the thickened aponeurosis leading to the Achilles heel.

RIGHT

This medial view shows the insertion of many thigh muscles above and beside the knee, indicating how they frame the joint and form continuous lines with the bone of the shin. Tendons passing across the ankle are protected by synovial sheaths (p. 150) and bound by retinacula – the thickened bands of deep fascia that hold them to the joint, as in the tendons of the wrist.

passes over and under the instep of the foot, inserting onto the first cuneiform and first metatarsal bones. When pulled tight, the muscle pulls back (dorsiflexes) and also inverts the foot (or turns it inward).

Extensor hallucis longus arises beneath tibialis, from the mid shaft of the fibula and the interosseus membrane. Its long tendon emerges along the front of the ankle, passes down the bridge of the foot, and inserts into the base of the distal phalanx of the great toe (p. 151). Its function is to extend the great toe.

The flesh of extensor digitorum longus (p. 150) presses against the lateral border of tibialis, helping to shape the front of the leg. It arises from the lateral condyle of the tibia and the anterior surface of the interosseous membrane. Its long tendon passes down the shin and divides into four parts. These insert into the second and third (middle and distal) phalanges of the lateral four toes (pp. 150 and 156). Extensor digitorum longus draws the four toes back against the foot. All of the tendons of extensor digitorum longus, extensor hallucis longus, and tibialis anterior are very prominent beneath the skin of the foot. Their movement is especially clear if the foot is strongly pulled toward the shin, and then moved from side to side.

Peroneus longus arises from the upper part of the fibula, while peroneus brevis and peroneus tertius arise from below and beneath (p. 150). The peroneal muscles shape the outside of the leg. The tendons of longus and

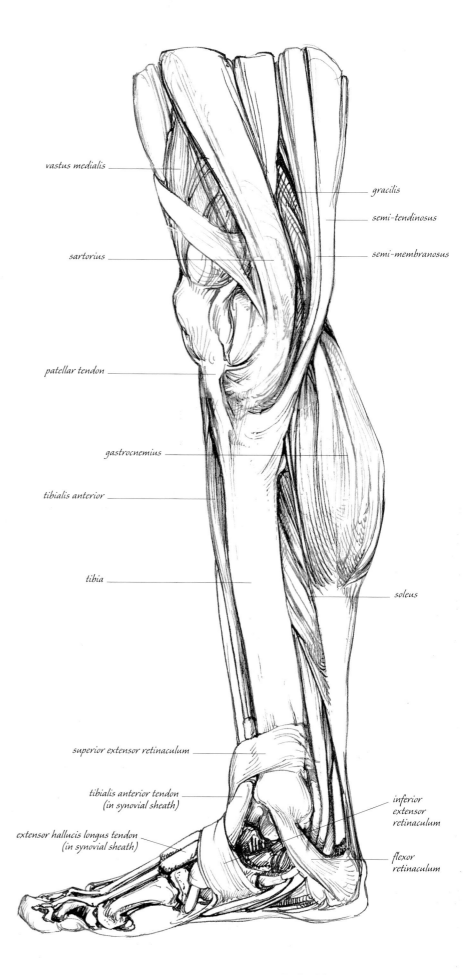

vastus medialis

gracilis

semi-tendinosus

sartorius

semi-membranosus

patellar tendon

gastrocnemius

tibialis anterior

tibia

soleus

superior extensor retinaculum

tibialis anterior tendon
(in synovial sheath)

inferior
extensor
retinaculum

extensor hallucis longus tendon
(in synovial sheath)

flexor
retinaculum

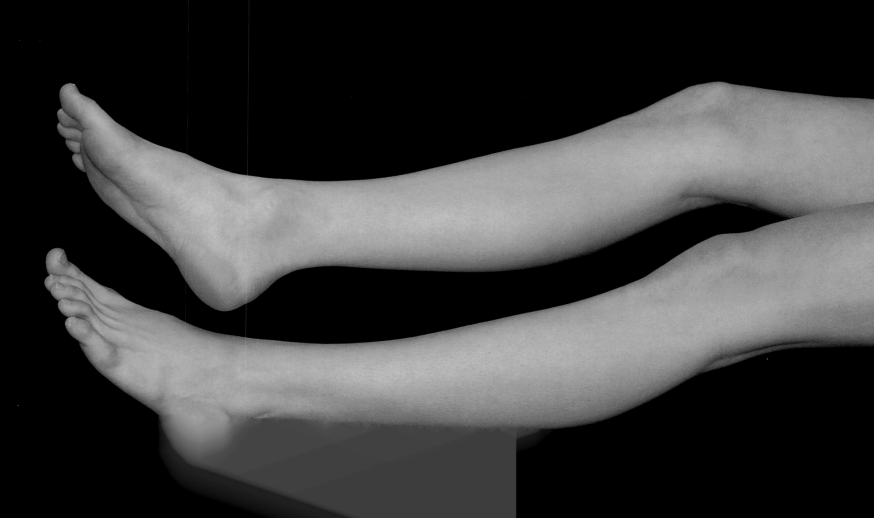

Above: the tendon of peroneus longus (p. 153) is clearly visible in the lower leg, passing behind the lateral malleolus. In the upper foot and using the drawings to the right, locate abductor hallucis (bottom right), shaping the instep from the calcaneus to the base of the great toe. Extensor hallucis longus (bottom right) is shown pulling the great toe back against the foot. Below: the plantar aponeurosis (p. 157), covering flexor digitorum brevis (p. 156), can be seen beneath the upper foot, at its center.

Above: observe the extent to which the plantar aponeurosis is continuous with the deep fascia of the foot. Below: retinacula (caption, p. 153) bind flexor and extensor tendons to the tarsal and metatarsal bones. The Achilles tendon is shown inserting onto the posterior superior surface of the calcaneus. The tendon's distance from the ankle joint gives greater leverage to plantarflex the foot (or point it downward). The space in front of the Achilles tendon is filled with fat.

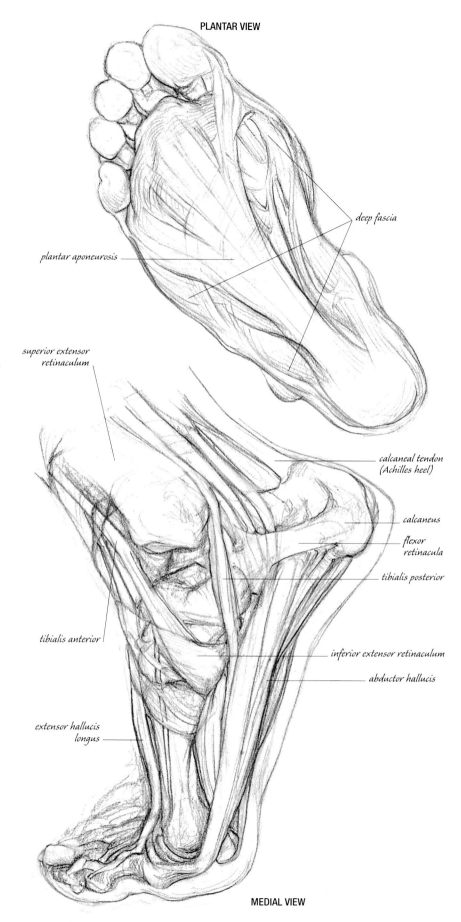

deep fascia

plantar aponeurosis

superior extensor retinaculum

calcaneal tendon (Achilles heel)

calcaneus

flexor retinacula

tibialis posterior

tibialis anterior

inferior extensor retinaculum

abductor hallucis

extensor hallucis longus

MEDIAL VIEW

brevis pass behind the lateral malleolus, that of tertius passes in front of the malleolus (p. 150). Brevis and tertius insert into the base and shaft of the fifth metatarsal (pp. 150 and 151). Longus mirrors the insertion of tibialis anterior, curling under and passing across the sole of the foot, through a groove in the cuboid bone, to insert into the medial cuneiform and first metatarsal. Together, the peroneals draw back, point down, curl under, and point the whole foot out. Acting with tibialis, they create a stirrup to raise the foot.

The calf of the leg is composed of six muscles, arranged into three distinct layers. The deepest muscle, tibialis posterior, arises from behind the tibia, fibula, and interosseous membrane. Its tendon passes behind the medial malleolus of the ankle (p. 142), beneath the instep, and into almost every bone of the sole. Tibialis posterior pulls the whole foot so that it points downward. Flexors digitorum longus and hallucis longus cover tibialis posterior. Arising from the bones of the tibia and fibula, respectively, their tendons also pass behind the medial malleolus and across the instep. Digitorum divides into four parts, one traveling to each of the four lateral toes (p. 156). Hallucis remains as a single tendon, reaching the last phalanx of the great toe (p. 156). Together, these muscles plantarflex all of the toes.

The three superficial muscles of the calf are named soleus, plantaris, and gastrocnemius (p. 151). These muscles point the ankle joint strongly downward. Soleus arises from the tibia and fibula, plantaris from the lateral epicondyle of the femur, and gastrocnemius via two heads from the medial

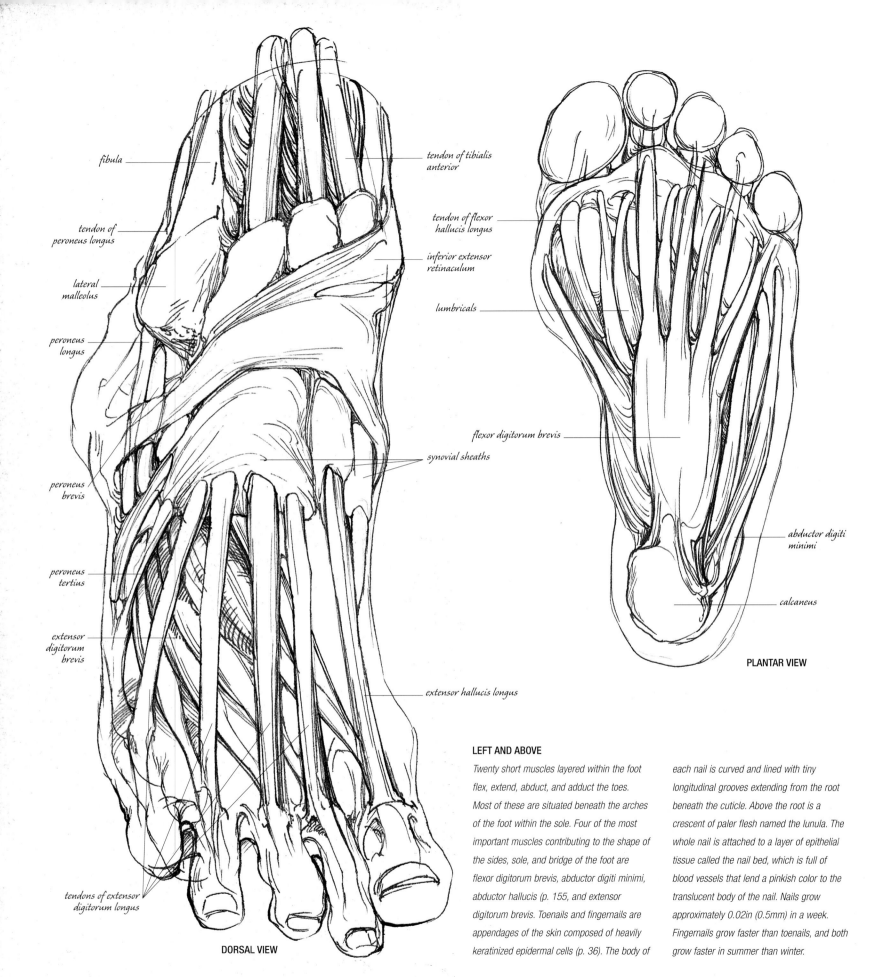

fibula

tendon of tibialis anterior

tendon of peroneus longus

tendon of flexor hallucis longus

lateral malleolus

inferior extensor retinaculum

peroneus longus

lumbricals

peroneus brevis

synovial sheaths

flexor digitorum brevis

peroneus tertius

abductor digiti minimi

extensor digitorum brevis

calcaneus

PLANTAR VIEW

extensor hallucis longus

tendons of extensor digitorum longus

DORSAL VIEW

LEFT AND ABOVE

Twenty short muscles layered within the foot flex, extend, abduct, and adduct the toes. Most of these are situated beneath the arches of the foot within the sole. Four of the most important muscles contributing to the shape of the sides, sole, and bridge of the foot are flexor digitorum brevis, abductor digiti minimi, abductor hallucis (p. 155, and extensor digitorum brevis. Toenails and fingernails are appendages of the skin composed of heavily keratinized epidermal cells (p. 36). The body of each nail is curved and lined with tiny longitudinal grooves extending from the root beneath the cuticle. Above the root is a crescent of paler flesh named the lunula. The whole nail is attached to a layer of epithelial tissue called the nail bed, which is full of blood vessels that lend a pinkish color to the translucent body of the nail. Nails grow approximately 0.02in (0.5mm) in a week. Fingernails grow faster than toenails, and both grow faster in summer than winter.

Rising along the back of each thigh, biceps femoris and semi-tendinosus are clearly defined as they insert each side of the knee onto the head of the fibula and upper medial surface of the tibia. The two heads of gastrocnemius, arising from the medial and lateral condyles of the femur, pass between the tendons of biceps femoris and

semi-tendinosus. They converge to shape the back of the calf and then (in this position, above) gastrocnemius inserts onto the calcaneus via the Achilles tendon. Note how the diamond-shaped hollow of the polipteal fossa at the back of the knee is so filled with fat that it presents a softly raised, elogated shape.

and lateral condyles of the femur (p. 144). Note that plantaris, like palmaris (p. 118), is slender, weak, and often missing from one or both legs.

All three muscles share one common tendon of insertion – the calcaneal tendon, better known as the Achilles tendon, which is a short, thick, tapered cord, seen clearly at the back of the foot as it inserts onto the upper and posterior surface of the calcaneus (pp. 151 and 155). Achilles, first among the Greek warriors at the seige of Troy, was the central character of Homer's epic poem *The Iliad*. His mother Thetis (a sea goddess) had foreseen his destiny and tried to protect her infant son by plunging him into the river Styx (the principal river of the underworld, separating the realms of the living and the dead). The waters rendered Achilles invulnerable except at the heel by which he was held. Achilles was later slain by Paris (guided by Apollo), who shot him in the heel.

The intrinsic muscles of the foot are twenty in number and, like those of the hand, are predominantly arranged beneath the foot, on its plantar surface (or sole). Layered and grouped according to their action on the toes, collectively they spread them, draw them together, pull them backward, or curl them under. The sole is covered by a plantar aponeurosis (p. 155), continuous with the deep fascia (p. 38) of the foot. This, like the palmar aponeurosis of the hand (p. 121), protects deeper layers, gives attachment to muscles, and above all ties the skin of the foot firmly in place so that it does not slip as we stand up.

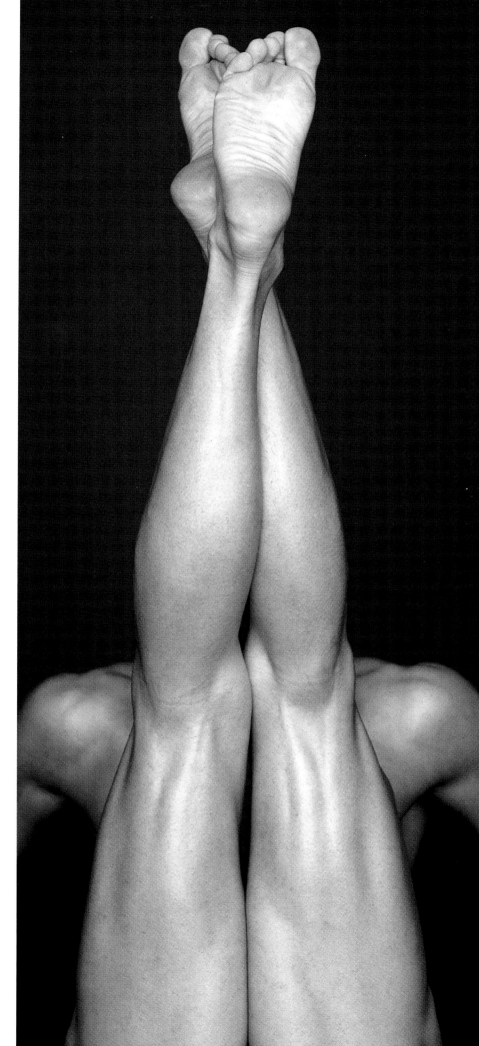

MASTERCLASS
CHRIST IN HIS TOMB HANS HOLBEIN

Hans Holbein the Younger (1498-1543), court painter to Henry VIII, made this astonishing image of Christ when he was 23 years old. The flush of life that so fills his later portraits is truly extinguished here.

Holbein was always a master of subtle anatomical detail; the cast of his subject's expression, their complexion and their posture all give his portraits a vivid intensity of life. This early painting of Christ entombed is like a negative of his later work, and yet its contrast is achieved with the same intensity and skill.

This is the uncompromising image of a corpse and not an idealized vision of death (compare David's Marat). We see the cadaverous shell of the Messiah without a trace of glory, his last gasp is still frozen on his face.

The body is stiffened, emaciated, and close to decomposition. Flesh is pulled down under the pressure of gravity, with paper-thin skin clinging to every sinew. His eyes are open, still raised to God, and yet blind to the rock face now in front of them. Christ is imprisoned, locked beneath a seemingly immovable tombstone, abandoned to claustrophobic darkness. This tomb is opened toward us. We are brought by our curiosity to peer through its absent wall. Christ's hair, fingers, and toes fall into our space, and as we gaze into the painting, we are buried alive with him. Our redemption or escape seems utterly hopeless.

Through the stark horror of this vision, Holbein leads us to speculate on the wonder of what is about to happen. The resurrection of Christ is made even more miraculous, and its immanence is told by the light shining from behind us.

THE RIBCAGE

Beneath the shallow pectoral muscle and indentation of the nipple, the bones of the rib cage clearly impress the skin of the chest. The cartilage of the thoracic arch marks the highest point of the body, from which the skin of the abdomen drapes across to the navel.

1521, print from oil-on-wood painting, 12 x 79in, Öffentliche Kunstsammlung, Basle

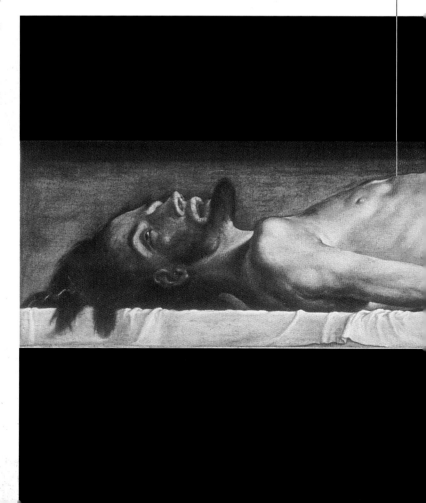

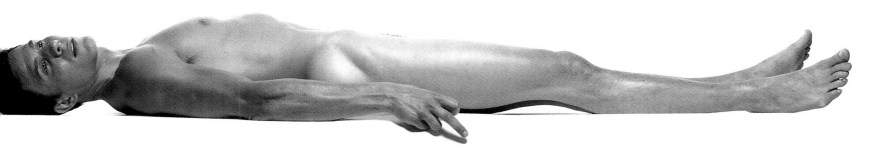

THE PELVIS AND THIGH

The iliac crest of the pelvis draws a small high arc above the loin cloth. This meets latissimus dorsi and external oblique above, and below it encloses the gluteal muscles of the hip. The flesh of the thigh is flattened to the side and drawn downward by gravity.

THE LEGS

The skin of the legs is creased along its length as if dehydrated. The eye is drawn along the furrowed skin of the thigh, past the knee to behind the calf. Two creases lead to the ankle, one in line with the great toe, and the other meeting the lateral malleolus of the fibula.

THE FEET

The feet of this figure give the impression that they have been painted from a cadaver (corpse). Skin is shrunk tight against the bones and tendons. The feet are dark, and the toes are pulled back as if the muscles of the calf and shin have dried and receded.

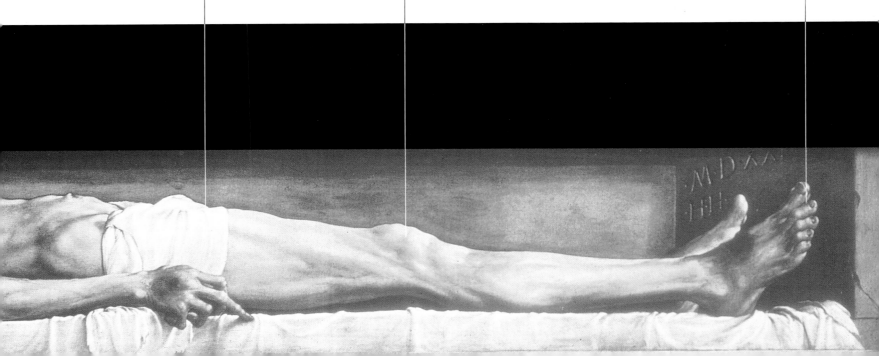

THE BODY

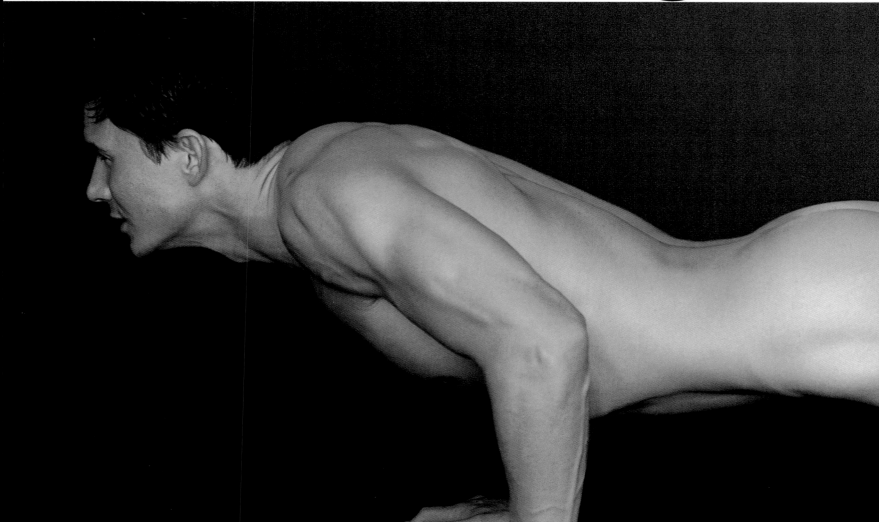

& BALANCE

This section examines the human body's relationship with space. As the balance and position of a pose are carefully observed, we build and accumulate knowledge of stance and the tension of presence. In the particular situation of the life-drawing class, the artist has the advantage of setting a pose and then drawing and learning directly from the model's statuesque stillness. In the following pages we will examine the role of the artist's model, the complexity of positions the body can maintain, and how these shift and distort the body's alignment, center of gravity, and perspective in space.

POSES

Artists began to draw from the posed nude during the Renaissance. At this time, many artists pursued notions of ideal human proportion. Some, like Brunelleschi, measured antique statuary in order to discover the principles underlying the classical ideal and devised canons to hold the human body in perfect philosophic symmetry, mapping its physical shape in unison with the world of ideas. Today, with advances in scientific research and knowledge of the workings of the brain and its nervous system, artists can understand how the human body recognizes its own position in space; how it perceives, manipulates, and steers itself in a three-dimensional world that is controlled by gravity. When we stand and balance on one foot, for example, myriad calculations are made by the brain and performed by the body. Any seemingly simple act that moves us through space, or holds us positioned within it, is a miraculous communication and response by nerves, muscles, and bones.

In this photograph (and those on pages 165–167), models have been posed and lit to display the entire atlas of the human body. This is the tensile structure of living bone and cartilage and its key landmarks on the surface of the body; the mass, tension, relative proportions, and actions of muscle groups; the details of tendons, aponeuroses and intermuscular septa, as they flatten, push up into, or pull down the surface of the skin. The photographs also reveal the tension and folds of the skin, the growth patterns of hair, and the prominence of surface veins. The standing poses show the entire height of the body pushed upward and balanced above the hands or balls of the feet. These photographs can be used to make your own drawn overlays. First locate the skeleton, using prominent bony landmarks such as the spine, sternum, clavicles, spines of the scapulae, iliac crests, and heads of the femurs, together with knee, ankle, elbow, and wrist joints. Then differentiate the most prominent muscle groups, tendons, and aponeuroses, estimating the thickness of fat and skin. Mark the origin and insertion of each muscle, not just its central mass.

POSES THE BODY IN SPACE

When the body is completely at rest, even very deeply asleep, its muscular tissue remains in a state of constant, though almost imperceptible, tension. This is known as tonic contraction, or muscle tone. Tone is a basic and steady degree of muscle activity perfectly balanced so that no actual movement is apparent. When tone is lost at death, all muscles lengthen very slightly. When awake and standing or sitting still, minimal muscle contractions just above the level of tone hold our posture and stance against the downward pull of gravity. This tension is maintained so long as we are conscious. If we fall asleep or faint, the body will collapse.

In the exertion of force, voluntary muscles shorten by 30 to 40 percent of their length. They also thicken, become hard, and press out against the skin, changing shape and position as they pull against their tendons. To achieve movement, muscles work together in large teams. First they press together the surfaces of a joint. Next they move the bones into position. Then, while some muscles hold the bones firmly in place, others act across the joint. Muscles are stimulated and controlled by motor neurons distributed throughout their length. These determine the speed, strength, and duration of each action. Overstimulation or strain exhausts a muscle entirely, so that it needs rest and renutrition to restore its power. Skeletal muscles are guided and governed by our will, which is informed by immediate sensory information and our previous experience.

Balance is a complicated and delicate sense, maintained by the collaboration of our sensory and motor systems. As we stand upright, pressure receptors on the soles of our feet tell the brain whether we are vertical or leaning to the side. These sensors are activated by our shifting weight and the movement of muscles within the feet. At the same time, if we are inside, our eyes assess the perpendicular and horizontal elements of the room, measuring our relationship to the floor, walls, and ceiling. You will tend to lean to one side if you stand for a few moments with your eyes closed. The proprioceptive sense is the brain's knowledge of where the body is located when the eyes are closed, which enables us to maneuver our limbs with accuracy when they are out of sight.

Somatic sense receptors located in every muscle and joint perpetually measure our movement. As the brain calculates the detail of the body's activity, it is able to locate each of its parts in space. Deep within the inner ear, minute instruments measure movement of the head in relation to the Earth's gravitational field, including acceleration and deceleration of the body. Fluid-filled chambers and semicircular canals are arranged together in different planes within the ear. These contain tiny hairs growing out of sensory cells. As the head moves, the hairs are pulled back and forth within the fluid. Each hair's sensory cell encodes this movement and sends it as a message to the brain. As the brain assesses information from the eyes, ears, muscles, joints, and skin, it instructs groups of muscles to relax or contract, shifting our weight to retain the body's stance.

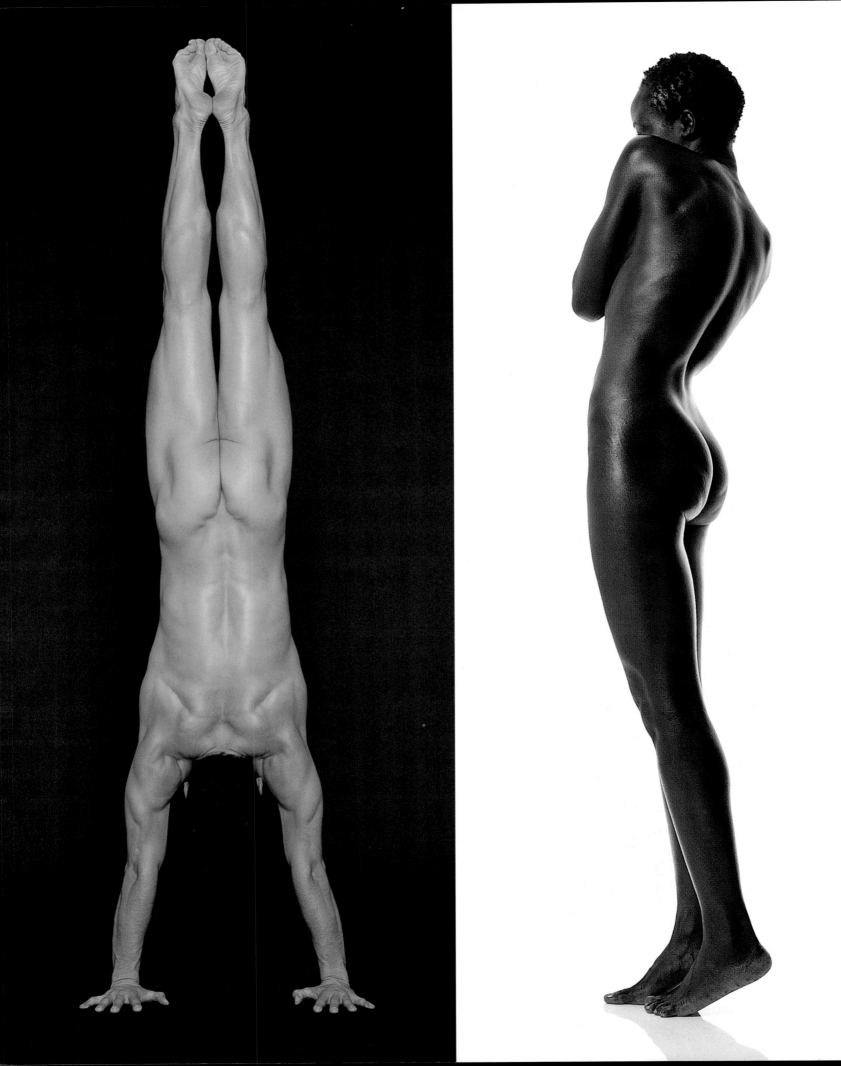

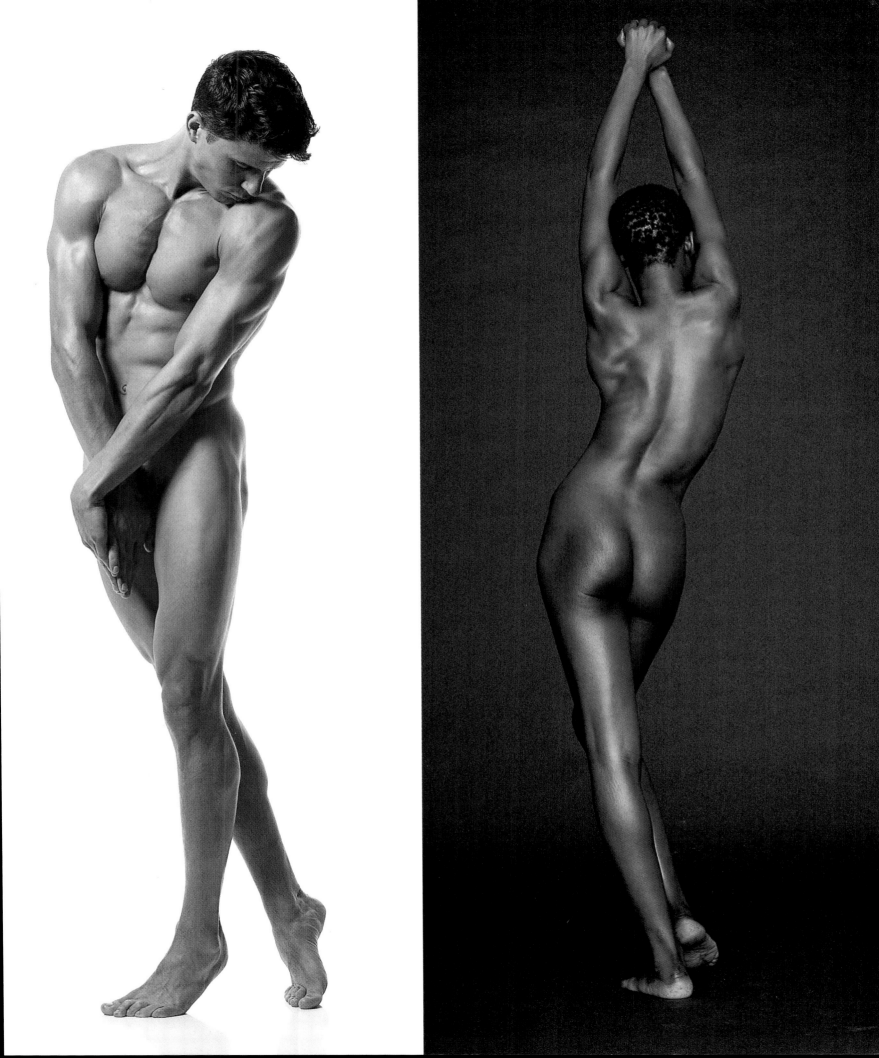

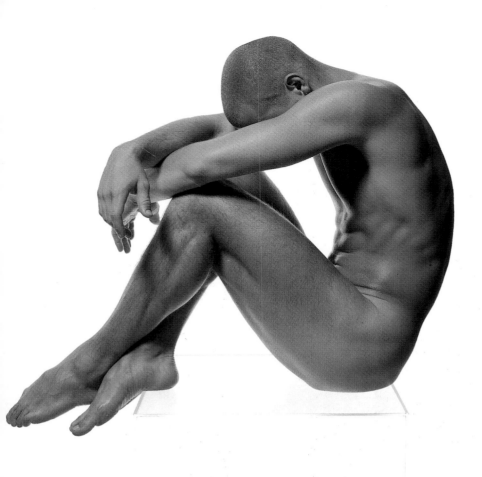

POSES THE MODEL ON PAPER

To remove a model from the three-dimensional world and place him or her accurately in the two-dimensional space of your paper requires concentration, clarity, and risk. The model will not seem to stand or lie convincingly on the paper at first, but with practice and as your drawing ability improves, you will learn to invent an imagined space inside the paper for the figure to inhabit.

In a life class, where the poses may be set for you, take plenty of time to look, think, and see each pose and the space around it before beginning to draw. If, for example, a 20-minute pose has been set, spend at least two or three minutes just looking, before you mark the paper.

Watch the model settle, see how he or she supports the body in the pose, and draw a vertical line in your mind's eye through the model's center of balance to see how the weight is counterlevered to either side. Perhaps, if both you and the model are standing, discreetly mirror the pose, and feel through your own body how the model has distributed his or her weight — which limbs are tense, which are relaxed, and how the spine is twisted.

Now observe the sources of light in the room, and consider how they will affect your view of the model and the composition. Which will you choose to emphasize and which will you omit? Decide what you want to draw.

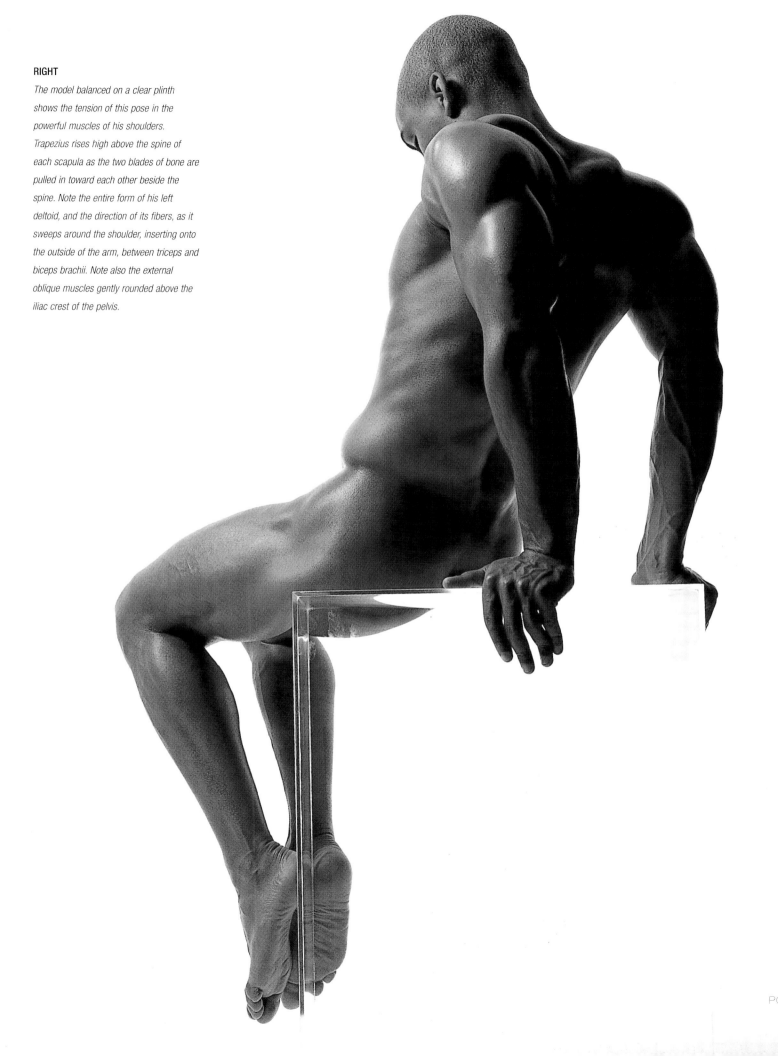

The model balanced on a clear plinth shows the tension of this pose in the powerful muscles of his shoulders. Trapezius rises high above the spine of each scapula as the two blades of bone are pulled in toward each other beside the spine. Note the entire form of his left deltoid, and the direction of its fibers, as it sweeps around the shoulder, inserting onto the outside of the arm, between triceps and biceps brachii. Note also the external oblique muscles gently rounded above the iliac crest of the pelvis.

LEFT

The poses to the left are relaxed in their stance, as each model adjusts her stance with the tilt of her pelvis and spine. As you study the photographs, envisage the gentle twists and curves of each woman's spine and locate her center of gravity.

RIGHT

When this photograph was being taken, the model slowly lifted his entire weight toward his hands. The studio lighting defines every superficial muscle of his left arm and shoulder, including biceps and triceps brachii, brachialis, trapezius, deltoid, teres minor and major, and latissimus dorsi sweeping up from the lower back to insert onto the arm. Tension in the shoulders reveals the exact position of the scapula, which is drawn around to the lateral side of the rib cage with its vertebral border facing down toward the center of the buttocks. Erector spinae muscles present two rigid columns in the small of the back, one on either side of the spine. The adductor and flexor muscles of the thighs are also defined as they raise the legs and feet behind.

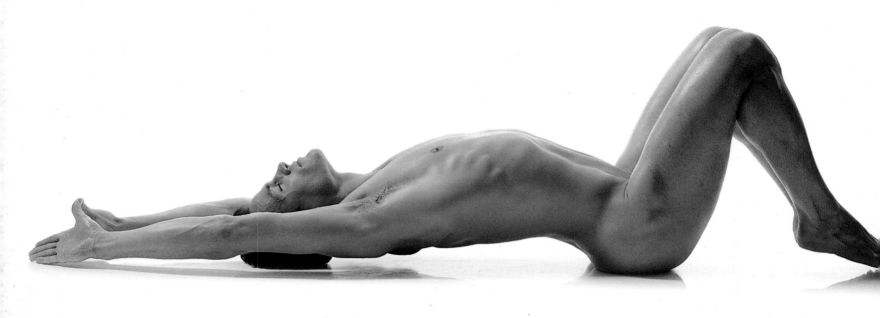

Ask yourself what is most exiting about the pose: is it the whole figure, a single detail, or perhaps the model's relationship within the room? Will this be one study among a whole page of studies, or just an isolated one? If a single study, where will you place it on the page?

Observe the stance of the model: is he or she frozen mid-movement, alert, focused, caught as if about to dart forward, or relaxed, languid, and sleeping? Choose a medium that will be sympathetic to the model's expression, and then emulate his or her demeanor with your body as you draw. In other words, express the emotion of the pose through the movement of your own arm and hand while drawing. Tense, sharp, vigorous movements of line will rarely convey the sense that someone is sleeping, and it is hard to render the strength or grace of movement with docile, uncertain smudgings.

Light is fundamental to the expression and depth of every drawing. If setting your own subject, never begin to draw without first arranging the light. If using

sunlight, consider its direct or indirect contact with the model. Gauze or mirrors can be used to soften or redirect the intensity of the lighting. If using electric lamps, observe how they highlight or cast deep shadows across the form, changing apparent depths of flesh, the prominence of bone, and affecting the entire mood of the pose. Use light to make structures clear, emphasize the essence of a composition, and subdue its peripheral detail.

If, however, you find yourself in a life class where there are many sources of light that cast complicated and unhelpful dappled shadows, do not draw all of these confusing patches of light. Many beginners do this, as if duty bound to account for everything they see; as a result, the figures in their drawings look as if they have been spattered with tiny bruises.

The eye must learn to see mass before detail and the tension of bone and muscle before the texture of the skin. An experienced artist will begin to draw a torso by rapidly placing a sense of the whole form, its mass, solidity,

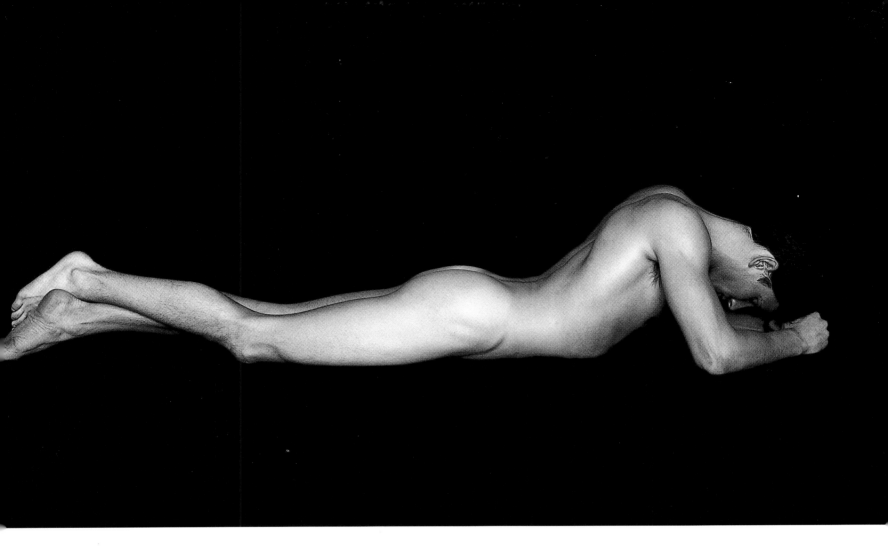

expressive tension, and angle in space. Beginners will draw a slow careful outline, then shade the nipples and shadows beneath the breasts. Experienced artists will either lightly mark out the mass and position of the entire figure or hold it in their mind's eye before developing its form. Beginners will often merely choose an arbitrary point to start, such as the top of the model's head, and then progress from there down either side of the body as if tracing a map. Proportion is quickly lost, and the feet are often cropped off the page.

The length of time given for a set pose must always be carefully considered before you begin to draw. If the pose is long, the model is likely to grow tired, slowly settle downward, or slightly move position. Rather than resist this inevitable change, and blame the model for faults in the drawing, anticipate the movement and keep your lines open enough to accommodate the change. In the finished drawing, this accommodation might be imperceptible, or key to its expression.

LEFT, ABOVE, AND OVERLEAF

In the model's pose (left), five digitations of serratus anterior describe a perfect arc across the side of the chest. The rib cage is clearly defined, as are the rectus abdominis and external oblique muscles. In the pose above, the model's rib cage is suspended beneath the shoulder girdle, and the full length of the spine can be traced from the occiput to the sacrum. Using these photographs, and the ones on pages 174–177, make a drawing of each model, not as they are presented and as you see them from the side, but as if viewing them from above. The information provided by each pose should be enough to enable you to reinvent each figure in your imagination.

Rather than focus on the outline, instead look at each model's volume, proportion, tension, and curvature or height in space. Once an impression of the whole body is in place, you can begin to hone the form. Characteristic details should be drawn last, and only if they enhance the image. Select the most essential elements of each pose. Do not describe every detail just because it is there to be described. This exercise may seem strange and difficult at first, but it is an invaluable aid to learning how to transpose a form from one view to another in one's mind's eye. It also forces the eye to see beneath the skin to locate and rationalize interior structure.

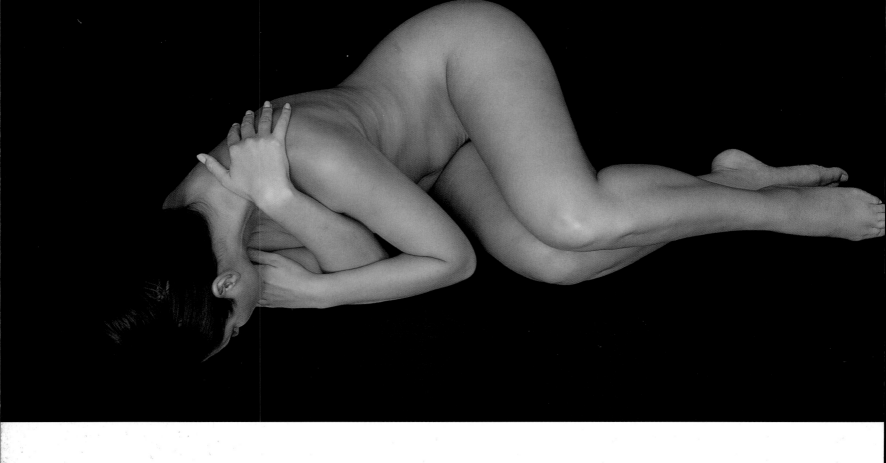

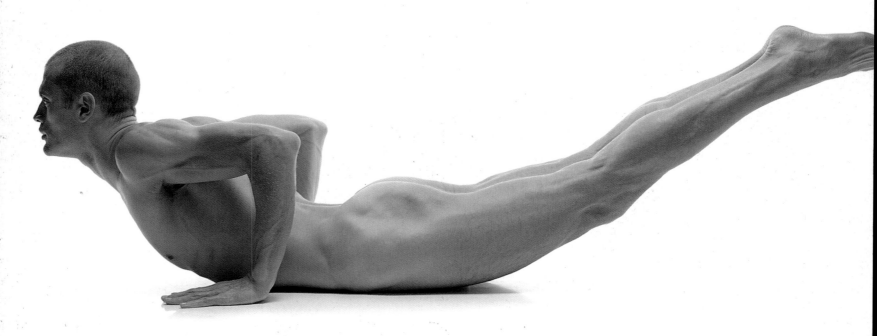

The photograph of a male model suspending his weight from a rope is of particular anatomical interest since it shows the extent of trapezius shaping the upper back and shoulders. The aponeurosis at the center of this muscle covering the spine is normally broad across C7, and T1. In this case, it is unusually expansive, appearing as a long, irregular flattened indentation surrounding the protrusions of five vertebrae. Compare this to the trapezius of the seated male model, bottom right. Here a small aponeurosis reveals one vertebra at the base of the neck.

When drawing a long pose, never feel obliged to use the time set to make only one image of the whole body. Studies of parts such as the feet, head, eyes, knees, or ears are as valuable as studies of the whole form. During a long pose of one hour or more, a whole page could be filled with repeated studies, made either from one position or from different views around the room. If you choose to make only one drawing, during one pose, do not keep adding lines to the same drawing, long after you feel that it is finished, just because the model is still in place. A half-hour pose does not force you to draw for half an hour.

Equally, if you are very pleased with a particular line, do not go over it again and again to confirm it. This will only take the life out of it and destroy what you were so pleased with.

If drawing the whole figure on one page, never shorten body parts to fit them onto the paper because you are running out of space. The distortions will attract more attention than the rest of the drawing, and you will never be pleased with it. Either allow the body part to stretch beyond the paper, in its normal proportions, and therefore be cut off the page, or add more paper to the edge. Added lengths of paper might seem awkward, but once the lines of your drawing have passed over the join, it will recede and be barely seen. Adding or trimming paper often improves the shape of the page; therefore, never feel obliged to work within the given proportions of commercial paper size.

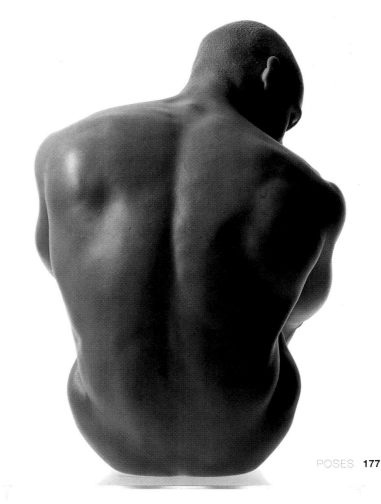

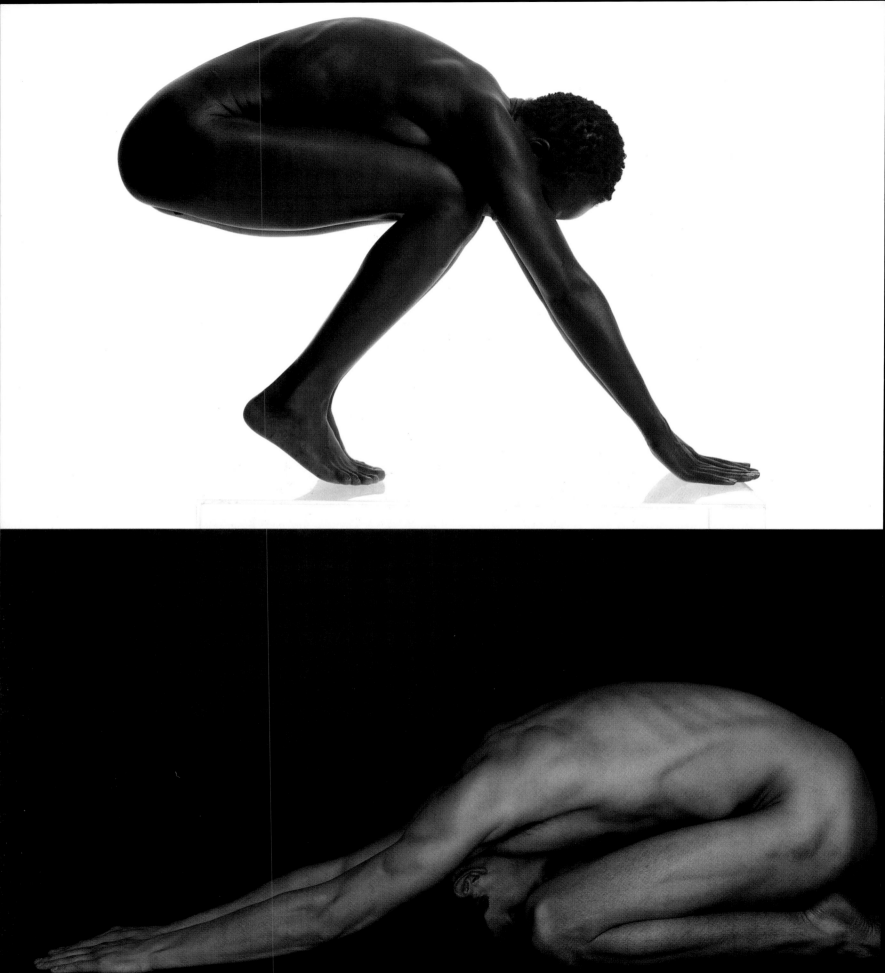

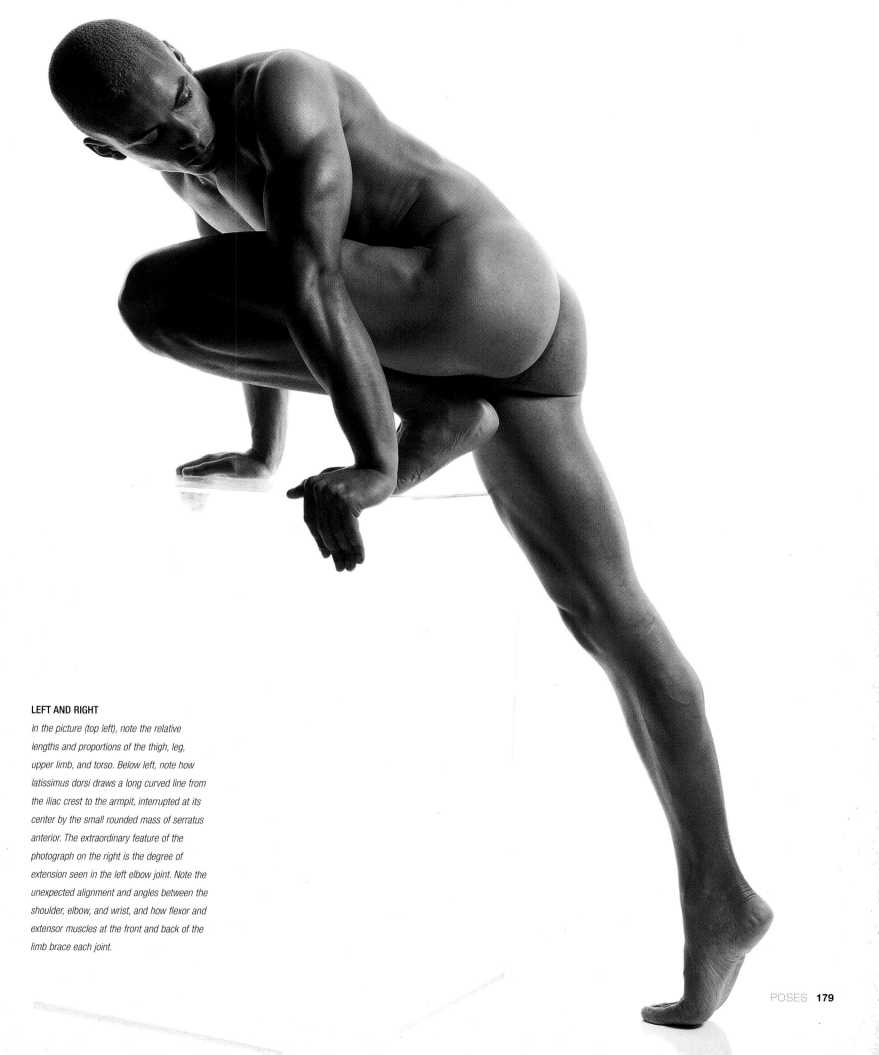

LEFT AND RIGHT

In the picture (top left), note the relative lengths and proportions of the thigh, leg, upper limb, and torso. Below left, note how latissimus dorsi draws a long curved line from the iliac crest to the armpit, interrupted at its center by the small rounded mass of serratus anterior. The extraordinary feature of the photograph on the right is the degree of extension seen in the left elbow joint. Note the unexpected alignment and angles between the shoulder, elbow, and wrist, and how flexor and extensor muscles at the front and back of the limb brace each joint.

MASTERCLASS
OLYMPIA EDOUARD MANET

Edouard Manet (1832-1883) was a gentleman and the son of a respected magistrate, but he scandalized Parisian society in the mid-19th century with his uncompromised attitude to sexual manners. *Olympia* is a painting of a prostitute, illustrious and unflinching in her repose.

This is a famous portrait of female sexuality. It caused a scandal when it was shown at the Salon des Refusés in Paris in 1865. Its frank and erotic sensuality affronted the hypocrisy of the powerful bourgeoisie, and it was only through the intervention of Manet's friends, the poet Charles Beaudelaire and the writer Emile Zola, that the exhibition was not closed.

The nude in the painting is very far removed from the chilled life-class model of an art school. Olympia is both magnificent and vulgar in her opulent domain. She is a courtesan waiting for her lover – rich, prepared, and, for the moment, in control. She tries to meet our gaze with confidence, but we are also allowed to see a flicker of vulnerability. Even as she covers her modesty with her hand, it is more graphically suggested elsewhere in the room. The bouquet of flowers, the cushions, the tasseled folds of the flesh-colored silk, even the composition of light along the edge of the screen behind her focus our attention on the true subject of the painting – the provocative declaration of the hidden and the available.

BELOW

The model is posed on a hard surface. Her body is not relaxed into soft cushions, and this accounts for the forward arch of her spine, supporting the weight of her torso. Lighting coming from above separates her neck from her chest, emphasizing the collar bones (clavicles) and both sternocleidmastoid muscles. Note the overall form of the neck, its tilt to the side, and how it is set deeply behind the clavicles.

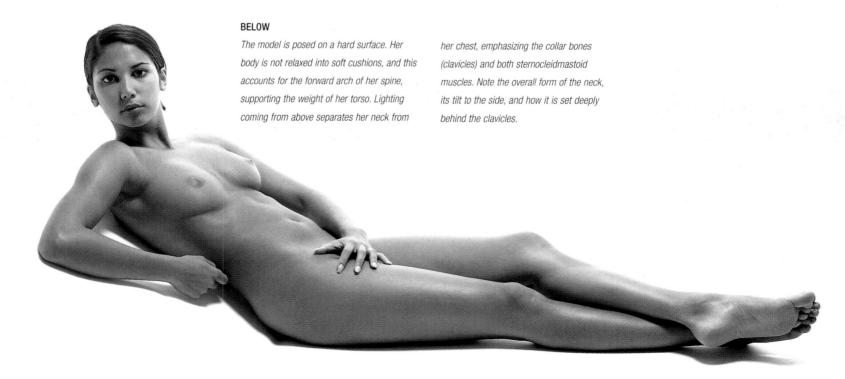

THE SHOULDER GIRDLE, AND NECK

Manet has accentuated the curves of his model's clavicles, projecting her shoulders upward and forward. Her pronounced sternum and upper ribs also push upward to meet her neck. There is no hollow at the base of her neck, the trachea is too far to her right and the left side of her neck merges with her torso. Her neck gives away her discomfort, and also suggests that at this point in the sitting Olympia was seated and facing forward.

THE ABDOMEN

The soft flesh is accentuated by the upper part of the linea alba passing from the base of her sternum to her navel. This is a white line of connective tissue between the two halves of the rectus abdominis muscle. The muscular wall of the abdomen is rounded and shaped from behind by the intestine and covered in front by soft fat and skin. Surface fat accentuates the navel, and the abdomen is cupped from below by her very narrow hips.

THE ANKLE AND FOOT

Olympia's small left foot is pointed downward flexing gastrocnemius and soleus at the back of her calf. As these muscles draw the heel upward, a shadowed indentation appears beneath her anklebone. Along the instep of the foot, muscles and tendons are concealed beneath soft surface fat. Fat also fills between the tibia and calcaneal tendon and surrounds calcaneous, shaping the back and underside of the heel.

1863, oil on canvas, 51 x 75in, Musée d'Orsay, Paris

he photographs in this chapter are testament to the astonishing beauty of the human body in motion. We, like other animals, change our relationship with time and space when we move through it at speed. The grace and agility of the body propelled through the air have been of continual interest to artists, who since the nineteenth century have made works based on its dynamic or its fleeting blur. In Marcel Duchamp's *Nude Descending a Staircase* (1911–12) fragmentary images of a woman are painted like frames of a film, interrupted as they flow into each other. Her action, not her presence, is the subject of the painting.

MOVEMEN

Umberto Boccioni's Futurist sculpture *Unique Forms of Continuity in Space* (1913) invents a machinelike human anatomy that is rippled and sucked by movement, a charging bronze figure caught forever in a powerful wind. Ninety years later, one of the new and controversial plastinated anatomical figures by Günther von Hagens is based upon this sculpture. The pioneering nineteenth-century photographer Eadweard Muybridge did much to redefine our ideas about human and animal movement. His classic work influenced generations of artists, dancers, and sports men and women who had never before seen humans and horses analyzed in motion. His sequenced photographs dissected action and exposed how the body works within it. The extraordinary series of human shapes that walk, run, jump, and cartwheel through these pages confirm not only the hypnotizing potency of

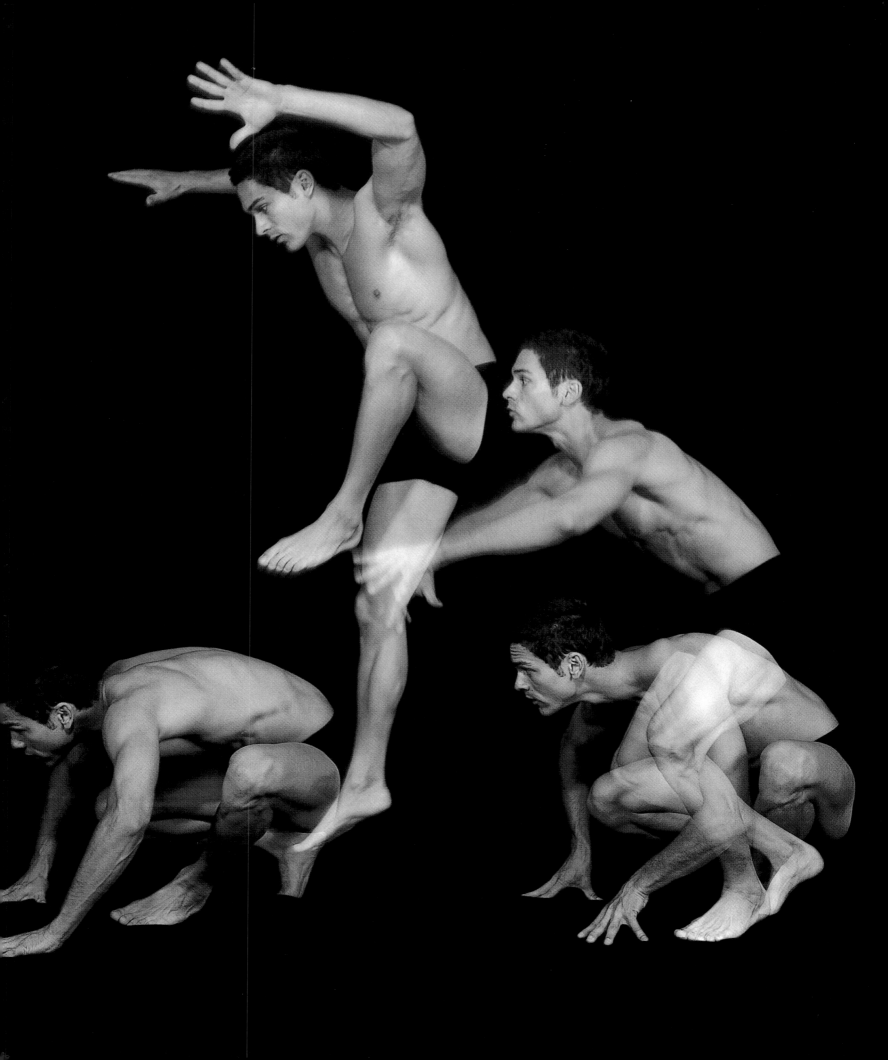

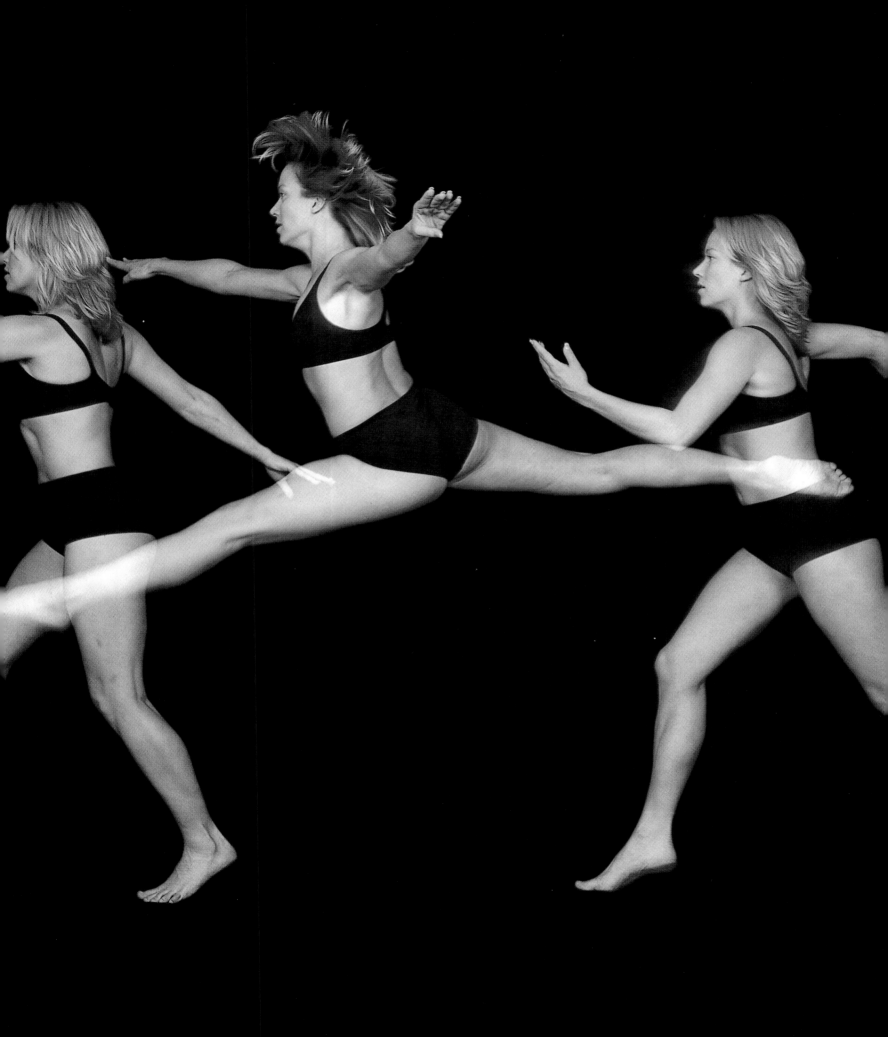

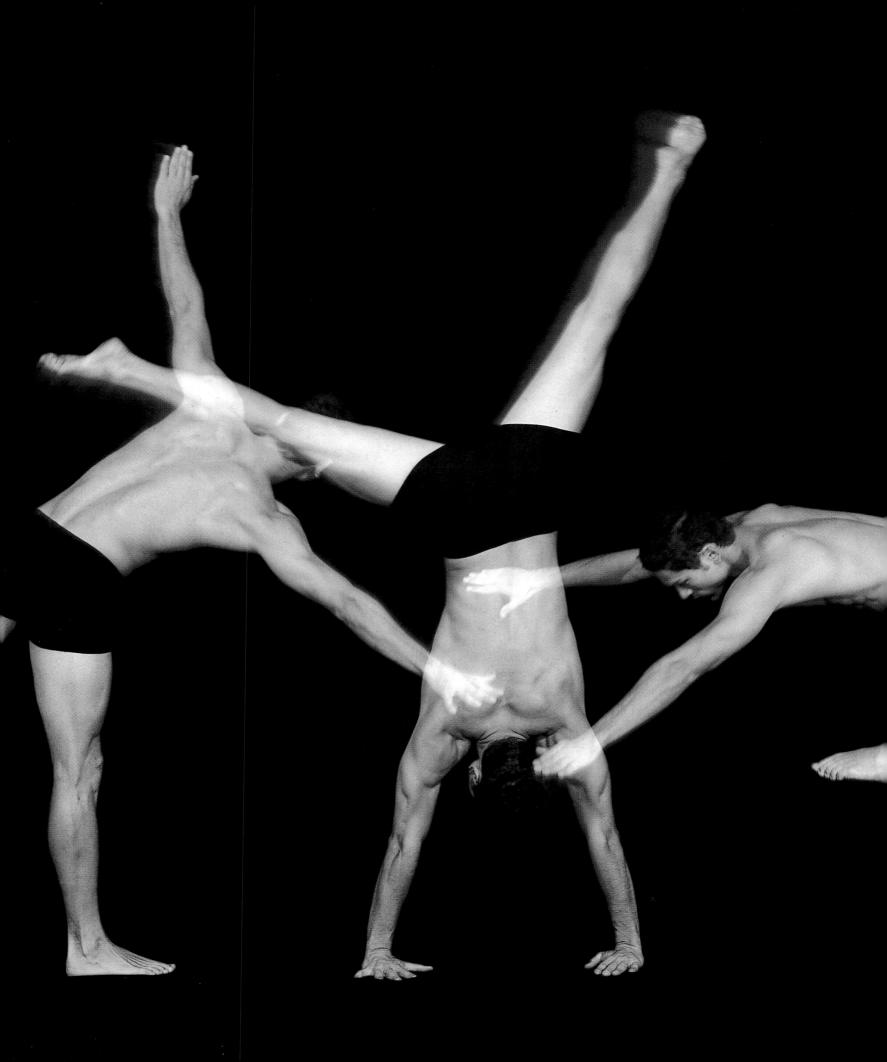

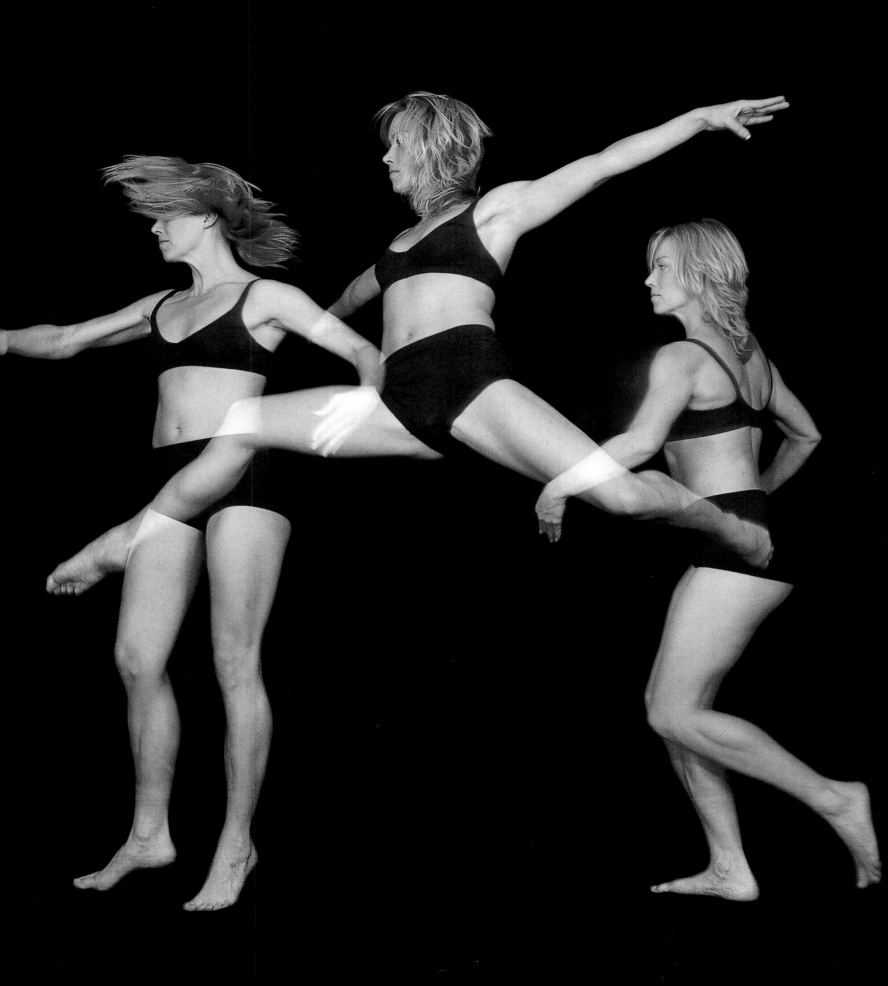

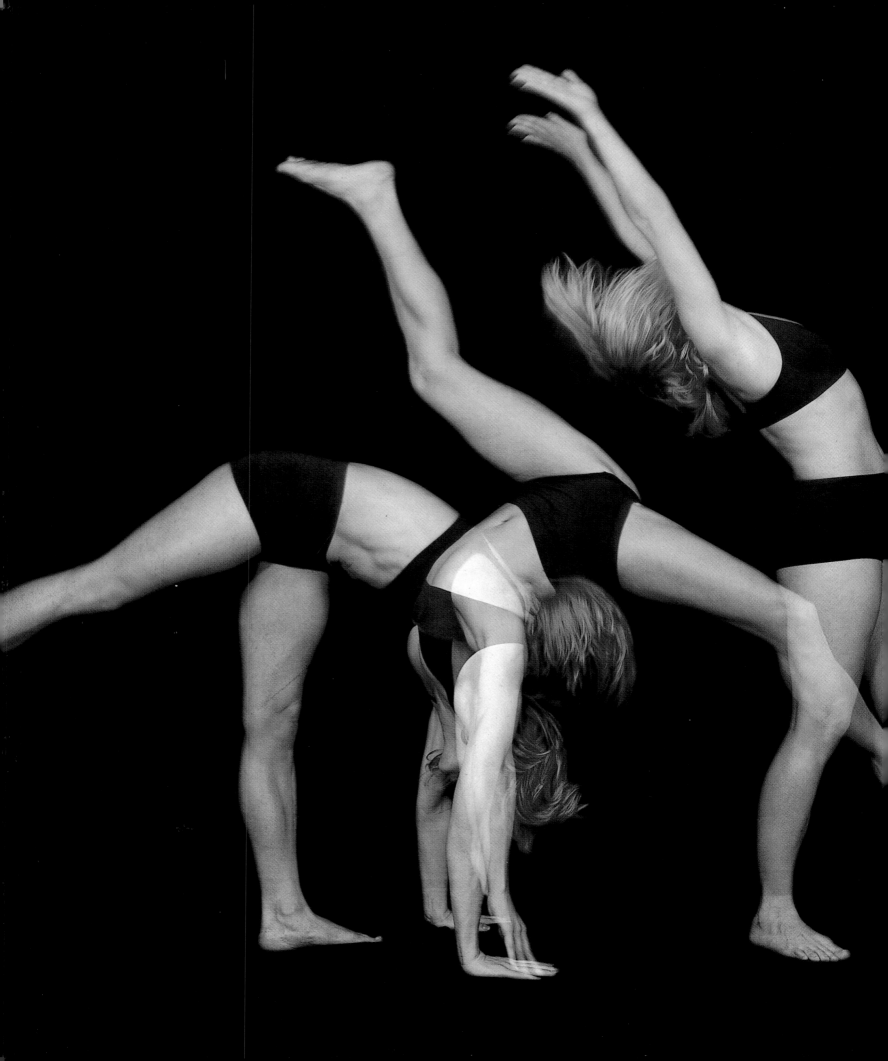

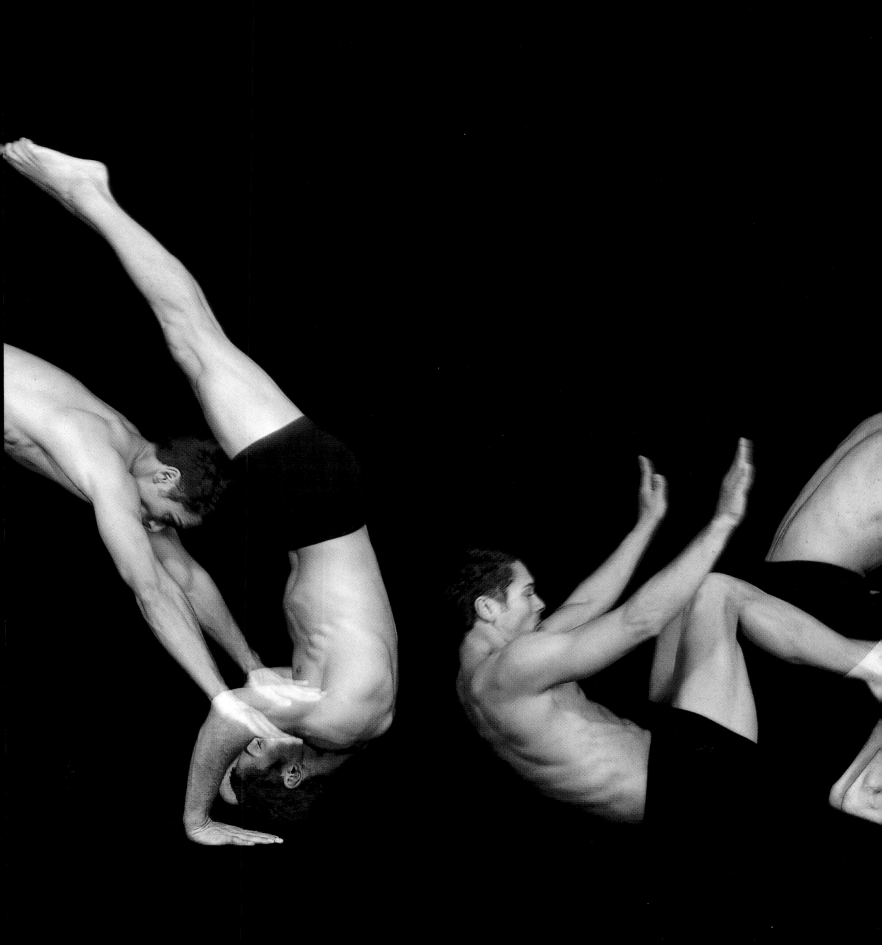

MASTERCLASS
THE TUB EDGAR DEGAS

Edgar Degas (1834-1917) was one of the key Impressionists who were innovative in painting the human body composed of light. This almost ethereal vision of domestic life is one of a large series of drawings by Degas of women bathing.

This drawing is made in colored pastel – a warm, chalky medium perfect for creating the shimmering movement of every surface in this room and the soft luminous glow of a bathing body. Degas' knowledge of anatomy was highly distinguished. His sharp powers of observation fused with his imagination to give him the ability to draw, paint, and sculpt alarmingly simple subjects that are radiant with atmosphere and existence.

In this painting, we have entered the interior a French domestic dwelling and are looking down onto the body of a woman who is stooping to replenish her sponge. The modesty of many of Degas' nudes is exemplified by the woman's pose, and she seems either unaware of our gaze or content to accept it. (Compare this to the statuesque and chilled coquettishness of Ingres' bather on pages 70–71.)

Degas was not reputed for his emotional life or temperament but for the methodical application of his artistic skills and superb draftsmanship. While looking at this picture, the viewer is held in wonder, not at the personality behind the woman's beauty, but at its tangible warmth and closeness. The smooth expanse of the woman's skin, and the curved forms of her back and hips, are constructed of solidified light that melts into the moist air above her. The scented temperature of her proximity is overpoweringly intimate – as if we could reach forward and touch her.

LEFT

Observe the extraordinary definition of the posterior superior iliac spines of the pelvis as they pull two indentations into the model's skin, one on either side of the base of her spine. Also see the clear protrusion of the spinous processes of her lowest six vertebrae (T12 – L5). The fold of her torso over her thighs compresses the flesh of her hips, increasing their apparent width.

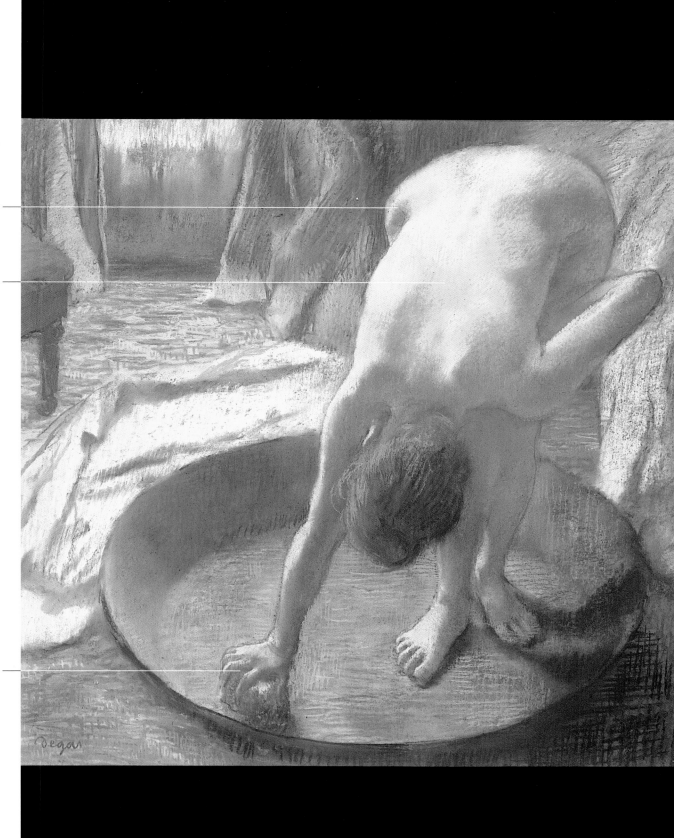

THE HIPS

The breadth of the woman's hips and thighs counterbalance the weight of her torso and arms, and hold her stance above her feet and right hand. If her hips were to shift to one side, she would fall. They are the highest point from which light shimmers down the length of her torso. A flattened triangular plane between the buttocks marks the sacrum, and posterior superior iliac spines.

THE TORSO

The model's rib cage is particularly wide. It expands the shape of her torso on either side of the spine, especially on her right, where the ribs describe an arc rising from her waist to meet the axial border of her shoulder blade. The indentation in the outline of her skin a little over halfway from her waist to her armpit marks the inferior angle (lowest point) of the scapula. The spinous process and acromion of her right scapula are described by a sharp change in light on her shoulder, which is directed toward her arm. Both shoulder blades may be easier to locate if the drawing is viewed upside down.

THE HAND

The right hand is pressed down against the sponge so that the skin of the wrist folds tightly across the back of her hand. The spread of the woman's fingers helps to hold her balance, and the whole hand leads our eye down into the bath, where it begins to encircle her feet.

1886, pastel, 28 x 28in, Hill Stead Museum, Farmington, Connecticut

DRAWING

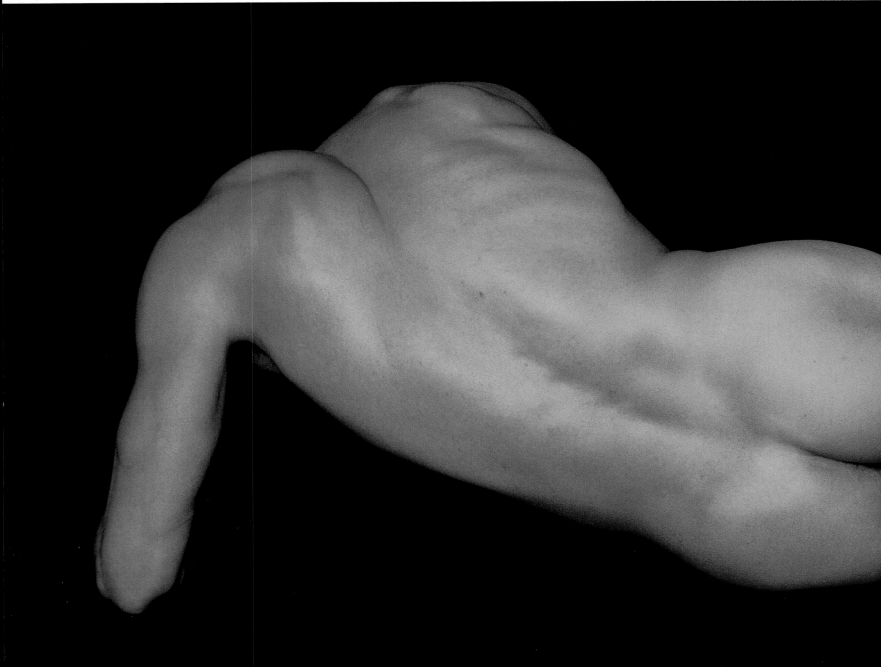

CLASSES

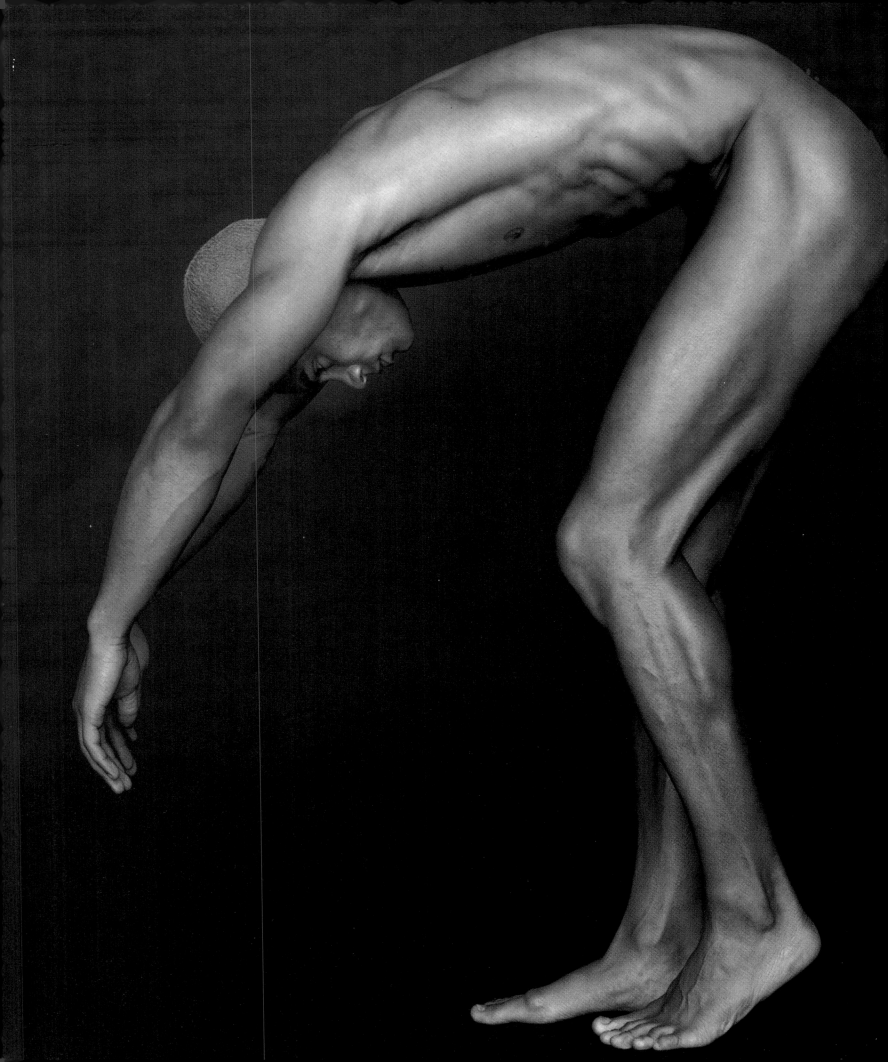

Artists have engaged in the exciting and complex study of human anatomy for many reasons over many centuries. Anatomy can strengthen and evolve the way an artist works, or it can be explored as a subject in its own right. A detailed understanding of the human body will instruct and enliven a figurative artist's rendering of movement, articulation, gesture, and pose. By looking through the sealed mass of the human form, and delineating its component parts, we invent the transparent body and this gives insight not just into the miraculous machinery of life, but into the mysterious workings of the imagination itself.

TRANSPARENT BODIES

When artists draw relationships between the body's interior and exterior, they do two things. They picture intricacies of structure that lie beneath the skin, using their knowledge to recognize and position component parts. And they develop a visual language that allows them to speculate and explain their observations and understanding. They use their imagination to map and express the invisible. This is the freedom that Leonardo found in anatomy. His drawings are domains of imaginative speculation – a forum of ideas where art and science meet. The body remains essentially the same. Our knowledge, expressive language, and portrayal of it continually shifts and evolves to invent new routes of vision.

BELOW, OPPOSITE, AND OVERLEAF

Below: one of four drawings, made with pencil on paper, measuring 94 x 34in (239 x 86cm) The density of the drawn line is focused along the center of the body, leading from the

sacrum and the base of the spine to the hair. Opposite: the figures and fragments of this interior are perched on a balcony within a fictional circular museum or library. A sense of

vertigo frames this whirlpool composition. Overleaf: we, the viewers, share this crowded museum case with the living and the dead. They embrace and clutch at life and each

other in a space that is compressed by reflection and accelerated by perspective. Books, cloth, bell jars, and racked specimens fight for space and our attention.

TRANSPARENT BODIES AUTHOR'S DRAWINGS

"Fix in the memory by constant exercise the muscles ... with the bones underneath. Then one may be sure that through much study the attitudes of any position can be drawn by help of the imagination without one's having the living forms in view. Again having seen human bodies dissected one knows how the bones lie, and the muscles and sinews, and all the order and conditions of anatomy." Giorgio Vasari (1511–1574)

Each of the drawings reproduced here was made without the use of a life model. They are works of the imagination, invented out of countless hours of study and observation in anatomical museums and dissecting rooms, where I make drawings and written notes in sketchbooks that, in the studio, work as a reference and an *aide-mémoire*.

In all my drawings the distinction between objective and subjective is questioned and the boundary between life and death is made permeable. The rooms and their occupants are invented at the same time.

To begin each drawing, I join together lengths of paper and stretch them against my studio walls. I use a ladder to reach different parts of the work; a large mirror placed across the room reflects and guides the composition, enabling me to check proportions, scale, and the development of multiple perspectives. These drawings measure up to 13 square. feet (4 sq. metres).

The long transparent woman reproduced at the top of this page is one of a series. Each displays her dissection with pride, showing us views through the interior and exterior of her powerful body. These women stretch and flex inside the tradition of living dissection (p. 20) but refuse the subservient depiction of the female body that is found throughout much of the history of medicine. The woman above dominates her space and invites our view inside the vitality of her existence. Anatomical details are selected to entice the eye through a series of rhythmic movements within her body. Musculature is barely described. Vivacity is expressed by her posture and by the intricacy and linear energy of her bones, hair, viscera, and nerves.

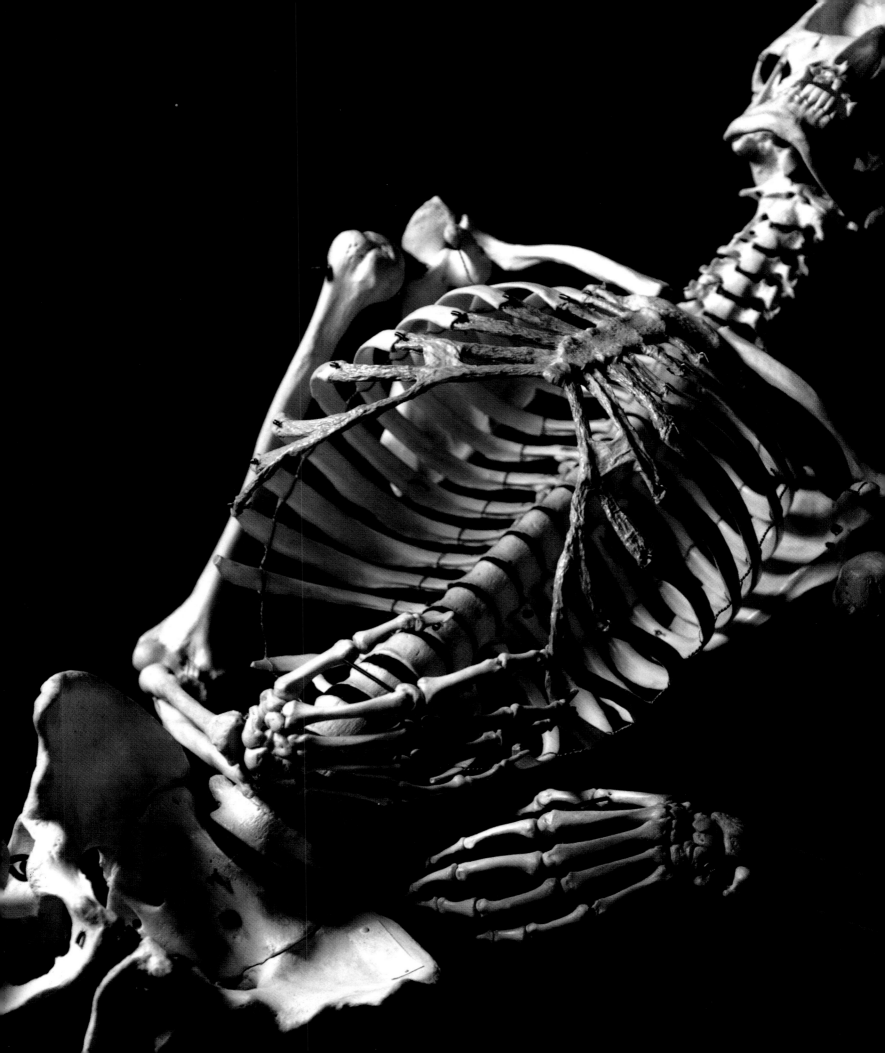

A skeleton is often the first anatomical subject that an artist draws. Be it human, animal, or bird, these sleek frameworks of bone are familiar to most of us. In terms of the human skeleton, there is a common sense of knowing what a skeleton looks like mainly through the images of art, popular culture, partially remembered school textbooks, and the movies. However, to look at a real human bone very closely, and to try to draw its linear structure, is a very different matter. The novice quickly learns that nothing is as it might at first have seemed: every bone curves, tapers, or thickens along its length.

DRAWING THE SKELETON

Some bones are dense with ridged and pitted surfaces, while others are translucent, paper-thin, and reveal their trabeculous detail in the sunlight passing through them. The relationship of one bone to another can be exquisitely subtle in its form and placement. The skeleton is without waste or embellishment. It has a purity of design that is sharpened by its purpose. It is a brilliantly evolved machine that will become a constant pleasure to draw. Try to look beyond its common representation and examine its elegance, detached from metaphor. Once truly seen, we realize how far the structure is from its constant comic depiction as a spooky or ghoulish sight. It is already a refined tensile diagram of ourselves that lives so comfortably within us.

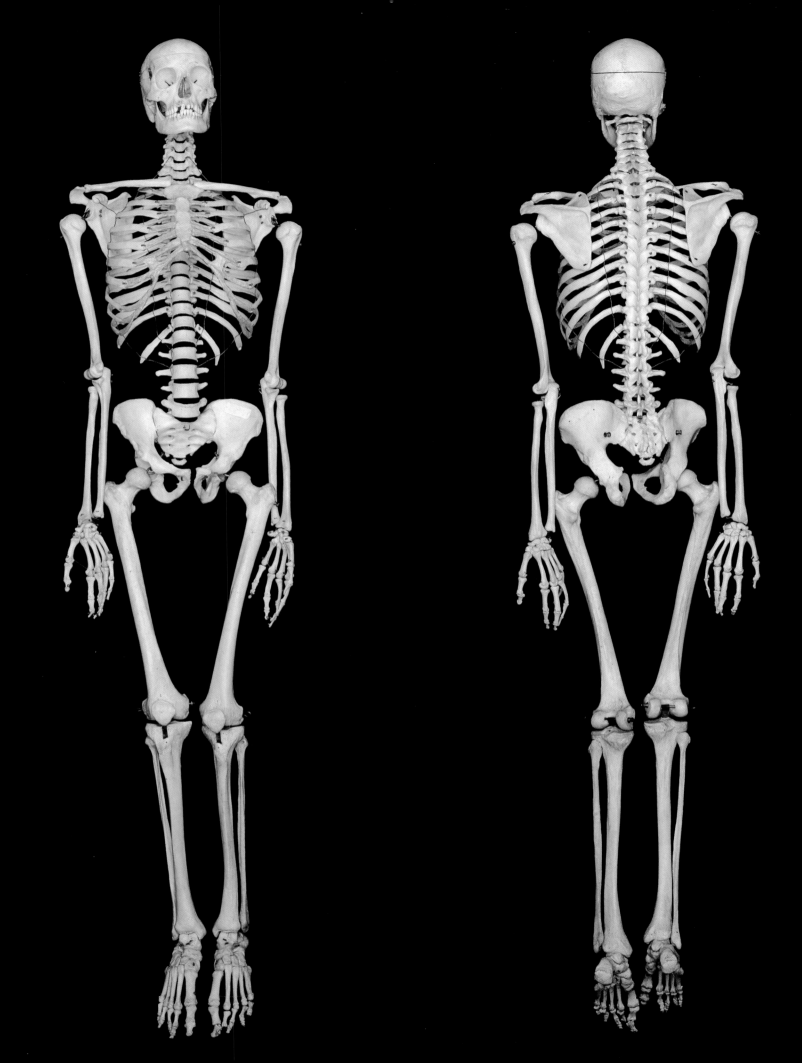

There is no good substitute for drawing directly from a human skeleton. Finding one to draw from will pay dividends. However, a real articulated skeleton in good condition, such as the female shown here, is a rare find. Most skeletons are fragmented, distorted, and discolored with age. Excellent plastic skeletons are now available, although they are expensive to buy. These may be found and studied in most schools, art colleges, evening classes, and museums. Make sure that you work from proper casts, and not scaled models, which tend to have strange proportions. When

beginning to draw, remember that the skeleton is symmetrical along its vertical axis. Although it seems obvious, this fact is often obscured by the way that articulated bones hang. Some parts may be missing, which may result in the skeleton having a lopsided appearance. Before you begin drawing, make sure that the limbs are attached to the correct sides of the body and that they are facing in the right direction. Illuminating the skeleton with a lamp will enhance its visible depth and dynamics.

THE SKELETON
IN PERSPECTIVE

Drawing the skeleton is a challenge to the artist's powers of observation and skill, and the biggest problem you will encounter in your drawing is proportion. The eye can become so fixed upon, and excited by, the complexity of one area that it loses sight and sense of the whole.

Begin by taping a large sheet of drawing paper to a vertical board or wall, and draw with a stick of charcoal because it is easy to erase. Mark out the width and length of the whole skeleton. Be bold but gentle with your marks, not hesitant, and do not start from one small detail and try to grow the drawing from it. Many students start from the skull and work down, or from the sternum and work outward, but this does not work.

Rapidly map the whole shape, volume, and proportion of the skeleton. Do not be distracted by small details, especially individual teeth, vertebrae, or ribs. Nothing is more infuriating than finishing a good drawing of a small part, only to find that it is alarmingly disproportionate to the rest of the image. Hold a vision of the whole in your mind while focusing upon each part. This will give you control and the flexibility to evolve the drawing.

After making preliminary drawings and getting used to seeing and thinking about this difficult and dynamic tracery of bone, try a different approach. Make a life-size drawing. Find a roll of paper wide and long enough to accommodate the subject or fix together several sheets to make a

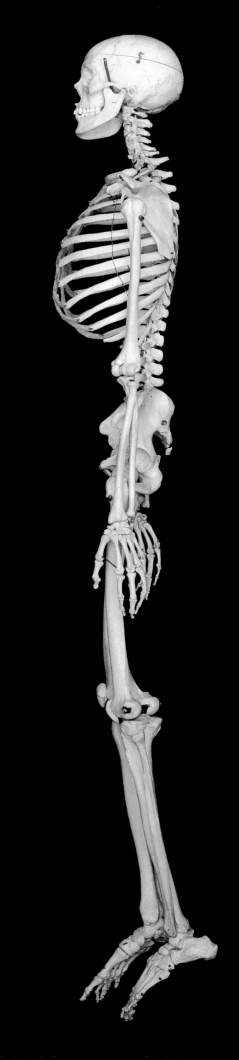

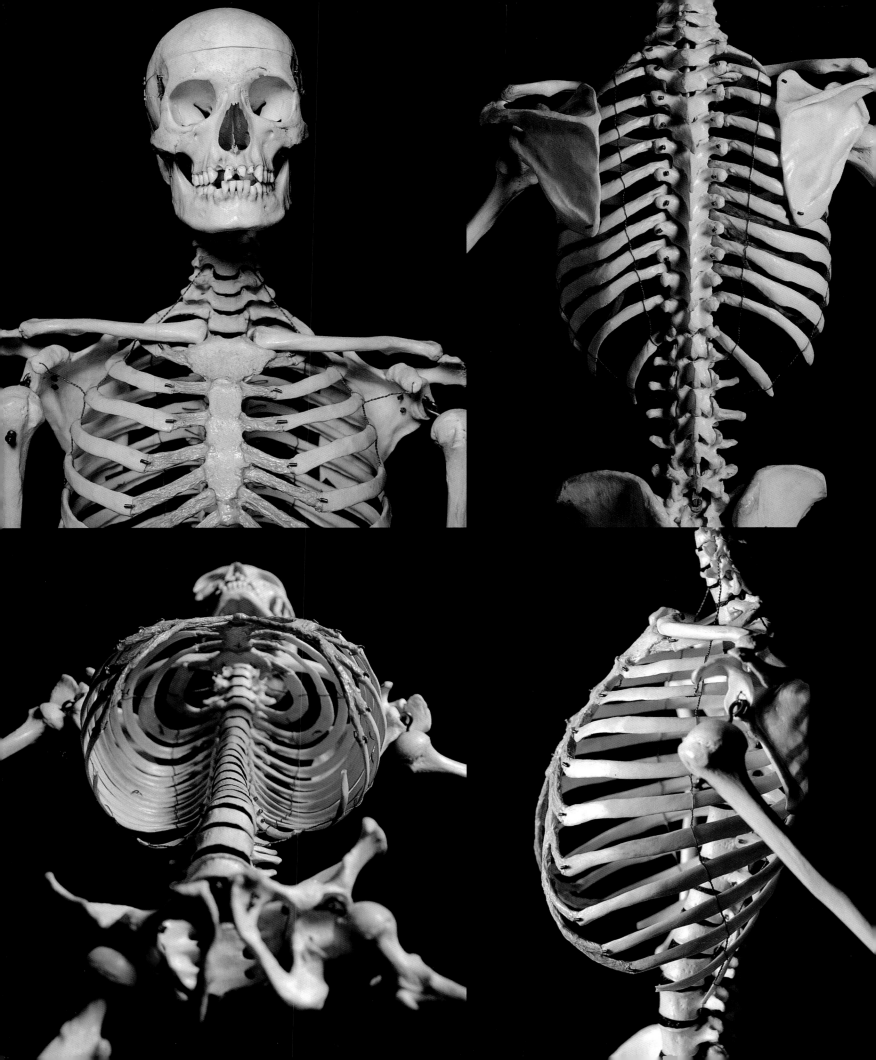

These four views of the skeleton present several important features. Top far left: three portions of the sternum (manubrium, blade, and xiphoid process) are clearly defined, together with the connection of each clavicle between the manubrium and acromion processes. Top left: note the arrangement and angles of the transverse and spinous processes of the vertebrae; the seating of the shoulder girdle over the upper ribs; the angle of each rib, and the posterior surface details of each scapula. Bottom far left: the interior volume of the thorax displaying the narrow aperture of the first pair of ribs; the forward projection of the vertebral bodies. Bottom left: note the curvature of the left clavicle, the rounded form of the rib cage seen from the left side, and the translucency of the scapula. Top right: observe the pattern of sutures surrounding the occiput; the mastoid processes; the size and position of the foramen magnum; the arrangement of the cervical vertebrae. Below right: The lighting of the rib cage has been arranged to show the interior and exterior contours of the structure simultaneously.

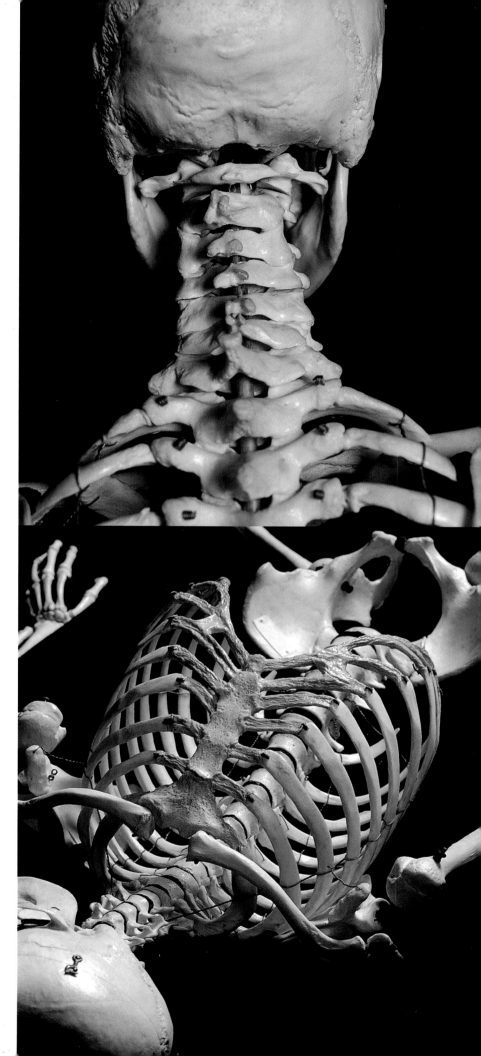

workable surface. The paper may be attached to a wall or laid on the floor. Both positions are worthy of experimentation. Drawing from the floor will give you interior views of the rib cage and set many challenges of foreshortening. Use broad sweeping lines to establish the figure's position on the paper. Move backward and forward between your drawing and the skeleton to make comparisons and measurements. Walk around the skeleton. As your drawing develops, it will become obvious that you are using your own body and its posture in a new way, as a physical intermediary, a measuring device between your drawing and the skeleton. By changing scale, in this way, we loosen our preconceptions about the constraints of picture making that often damage a drawing, preventing it from becoming a visual journey of discovery.

Another useful study of the skeleton involves a life model set in a long pose, with an articulated skeleton placed in a similar position. Take a large sheet of drawing paper and a thick piece of willow charcoal. Gently, evenly, and thoroughly cover the paper with the charcoal to create a mid-gray ground. Do not make a bold rubbing of the surface beneath your paper or grind in the charcoal so hard that it will not lift away with an eraser. The finished page should be a smooth, even mid-gray. To draw on this you will need willow charcoal – or compressed charcoal – to make dark lines and a clean white eraser to make light lines. Erasers are good drawing tools if kept clean and trimmed or cut into pieces with a scalpel. Purchase white erasers that are not too greasy.

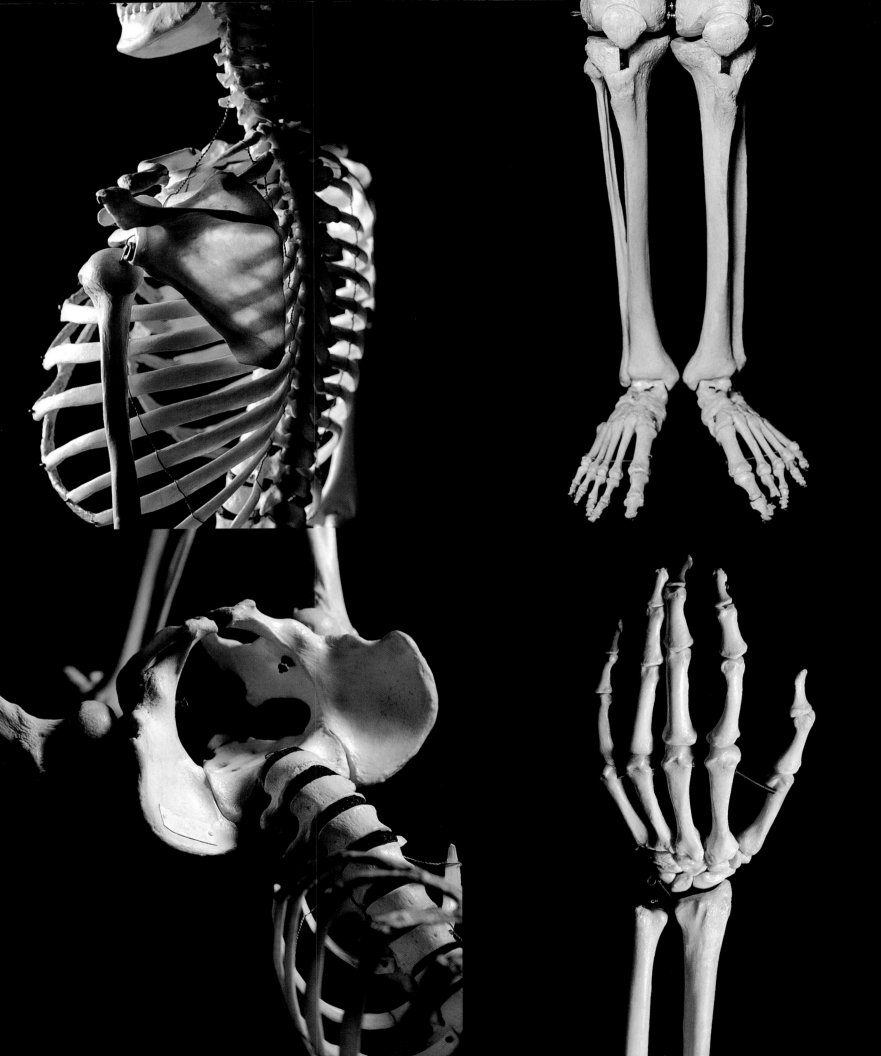

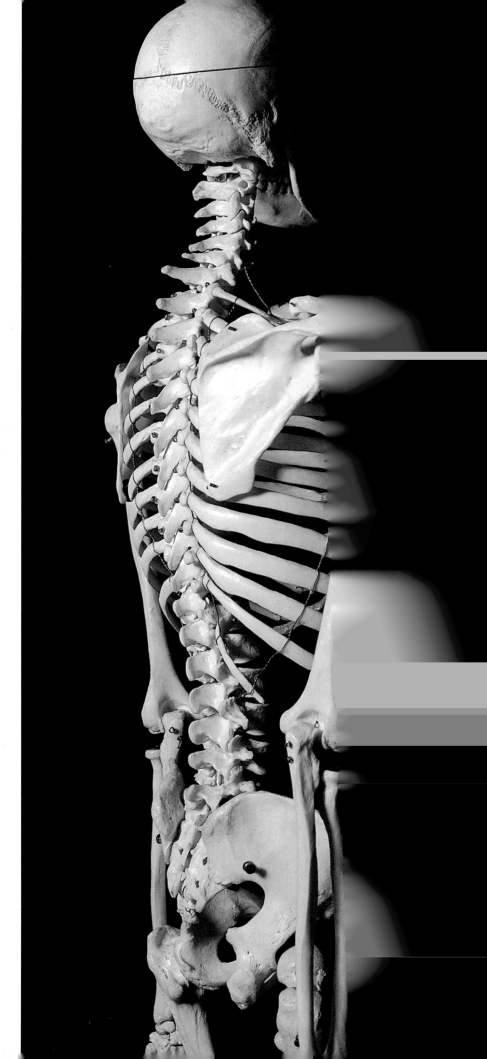

LEFT

The view, top right, shows the arrangement, proportions, and surface details of the tibia, fibula, and patellae of the knee and leg, together with the tarsals, metatarsals, and phalanges of the feet. Bottom right: note the relative proportions, arrangement, and surface details of the carpals, metacarpals, and phalanges of the hand. The view, top left, shows the density of bone within the scapula and the spherical head of the humerus. The view, bottom left, shows the greater and lesser pelvis, the symphysis pubis, and sacrum.

RIGHT

Note the posterior curve of the cranium; the level of the base of the cranium in relation to the jaw; the mastoid processes behind the ear; and the lambdoidal and sagittal sutures. Note the inclination of the spinous processes of the vertebrae, especially the prominence of C7 visible at the base of the neck. The olecranon of the ulna can be seen fitting into the olecranon fossa of the humerus. Light catching the head of each radius emphasizes how the bones have dropped down out of place.

Observe the pose, as directed on pages 168–179. Then envisage the model's skeleton inside his or her flesh. Now imagine the bones of the model as a source of light within their flesh. Bones close to skin will appear bright, while bones deep within the body will be dimmer. Practice visualizing this for about a minute, following individual bones from one joint to another. Imagine how, if the skeleton were luminous, its luminosity would dull as it passes deeper into the body.

Now draw the skeleton within the model as if it is made of light. Use charcoal to describe depths of flesh as darkness and an eraser to draw gradations of light emitted from bones. Do not make a finished drawing of the model and then fit a skeleton inside the outline. Your drawing should look a little like an X-ray photograph. For the drawing to work, it is imperative that the only light in your drawing be that of bone. Do not describe light on the skin of the model.

Keep a sketchbook or file of smaller drawings, which will give you the freedom to adjust ideas and invent during those times when you have neither a model nor a skeleton. If these resources are not available at all, the last exercise could be made by observing bones within your own body, with help from the illustrations in this book. Photocopy some of your best smaller drawings and work over them. Test your knowledge and memory by adding muscles and tendons to studies of bones. In this way, you will begin to build your own atlas of the body.

MASTERCLASS
STUDIES FOR THE LIBYAN SIBYL MICHELANGELO

Michelangelo Buonarroti (1475-1564) was one of the great masters of the Renaissance — painter, sculptor, architect, and poet — who, like his rival Leonardo, had an active and prodigious knowledge of human anatomy.

Michelangelo used a carver's touch to define and see through mass and form – to conceptualize muscle and bone. *Studies for The Libyan Sibyl* demonstrate the complexity of his visual thinking. On a single page, we see conjecture and diagram fight for space. Michelangelo destroyed many of his own drawings, but those that survive are largely responsible for the recognition of drawing as an independent medium.

Michelangelo's passion for anatomy was fundamental. He emphasized the physical power of the body. He informed his work with studies of dissections prepared by the anatomist Realdo Columbo, and produced many drawings of *écorchés* (*see* glossary). This study is of a living man, slightly modified to appear female. Female characters were often modeled by a young male apprentice. The nude male was at this time deemed less offensive to the Church. Moreover, the female body was considered an inferior form.

A sibyl is a classical prophetess, a priestess of Apollo, God of medicine, music, archery, light, and prophecy. The nine most important sibyls (of Libya, Persia, Delphi, Cimmeria, Eritrea, Samos, Cumae, Hellespont, and Tiber) are the supposed authors of the Sybelline Oracles, late Judeo-Hellenic or Judeo-Christian texts dating from circa 200 BC. Some warned of catastrophe and were said to foretell the fate of the Roman Empire. Eritrea uttered prophesies of the Trojan War. Tibertina is charged with striking Christ. In the Sistine Chapel, Michelangelo painted sibyls among biblical prophets to represent belief, hope, and the confirmation of Christ's return.

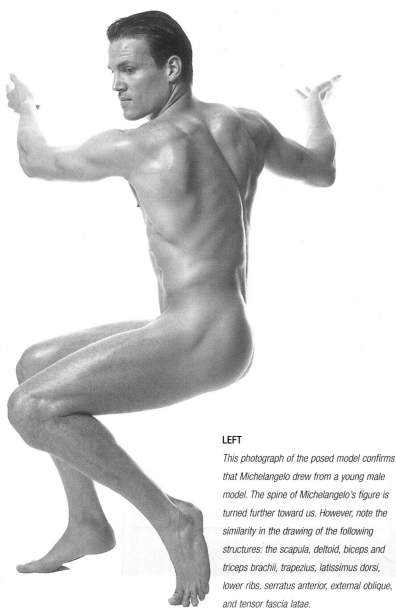

LEFT

This photograph of the posed model confirms that Michelangelo drew from a young male model. The spine of Michelangelo's figure is turned further toward us. However, note the similarity in the drawing of the following structures: the scapula, deltoid, biceps and triceps brachii, trapezius, latissimus dorsi, lower ribs, serratus anterior, external oblique, and tensor fascia latae.

THE HEAD

This magnificently modeled head looks down over her shoulder. The broad, high curve of the forehead is emphasized by light from above. The nose and shadowed brow give depth to the eye. The lips and chin, diminished by perspective, are directed forward to aid the tilt of the head.

THE LEFT SHOULDER

The scapula is rotated forward by serratus anterior, pulled down and rotated superiorly by trapezius. The spine of the scapula, emphasized by light, is at 45 degrees, rising to meet the clavicle. Note the light striking the acromion process and shadow defining the vertebral border of the bone.

THE TORSO

The torso is made short and wide by the perspective of her leaning back to look down. Deep longitudinal dorsal muscles flank the spine. Note the diamond-shaped aponeurosis amid trapezius at the base of the neck. Three ribs visible on the figure's left are almost level with three parts of serratus anterior sketched in front of the scapula. The sibyl appears to be without breasts, although a rounded feminine abdomen is placed in front of her hip, with a single line. The soft red chalk gives a deep warmth to her flesh, contrasting to Michelangelo's many ink studies, where the pen is used to carve into the paper.

c.1510, red chalk on paper, 11 x 8in, Metropolitan Museum of Art, New York

To draw the head is to begin the delineation of personality. A detailed understanding of the head's interior structure will greatly enliven an artist's ability to capture shifts and hues of expression. However, this class is not about portraiture. It will purposefully avoid fine details of the face, concentrating instead on the mass and form of the whole head and neck. Students often focus on the eyes, lips, and nose, then find a floating shape to pin them to. In life, the face grows outward from the skull. The balance of the neck, cranium, and face presents a fused conjunction of expression, character, mass, and form.

DRAWING THE HEAD

Professor Richard Neave of Manchester University, England, reconstructs the faces of ancient and modern human skulls. Through measurement and his knowledge of how tissue is attached to bone, its precise depth and composition, he can estimate and extrapolate the contours of a face that once lived, so that we can see its personality and type. This drawing class will follow a similar process, only in reverse. As we rotate and tilt the living head – our own or that of a life model – we will use our informed imaginations to pinpoint its interior structure and detail, beginning with the bones and cartilages of the skull that can be felt so clearly beneath the muscles and fatty tissue, skin, and hair of our own face.

DRAWING THE HEAD

If you have access to a plastic skeleton you will find the skull is removable. Take the skull from the main frame and examine it in your hands. Feel its overall shape and texture and, with reference to pages 48–49, investigate individual bones.

The cranium will be cut in half around its circumference (see p. 50). Open it, and study its interior space. Close the cranium and turn to the bones of the face. Look at their depth and detail as they shape each feature. Articulate the jaw, observing its strength, the hinged joint in front of each ear, and its closure beneath the upper teeth. Feel the size and texture of each mastoid process and the occiput. Then replace the skull, turn it to a side view, and illuminate it with a lamp.

Position a 22in x 34in sheet of paper on an upright support. If you are right-handed, work with the skeleton to your left, or vice versa. Never work so that you are looking across your own drawing arm. This restricts the body's movement. Using a broad medium such as a crayon, draw the skull five times its actual size – filling the whole page. Leave aside detail, and use long sweeping marks to delineate the mass, shape, and balance of the cranium and face. Imagine you are explaining the skull to someone who has never seen it. Go back to the skeleton and refresh your memory, jot notes into a book, look at the skull from behind, in front, above, and below, and take these aspects into account as you build your side view.

These heads (left) made in pen and ink were drawn from my imagination without reference to models or photographs. Each person was visualized within the paper, moving (not static) with a clear expression. I begin to draw a head with light rapid marks placing (but not fixing) the mass, form, and angle of the cranium – the most important part of its structure. Forward of the cranium, rapid lines mark essential planes of the face – the breadth, depth, angle, and curvature of the forehead, nose, cheeks, and chin. Eyes and mouths are found with single lines describing light on the upper lids or lips. Last of all, lines are added to describe light striking the contours and texture of the whole face, hair, and neck. The head and neck are considered as one. Structure and expression are developed simultaneously. The photographs (right) display how the length of the hand is similar to the height of the face, and how strong neck muscles can form a ridge across the back of the cranium, level with the ears.

Later, draw the skull viewed from in front. Do not introduce detail until you have mastered mass, structure, proportion, and stance. These are the keys to drawing a living head convincingly. Beware of falling into caricature. One way to avoid this is to draw the skull upside down. To do this, you must leave the actual skull the right way up, and transpose it (turn it over) in your imagination. This is challenging, but with patience it works well, and can be practiced whenever you feel your drawing has become stale.

After making no fewer than 10 drawings of the skull, begin to add the soft tissue of the head and neck. Look at, and palpate, your own flesh reflected in a mirror. Locate each bone, and move your face through a range of expressions. Using pages 53 and 55 as a guide, consider each muscle and see how it is masked by fatty tissue.

As your skin creases, observe if lines run in the same or opposite direction to muscle fibers beneath. Feel the cartilages of your throat, and the thick muscles behind and either side of your neck. Trace each of these from their origin to insertion. Then find a model with short hair, illuminate their head, and ask them to stretch their face and neck. See how many angles and poses you can invent, and sketch each one from at least three views. Use different media and abstract the structure of the head and its facial expression into simple elements. Fill an entire sketchbook with 50 or more drawings. Practising such studies will increase the fluency of your drawing and give you confidence in creating fictional heads from your imagination.

The rib cage can be a daunting subject for the artist at first. It takes good observation, practice, and a lot of patience to master its convoluted form. However, like swimming, once achieved, the knowledge of its process stays in the memory, giving solid ground to build upon. I have witnessed the struggle and rage of students trying to understand its shape. I have also seen their joy and accomplishment when the rib cage finally gives up its secrets on their paper. When this complex framework is finally conquered, it gives the artist great insight and confidence in drawing the rest of the body.

DRAWING THE RIB CAGE

Every bone of the rib cage tilts and inflects through three dimensions. There is not a straight line to be found in its tapered construction. Continually in motion, it gently expands and contracts throughout every moment of our lives. Its small neck lies hidden beneath the shoulder girdle, leading many artists to draw a tall box with corners rising into each shoulder. Beautiful but inaccurate square rib cages are found among the pre-scientific illustrations of medieval manuscripts and broadsheets. The lower ribs are covered by thin sheets of muscle, allowing their curvature to be seen through the skin. This helps the artist to locate, imagine, and draw this beautiful structure as it smoothly rises and falls within the body.

DRAWING THE RIB CAGE

Many artists embark on drawing the rib cage by describing in great detail the first pair of ribs. Then they add the second pair beneath, then the third, and so on, growing the sternum as they progress. Some, with great enthusiasm, continue adding ribs and lengths of sternum until they think it all looks long enough. Proportion, scale, and volume never enter the scene. This is not a helpful way to start.

To begin, position an articulated skeleton in good light, raise its arms and tape them above the head, out of the way. Look for and take into account any distortions. Plastic rib cages are often compressed if stored without care. Conversely, real rib cages may appear expanded as cartilages and ligaments no longer hold the bones in tension. If possible, reposition any displaced ribs. Take a notebook and move around the rib cage, making no fewer than 12 non-detailed impressions. Focus on the whole form, its volume and angle in space, not each individual rib.

Draw from in front, to the side, behind, below, and above. As you make more impressions your confidence will grow. Working rapidly will help you to avoid becoming trapped in detail. It may also help to imagine the ribs covered by a fine opaque-white stocking which would bridge, smooth, and eradicate intercostal spaces as intercostal muscles do in life. Or even wrap the actual rib cage with lengths of fine fabric, such as muslin. This will draw attention to smooth contours and conceal distracting detail.

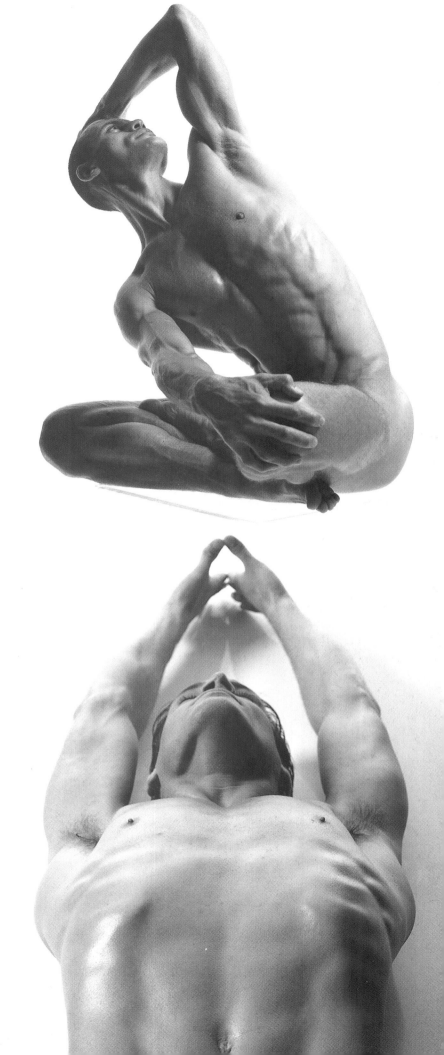

Imagine you are sculpting the rib cage on your paper, cutting a simplified form with only a few strokes of the pencil. You might go on to envisage and draw the shape of the space inside which in life would be filled by the heart, lungs, and liver (p. 39). However, as you become familiar with the its general form, beware of caricature. Quick schematic reductions of the ribs into a series of loops will trip you up later.

Once you have gained a sense of the structure, find a lean friend to model for you, and ask them to take in deep breaths, stretch, and move their arms. Study the model's torso carefully and search for skeletal structure beneath their skin (following the key landmarks mentioned above). On a large sheet of paper, make a life-size drawing of his or her torso, mapping the rib cage within it. Distinguish flesh from bone using a range of marks, and resist the temptation to draw disconnected details.

Use flowing, continuous lines that remain loose and light to encompass and capture the volume and stance of the entire form. Give them plenty of rest breaks. These poses can be surprisingly strenuous, and you do not want to put them off – working with the same model over a period of time can be very rewarding. Make repeated life-size studies from different views using different media, until you feel confident that you understand the shape and dynamic of the rib cage. Stay with its mass and leave aside its detail. It will be worth the wait. A strong and intuitive sense of three-dimensional structure will guide and inform the rendering of detail later.

The word "hip" in English is used as a common term to denote two very different points on the body. Hands placed on the hips rest low on the waist, usually over each iliac crest. The tailors' measurement of the hips, however, is around the widest point of the buttocks, level with the greater trochanter of each femur. These two levels bound the region of the body that contains the pelvis, and that in men and women is considered to be the seat of strength and generative power. The pelvis holds our center of balance when we are standing, and gives a base to our weight when we are seated.

DRAWING THE PELVIS

The complex curvature of the pelvis, its discrete and changeable angle, and concealment deep within flesh of the belly, buttocks, and thighs, must qualify it as the most complicated bone structure to locate and draw. The pelvis closes, cups, and supports the torso, distributes weight to each leg, and suspends genitalia in front, below, and within. Its angle changes dramatically as we move from one stance to another. It rolls forward as the back is arched, and backward the more the spine is straightened. It can be tilted and twisted from side to side, projected forward, or folded under flesh. The angle of the pelvis tells much about the poise of the body, and the poise tells much about its character.

LEFT AND RIGHT

As you locate the pelvis, for example in each of the photographs shown here, focus upon balance and the support of weight. Try to visualize structure in the round. Use knowledge of the back and side of the pelvis to inform a view from in front. As you draw the body, do not see its outline as an abrupt edge at which to stop. Follow through with each line as if leading the eye to a hidden view. The direction, weight, and quality of every line is key to a drawing's expression. A single line should encompass many qualities, and perform several tasks. It might describe surface tension, texture, temperature, speed, light, darkness, emotion, and guide the eye through the composition. Drawings can also be composed in layers. The figures to the right were made in compressed charcoal, a medium that does not completely erase, leaving shadows and traces of earlier thoughts beneath the completed drawing.

DRAWING THE PELVIS

In this class, we will use stretched paper. This is a useful technique to learn. Stretched paper can be worked with any medium, but it is especially effective for ink or watercolor as the paper will remain as taut as a drum.

Put a clean drawing board on a table, and crop a sheet of cartridge paper to fit, leaving a 1in (3cm) border. Cut four lengths of gum strip – brown-paper tape gummed on one side. Take a sponge. Load it with water – enough to be wet, but not dripping. Quickly, gently, wet but do not flood the paper. It will now expand. Moisten each length of the gum strip, and tape the paper to the board, gently pushing out from the center any large waves that appear in the surface. The paper should now look a little buckled all over. Leave it to dry flat. As it dries, it will shrink, pull against the tape, and become smooth and taut.

Use a dip pen and some metal drawing nibs. Avoid mapping pens (smaller, needle sharp, impossible to work with). Invest in some calligraphy inks – black and a range of colors that can be mixed or diluted to build a range of intensity from dark to very light. Graded dilutions of ink can give depth and focus to your drawing. Calligraphy ink will not congeal or block your pen like India ink, which is temperamental, often deterring beginners. Pen (or brush) and ink is a magnificent medium. Before you begin to experiment, look at the drawings of Rembrandt, Hokusai, and Henry Moore to discover its vast but subtle range of expression.

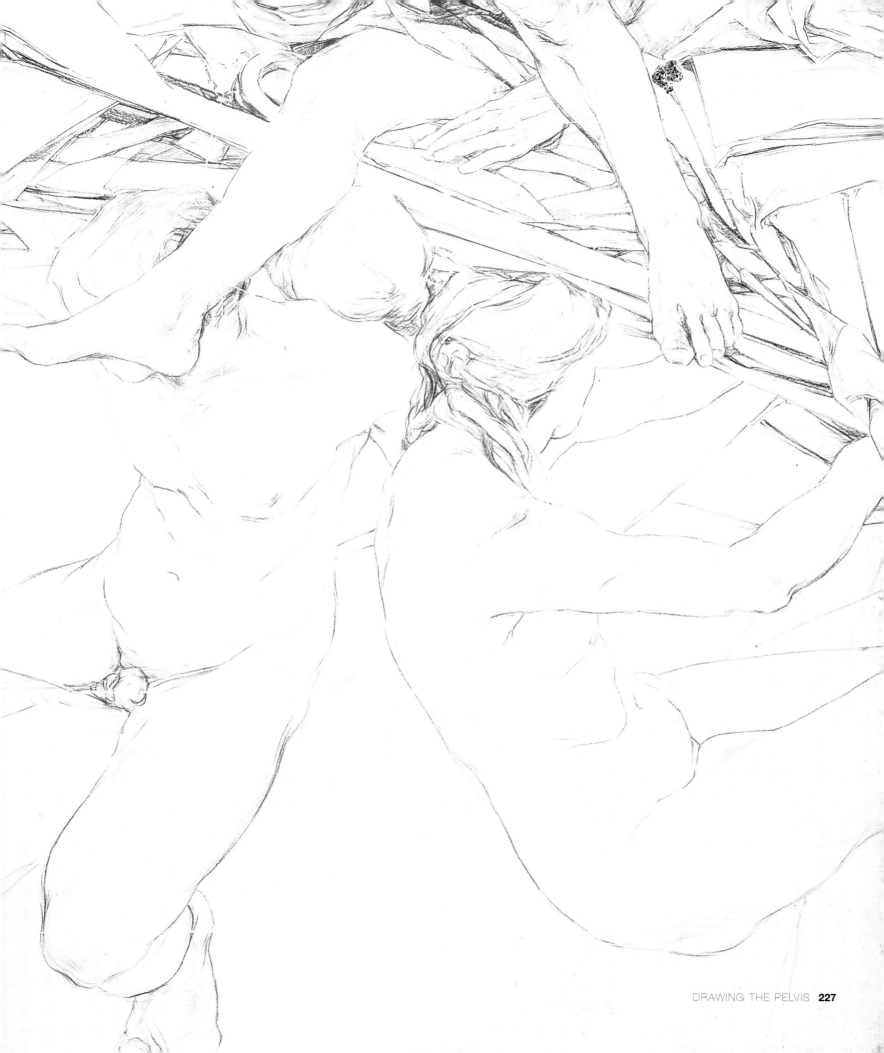

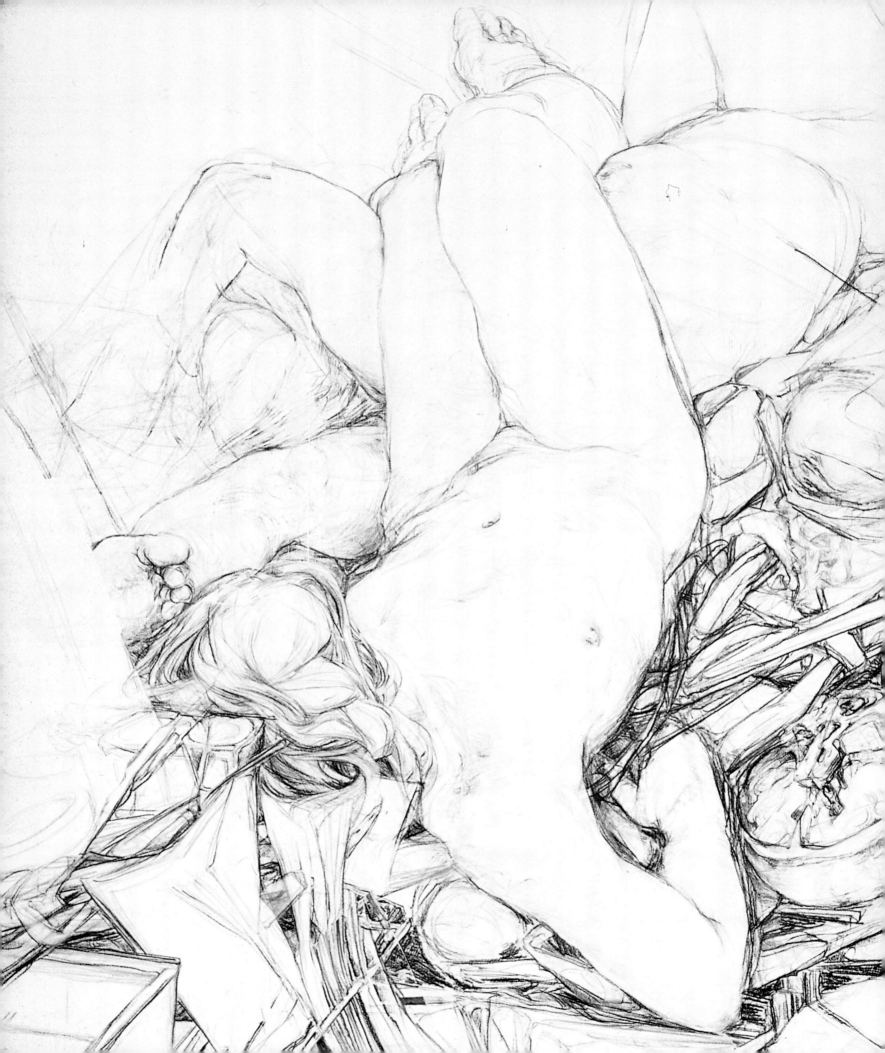

A woman's pelvis is normally wider than her rib cage, and comparable in width to her shoulders (left), and accentuated by a greater covering of fat (left and top right). The male pelvis is the narrowest region of the torso, often defined by the attachment of surrounding muscles (below right). Numerous ancient and modern theories relating to proportion can be used as a guide in drawing the human body, and many artists have held strong views on the subject. Leonardo considered the ideal height of a man to be seven and a half times that of his head, and extraordinarily obsessive analyses of idealized human proportion were made by Albrecht Dürer. However, theories can be hazardous if followed at the expense of observation – they may not apply to the model in view. Measurement, which is an invaluable tool, can begin to steal confidence and stunt the spirit of intuition if it is overused.

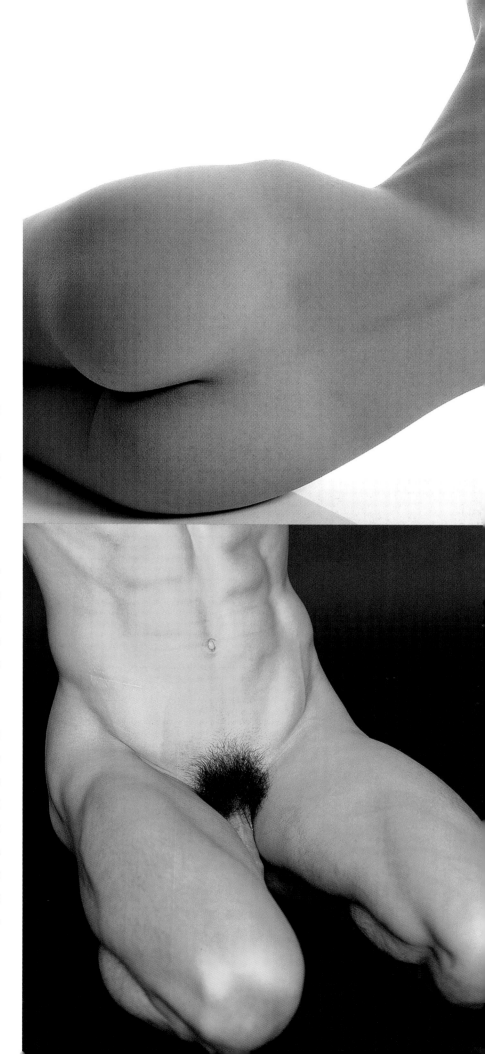

As your paper dries, strongly illuminate the pelvis of an articulated skeleton. Contrast light and shadow to emphasize depth and curvature. Feel the shape of the pelvis in your hands. Use pages 126–134 to locate structural details and envisage significant overlying muscles. Locate your own anterior and posterior superior iliac spines (p. 126), twist your pelvis, and follow its range of movement (see caption on page 128).

If possible, pose a lean male model next to the skeleton and observe how his musculature defines his pelvis. Erector spinae (p. 69) arise in two columns from the sacrum behind. Oblique muscles (p. 84) inserting onto each iliac crest make a gentle horizontal bulge of flesh to each side, while their aponeuroses forming the inguinal ligaments draw sharper lines in front. Think of the stylization of these lines in Greek sculpture.

Once your paper is dry, begin to draw from the skeleton and model simultaneously, and aim to create a full sheet of small exploratory studies (see p. 216). Keep your lines light and free, and make impressions of the whole form. Try to catch the feeling of the pelvis both as a skeletal structure in open space and hidden deep within the living body. Focus on the pelvis's gravity, and rotate it through every imaginable view. Make simple diagrams to break down its structure into essential parts. As you analyze the pelvis, be rigorous but daring and do not be afraid of making mistakes. This is safe visual surgery, and there is no correct way for the drawings to be. Use this class as an exercise in understanding.

Faced with the prospect of drawing hands, some artists are overcome with trepidation. It is not that they are more difficult to draw than other parts of the body, but they have an attached stigma that quells confidence. Many artists hide the hands in their pictures, leave them out altogether, or experience a sudden conversion to expressive abstraction as they reach the wrist. Second only to the face, hands are the most agile and intimately expressive parts of our frame, and this may be why they are considered so hard to draw; their complex structure and emotional significance are entwined and viewed as one.

DRAWING THE HANDS

The first step in learning to draw a hand is to separate its structure from its significance and view it dispassionately – in a simple and objective way. Discovering its interior structure and movement will help you to draw its elusive agility. Look very closely at your both of your own hands. See and feel their bones, tendons, and muscles, the thickened aponeurosis of each palm, dorsal veins, and the coverings of fat and skin. Your wrists will reveal tension in the tendons passing through them. Observe how the distal ends of the radius and ulna create a thickening just at the point where so many artists pinch their lines together in an attempt to show where they feel the forearm should finish and the hand begins.

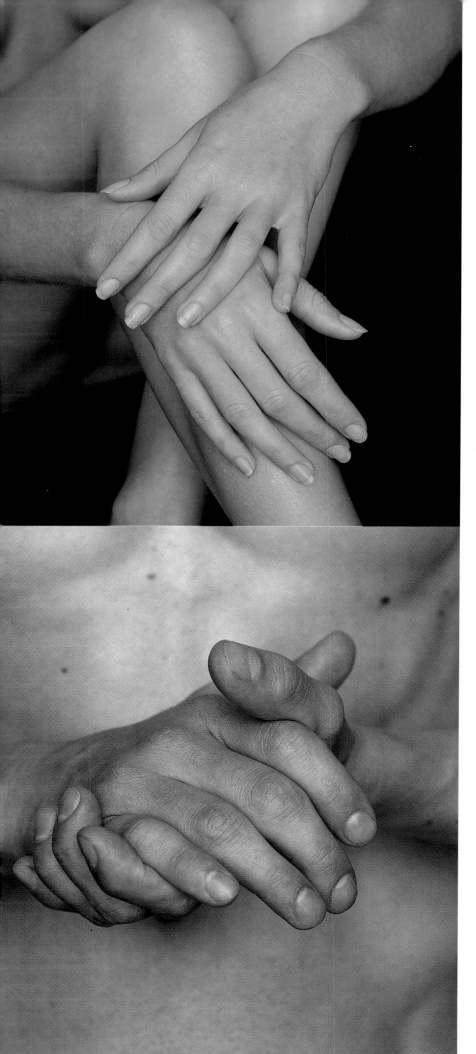

The grace and power, subtlety, and strength of the hand has long been of interest to artists and photographers and it continues to challenge their powers of observation and invention. The touch, gesture, and grip of the hand is often as significant as facial expression. Sometimes, the hand expresses more than the face, and with greater sincerity. On the right are studies of my own left hand that I made in compressed charcoal on paper. I observed the hand directly and reflected in a mirror.

Shown here reduced in size, each image of the hand was in fact drawn life-size. The repeated study of one body part may be equivalent to practicing scales on a musical instrument in preparation for more imaginative and ambitious compositions. In drawing, like many other physical manifestations of endeavor, it is necessary to warm up, and flex the pathways between skill and attainment, imagination and reality. An artist rarely achieves pleasing results from a cold start.

DRAWING THE HANDS

The key to this drawing class is proportion, finding a balance between the fingers and palm, and establishing the size of the whole hand in relation to other elements of the body. The hand in many cultures is itself a tool or unit of measurement; yet, despite this, many artists draw the hands and feet of their figures disproportionately small in relation to the rest of the body.

Take a sheet of 22 x 34in paper and attach it securely to a smooth table. Ensure the paper is flat, so you are not chasing ripples with every line. Choose a delicate medium that you will enjoy drawing with. Pencil can be beautiful, but is not obligatory. Sometimes, its precision amplifies mistakes and this can be daunting. If trying a new medium, experiment on a rough sheet of paper to see what range of marks and textures can be achieved.

The subject of this class is your own hand, so begin by placing the hand you will draw in a supported and comfortable position; one you can easily hold still for some time. Hold your palm open and facing toward you, with your fingers straight but relaxed. Take time to look at it carefully. Then make a life-size drawing of your palm and at least two inches of your wrist. It is important not to separate the hand from the forearm, but consider them as one. As with each previous class, avoid detail. Start by describing the shape, depth, weight, and surface contours of the palm (not just its outline). Imagine your pen or pencil is in contact with the skin and that you are carving the surface. Create close contour lines like those which define

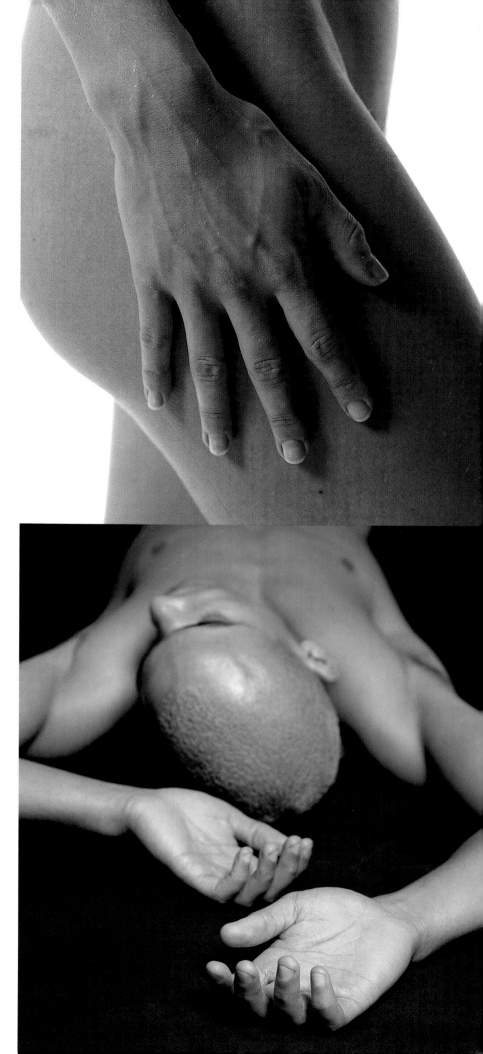

Hands form only a small part of this drawing (left), but they dominate the drama of these entangled figures as they hover in an intimate embrace between life and death. Gently knotted at the focal point of the composition, hands are the fulcrum of the drawing, making a potentially alarming subject strangely affectionate. The power of the hands to influence a work of art emotionally should not be underestimated. According to Vasari, Leonardo engaged in heated debates with his contemporaries about the correct gesture of the Virgin's hands, seeing their accuracy as vital to a painting's meaning. This might seem very distant as you struggle with drawing the hand. But once you have mastered the rudiments, you will be able to experiment with a wide and satisfying vocabulary of gestures. Look at the hands in these photographs, for example. Copy their gesture and give them a metaphorical meaning. Try various different gestures, draw them, and make a book of them – a book of hands.

mountains on a map. This may look alien at first, but once you have grasped the form you can develop other ways of phrasing your lines so that the hand looks more natural.

As you progress to the fingers, beware of relying on their outline. Many students draw lines traveling up and down between each finger, as when we drew around our hands at school before we colored them in. Beyond its rudimentary lesson, this is an unhelpful approach. A series of close lines produces an optical effect that can distort a drawing by appearing to darken and reduce space. It can also be difficult to tell which shape is meant to be solid and which is space. Concentrate on the length and width of each finger in relation to the palm. Map the curvature between each joint and the complexity of surface contours. No two fingers are the same. It may help at first to draw each segment of the fingers as a tapered cylinder, although beware of how stylization can interfere with intuition and observation. Draw your hand repeatedly in the same position. You will soon see improvement, as your understanding grows.

Then draw your hand in more complex positions, cupped, clenched, pressing, pulling, stretching, and holding different objects. The hand using a hammer is very unlike the hand sewing. Draw your own hand by looking directly at it and also use a mirror. Between reality and a reflection you can create almost any left- and right-hand view. Keep all your drawings so that you can see your progress.

MASTERCLASS
A COMBAT OF NUDE MEN RAPHAEL

Raffaello Sanzio (1483-1520), known as Raphael, was a painter, draughtsman, and one of the most influential High Renaissance artists whose attitude and approach to drawing the human figure determined how the subject would be taught across Central Europe and America for the following 450 years.

This fluid drawing made in sharp red chalk has the immediacy of a study produced only yesterday. Its line has a bright intensity that seems modern in its speed and certainty. This image was first laid down with a metal-point stylus, before being overworked in a fine tracery of chalk. Metal point was considered old fashioned and inflexible by many of Raphael's peers, and yet his practiced hand and eye give a gentle vigor to this strange choreography of violence.

As a young artist, Raphael studied fragments of famous sculptures brought back from ancient Greece. He drew from live models and from contemporary works of art. This taught him much about how line, detail, form, and shadow can be used to bend the body convincingly into poignant compositions. He was an obsessive and prolific draftsman. Each of his paintings was meticulously planned using drawings to instruct the work of his assistants. At his death, he left an abundance of drawings for unfinished commissions. His apprentices worked with these, adapting compositions to try and complete works without their master. During his brief career – spanning only 20 years – Raphael became recognized as a supreme master of drawing. Aspiring artists flocked to his studio to apprentice themselves. This was a vital time in Rome. As this drawing was being made, Michelangelo, close by, was painting the ceiling of the Sistine chapel. His influence, together with that of Raphael, helped to shape a form of academic training that would last for more than 450 years. Only in the mid-20th century would this be viewed by modern artists as a repressive and archaic tradition.

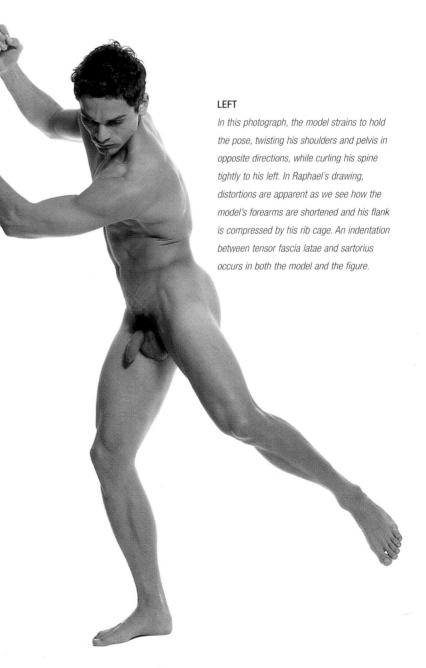

LEFT

In this photograph, the model strains to hold the pose, twisting his shoulders and pelvis in opposite directions, while curling his spine tightly to his left. In Raphael's drawing, distortions are apparent as we see how the model's forearms are shortened and his flank is compressed by his rib cage. An indentation between tensor fascia latae and sartorius occurs in both the model and the figure.

THE FOREARMS

In many of Raphael's drawings, figures of the middle distance are brought close to us by the attention given to details of their flesh and clothing. Here Raphael also distorts scale, proportion, and perspective to increase the drama of the event. Both forearms are heavily exaggerated, the right forearm appearing greater in size than the left (upper) arm. This shift in scale brings the hands forward before they lash down with the stick.

THE TORSO

In this gentle treatment of the subject of war, Raphael avoids the wrought muscularity expressed by Michelangelo and the extreme facial expressions produced by Leonardo. Instead, this body is elongated and dislocated at the waist, to attain elegance and poise, as the thorax is lifted and turned from the pelvis.

THE LEGS

The right leg bears the weight and balance of this body, and yet its muscular tension is underplayed. It is dissolved in light, to allow the darker torso above to be carried forward. Delicately modelled, the raised left leg shows knowledge of several muscle groups. Gluteus maximus and tensor fascia latae form the buttock and hip, and six small chalk marks shade the indentation between tensor fascia latae and sartorius at the top of the thigh. Sartorius catches the light as it divides the adductors from quadriceps.

1509-1511, red chalk over stilus, 15 x 11in, Ashmolean Museum, Oxford

t is all too easy to underestimate the foot – to forget about its focused agility and strength. Pliant acts of dexterity can be performed by the feet. Many people who lose their upper limbs or who are born without them have trained their feet to perform very subtle acts, including writing, drawing, and playing musical instruments. The curbed movement of the toes that most of us experience is essentially related to how we use our feet and not the limitations of anatomy. Training your understanding, sight, and memory of details of the feet will directly inform the expression of your drawing and increase your understanding of other artists' work.

DRAWING THE FEET

Before drawing, watch people's feet working together, say at the swimming baths or on the beach. Look at the spaces and angles between the feet, the way they are directed to express position and character, and how the body's weight is held over them. See how the feet grip or push the surface beneath them – their momentary gravitational position on the earth, and observe the flow of structure and movement from the leg through the ankle and foot to the toes. Consider the similarity of this relationship to that of the forearm, wrist, and hand. Such observations can reveal surprisingly pertinent information about the body in space and its personality in the world.

LEFT AND RIGHT

These are studies I made in compressed charcoal (right). Placing each of my feet on a table I drew them directly and in reflection, using a mirror suspended at various angles. Lighting was essential. I used an anglepoise lamp to increase contrast, and to emphasize the interior structure and textures of skin. When you are drawing the foot, it is important to explore its full range of form and movement. Begin with your own feet, if possible, then ask friends or relatives to sit for you. If you can, compare the feet of a child with those of a senior relative or friend, and observe the differences in youth and age. If you are drawing from photographs of feet such those at left, avoid focusing upon outline, or your drawings will appear flat. If you are drawing the feet of a model in a life class, beware of their soles blackened with charcoal from the floor. Some students will draw this as a natural tonal quality of the foot.

DRAWING THE FEET

It is hugely satisfying to begin a study of the human foot from works of art that inspire you. Dedicate an entire day to the foot, and take a sketchbook to an art gallery. Allow yourself to become totally immersed in its anatomy and expression. Armed with your own anatomical drawings or your copy of this book, look for images of feet and observe the range of their interpretation through painting, sculpture, drawing, or prints.

While sitting in the gallery, fill your sketchbook with carefully observed studies from masterworks. Consider how each artist has understood and defined the essential architecture of bone, ligaments, muscles, and tendons, that give strength, agility, propulsion, and balance to the foot. How are these elements softened or disguised by depths of fat, surface veins, and differing textures, colors, and ages of skin? Use the illustrations here and on pages 140–157 to help identify anatomical details of feet within different works.

Make at least three drawings of each foot that you select. Analyze its proportion, perspective, and movement. The more you draw, the more you will see, and the more you will understand what the artist has done.

If you can become obsessively absorbed your understanding, drawing skills, and confidence will improve rapidly. Collect reproductions of details of the body, and compare one artist's interpretation to another. If you are

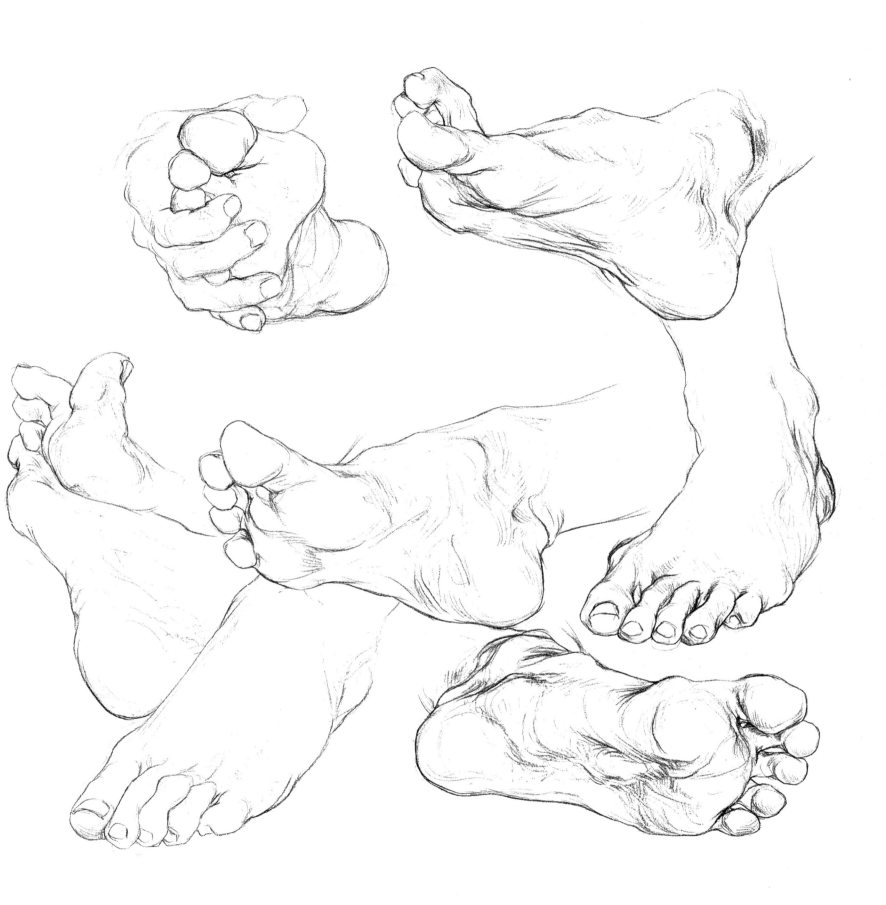

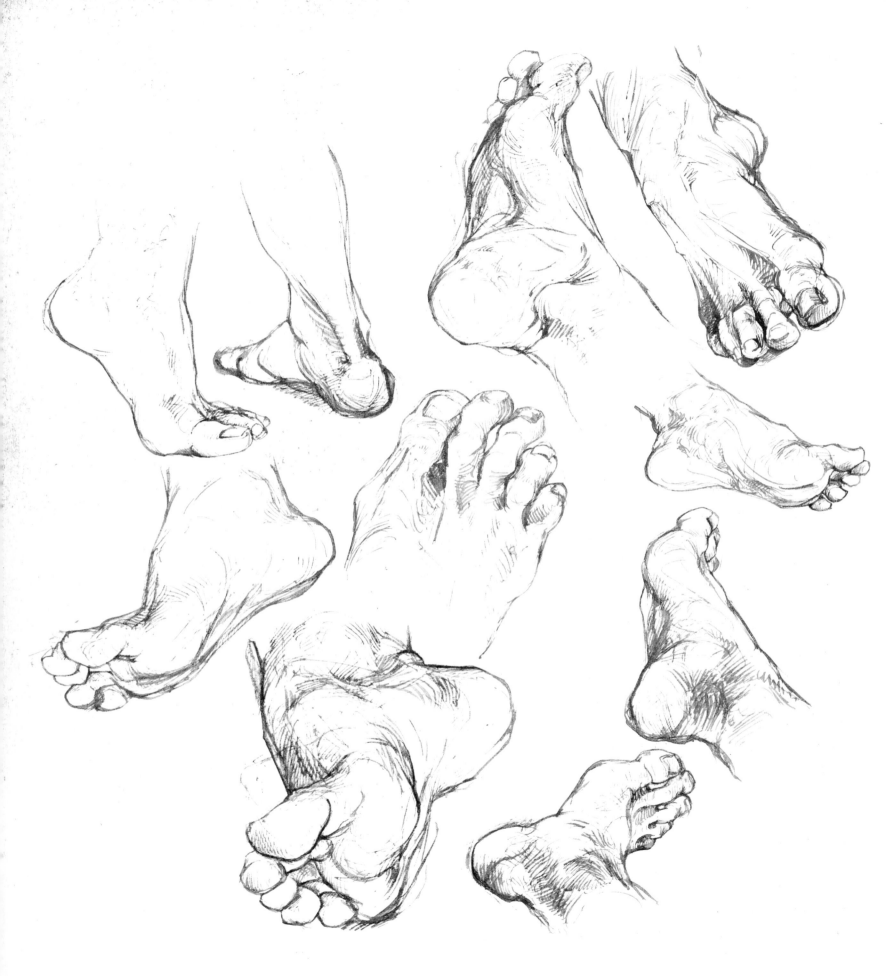

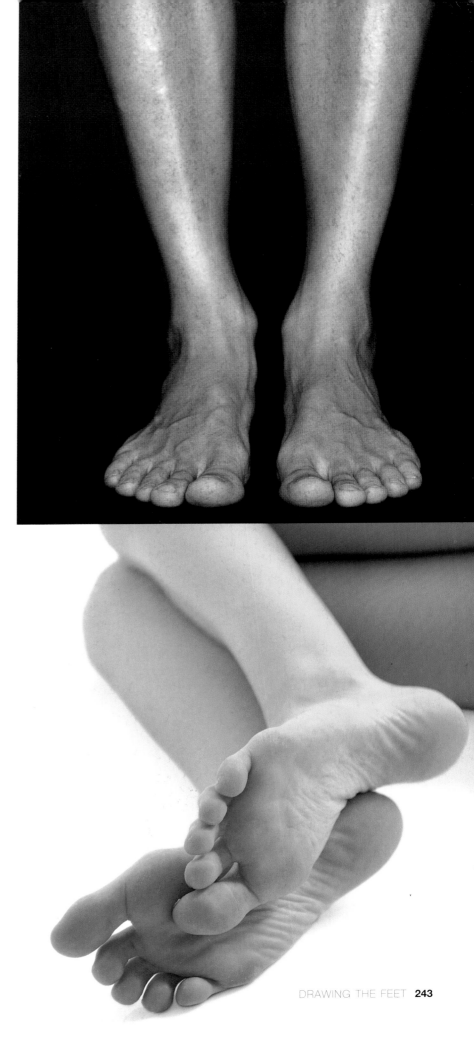

LEFT AND RIGHT

At left are studies of my own feet made with pen and ink. When establishing the proportion of a life model on the page, remember that parts of the body such as the feet may be unexpectedly enlarged or diminished by perspective (see photographs below right, and previous page above left). Taking simple measurements to compare the width or length of one body part to another, will reveal disproportions created by perspective. These might be underplayed if an artist allows their

reason to override what they see. A reclining model presenting their feet toward you, might appear to have feet the same width as their chest, and twice the size of their head. Your knowledge of the size of feet tells you that this cannot be true, and so you might make them smaller, in more reasonable proportion to the torso. Such reasoning can destroy the perspective of an image, and prevent a figure from lying convincingly in space.

seated in front of a sculpture, make a series of drawings in rotation working from one side to the other. If you are studying a painting, observe how the artist has lit the foot. Perhaps its life and movement are given by the illumination of only those elements essential to the view. If so, what are the essential elements of this view, and how do they bring the foot alive? How has light been used to abstract the foot? Subtle abstraction working hand-in-hand with figuration can greatly emphasize the expression of a form. Conversely, in some figurative work, when every minute detail of a subject is described, little is left for the imagination.

On your return to the studio, lay out your drawings or any postcards you have bought, or photocopies you have made so that you can see them all at once. Put together four 22 x 34 in sheets of paper, and tape them to the wall or floor. If possible, take off your shoes and socks so that you can see your own feet. Find a broad drawing medium such as charcoal, crayon, a brush dipped in paint, or a felt pen, and with reference to all your collected information and your own feet, make a drawing of one single foot in side view (medial or lateral) that fills the expanse of the paper. Imagine the foot as big as an entire body. Draw its tensile and arched construction as a monument in space.

Such a leap of scale will force a sense of detachment, present you with a new perspective, demand greater objectivity, and let you see one of the most familiar parts of the body as if it were a completely new subject.

KEY TERMS

Below is a list of terms frequently used in the book, together with explanations of their meaning. The words appearing in italic type refer to other entries in the Key Terms or Glossary on pages 246–249

COMMON TERMS

Anatomy The structure of the body of a living thing, and the study of its component parts. Derived from the Greek for "cutting up"

Anatomical position A position in which the body stands upright with arms to the side and head, feet, and palms facing forward; a reference position that gives meaning to all anatomical directions

Articular Pertaining to a joint or joints

Bilateral symmetry The mirror-image arrangement of the left and right side of the body. Although, in most people, one side of the body is higher or broader or, for example, one foot is slightly bigger than the other

Body planes Three major planes divide the body, lying at right angles to each other: *median*, *coronal*, and *transverse* planes

Median plane The body plane, also called the mid-sagittal plane, that divides the body lengthwise, front to back, into two *bilaterally symmetrical* halves

Coronal plane The body plane, also called the frontal plane, that divides the body from side to side into two halves (a front and a back half)

Transverse plane The body plane, also called the horizontal plane, that divides the body or any of its parts into upper and lower parts

DIRECTIONAL TERMS

Anterior In front, or toward the front, of a body. For example, the *quadriceps* muscle of the thigh is anterior to the femur

Cutaneous Pertaining to or affecting the skin

Deep Extending inward from the surface or backward from the front. For example, the heart is deep to the sternum, or deep muscles are found closest to the bone

Distal Away or farthest from the torso. For example, the fingers are distal to the wrist

Dorsal On the *posterior* surface or back of the body. For example, the dorsum of the hand is the back of the hand

Inferior Below, or toward the feet. For example, the knee is inferior to the thigh

Lateral Toward the side, or away from the *median plane*. For example, the ribs are lateral to the sternum and spine

Medial Toward or nearer to the *median plane*. For example, in the *anatomical position* the ulna is medial to the radius

Median Located on the midline (*median plane*) of the torso or limbs. For example, the sternum lies in the median plane.

Palmar Pertaining to the palm of the hand

Plantar Pertaining to the sole of the foot

Posterior Toward the back or behind. For example, the shoulder blade is posterior to the rib cage

Proximal Near or nearest the torso of the body. For example, the upper arm is proximal to the forearm

Subcutaneous Situated or placed just below the surface of the skin

Superficial Nearer or nearest to the skin. For example, superficial muscles influence the form of the body surface by being near the skin

Superior Above, or toward the head. For example, the nose is superior to the mouth

Ventral On the *anterior* surface, or front, of a body. For example, the navel is on the ventral surface of the torso

BONES

Angle The corner of a bone as, for example, the superior or inferior angle of the shoulder blade

Appendicular skeleton All the bones of the limbs

Axial skeleton All the bones of the skull, spine, thorax, and pelvis

Body The main part of a bone

Condyle A rounded protrusion at the end of a bone, fitting into the *fossa* of an adjoining bone to form a joint

Epicondyle A small protrusion of bone close to or on top of a *condyle* or larger protrusion of bone. Epicondyles are usually sites of muscle attachment

Crest A prominent ridge of bone for powerful muscle attachment

Foramen A natural hole or passage in a bone or other structure, most often to permit the passage of nerves or blood vessels

Fossa A cupped depression in the surface of a bone

Head The distinct and often rounded end of a long bone, separated from the *shaft* of the bone by a neck, for example, as seen in the *superior* end of the femur (thighbone)

Margin The edge of a flat bone or flattened area of bone

Ossify To turn to bone. Ossification is the natural process of bone formation

Process A distinctly raised or projecting part of a bone

Shaft The main length of a long bone

Sinus Any of the air-filled cavities within the skull bones

Spine A sharply pointed crest of bone for muscle attachment

Trochanter A bony outcrop toward the *superior* end of the femur (thighbone) for muscle attachment

Tubercle Any small, rounded protrusion on the surface of a bone

Tuberosity A raised irregular mass on the surface of a bone, usually for strong muscle or tendon attachment

MUSCLES

Abduction The movement of a body part away from the midline (*median plane*) of the body through the *coronal plane*, or of a digit away from the axis of a limb. Muscles that perform this action are called abductors. The opposite of abduction is *adduction*

Adduction The movement of a body part toward the midline

(*median plane*) of the body through the *coronal plane*, or of a digit toward the axis of a limb. Muscles that perform this action are called adductors

Compressor A muscle that compresses a structure when it contracts

Contractibility Muscle tissue's capacity to contract and produce movement

Circumduction Movement of a body part in a circular direction

Depression The lowering of a body part in an *inferior*, or downward, direction, as, for example, when drawing down the shoulders. Muscles that carry out this action are called depressors

Dilator Any muscle that widens an orifice, for example the pupil,or a body part, for example a blood vessel

Dorsiflexion Flexion of the foot at the ankle, as, for example, when lifting it from the floor toward the shin

Elevation Raising a body part upward, as, for example, when raising the shoulders to the ears. Muscles that carry out this action are called elevators

Eversion The turning outward of a body part. Any muscle that turns a body part, for example the foot, outward is called an evertor

Excitability Muscle tissue's responsiveness to nerve impulses

Extensibility Muscle tissue's ability to extend and rest after contraction

Extension Straightening or increasing the angle of the joint

between two bones, for example, straightening the fingers, arms, or legs. Extension is the opposite of flexion. Muscles that straighten joints are called extensors

Fixator Any muscle that holds still or stabilizes one part of the body while another part is being moved

Flexion The act of closing the angle of a joint between two bones, as, for example, when folding the forearm against the upper arm or when making a fist. Flexion is the opposite of extension. Muscles that flex are known as flexors

Hyperextension Stretching a joint beyond its normal range of movement. Double-jointedness is the ability to hyperextend a joint

Insertion The point of attachment of a muscle to the bone or body part that it moves. The opposite of origin

Inversion The turning inward of a body part. Any muscle that turns a body part, for example the foot, inward is called an invertor

Muscle tone The partial activity of the muscles that occurs all the time, even during sleep. When awake, muscle activity slightly above muscle tone helps us to maintain posture

Opposition The muscle action that presses the thumb and fingertips together

Origin The point of attachment of a muscle that remains still during contraction. The origins of long muscle are called heads and they may be multiple, as in the *biceps*, *triceps*, and *quadriceps*

Plantarflexion Pointing the foot downward or curling the toes under

Pronation The turning of the arm or hand so that the palm faces downward. Muscles that carry out this action are called pronators

Protrusion The muscle action of pushing a body part forward, as, for example, when jutting out the lower jaw

Retrusion The opposite of protrusion. Pulling a body part backward, as, for example, when drawing in the chin toward the neck

Rotation Revolving a body part on its own axis, as, for example, when turning the head from side to side. Muscles that perform this action are called rotators

Supination The act of turning an arm or hand so that the palm faces upward. Muscles that carry out this action are called supinators

GLOSSARY

Abdominal cavity The space bounded by the ribs and *diaphragm* above, and the muscles and bones of the pelvis below. The spine and abdominal muscles form the back, sides, and front walls. The abdominal cavity contains the liver, stomach, spleen, intestines, pancreas, and kidneys

Adipose tissue A protective layer of *connective tissue*, chiefly consisting of fat, beneath the skin and around certain internal organs. Also known as panniculus adiposus

Adrenaline A hormone (also called epinephrine) secreted by the adrenal glands of the kidneys in response to stress, exercise, or by emotions such as fear. The hormone increases heart rate, pulse rate, blood pressure, and raises blood glucose levels, preparing the body for a "fight or flight" response

Alveoli Small air sacs in the lungs through the walls of which gases diffuse into and out of the blood during respiration

Annular In the shape of, or forming a ring

Aorta The largest *artery* of the body, arising from the left *ventricle* of the heart and supplying all other arteries (except the pulmonary artery) with oxygenated blood

Apocrine sweat gland A type of sweat gland that discharges thick, pungent sweat and appears after puberty in the skin of hairy body areas, such as the armpits and pubic regions, and in the *areolae* of the breasts

Aponeurosis A wide fibrous sheet of *connective tissue* that acts like a *tendon*, attaching muscle to a bone, a joint, or another muscle

Appendix A worm-shaped structure of no known function attached to the first part of the *large intestine*

Areola A circle of pigmented skin surrounding the nipple

Arteriole A small branch of an *artery*, branching in turn into finer vessels called *capillaries*

Artery An elastic, muscular-walled blood vessel that carries blood away from the heart to all other parts of the body

Ascending colon The first part of the colon, extending up from where the colon is joined to the small intestine to just below the liver, where the colon sharply bends to form the section known as the *transverse colon*

Ascending tracts Nerves in the spinal cord that carry impulses upward to the brain

Atrium Either of the two thin-walled upper chambers of the heart

Auricle Also called the pinna, the external flap of the ear that surrounds the ear hole

Autonomic communications The part of the nervous system that controls the unconscious actions of organs, such as heart rate and contraction of smooth muscle in the intestines. The autonomic nervous system has two divisions: sympathetic, which increases activity in the body, and parasympathetic, which has the opposite effect

Axilla Another name for the armpit

Biceps A muscle that originates at one end as two separate parts. The term usually refers to the biceps muscle in the upper arm, which flexes the forearm

Bile A greenish-brown fluid that helps in the digestion of fats. It is made by the liver and stored by the *gall bladder*, before being released into the duodenum (part of the small intestine)

Bladder The hollow, muscular organ in the lower abdomen that collects and stores urine until it can be expelled

Brachial Pertaining to the arm

Brain stem The lowest part of the brain. It connects to the spinal cord and controls basic functions including heart rate and breathing

Bronchi Air passages that lead from the end of the *trachea* to the lungs and divide into branches known as segmental bronchi, which further divide into bronchioles

Bursa A protective, fluid-filled sac found within joints, between muscles and tendons, and beneath certain points on the skin. Bursae help to reduce friction between moving body parts

Cadaver A corpse set aside for anatomical study

Caecum A blind pouch located at the beginning of the colon

Capillaries Tiny blood vessels that link the smallest *arteries* (arterioles) to the smallest *veins* (venules). Blood and tissue cells exchange nutrients, gases, and wastes across the walls of the capillaries

Cardiac Pertaining to, or situated near, the heart

Cartilage A tough, fibrous *collagen*-rich *connective tissue* that forms an important structural component of many parts of the skeletal system and other structures. There are three

main types: *elastic*, *fibrous*, and *hyaline* cartilage

Cavity A hollow space within the body, such as a *sinus* in the skull, or externally, such as an armpit

Cell The basic structural unit or building block of life. Each person consists of about 100,000 billion cells, structurally and functionally integrated to perform the tasks necessary for life

Cerebrum The largest part of the brain, made up of two hemispheres. It houses centers for thought, personality, the senses, and voluntary movement

Cerebellum A region of the brain below the *cerebrum* and behind the *brain stem*. The cerebellum is concerned with smooth, precise movements and the control of balance and posture

Cervical Pertaining to the neck or any neck-shaped structure, such as the cervix of the uterus (womb)

Circumcision The surgical removal of part or all of the *foreskin*

Clitoris A sensitive, erectile organ that is part of the female genitalia and situated just below the pubic bone and partly hidden by the folds of the labia. The clitoris swells and becomes more sensitive during sexual stimulation

Coccygeal Pertaining to the coccyx, the bone at the base of the spine formed by the fusion of four *vertebrae*

Collagen A tough, structural protein present in bones, *tendons*, *ligaments*, and other *connective tissues*

Colon The major part of the large intestine that extends from the

caecum to the rectum. Its main role is to conserve water in the body by absorbing it from food residues

Connective tissue The material that connects, holds together, and supports the various structures of the body. Bone, cartilage, and adipose tissue are all types of connective tissue

Cornea The transparent dome at the front of the eyeball that covers the iris and pupil

Corona Also called the crown, the circular projecting lip on the glans of the penis, surrounding the opening of the urethra

Comparative anatomy The study and comparison of human and animal anatomy

Cortex The outer layer of certain organs, such as the brain or kidneys

Costal cartilage Hyaline cartilage that forms the anterior extension of a rib

Cranium The part of the skull that encases the brain

Cricoid cartilage The lowermost of the cartilages in the larynx (voice box). The cricoid cartilage connects the thyroid cartilage to the trachea

Cytology The study of the structure and function of individual cells

Deep fascia A thin layer of fibrous connective tissue that envelops all muscles and muscle groups, blood vessels, nerves, joints, organs, and glands

Dermis The inner layer of the skin, made of connective tissue and containing blood vessels, nerve fibres, hair follicles, and sweat glands

Descending tracts Nerves in the spinal cord that carry impulses downward from the brain

Developmental anatomy The study of growth and physical development

Diaphragm A muscular sheet separating the chest from the abdomen. The diaphragm contracts during inhalation, enlarging the chest

Digital Pertaining to the fingers or toes

Dissection The action of separating and cutting a tissue for the purpose of anatomical study

Dorsum The back, or the back or upper outer surface of an organ or body part

Ecorché French term for a flayed body, for the purpose of showing the arrangement of the superficial muscles

Eccrine sweat glands Any of the small sweat glands located in skin all over the body that produce a clear watery liquid important in temperature regulation

Elastic cartilage A flexible type of cartilage that contains elastic fibres. It gives shape to the external ears

Epidermis The outer layer of the skin, thinner than the dermis. The cells of the epidermis flatten and become scale-like toward the surface

Epithelial tissue A tissue of one or more layers of cells that covers the body surface (as skin) and lines most of the hollow structures and organs within the body. The cells of epithelial tissue vary in structure according to their function

Expiratory Pertaining to the expiration, or exhalation, of air from the lungs

Fascia A fibrous connective tissue that covers many structures in the body. There are two main types: superficial fascia (hypodermis) and deep fascia

Femoral Pertaining to the femur (thighbone) or thigh

Fibrous cartilage A type of cartilage found, for example, in the disks between the vertebrae of the spine and in other symphyses

Fissure A narrow split or groove that divides an organ such as the brain, liver, or lung into lobes

Fixative A spray that sets or makes stable the surface of a drawing, usually sold in aerosol canisters. The term is also applied to chemical solutions used for the preservation of a cadaver before it is dissected

Foramen magnum The large opening in the base of the skull through which the spinal cord is connected to the brain

Foreskin Also known as the prepuce, a loose fold of skin covering the glans of the penis when it is flaccid and which retracts when the penis is erect

Gall bladder A small pear-shaped sac lying below the liver, in which bile secreted by the liver is stored

Glans The conical, acorn-shaped head of the penis

Gray matter The regions of the brain and spinal cord composed chiefly of the cell bodies of neurons, rather than their projecting fibres (which form white matter)

Gross anatomy The study of body parts that are visible to the naked eye

Hair follicle A small, deep cavity in the skin that encloses the root of a hair

Hepatic Pertaining to the liver

Histology The study of the structure and function of tissues

Homeostasis The ability of an organism to maintain a relatively constant internal environment by the adjustment of physiological processes

Hormone One of various chemicals, released into the blood from some glands and tissues, that act on tissues elsewhere in the body

Hyaline cartilage A glass-like tough type of cartilage found on joint surfaces that provides an almost frictionless layer over the bony parts of the joint. It also forms the anterior extensions of the ribs and the rings of the trachea and bronchi

Hypodermis Also called the superficial fascia, a fine layer of white fatty connective tissue below the skin

Infrasternal angle The inverted V-shape at the front of the rib cage formed by the cartilage extensions of the lower ribs arching up to meet the sternum. Also called the thoracic arch

Inspiratory Pertaining to the inspiration, or inhalation, of air into the lungs

Integumentary system The skin along with its hair, nails, and the glands responsible for the production of sweat, oils, and breast milk

Intercostal Located between the ribs

Intermuscular septum Any of the thickened sheets of deep fascia that separate muscle groups

Interosseous Located between bones

Intervertebral disk A plate-like disk of fibrous cartilage that lines the joints between the vertebrae. The disks have a hard outer layer and a jelly-like core and act as shock absorbers during movement of the spine

Iris The colored, ring-shaped part of the eye that lies behind the transparent cornea. The iris has a central perforation called the pupil, through which light enters the eye

Keratin A water-repellent protein found in the outermost layer of skin, nails, and hair

Kidneys Two reddish-brown, bean-shaped organs at the back of the *abdominal cavity* that remove wastes and excess water

Labia The lips of the vulva (the female external genitalia) that protect the openings of the *vagina* and *urethra*. There are two pairs of labia: the outer, fleshy, hair-bearing labia majora and the inner, smaller, hairless labia minora

Large intestine A region of the intestines including the *caecum*, *colon*, and *rectum*. In the large intestine, water is extracted from food residues, and the remaining content is later expelled as faeces

Larynx Also known as the voice box, the structure at the top of the *trachea* that contains the vocal cords

Ligament Any short band of tough fibrous tissue that binds two bones together

Linea alba A band of connective tissue (*aponeurosis*) that vertically halves the rectus abdominis (the long flat muscle covering the center of the abdomen)

Linea aspera A pitted ridge along the *posterior* of the femur (thighbone) for muscle attachment

Lunula The crescent-shaped white area at the base of a fingernail

Lymphatic system A network of lymph vessels and *lymph nodes* that drains excess tissue fluid into the blood circulation; it is also involved in fighting infection

Lymph nodes Small oval structures that occur in groups along lymph vessels. They contain white blood cells, which help to fight infection

Magnus Used in the names of muscles to mean large

Major Greater in size

Matrix The non-living framework surrounding the cells of *connective tissue*. Also called ground substance

Melanin The brown pigment that gives coloring to the skin, hair, and the *iris* of the eye

Membrane A thin sheet of tissue that may cover or protect a surface or organ, line a cavity, or separate or connect structures and organs

Meniscus A crescent-shaped disc of *cartilage* found in several joints, for example the knee. Menisci reduce friction during joint movement and increase joint stability

Mesenteric Pertaining to or situated near a mesentery, a fold of the peritoneum (a folded membrane that covers the digestive organs and the inside of the *abdominal cavity*) that fixes the *small intestine* to the rear of the abdomen

Metabolism A collective term for all the physical and chemical processes occurring in the body

Minor Lesser in size

Mons veneris In women, the fleshy protuberance over the pubic arch that is covered in pubic hair

Myology The study of muscles

Nasolabial furrows The creases from the sides of the nose to the corners of the mouth, seen when smiling

Navel A depression in the abdomen marking the point at which the umbilical cord was attached to the fetus during pregnancy. Also called the umbilicus

Neuron A nerve cell that transmits electrical impulses. Neurons usually consists of a cell body with fine branches and a process (nerve fibre)

Nerve A filamentous projection of an individual *neuron* (nerve cell) that carries electrical signals to and from the brain and spinal cord and the rest of the body

Oesophagus The muscular tube extending from the pharynx at the back of the throat to the stomach. Swallowed food passes down the oesophagus

Os A technical name for bone

Osteoblast A bone-forming cell

Osteoclast A large cell found in growing bone that dissolves bony tissue to form canals and cavities in the bone

Osteocyte A mature bone cell

Pancreas A lobular gland behind the stomach that secretes digestive enzymes and hormones that regulate the levels of blood glucose

Paranasal Beside or near to the nose. For example, the paranasal sinuses are in the skull around the nasal area.

Pathological anatomy The study of diseased body structures

Pelvic girdle The ring of bones at the base of the torso to which the femurs of the legs are attached

Periostium A fibrous membrane that covers all the bones of the skeleton except at the surfaces of joints

Peripheral nerve Any nerve leaving the brain or spinal cord, linking them with the rest of the body

Perspective The art or theory of drawing three-dimensional objects on a two-dimensional surface so as to recreate the depth and relative positions of the objects

Physiology The study of how the body functions, including the physical and chemical processes occurring in cells, tissues, organs, and systems, and how they interact

Plastinate A specimen that has been treated by the process of *plastination* for the purpose of anatomical teaching

Plastination A preserving process that involves replacing the water and lipids in biological tissues with a substance known as a reactive polymer, such as silicone rubber or polyester resin, invented by Professor Gunther von Hagens

Plexus A network of blood vessels or nerves

Propioception The internal unconscious system that collects information about the body's position relative to the outside world by way of sensory nerve endings in muscles, *tendons*, joints, and in the organ of balance in the inner ear

Pulmonary Pertaining to or affecting the lungs

Quadriceps The muscle at the front of the thigh that consists of four parts and straightens the knee

Radial Pertaining to the radius (the shorter of the two forearm bones) or the forearm

Rectum A short muscular tube that forms the final section of the large intestine, connecting it to the anus

Rectus A straight muscle; for example, the rectus abdominis in the abdominal wall

Retinaculum A band-like structure that holds a body part in place

Sacral Pertaining to the sacrum, the triangular segment of five fused *vertebrae* that form part of the pelvis

Sclera The white of the eye

Scrotum The pouch that hangs behind the penis and contains the testicles

Sebaceous glands Glands in the skin that secrete sebum, an oil that keeps the skin and hair soft

Sigmoid colon An S-shaped section of the *colon*, situated between the descending colon and the *rectum*

Small intestine The first part of the intestine, consisting of regions called the duodenum, jejenum, and ileum. In the small intestine, digestion is completed and nutrients are absorbed into the blood

Smooth muscle A type of muscle that contracts involuntarily and is found in various internal organs, such as the intestines, and blood vessels

Somatic communications The part of the nervous system that controls the skeletal muscles responsible for voluntary movement

Stratum A layer; for example, a layer of tissue in a body structure

Striated muscle A type of muscle, which appears striped under the microscope, that is skeletal, can be controlled voluntarily, or occurs in the heart (cardiac muscle)

Subclavian Situated below the clavicle (collar bone), usually referring to a blood vessel

Subcostal Situated below the rib cage

Superficial fascia See hypodermis

Suprasternal notch The shallow indentation on the uppermost edge of the manubrium, the upper part of the sternum (breast bone). Also the name given the pit in the flesh at the base of the neck

Sutures The immovable joints found between the bones of the skull

Symphysis A joint in which two bones are firmly joined by *fibrous cartilage*, for example, between the *vertebrae* of the spine and the pubic bones at the front of the pelvis

Synovial fluid A clear lubricating fluid secreted by membranes in joints, *tendons*, and *bursae*

Synovial joint A movable joint that is lubricated by *synovial fluid*

System A group of interdependent organs working together to perform a complex function

Temperature A measure of the heat in a substance or medium. Normal human body temperature is about 37°C (98.6°F), although strenuous exercise or an infection may raise the temperature to about 40°C (104°F)

Temporal Pertaining to or near to the temples of the skull

Tendon A strong inelastic band of *collagen* fibres that joins muscle to bone and transmits the pull caused by muscle contraction

Testicle One of two male sex organs that produce sperm and the male sex hormone testosterone. The testicles hang externally in a sac called the scrotum

Thoracic arch See *infrasternal angle*

Thoracic cavity The space within the walls of the chest containing the heart and lungs

Thorax Another name for the chest

Thyroid cartilage An area of *cartilage* in the *larynx* (voice box) that projects at the front to form the Adam's apple

Thyroid gland An important endocrine gland, situated in the front of the neck, that secretes hormones that help to regulate the body's energy levels

Tibial Pertaining to the tibia (shinbone)

Tissue A group of similar *cells* specialized to perform the same function

Trachea Commonly known as the windpipe, an air tube beginning immediately below the *larynx* (voice box) and running down the neck to end behind the upper part of the sternum (breastbone), where it divides into two *bronchi*

Tract A bundle of nerve fibres arising from a common origin

Transverse colon A section of the *colon*, between the *ascending colon* and descending colon, that loops across the abdomen below the stomach

Triceps The three-headed muscle of the upper arm. Contraction of the triceps straightens the arm

Tympanic cavity The middle ear, which contains the small bones that carry vibrations from the eardrum to the inner ear

Ulnar nerve A nerve in the arm, running down its full length into the hand. It controls muscles that move the fingers and thumb and conveys sensation from the fifth and part of the fourth fingers

Ulnar Pertaining to the ulna, the larger of the two bones in the forearm

Umbilicus Another name for the *navel*

Ureter One of two tubes down which urine flows from the *kidneys* to the *bladder*

Urethra The tube that carries urine from the *bladder* to outside of the body. The urethra is much longer in males.

Vagina The highly elastic muscular passage that connects the uterus to the external genitals

Vein A thin-walled blood vessel that carries deoxygenated blood from the body tissues to the heart

Ventricle Either of the two muscular-walled lower chambers of the heart

Venule A small *vein* that receives deoxygenated blood from the capillaries in tissues and returns it to the heart via larger veins

Vertebra A component bone of the spinal column

Vertebral Pertaining to a vertebra (a bone of the spine)

Vertebral arch A posterior projection on a vertebra (a bone of the spine) that surrounds the *vertebral foramen*

Vertebral foramen A hole enclosed by a *vertebral arch* and the body of the *vertebra* (a bone of the spine) from which it projects. The succession of vertebral foramina behind the *vertebral column* forms the canal that houses the spinal cord

Vertebral column Commonly called the spine, the column of 33 bones called vertebrae that extends from the base of the skull to the pelvis. The vertebral column encloses and protects the spinal cord

White matter Regions of the brain and spinal cord chiefly composed of nerve fibres (projections from *neurons*). See also *gray matter*

Wormian bones Tiny islets of bone occasionally found within a *suture* of the skull

FURTHER READING

The Origins of European Thought about the Body, the Mind, the Soul, the World, Time and Fate, Richard Broxton Onians, Cambridge University Press, 2nd ed. 1954.

Wonders and the Order of Nature 1150 - 1750, Lorraine Daston, Katharine Park, Zone Books, New York, 1998.

Religion and the Decline of Magic, Keith Thomas, Penguin, 1991

The Art of Memory, Frances A. Yates, 1st ed. Routledge & Kegan Paul 1966, reprinted by Penguin 1978.

Discovering the Human Body: How pioneers of medicine solved the mysteries of anatomy and physiology, Dr. Bernard Knight, Heinemann Press, London, 1980.

History of Medical Illustration from Antiquity to AD. 1600, R. Herrlinger, Pitman Press, London, 1970

Galen on Anatomical Procedures: Translation from the Surviving Books with Introduction and Notes, Charles Singer, Oxford University Press 1956, Special edition for Sandpiper Books, 1999.

The Fabric of the Body, European Traditions of Anatomical Illustration, K.B.Roberts, J.D.W Tomlinson, Clarendon Press, Oxford, 1992.

The Body Emblazoned, Dissection and the Human Body in Renaissance Culture, Routledge, London, 1996.

Death, Dissection and the Destitute, Dr. Ruth Richardson, 2nd ed. Chicago University Press, 2001.

Albion's Fatal Tree, Crime and Society in Eighteenth Century England, Allen Lane Press, London, 1975.

An Enquiry into the Causes of the Frequent Executions at Tyburn, Bernard Mandeville, London, 1725.

Jeremy Bentham's self image: an exemplary bequest for dissection, Ruth Richardson, Brian Hurwitz, British Medical Journal, London, Vol. 357, 1987.

Donors' attitudes towards body donation for dissection, Ruth Richardson, Brian Hurwitz, The Lancet, Vol. 346, July, 1995.

The Body in Question, Jonathan Miller, Book Club Associates, 1979.

Western Medicine, An illustrated History, (essays by numerous contributors) editor – Irvine Loudon, Oxford University Press, 1997.

Body Criticism, Imaging the Unseen in Enlightenment Art and Medicine, Barbara Maria Stafford, MIT Press 1993.

Great Ideas in the History of Surgery, Leon M. Zimmerman, Baltimore, 1961.

Picturing Knowledge. Historical and Philosophical Problems Concerning the Use of Art in Science, ed. B. Baigrie, Toronto, 1996.

Books of the Body. Anatomical Ritual and Renaissance Learning, A. Carlino, trs. J. and A. Tedeschi, Chicago and London, 1999.

Medicine and the Five Senses, W. F. Bynum and R. S. Porter, Cambridge, 1993.

The Rhinoceros from Dürer to Stubbs, 1515 – 1799, T. H. Clark, London, 1986.

The Spectacular Body: Science, Method and Meaning in the Work of

Degas, Anthea Callen, Yale University Press, 1995.

Bodily Sensations, D. M. Armstrong, Routledge & Kegan Paul, 1962.

Sexual Knowledge, Sexual Science: The History of Attitudes to Sexuality, Editors Roy Porter and Mikulas Teich, Cambridge University Press, 1994.

Finders, Keepers: Eight Collectors, S.J. Gould, R.W. Purcell, Pimlico Press, London, 1992.

The Quick and the Dead, Artists and Anatomy, Deanna Petherbridge, Hayward Gallery Touring Exhibitions, London, 1997.

Corps à vif, Art et Anatomie, Deanna Petherbridge, Claude Ritschard, Musée d'art et d'histoire, Ville de Genève, 1998.

Le Cere Anatomiche della Specola, Benedetto Lanza, Arnaud Press, Florence, 1979.

The Anatomical Waxes of La Specola, Arnaud Press, Florence, 1995.

Encyclopedia Anatomica, A Complete Collection of Anatomical Waxes, Museo di Storia Naturale dell'Universita di Firenze, sezione di zoologia La Specola, Taschen, 1999.

La Ceroplastica nella scienza e nell'arte, ed. L. Olschki, Atti del I congresso internazionale, Biblioteca della rivista di storia delle scienze mediche e naturali, Vol. 20, 1975.

Le Cere Anatomiche Bolognesi del Settecento, Universita degli studi di Bologna, Accademia delle Scienze, Editrice Clueb, Bologna, 1981.

Two essays: The birth of wax work modelling in Bologna, and The skinned model: A model for science born between truth and beauty, Anna Maria Bertoli Barsotti, Alessandro Ruggeri, Italian Journal of Anatomy and Embriology, Volume 102 - Fasc. 2 - Aprile-Giugno, 1997.

Honore Fragonard, son oeuvre à L'Ecole Veterinaire d'Alfort, M. Ellenberger, A. Bali, G. Cappe, Jupilles Press, Paris, 1981.

The Ingenious Machine of Nature, Four Centuries of Art and Anatomy, M. Kornell, M. Cazort, K.B. Roberts, National Gallery of Canada, Ottawa, 1996.

The Waking Dream, Fantasy and the Surreal in Graphic Art 1450-1900, with 216 plates, Edward Lucie Smith, Aline Jacquiot, Alfred A. Knopf, New York 1975.

L'Ame au corps, arts et sciences 1793-1993, ed. Jean Claire, Reunion des Musees nationaux, Gallimard Electa, Paris, 1993.

Grande Musée Anatomique Ethnologique du Dr. Paul Spitzner, au Musee d'Ixelles, 1979.

Vile Bodies, Photography and the Crisis of Looking, Chris Townsend, A Channel Four Book, Prestel, 1998.

Spectacular Bodies, The Art and Science of the Human Body from Leonardo to Now, Martin Kemp, Marina Wallace, Hayward Gallery, University of California Press, 2000.

Körperwelten, die Faszination des Echten, Katalog zur Ausstellung, Prof. Dr. med. Gunther von Hagens, Dr. med. Angelina Whalley, Institut für Plastination, Heidelberg, 1999.

The Primacy of Drawing, An Artists View, Deanna Petherbridge, South Bank Centre, London, 1991.

The Elements of Drawing, John Ruskin, introduction by Lawrence Campbell, Dover Press, London, 1971.

Drawing, Philip Rawson, 2nd Edition, University of Pennsylvania Press, Philadelphia, 1989.

Drawing in the Italian Renaissance Workshop, Francis Ames-Lewis, V&A Publications, London, 1987.

Techniques of Drawing from the 15th to 19th Centuries, with illustrations from the collections of drawings in the Ashmolean Museum, Ursula Weekes, Ashmolean Museum, Oxford, 1999.

The Nude, Kenneth Clark, Penguin, 1956.

The Science of Art, Optical Themes in Western Art from Brunelleschi to Seurat, Martin Kemp, Yale University Press, 1990.

Art and Illusion, A study in the Psychology of Pictorial Representation, E.H. Gombrich, Phaidon Press, London, 1995.

Eye and Brain: The Psychology of Seeing, Richard L. Gregory, 4th Edition, Oxford University Press, 1995.

Mirrors in Mind, Richard Gregory, Penguin, 1997.

The Human Figure: The Dresden Sketchbook, Albrecht Dürer, Dover, New York, 1972.

The Illustrations from the Works of Andreas Vesalius of Brussels, J. B. Saunders and C. D. O'Malley, World Publishing, Cleveland, 1950.

The Anatomy of the Human Gravid Uterus Exhibited in Figures, William Hunter, Birmingham,1774.

Lives of the Artists, 3 vols, Giorgio Vasari, trans. George Bull, Penguin, 1987.

Drawings by Michelangelo and Raphael, Catherine Whistler, Ashmolean Museum, Oxford, 1990.

The Drawings of Leonardo da Vinci, A. E. Popham, Cape, London, 1946.

Leonardo da Vinci on the Human Body, J. Saunders and C. O' Malley, Henry Schuman, New York, 1952.

The Literary Works of Leonardo da Vinci, ed. J. P. Richter, 3rd edition, 2 vols, London and New York, 1970.

Leonardo da Vinci, The Marvellous Works of Nature and Man, Martin Kemp, Dent Press, London, 1981.

Anatomy and Physiology International Edition, Prof. Dr. Gary A. Thibodeau, Prof. Dr. Kevin T. Patton, 2nd edition, Mosby-Year Book Inc., 1993.

Gray's Anatomy Descriptive and Applied, Henry Gray, 38th edition, 1995

Core Anatomy for Students, Volume 1: The Limbs and Vertebral Column. Volume 2: The Thorax, Abdomen, Pelvis and Perineum. Volume 3: The Head and Neck, Christopher Dean, John Pegington, Department of Anatomy and Developmental Biology, University College London, UK, published by W.B Saunders Company Ltd, 1996.

Sibyls and Sibyline Prophesy in Classical Antiquity. Editors H. W Parke, Brian C McGing, June 1988, Routledge, US.

Interviews with Francis Bacon, David Sylvester, Thames and Hudson, 1975.

DIRECTORY

Istituto di Anatomia Umana Normale, Universita di Bologna, Italy Anatomical waxes by Ercole Lelli 1702–66, Anna Morandi 1716–74, Giovanni Manzolini 1700–55, Ciemente Susini 1754–1814.

Museo Zoologico della La Specola, 17 via Romana, Florence, Italy.

Josephinum, Vienna, Austria, 1,200 piece copy of La Specola, by Fontana and Susini.

Anatomy Museum of The Faculty of Medicine, University of Edinburgh, Scotland.

Hunterian Museum and Art Gallery, University of Glasgow, Scotland. Hunterian Museum, Royal College of Surgeons of England, Lincolns Inn Fields, Holborn, London.

Sir John Soane's Museum, Lincoln's Inn Fields, Holborn, London, England.

Anatomical waxes by Joseph Towne 1808-1879. Private collection. The Gordon Museum, United Medical and Dental Schools, Guy's Hospital, St. Thomas Street, London, England.

The Old Operating Theatre, Museum and Herb Garret, St. Thomas Street London, England.

The Wellcome Trust, 183 Euston Road, London, England. Library and Science-Art exhibitions. Extensive open-shelf libraries.

L'Ecole Nationale Veterinaire d'Alfort, Paris, France. Pathology collection with preparations by Honoré Fragonard (1732-1799). Apocalyptic figures including a dissected woman astride a charging dissected horse.

Comparative Anatomy and Paleontology Galleries, Museum National d'Histoire Naturelle, Paris, France.

Musée Delmas-Orfila-Rouvière, Institut d'Anatomie de Paris. (incorporating the 19th-century collection of Dr. Paul Spitzner).

Musée d'Histoire de la Médecine, Paris, France.

Das Museum vom Menchen, Deutsches Hygiene-Museum, Dresden, Germany.

Körperwelten: Exhibition of works by Gunther von Hagens, Institut für Plastination, Heidelberg, Germany.

Anatomisch Museum, Utrecht University, The Netherlands.

Museum Boerhaave, Leiden, The Netherlands.

Mutter Museum, The College of Physicians of Philadelphia, USA

J.L.Shellshear Museum of Physical Anthropology and Comparative Anatomy, University of Sydney, Australia.

INDEX

ACKNOWLEDGMENTS

The author wishes to express her warmest thanks to the following, for their very generous help, encouragement, and tireless patience.

Elizabeth Allen, Denys Blacker, Tew Bunnar, Vahni Capildeo, Daniel Carter, Brian Catling, Annie Cattrell, John Cordingly, Nelly Crook, John Davis, Mary Davies, Stephen Farthing, Trish Gant, Oona Grimes, Tony Grisoni, Gunther von Hagens, Heather Jones, Phyl Kiggell, Simon Lewis, Neil Lockley, Judith More, Deanna Petherbridge, Louise Pudwell, Karen Schüssler-Leipold, Dianne and Roy Simblet, Anthony Slessor, Kevin Slingsby, Andrew Stonyer, Anita Taylor, Janis Utton, John Walter, Roger White, Nigel Wright. The Department of Human Anatomy and Genetics, University of Oxford, Cheltenham and Gloucester College of Higher Eductation, The Hunterian Museum at the Royal College of Surgeons of England, Institut für Plastination, Heidelberg, The Ruskin School of Drawing and Fine Art, University of Oxford. Wolfson College, Oxford.

PICTURE CREDITS